the
DICTIONARY *of* LOVE

the DICTIONARY *of* LOVE

John Stark

with Will Hopkins and Mary K. Baumann

AVON

An Imprint of HarperCollins*Publishers*

To all the world's lovers – past, present, and future

HarperCollins books may be purchased for
educational, business, or sales promotional use.
For information please write:
Special Markets Department,
HarperCollins Publishers,
10 East 53rd Street, New York, NY 10022.

FIRST EDITION

Designed & Produced by Hopkins/Baumann
Editor: Jennifer Dixon
Consultant: Jeffery A. Naiditch, M.D.
Designers: Wenjun Zhao, Wei Chen, Binbin Li
Copy Reader: Mary Beth Brewer

Jacket Illustration: Clare Mackie © 2006

Library of Congress Cataloging-in-Publication Data
has been applied for.

ISBN: 978-0-06-124213-7

08 09 10 11 SCPCO 10 9 8 7 6 5 4 3 2

About this Book
(Romance & Information)

THIS BOOK DOES NOT CLAIM TO BE THE DEFINITIVE word on love, just as a telescope cannot encapsulate all of the stars. It does, however, offer 26 chapters, A through Z, of words and phrases that were culled from all areas of life and that are associated with the joy and wonder of love, or a good time. All entries are in alphabetical order and not categorized by specific subject matter. A pronunciation guide precedes each definition. Although in a standard dictionary a word may have several meanings, for the purposes of this book it is defined only in terms of how it relates to the subject of love. In no way is this book an attempt to be salacious or vulgar. Still, it does not beat around the bush when it comes to the science and anatomy of lovemaking. Included are names of people, places, and products identified with love and, when appropriate, modern slang words discovered on the Internet and overheard on public transportation. It may not be the last word on love, though it may be a first, of some sort.

LET'S FALL IN LOVE....

aah \\'ä\ *interj* vocal sound that follows orgasm *var* aahhhhhhhhhh

abalicious \a-bə-'li-shəs\ *adj* having hot abs <"That lifeguard's *abalicious*.">

abdomen \\'ab-dəmən\ *n* the part of the body between the chest and the pelvis that's for showing off tan lines <see *HAPPY TRAILS*> and 6-packs **abdominoplasty** \ab-dä-'mə-nȯ-plas-tē\ *n* cosmetic tummy-tuck – see *BODY-LIFT*

Abélard and Héloïse \\'a-bə-ˌlärd-ən(d)-ˈā-lə-ˌwēz\ **a :** the Middle Ages' most famous star-crossed lovers and letter writers <"*Abélard*, you've got mail."> **b :** while a tutor of theology at Paris's Notre Dame Cathedral, Abélard fell in love with his pupil Héloïse, niece of the hot-tempered Canon Fulbert **c :** after Héloïse bore Abélard's child (named Astrolabe, after an astronomical instrument for measuring time), they were secretly married **d :** angry with Abélard for soiling the family's

honor (if not for naming his nephew after an astronomical instrument), Fulbert had Abélard castrated by his henchmen **e :** with his lovemaking days finis, Abélard became a monk and Héloïse a nun and, despite separate cloisters, they maintained a passionate epistolary relationship and are entombed together in Paris's Père Lachaise Cemetery **f :** a sculpture of Héloïse embracing Abélard's severed gonads <called also *nads*> can be found at Paris's Conciergerie prison

absence \\'ab-sən(t)s\\ *n* the undesirable state of being away from one's partner <"*Absence* makes the heart grow fonder." –THOMAS HAYNES BAYLY, 1797–1839>

ABSINTHE DRINKER

absinthe \\'ab-(ˌ)sin(t)th\\ *n* **a :** a green liqueur flavored with the European herb wormwood *(Artemisia absinthium)* that was popular in fin de siècle Paris and New Orleans, where it was called the drink of artists, writers, madams, and lovers and which played a prominent role in the Baz Luhrmann film *Moulin Rouge* (2001) **b :** due to its high alcohol content and evidence suggesting it caused madness, it was banned in the U.S. in 1912 and in most of Europe by 1915 **c :** with modern-day evidence showing properly distilled absinthe to be no more dangerous than ordinary alcohol, its manufacture has been revived in Britain, France, and other European countries, and although still banned in the U.S., it is not illegal to possess, consume, or buy it off the Internet – called also *La Fée Vert* (the green fairy)

absofuckinlutely! \\'ab-sō-'fə-kin-ˌlüt-lē\\ *adv* used to express agreement <"I think Earl and Shakura are going to make it, don't you?" "*Absofuckinlutely!*"> – called also *fuckin' A!*

abstain \\əb-'stān\\ *vb* to temporarily give up sexual activity to heighten sensitivity and increase the force of orgasm <*as in* "Hot and horned up and ready to bust." –CRAIGSLIST>

abuzz \\ə-'bəz\\ *adj* resounding with romantically generated electricity <"They went to lunch – again. The whole office is *abuzz*."> **syn** atwitter

8

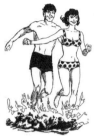

ACAPULCO FUN

Acapulco \ä-kä-'pül-(ˌ)kō\ city, port, beach, and honeymooners' paradise located on Mexico's SW coast and immortalized by Frank Sinatra in the swinging ballad "Come Fly With Me" –SAMMY CAHN/JIMMY VAN HEUSEN <"You just say the words, and we'll beat the birds down to *Acapulco* Bay.">

accessory \ik-'se-sə-rē\ *n* one's boyfriend or girlfriend <"My main cool was bagging on my *accessory*."> *syn* arm candy

accidental touching \ˌak-sə-'den-tᵊl-'tə-chiŋ\ *n* indication of sexual attraction when one "accidentally" bridges a physical gap by gently brushing up against another person, clutches his or her arm to make a point, flicks a speck of dust from his or her shoulder, or touches his or her shoe with one's own shoe under a table

accoutrement \ə-'kü-trə-mənt\ *n* superficial props used by (usu. older) men to attract (usu. younger) women *such as* expensive cars, watches, and time-shares

action \'ak-shən\ *n* **1** : what's happening; what's going down <"There's plenty of *action* here," *as in* nightclub> **2** : implies having made love <"I finally got some *action* last night.">

act of desperation \'akt-əv-ˌdes-pə-'rā-shən\ *n* need-filled cry for attention that invokes a hastily enacted action one later regrets <*as in* "I should not have left it," *as in* phone message>

act of God \'akt-əv-'gäd\ *n* manifestations of the forces of the universe that are difficult to predict *such as* earthquakes, tsunamis, tornadoes, and love at first sight

Adam's apple \'a-dəms-'a-pəl\ *n* the bulge at the front of the human neck that is formed by the thyroid cartilage of the larynx and known to visibly jump in males when females start talking about commitment – called also *laryngeal prominence*

adieu \ə-'dyü\ *n* [French] used by lovers when the emotion of parting seems almost unbearable <"*Adieu*, my darling. I'm off to the bathroom.">

9

SHOOTING HIS CANNON

adolescence \a-də-le-sən(t)s\ *n* a stage of development in a male's life between (roughly) the ages of 50 and 60 that is marked by increased sexual longing and the purchase of expensive toys

Adonis \ə-'dä-nəs\ *n* **1 :** a species of mostly young, often vain, adult male homo sapiens who live in or around the coastal waters of S California **2 :** a young Greek god who had perfect looks and body and was loved by Aphrodite

CALIFORNIA
MALIBU

adore \ə-'dȯr\ *vb* to worship a divine creature or entity <"I *adore* him!" *as in* UPS delivery man>– see *PACKAGE*

adorn \ə-'dȯrn\ *vb* to furnish with beautiful objects <"If you adore her, you must *adorn* her. There lies the secret of a happy marriage." –ANNE FOGARTY, fashion designer>

adrenaline \ə-'dre-nə-lən\ *n* a hormone that acts as a powerful short-term stimulant in times of fear or arousal <*as in* getting the nerve to ask someone out>; the "flight or fight" hormone, it raises the blood pressure, speeds the heartbeat, and causes increased muscle contraction – called also *epinephrine*

adversity \ad-'vər-sə-tē\ *n* the small barriers and annoying inconveniences that intensify emotions by adding friction to a relationship <*as in* "I have to cancel Tuesday night." "But I bought a dress.">

advise \əd-'vīz\ *vb* to counsel or offer suggestions to a friend, relative, or colleague as to the state of his or her romantic relationship <*as in* "You know, you might want to see who else is out there.">

affair \ə-'fer\ *n* a passionate liaison of limited duration between 2 consenting adults <"Charles and I decided to end our *affair*," *as in* husband got wind>

affection \ə-'fek-shən\ *n* **a :** a display of tender admiration for another person, both lasting and spasmodic **b :** signs of affection include hugs, comforting words, and fanny pats among football players

affirmative action \ə-'fər-mə-tiv-'ak-shən\ *n* a thumbs-up sign given by males to signify having scored – see *GETTING ANY?*

AFGE *n* Internet and e-mail acronym for "another fucking growth experience" <"We ended the relationship. *AFGE.*">

Afrodesiac \ˌa-frə-'dē-zē-ˌak\ *n* a sexy African American male

afterglow \'af-tər-ˌglō\ *n* a post-coital radiance that can be observed on lovers' faces – see *WHADDYA THINKING?*

age \'āj\ *n* ascending stages of life during which one can look at the mystery of love from different perspectives <"In youth, it is by the senses that we arrive at the heart; in ripe *age*, it is by the heart that we arrive at the senses." –RÉSTIF DE LA BRETONNE, 1734-1806>

airplane \'er-plān\ *n* a tubular vehicle that has fixed wings and is designed to fly one to romantic places – see
COCKPIT, FLIGHT ATTENDANT, JET ENGINE, MILE-HIGH CLUB

AIRPLANE

aisle \'ī(-ə)l\ *n* the longitudinal division of a church's interior down which a bride holding a bouquet walks on her way to the altar

alabaster skin \'a-lə-ˌbas,tər-'skin\ *n* creamy-pink flesh found on forest nymphs, nuns, and other women who avoid the sun – see *RUBENESQUE*

AFTERGLOW

Alaska \ə-'las-kə\ *n* U.S. state located in the extreme NW corner of North America and whose male population of 324,000 has the nation's strongest sex drive ***source*** *Men's Fitness* "Sex in the U.S.A." study

albatross \'al-bə-'tròs\ *n* **a :** a large oceanic seabird (family Diomedeidae) with a wingspan that can reach 11 ft. and whose parenting skills put other birds to shame **b :** female albatrosses lay only 1 egg a year, which both birds help incubate; both also help raise the fledgling **c :** albatrosses can live more than 50 years and don't become sexually mature until the age of 5 **d :** males often spend years courting a female, during which time the couple will perform intricately choreographed mating dances whose moves are unique to the pair **e :** albatrosses mate for life but quit dancing

alcohol myopia effect \'al-kə-ˌhòl-mī-'ō-pē-ə-i-'fekt\ *n* a state of inebriation in which one unleashes one's truer feelings or traits without immediate regard for the consequences <*as in* "It wasn't me talking, baby – it was the Chivas."> ***syns*** in vino veritas, drunk dialing, drunk text messaging

alias \'ā-lē-əs\ *n* an assumed name for registering at motels

all aboard! \'òl-ə-bòrd\ *interj* anticipatory announcement by a train conductor that romance might be around the next bend, through the next tunnel, or in the dining car

CONDUCTOR

Allen, Peter \'a-lən-'pē-tər\ (1944-1992) flamboyant and sexually charged performer from Australia whose mariachi-playing rendition of "I Go to Rio" had American lovers of the early 1980s doing the samba, the mamba, and the bamba and who was the 2nd husband of Liza Minnelli, from 1967-1972

PETER ALLEN

ALLEN WRENCH

allen wrench \'a-lən-'rench\ *n* **a :** an L-shaped metal bar either end of which fits the socket of a screw or bolt **b :** used by newlyweds to assemble furniture from Ikea

almost \'òl-ˌmōst\ *adv* **1 :** saddest word in the English language **2 :** very nearly

12

<"This time we *almost* made it, didn't we, girl?" –JIMMY WEBB, "Didn't We">

aloha \ə-'lō-(h)ä\ *interj* [Hawaiian] island greeting that means both hello and good-bye and imparts love, compassion, or mercy; saying *aloha ahiahi* (good evening) over mai tais and a pu pu platter can lead to *aloha kakahiaka* (good morning) **aloha Fridays** \ə-'lō-ˌ(h)ä-'frī(ˌ)dāz\ *n* a variation of workplace casual Fridays, when one can wear a Hawaiian shirt to the office and bring in a blender

HULA DANCER

alone \ə-'lōn\ *adj* a temporary condition that can change in an instant <*as in* "I'd like you to meet my cousin."> *syn* unattached

always \'ȯl-wēz\ *adv* to be a constant presence in another's life <"I'll be loving you, *always.*" –IRVING BERLIN, "Always">

A Man and a Woman *(Un Homme et Une Femme)* \ä-'man-ən(d)-'ä-'wü-mən\ *n* (1966, *dir* Claude Lelouch) **a :** definitive French love story and quintessential date movie in which a young widowed actress (Anouk Aimée) falls in love with a young widowed race car driver (Jean-Louis Trintignant), who wears out his clutch driving back and forth to see her **b :** memorable musical score by Francis Lai **c :** Academy Award for Best Foreign Language Film

Ambassador of Love \am-'ba-sə-dər-əv'-ləv\ *n* **a :** the title bestowed upon singer-actress Pearl Bailey (1918-1990) by President Gerald Ford in 1975, when he appointed her Goodwill Ambassador to the United Nations **b :** her signature songs include "Takes Two to Tango" and "She Had to Go and Lose It at the Astor" <*as in* New York hotel>

amen \(')ä-'men\ *interj* a thankful answer to one's prayers <"He finally stopped calling me. *Amen.*">

JENNIFER ANISTON

American Sweetheart \ə-'mer-ə-kən-'swēt-ˌhärt\ *n* a fan-based distinction bestowed upon a movie or TV actress who best represents the vulnerabilities of her particular generation *such as* Jen-

nifer Aniston, Doris Day, Alice Faye, Mary Tyler Moore, and Mary Pickford

American Venus \ə-'mer-ə-kən-'vē-nəs\ *n* the title bestowed upon Audrey Munson (1891-1996), who was a fine arts model and muse for dozens of U.S. civic monuments, U.S. currencies, murals, tapestries, sculptures, and paintings and who shocked movie audiences by appearing nude in early silents and who died at age 105 in a psychiatric hospital in upstate New York, where she lived out the last 65 years of her life

ammunition \ˌam-yə-'ni-shən\ *n* material for use in attacking another or defending one's position on the battlefield of love, which women are known to stockpile for later use <*as in* "That's not what you said to me at the time. Your exact words were....">

amore \ə-'mȯr-ē\ *n* [Italian] a condition that occurs when the moon hits one's eye like a big pizza pie – see *MOONSTRUCK*

amusement park \ə-'myüz-mənt-'pärk\ *n* a commercially operated park that features roller coasters and other thrill-seeking rides that augment the bonding process between lovers by triggering the release of hormones *such as* adrenaline and vasopressin – see *CONEY ISLAND*

amygdala \ə-'mig-də-lə\ *n* **a :** the central command center for the dark side of love **b :** a pair of almond-shaped masses of gray matter located in the brain's medial temporal lobe and linked to the processing of emotions *such as* fear, anger, rage, avoidance, aggression, and defensiveness and whose inner turmoil is reflected outwardly in actions *such as* tensing up during an argument or lovers' quarrel **c :** by prompting the release of adrenaline and other hormones into the bloodstream can cause a perfectly level-headed person to suddenly storm out of a restaurant or slam the bedroom door

An Affair to Remember \ən-ə-'fer-tə-ri-'mem-bər\ *n* (1957, *dir* Leo McCarey) tearjerker movie in which Cary Grant and Deborah Kerr agree after a whirlwind shipboard romance to meet 6 months later

DEBORAH KERR

on the 86th-floor observation deck of the Empire State Building to see if they really are in love; as Kerr is excitedly crossing the street for her rendezvous, she is hit by a cab and paralyzed for life <*as in* "Oh, it's nobody's fault but my own! I was looking up. It was the nearest thing to heaven. You were there." –KERR to Grant> *note* voted by the American Film Institute as the fifth most romantic movie ever made

anal intercourse \'ā-nᵊl-'in-tər-ˌkòrs\ *n* **a** : a sexual act in which the erect penis enters the back door and not the front **b** : even though anal intercouse is usu. associated with gay men <see *HE-SPOT, TOP AND BOTTOM*>, Brazilians, and French, its popularity among heterosexual American couples is growing; the Centers for Disease Control's National Survey of Family Growth reports that 38.2% of men between the ages of 20 and 39 and 32.6% of women between the ages of 18 and 44 engage in the formerly taboo act **c** : the increasing popularity of sexual toys has allowed more heterosexual men to receive anal intercouse from a female partner – see *DILDO (STRAP-ON)* **d** : depictions of anal intercouse can be found on pre-Columbian pottery, medieval Japanese woodcuts, and Roman cameos – called also *buggery, butt surfing, Greek love, sodomy*

anal retentive \'ā-nᵊl-ri-'ten-tiv\ *adj* adult behavior in which one is very rigid, overly organized, and often defiant, which stems from being improperly potty trained and is a leading cause of relationships ending up in the toilet <"I can't be around my girlfriend during the holidays – she suffers from *anal-retentive* Christmas decorating syndrome.">

Ananga Ranga \'an-'aŋ-gə-'raŋ-gə\ *n* **a** : an Indian love manual for married couples by the 15th-c. poet Kalyana Malla, which advocates sexual variety to keep a relationship alive **b** : illustrated positions include Monkey, Crab, and Splitting Bamboo – see *ANIMAL POSITIONS p. 17* **c** : translated into English by Sir Richard Francis Burton in 1885

ancient history \'ān-shənt-'həs-t(ə)-rē\ *n* one's exes <"Don't be jealous. Eric's *ancient history*.">; can also apply to unpleasant events <"Let it go, Brenda. It's *ancient history*.">

and \ən(d)\ *conj* **a :** takes the form of a goading question as to whether or not somebody got any action <"So, we went to dinner last night." "*And...?*"> **b :** used to connect one person to another to form a couple <Mark *and* Lisa>

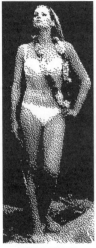

URSULA ANDRESS

Andress, Ursula \'an-drəs-'ər-sə-lə\ (b. 1936, Switzerland) **a :** original Bond Girl and blond bombshell who in *Dr. No* (1962, *dir* Terence Young) makes her iconic entrance from the sea wearing a white bikini, an image that Halle Berry would re-create in *Die Another Day* (2002, *dir* Lee Tamahori) though wearing a red bikini **b :** Andress was married to Hollywood actor/director John Derek, pre-Bo

androsterone \an-'dräs-tə-ˌrōn\ *n* **a :** a pheromone with a smell both pleasant and unpleasant <*as in* woody, ruinous, sweaty, sweetly floral> that is excreted by men and can create a powerful or dominant presence when a manly man enters a room **b :** androsterone can be bought commercially in various forms *such as* colognes and concentrates and is the active ingredient in BoarTaint, a product whose essence causes sows to immediately assume the mating position

angel \'ān-jəl\ *n* **1 :** an unusually understanding female partner <"She took him back. She's an *angel.*"> **2 :** a male who performs an unselfish (and often out-of-character) act for his partner <"He cleaned up the kitchen without being asked. He's an *angel.*"> **3 :** can also imply suspicion <"He's being an *angel*. Something's up.">

ANGEL

animal positions \'a-nə-məl-pə-'zi-shənz\ *n* primitive sexual positions that are designed for pure carnal pleasure and were first described in the *Kama Sutra* and *Ananga Ranga*

ANIMAL POSITIONS

Cat Position The woman kneels down on the floor while facing a chair or wall, which she uses for support. While she arches her back,

CAT

the man caresses her body with his hands, lightly bites her neck, and reaches around to touch her clitoris. This can lead to anal intercourse.

Congress of the Cow The woman places herself upon all fours, supported on her hands and feet but not her knees. Approaching from behind, the man falls upon her waist and enjoys her as if he were a bull.

COW

Dog Position The woman supports herself on hands and knees, allowing the man to enter her from behind.

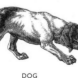

DOG

Elephant Position The woman lies down facing the bed or carpet. The man extends himself upon her. Bending like an elephant, with the small of his back much drawn in, he works underneath her to effect insertion.

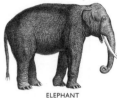

ELEPHANT

ankle bracelet \'aŋ-kəl-'brās-lət\ *n* a sexy ornament worn around a woman's ankle *note* see Barbara Stanwyck's entrance down a staircase in *Double Indemnity* (1944, *dir* Billy Wilder) for maximum effect

anniversary \a-nə-'vərs-rē\ *n* **a :** the annual recurrence of a date marking a notable event in a relationship, when couples book dinner reservations or hotel rooms to celebrate their partnership and rekindle neglected passions **b :** a date that is sometimes forgotten by men <*as in* hell to pay> – see *ANNIVERSARY ELEMENTS p. 18*

Ann-Margret \an-'mär-g(ə-)rət\ (b. 1941, Sweden) **a :** red-haired actress-singer-dancer who projected a sizzling *grrrrrl* next door image and became a star in the film *Bye Bye Birdie* (1963), based on a teen-

17

ANNIVERSARY ELEMENTS

YEAR	ELEMENT	YEAR	ELEMENT
First	Paper	Thirteenth	Lace
Second	Cotton	Fourteenth	Ivory
Third	Leather	Fifteenth	Crystal
Fourth	Fruit/Flowers	Twentieth	China
Fifth	Wood	Twenty-Fifth	Silver
Sixth	Candy/Iron	Thirtieth	Pearl
Seventh	Wool/Copper	Thirty-Fifth	Coral
Eighth	Bronze/Pottery	Fortieth	Ruby
Ninth	Pottery/Willow	Forty-Fifth	Sapphire
Tenth	Tin/Aluminum	Fiftieth	Gold
Eleventh	Steel	Fifty-Fifth	Emerald
Twelfth	Silk/Linen	Sixtieth	Diamond

ANN-MARGRET

age girl's crush on a fictionalized Elvis Presley **b :** in real life she did have an affair with The King, who she co-starred with in *Viva Las Vegas* (1964), the same year she made 2 other sexy cult classics, *Kitten With A Whip* and *The Pleasure Seekers* **c :** married to actor Roger Smith since 1967

anorgasmia \'a-nər-'gaz-mē-ə\ *n* the inability to have an orgasm, which is often caused by antidepressants, particularly selective serotonin reuptake inhibitors <*as in* "Courtney, it's not you. It's my SSRIs.">

anterograde amnesia \'an-tə-(ˌ)rō-ˌgrād-am-'nē-zhə\ *n* **a :** the ability to recall events from long ago but not what happened the night before **b :** can be brought on by margaritas

18

anticipation \(ˌ)an-ˌti-sə-ˈpā-shən\ *n* the waiting period between answering a personal ad and receiving a response

anxiety zones \aŋ-ˈzī-ə-tē-ˈzōnz\ *n* parts of the body that one feels uncomfortable about as swimsuit season approaches

ape fest \ˈāp-ˌfest\ *n* a party for singles in which a disproportionate number of men are in attendance *syn* sausage party

aphrodisiac \ˌa-frə-ˈdē-zē-ˌak\ *n* a food, beverage, or other digestible agent that is thought to arouse sexual desire or increase fertility and that historically has included almonds, anise, arugula, asparagus, bananas, basil, carrots, chocolate, eggs, mustard greens, pistachios, snails, and turnips and, because Aphrodite, the inspiration for the word, came from the deep, any kind of seafood, including shellfish and caviar

••••••••••••••••••••••••••••••••••••••

NATURAL APHRODISIACS
ArginMax A multivitamin that contains ginseng, ginkgo, damiana, and the sex-critical amino acid L-arginine, it is reported to raise women's libidos.

Damiana *(Turnera aphrodisiaca)* An herb whose leaves are made into tea. To make a love potion, soak 1 oz. dried damiana leaves in 1 pt. vodka for 5 days. Strain through a coffee filter; store vodka in a cool place. Soak damiana leaves in ¼ pt. springwater for 5 more days. Strain through a coffee filter. Discard leaves. Heat water enough to dissolve ¾ cup honey. Allow water to cool, then mix with vodka; store in a glass bottle. Drink 1 or 2 cordial glasses before having sex.

Ginkgo *(Ginkgo biloba)* Taken from the leaves of ginkgo trees, ginkgo extract has been shown to improve overall circulation. It also increases blood flow into the genitals.

GINKGO

Ginseng Root *(Panax schinseng)* Besides claims of increasing longevity and lowering cholesterol, studies show that ginseng root can improve erections.

Maca *(Lepidium meyerii)* An Andean ground cover that grows at elevations over 13,000 ft., whose

GINSENG

19

tubers have been credited with boosting libido and fertility as far back as the Incas.

Muira Puama *(Ptychopetalum olacoides)* Extracted from the bark of an Amazonian shrub, people indigenous to that region drink muira puama tea and rub it onto their genitals. It has been said to improve sexual function and intensify orgasms. To make the tea, boil 2 tbsp. of powdered muira puama bark in water for 15 mins. and drink (hot or cold) before bedtime.

Yohimbe *(Coryanthus yohimbe)* For centuries the bark of the W African yohimbe tree has been reputed to restore faltering erections. Studies show that yohimbine, a chemical in the bark, increases blood flow to the penis. The Food and Drug Administration has approved yohimbine as a prescription treatment for erectile problems. The herbal extract is available in several drugs, including Yocon and Yohimex.

••

Aphrodite \ˌa-frə-ˈdī-dē\ *n* **a :** Greek goddess of love and beauty who was Cupid's mom and lover of Adonis and who was born of the sea from the severed genitals of Uranus, which had been tossed out with the tide **b :** she is rumored to have been vain, ill-humored, and testy – called also

Venus (Roman), Ishtar (Mesopotamian), Hathor (Egyptian), and Turan (Etruscan)

APHRODITE

20

apple \\'a-pəl\\ *n* **a :** a fleshy red, yellow, or green fruit (genus *Malus*) that when bitten into makes a crisp, erotically charged sound

APPLE

b : the original forbidden fruit that made Adam and Eve body conscious once they partook of it <*as in* "Does this fig leaf make me look fat?"> **c :** in ancient Greece, a man who wanted to propose to a woman would reportedly toss her an apple; if she caught it, she would accept **apple q** *vb* to end a relationship based on the Macintosh Apple "quit" command function <"I wish I knew how to *apple q* you."> **apple z** *vb* to escape from something based on the "undo last" command function of the Apple computer <"He *apple z'd* her at the altar.">

approach \\ə-'prōch\\ *n* a strategy for getting what one wants from his or her partner <"It's all in the *approach.*"> ***vars*** "You never want to try anything new in bed," *as in* losing approach; "You're such a tiger – let's misbehave!" *as in* winning approach

après-ski \\'ap-rə-'skē\\ [French *after ski*] a romantic period of relaxation that takes place at ski lodges, when people wear après-ski attire, drink brandy, and check each other out in the fire's glow

April \\'ā-prəl\\ *n* **a :** the 4th month of the Gregorian calendar, when spring, cherry blossoms, and passions are in full bloom **b :** declared National Poetry Month in 1996 <"The *April* winds are magical / And thrill our tuneful frames; / The garden-walks are passional / To bachelors and dames." –Ralph Waldo Emerson, 1803–1882> **c :** a time lovers prefer to spend in Paris

apron \\'ā-prən\\ *n* a protective garment that men wear to cook romantic meals for their lovers <"I'm convinced that wearing an *apron* is a turn-on for women. It's one of the moves that gives the impression that you're domesticated, and the allure of domestication can be irresistible." –Rocky Fino, author, *Will Cook for Sex: A Guy's Guide to Cooking*>

aqua box \\'ä-kwə-'bäks\\ *n* a small container from Tiffany's that can hold a big surprise <*as in* engagement ring or wedding ring>

Arabian Nights \ə-'ra-bē-ən-nīts\ *n* **a :** a medieval collection of Persian, Arabian, and Indian folktales that are big on nuanced eroticism, feats of derring-do, and

AN ARABIAN NIGHT

blood and gore and in their unexpurgated forms are not the stuff of animated Disney features **b :** translated into English in 1885 by Sir Richard Francis Burton as *The Book of the Thousand Nights and One Night*, they comprise 16 volumes that include *The Seven Voyages of Sinbad the Sailor*, *Ali Baba and the Forty Thieves*, and *Aladdin and His Lamp*

arch \'ärch\ **1 :** *n* a curved structure covered with flowers that couples who have just gotten married stand under to have their portraits taken **2 :** *vb* [Australian slang] to curve one's back in a catlike gesture that communicates a desire for sexual activity <"She was *arching* her way to the barby.">

argument \'är-gyə-mənt\ *n* a dispute (usu. unimportant) between 2 parties that must be resolved before said parties can go to sleep that night <*as in* "Never go to bed mad. Stay up and fight." –PHYLLIS DILLER>

arms \'ärmz\ *n* the upper limbs of the human torso that are situated between the shoulders and the hands and are comprised of the upper arm bone (humerus), forearm bones (ulna and radius), and wrist bone (carpus) and are used for performing manipulative tasks *such as*

ARM

holding and caressing the object of one's desire <"What are these *arms* for? What are my charms for? Use your imagination." –GEORGE AND IRA GERSHWIN, "Just You Just Me">

arousal \ə-'raůz-əl\ *n* **a :** sexual stimulation resulting from elevated levels of dopamine, testosterone, norepinephrine, and hope **b :** arousal tends to manifest itself in 3 stages that can be different for males and females

arrange \ə-'rānj\ *vb* **1 :** to position one's penis on either the right or the left side

22

of one's testicles <"While Duboce *arranged* his penis to the right, Marcus *arranged* his to the left."> **2 :** to make a bouquet <"She *arranged* the flowers before he arrived."> **3 :** to rendezvous <"He *arranged* to meet her at Starbucks."> **arrangement** \ə-'rānj-ˌmənt\ *n* an informal agreement <"They had an unusual sleeping *arrangement*.">

Arrowsmith, Percy and Florence \'er-(ˌ)ō-'smith-'pər-sē-ə(n)(d)-flȯr-ən(t)s\ **a :** a British couple who hold the record for having been married longer than anyone else (80 years), having tied the knot on June 1, 1925, in Hereford, England (Percy died in 2005, at age 105) **b :** the secret of their marital success: "If you have a quarrel, you make it up - never be afraid to say sorry." –Florence; "Saying yes, dear." –Percy *source Guinness Book of World Records*

．．．．．．．．．．．．．．．．．．．．．．．．．．．．．．

STAGES OF AROUSAL

	Women	Men
One	Attraction	Attraction
Two	Desire	Desire
Three	Intimacy	Over

．．．．．．．．．．．．．．．．．．．．．．．．．．．．．．

ascend \ə-'send\ *vb* to feel elated by someone's love <"I saw your face, and I *ascended* out of the commonplace and into the rare." –Robert Wright/George Forrest, "Stranger in Paradise">

ashram \'äsh-rəm\ *n* a secluded dwelling of a Hindu guru where one can light candles and chant all day or night and not have to talk to anyone and a good place to look for one's ex-girlfriend after a difficult breakup

as if \'as-'if\ *interj* a reply to someone who thinks he or she has a chance with someone really hot

asshole \'as-(h)ōl\ *n* a man who sleeps with his ex-girlfriend's best friend after a breakup **assoholic** \'as-ō-'hȯ-lik\ *n* a male partner who continues to embarrass or upset others despite being told to knock it off <"The *assoholic* just doesn't get it.">

assignation \ˌa-sig-'nā-shən\ *n* a quickie with class; a nuanced nooner; euphemism for a secret meeting or rendezvous <"Dorothea had an *assignation* with her office temp.">

attached \ə-'tacht\ *adj* belonging to another; spoken for <"Don't bother; he's *attached*."> **attached at the hip** \ə-'tacht-at-<u>th</u>ə-'həp\ *adv* to be extremely attached (often annoyingly so) to another <"You can never see her without him. It's like they're *attached at the hip*."> **attachment** \ə-'tach-mənt\ *n* **a :** warm secure feelings that couples experience in the later stages of infatuation that are caused by the triggering of feel-good endorphins in the brain **b :** for these feelings to grow, couples must always find new thrills, such as taking trips, having children, giving massages, or going to motels (*note* with each other)

attention \ə-'ten(t)-shən\ *n* a condition of readiness that requires receptivity <"Her showing up at his office sure got his *attention*."> **attention shoppers!** \ə-'ten(t)-shən-'sha-ˌp̈ərz\ *interj* an expression used when someone who is shamelessly promoting his or her body parts walks by **focused attention** \'fō-kəst-ə-'ten(t)-shən\ *n* the ability to con-

ATTENTION

centrate solely on another <*as in* "The moon may be high, but I can't see a thing in the sky." –AL DUBIN/HARRY WARREN, "I Only Have Eyes for You"> **full attention** \'ful-ə-'ten(t)-shən\ *adj* used when describing an erect penis <"In seconds he went from half-mast to *full attention*.">

Attention Deficit Disorder \ə-'ten(t)-shən-'de-fə-sət-(ˌ)dis-'ȯr-dər\ *n* a neurological condition whose symptoms include difficulty with time management, impulsive actions, careless behavior, and the inability to focus on the task at hand and often misdiagnosed as love – called also *ADD*

attraction \ə-'trak-shən\ *n* the force that moves one object toward another <*as in* "Why don't you come up sometime and see me?" –MAE WEST to Cary Grant in *She Done Him Wrong*, 1933, *dir* Lowell Sherman> **that's attractive** \thəts-ə-'trak-tiv\ *interj* a verbal reaction to a date who belches or passes gas

aubade \ō-'bäd\ *n* a song to greet the morning that lovers sing to each other when they wake up

HARK! hark! the lark at heaven's
 gate sings,
And Phoebus 'gins arise,
His steeds to water at those springs
On chaliced flowers that lies;
And winking Mary-buds begin
To ope their golden eyes:
With everything that pretty bin,
My lady sweet, arise!
Arise, arise!
 –WILLIAM SHAKESPEARE, *Cymbeline*,
 Act II, Scene II

August \\'ȯ-gəst\ *n* the 8th month of the Gregorian calendar, named for Augustus (*aka* Gaius Julius Caesar Octavianus), founder of the Roman Empire; when nature is at its fullest, and love, like tomatoes, peaches, plums, and blueberries, at its ripest

Auld Lang Syne \\'ȯl(d)-'laŋ-'sīn\ *n* a poem by Scotsman Robert Burns (1759-1796), whose words about "old times remembered" are sung at New Year's parties shortly after the stroke of midnight to break apart people who are still kissing

aura \\'ȯr-ə\ *n* a multilayered energy field that surrounds the body and encloses the 7 other chakras, giving a truly loving person a vibrant presence and shimmering glow – called also *Eighth Chakra*

au revoir \ˌȯr-ə-'vwär\ *interj* [French] a leavetaking of lovers that implies a passionate or tearful reunion <"Off to the car wash. *Au revoir* but not good-bye!">

aurora borealis \ə-'rȯr-ə-ˌbȯr-'a-ləs\ *n* a luminous phenomenon caused by overly excited atoms, which occurs after dark when 2 magnetic bodies come together – called also *northern lights*

autonomic nervous system \ˌȯ-tə-'nä-mik-'nər-vəs-'sis-təm\ *n* **a :** the part of the nervous system that regulates one's involuntary vital functions *such as* how hard one's heart pounds, how much one perspires, and whether or not one blushes or (in males) sports a boneroni <see *ERECTION*> when one counters eye candy or a bomb diggity **b :** the autonomic nervous system also regulates the dilation of one's pupils in dark places *such as* bars, movie theaters, or bistros, so that one can get a better look at a potential

love object **c :** called also *ANS,* the system is composed of 2 main subsystems, the sympathetic nervous system (SNS) and the parasympathetic nervous system (PNS), which act both in unison *and* in opposition to each other to maintain the body's homeostasis; in general, the SNS speeds things up, so that one can make a quick escape from a party or annoying suitor, while the PNS slows things down, so that one can cuddle with one's lover while dinner digests

autumn \'ȯ-təm\ *n* a period of time in the northern hemisphere that extends from the September equinox to the December solstice, during which lovers can choose from a multitude of photo ops to build memories upon *such as* carving pumpkins, leaf peeping <see *BED-AND-BREAKFAST*), attending college football games, or cross-dressing <*as in* Halloween> **autumnal** \'ȯ-təm-nəl\ *adj* used to describe a mature woman or smokin' mama <"Her *autumnal* beauty fulfilled its vernal promise."> **Autumn in New York** \'ȯ-təm-'in-'nü-'yȯrk\ *n* **a :** bittersweet romantic ballad written by Vernon Duke that captures the melancholy confluence of being in New York City in the fall and longing to be in love <"It's *autumn in New York* that brings the promise of new love. *Autumn in New York* is often mingled with pain."> **b :** made famous by Billie Holiday, Frank Sinatra, Ella Fitzgerald, and other crooners

••

ON AUTUMNAL BEAUTY

No spring nor summer beauty hath
 such grace,
As I have seen in one autumnal face.
 –JOHN DONNE
The autumn of a beauty like hers is
 preferable to the spring in others.
 –LORD BYRON
Take the green who will, but ripe fruit
 for me.
 –RICHARD BRINSLEY SHERIDAN

••

Avalon, Frankie \'a-və-ˌlän-'fraŋ-kē\ (b. 1939, Philadelphia) singer-heartthrob-actor of the 1950s who was often paired with Annette Funicello and whose *oeuvre de la plage* includes *Beach Party* (1962), *Operation Bikini* (1963), *Muscle Beach Party* (1964), *Beach Blanket Bingo*

FRANKIE AVALON

26

(1965), *How to Stuff a Wild Bikini* (1965), and *Dr. Goldfoot and the Bikini Machine* (1965) – see *BIKINI*

average \'a-v(ə-)rij\ *adj* the norm <"Just an *average* hardworking guy."> ***note*** studies show that when men and women are asked what physical traits they would like in a mate, most reply nothing too extreme <*as in* "not too beautiful" and "not too handsome">

aviator sunglasses \'ā-vē-ˌā-tər-'sən-ˌgla-səz\ *n* a lightweight, 2-lens convex shield that rests atop the nose to protect the eyes from the sun, which gives even the nerdiest of males a mysterious *je ne sais quoi* – called also *Ray-Bans*

awake \ə-'wāk\ *adj* a biological symptom of infatuation in which natural amphetamines rev up the brain so that lovers can stay up late together talking about themselves to someone who acts interested and isn't yawning

awareness \ə-'wer-ˌnes\ *n* being perceptive to what one's partner really wants or is hinting at <*as in* "You don't like it, do you? Fine. I'll take it back," *as in* wrong birthday present>

••••••••••••••••••••••••••••••••••••••

AWARENESS EXERCISE

Both partners sit naked on the floor facing each other. While one is blindfolded, the other feeds him or her various aromatic foods, such as strawberries, orange slices, or chocolates.

••••••••••••••••••••••••••••••••••••••

awkward moment \'ò-kwərd-'mō-mənt\ *n* a situation that occurs when one runs into someone he or she had a 1-night stand with but can't recall his or her name – called also *boy was I drunk*

awrightawready! \ò-'rīt-ò-'re-dē\ *interj* a male's eventual response to a female's repeated request

ayooga \ī-'yü-gə\ *vb* to have oral sex, or go down on someone <"He *ayooga'd* her on the second date."> ***note*** derived from the sound a submarine makes before submerging

SUBMARINE

27

babe ratio \'bāb-'rā-(ˌ)shō\ *n* the proportion of people (male or female) that one finds attractive versus the total number of people in a room

babyfacekilla \'bā-bē-fās-'ki-lä\ *n* a guy with little or no facial hair who is super-cute, has a big, winning smile, and who women can't refuse <"Let's take Bobby along for bait. No woman can refuse that *babyfacekilla*.">

baby phase \'bā-bē-'fāz\ *n* an arrested stage of development in which a man thinks of his significant other as his mother and when away from his partner can't be faithful because he needs his mommy ***source*** Carol Botwin, author, *Men Who Can't Be Faithful*

baby talk \'bā-bē-'tȯk\ *n* a non-standard speech form that uses phonetically modified sounds, the substituting of *l* and *r* with *w*, and glissandolike rises in pitch that lovers communicate with during the throes of infatuation ***note*** can cause severe nausea in friends <*as in* "We go bye-bye now.">

backfire \'bak-fī(-ə)r\ *vb* the reverse result of a plot whose desired effect was to make a boyfriend or girlfriend jealous <*as in* "I told her I was getting calls from other girls and she said, 'Oh really? I've been getting calls from other guys, so now we can start seeing other people.'"> - see *WAH-WAH*

Bagemihl, Bruce \'ba-gə-mēl-'brüs\ Seattle scientist, linguist, and author whose 1999 book *Biological Exuberance* documents 470 species of animals that engage in gay and lesbian behavior *such as* pygmy chimpanzees <see *BONOBO*>, Asian macaques, bottlenose dolphins <see *FLIPPER*>, flamingoes, giraffes, vampire bats, whiptail lizards, and terns <see *LESBIAN SEAGULL*>

baldy-bod \'bȯl-dē-bäd\ *n* a prematurely bald man or one who has shaved his hair and is in really buff shape <"Check out that *baldy-bod* strutting down the Rive Gauche runway in his Hugo Boss.">

balk \'bȯk\ *vb* a mild to serious resistance that men exhibit when things get too girly <*as in* going to a baby shower, shopping at Bed Bath & Beyond, or being asked to hold a purse>

ballabust \'bȯl-ə-bəst\ *n* a controlling girlfriend or wife <"I'd love to play golf on Sunday, but my *ballabust* says 'no-can-do.'">

ballroom dancing \'bȯl-ˌrüm-'dan-siŋ\ *n* **a :** a sophisticated form of social dancing that includes the waltz, fox-trot, swing, cha-cha, and tango and is carried out by emboldened lovers on a polished wood dance floor to dreamy, sexually charged rhythms <"For what is *dancing* but making love set to music playin'." –SAMMY CAHN/ JIMMY VAN HEUSEN, "Come Dance With Me"> **b :** a seemingly effortless form of exercise in which 200–400 calories are burned in a half hour *source* University of West Australia **ballroom dancing les-**

30

BALLROOM DANCING

sons \'bȯl-ˌrüm-ˈdan-siŋ-ˈle-sᵊns\ *n* a way for men who are shy or socially awkward to gain confidence with women <*as in* "I've taught several male students how to talk to a woman. That's not the reason they give for coming here, but a good teacher can pick up on it." –KIMBERLY RICHARDSON, dance instructor, Fred Astaire Dance Studio, Birmingham, Alabama>

banana \bə-ˈna-nə\ *n* **a :** the world's sexiest fruit (genus *Musa*) that is grown in the tropics and though it has a yellow skin is picked green as its flavor intensifies when ripened off the tree **b :** bananas are used in sex-education classes to emulate the penis <"Now I'm putting the condom on the *banana*."> **c :** a telephone <"I can't talk right now – I'm on the *banana* with my girlfriend."> **banana split** \bə-ˈna-nə-ˈsplit\ *n* a mythic malt shop dessert shared by wholesome sweethearts that's made with bananas, ice cream, whipped cream, and nuts, then topped with a cherry

Bardot, Brigitte \ˈbär-dō-ˈbrē-ˈjēt\ (b. 1934, Paris) French film star of the 1950s and 1960s known for her pouty lips, messy blond bun, and curvy figure and who, when

BRIGITTE BARDOT

French sex kittens were put on the endangered species list, retired from movies and became an advocate for animal rights; in 1986 she founded the Brigitte Bardot Foundation for the Welfare and Protection of Animals

barefoot \ˈber-fu̇t\ *adv* joyous partial nudity; a physical and spiritual connection that one makes with the Earth when freed from one's shoes <"I must dance *barefoot* on her wedding day." –WILLIAM SHAKESPEARE, *The Taming of the Shrew* >

barn \ˈbärn\ *n* a storage area on a farm, which is painted red and has hay strewn about for people to make love on

barometer \bə-ˈrä-mə-tər\ *n* **a :** an instrument for measuring atmospheric pressure and determining upcoming weather conditions that was invented in 1643 by Italian scientist Evan-

BAROMETER

gelista Torricelli so that lovers could plan their matinees, trysts, and love-making sessions accordingly **b :** when a barometer is falling, one can expect a storm, and when rising, fair skies

bar stool \'bär-ˌstül\ *n* a perchlike seat found in bars and saloons that is usu. without back or arms and is supported by 3 or 4 legs or by a central pedestal and whose purpose is to put the

BAR STOOL

person sitting on it on full display so that others can make a more informed decision about whether or not to say hello

baseball \'bās-ˌbȯl\ *n* a game of ball between 2 9-member teams, whose history can be traced to 1869, when the first professional team was formed (the Cincinnati Red Stockings); baseball's terminology is often used to define the game of love <*as in* dropping the ball, making a play, getting to 1ˢᵗ, 2ⁿᵈ, or 3ʳᵈ base, scor-ing, striking out – and, as Yogi Berra observed, "It ain't over till it's over.">; appropriately, the game is played on a diamond

basement \'bās-mənt\ **1 :** *n* the part of a house that is below ground level and is often converted into a cozy recreation room so that lovers can watch TV while snuggling on the couch and eating popcorn **2 :** *adj* substandard <"That birthday gift was so *basement*.">

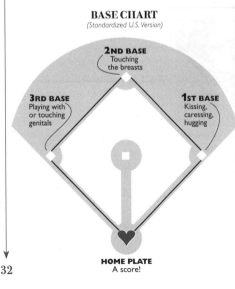

BASE CHART
(Standardized U.S. Version)

2ND BASE
Touching the breasts

3RD BASE
Playing with or touching genitals

1ST BASE
Kissing, caressing, hugging

HOME PLATE
A score!

basil \\'ba-zəl\\ *n* **a :** an aromatic member of the mint family (genus *Ocimum*) that was called the "royal herb" by ancient Greeks and whose powerful aroma calls forth sexual energy; when eaten raw, or used as a seasoning in Italian tomato and pesto sauces, can

BASIL

invigorate one's sexual appetite **b :** place dried leaves under a bed to reawaken sexual fires *source The Encyclopedia of Magickal Ingredients*

basket \\'bas-kit\\ *n* a visible bulge in a man's crotch; the male genitals as seen through tight trousers or shorts <"Don't give me that. I saw you staring at the waiter's *basket*."> **basket case** \\'bas-kit-ˌkās\\ *n* used to describe a person who's an emotional wreck after a bust-up **basket days** \\'bas-kit-ˌdāz\\ *n* a term to describe the summer months (mid-May to mid-August in the northern hemisphere and mid-November to mid-February in the southern hemisphere), when buff men wear Lycra

bathtub \\'bath-ˌtəb\\ *n* **a :** a large, fixed ceramic basin that is used for bathing and can fit 1 person comfortably or 2 people who are in love **b :** a place where female sex objects are often photographed taking bubble baths and where in movies single women go to de-stress when a crazed killer is loose in their house

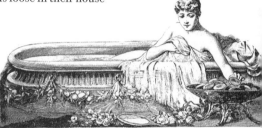
BATHTUB

battery \\'ba-tə-ˈrē\\ *n* a combination of 2 or more cells that work together to produce electric energy so that one doesn't always have to be with someone to have fun <*as in* TV remote, vibrator> **Battery Park** \\'ba-t(ə-)rē-ˈpärk\\ *n* the 21-acre historical park located at the S tip of Manhattan, where lovers go to sit and watch the ships come in from around the world

BBW *n* **a :** acronym for "big beautiful woman" **b :** the BBW woman embraces her

larger size and does not diss herself with excuses *such as* "dysfunctional thyroid" and "slow metabolism" **c :** BBWs are pursued by FAs, or fat admirers, and FFAs, or female fat admirers **d :** can also stand for "big beautiful wench," "big bonny woman," "big bountiful woman" **BHH** *n* acronym for "big handsome man," the hefty male equivalent of a BBW – see *CHUBBY CHASER*

beach \'bēch\ *n* **a :** a landform consisting of sand and created from wave action over eons of time to provide honeymooners a place to go off and do things BEACH *such as* sunbathe, splash in the surf, build sand castles, rub coconut-scented suntan lotion on each other's backs, and make love **b :** a romantic setting where at dusk graying lovers can be seen walking hand in hand in Cialis erectile dysfunction TV commercials that feature a tall lighthouse in the background

bear \'ber\ *n* a husky, often hirsute adult gay male who does not fit the idealized gym-toned stereotype and who eschews designer threads for grunge wear *such as* overalls, Levi's, leather vests, and work boots **bear community** \'ber-kə-'myü-nə-tē\ *n* an umbrella term for the international bear scene **bear cub** \'ber-'kəb\ *n* a young bear **huzbear** \'huz-ber\ *n* a partner in a committed relationship between 2 bears **polar bear** \'pō-lər-'ber\ *n* an older bear who has silver or white hair

beard \'bird\ *n* **1 :** hair that grows on a man's chin, cheeks, neck, and above his upper lip and since the days of Alley Oop has been a sign of his virility and ability to impregnate a mate **2 :** a woman who is seen with a gay man so that people will think he's straight <*as in* at a Hollywood premiere or corporate Christmas party>

beast \'bēst\ *n* a ferocious, aggressive, untamed animal that dwells in the wild <*as in* tiger, gorilla, or grizzly bear> and in the heart of even the mousiest of CPAs when sexually aroused

beater \'bē-tər\ *n* **1 :** an older midsize to large sedan or wagon that needs extensive bodywork, paint, and hubcaps and that a

loser picks his date up in **2 :** a sexy male tank top in redneck cultures <"T-bone was wearing a *beater* when he picked Keena up in his *beater*.">

bed \'bed\ *n* a rectangular piece of furniture that is found in most bedrooms of the world and was invented so that couples could make love lying down instead of standing up

bed-and-breakfast \'bed-ən(d)-'brek-fəst\ *n* a private usu. Victorian residence located in a country or scenic setting, in which the owners rent out bedrooms that are furnished with 19th-c. objects <*such as* wicker baby carriages and embroidered pillows>

and where paper-thin walls allow all the guests to enjoy the nocturnal sounds of lovers in love – called also *B&B* – see *SQUEAK*

bedrock \'bed-'räk\ *n* a faithful husband or male partner who has been there through thick and thin **Bedrock** *n* the town where Stone Age couple Fred and Wilma Flintstone lived with their baby girl, Pebbles

bedroom \'bed-ˌrüm\ *n* **a :** a room in one's house or living quarters that is designed for sleeping and making love in *note* should be free of electronic items that can prevent, derail, or interrupt that process *such as* TVs, radios, computers, and video games

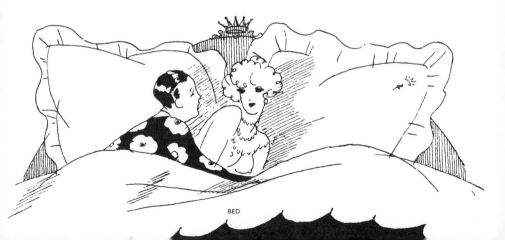

BED

bed sheet \'bed-'shēt\ *n* a white cotton bed covering of preferably 600+ thread count that movie goddesses, sex kittens, muses, models, and women seeing their lovers off in the morning have traditionally wrapped themselves in for modesty and memorable effect

bedside table \'bed-ˌsīd-'tā-bəl\ *n* a small 4-legged table or stand that sits alongside a bed and whose top is for holding or displaying items *such as* Kleenex boxes, scented candles, Rumi anthologies, and alarm clocks and which often has a drawer for personal items *such as* vibrators, clamps, lubes, and condoms – called also *nightstand*

beef-a-roni \'bēf-ə-ˌrȯ-nə\ *n* a muscular, handsome male <"Is Perciful a *beef-a-roni*, or what?">

BEEF-A-RONI

beep \'bēp\ *interj* the sound a homosexual male makes to let people know that his radar has detected the presence of another homosexual male – see *GAYDAR*

Belafonte, Harry \'be-lä-fȯn-tə-'her-ē\ (b. 1927) singer, actor, and social activist who was born in Harlem and raised in Jamaica and who brought Caribbean culture and its sensual rhythms to

HARRY BELAFONTE

the U.S. in 1956 with the release of his album *Calypso*, the 1st full-length LP to sell more than a million copies; still in print, its rhythmic songs of hard work *such as* "The Banana Boat Song (Day-O)" and longing *such as* "Jamaica, Farewell" and sly humor *such as* "Man Smart (Woman Smarter)" still excite the heart, not to mention the cover photo of a young Belafonte in a green silk shirt against a solid red background

belly dancing \'be-lē-'dan(t)-siŋ\ *n* a strenuous form of Middle Eastern dancing traditionally done by women who want to look sexy, burn calories, get in touch with their emotions, shake away stress and depression, build confidence, free their minds from everyday distractions, and have a joyous time twirling about in flowing outfits

belly rubber \'be-lē-'rə-bər\ *n* a slow song in which partners connect to the emotion of the words and music by dancing close to one another, with her arms slung around his neck and his hands pressing against her lower back and their pelvises tilted inward

belongings \'bē-'lòŋ-iŋz\ *n* term for one's personal stuff that is still in an ex-lover's house or apartment following a break-up <"It's been a month now. Would you please come get your *belongings*?">

Ben & Jerry's \'ben-ən(d)-'jer-ēz\ *n* a brand of ice cream made in Vermont and owned by the Unilever conglomerate, which features evocative names *such as* Cherry Garcia, Phish Food, and Chunky Monkey and that

CHUNKY MONKEY

broken-hearted lovers turn to for comfort <"After my boyfriend dumped me, I spent the night with *Ben & Jerry*.">

Ben Wa balls \'ben-wä-'bȯlz\ *n* small, usu. hollow, marble-size balls attached together by a chain that women have been using since ancient Asian times to insert into their vagina to help strengthen pelvic floor muscles; provide subtle stimulation that can sometimes lead to orgasm; some women leave them in all day, experiencing clandestine fun at the office, grocery store, and even on dates

besot \bi-'sät\ *vb* a feeling of infatuation and muddled drunkenness that in romance novels occurs among the gentry <"You look lovely, Lady Sarah," Meredith said. "Lord Greybourne will be *besotted* the moment he sees you." –JACQUIE D'ALESSANDRO, author, *Who Will Take This Man?*>

better man \'be-tər-'man\ *n* what a man who is not ashamed to share his feelings with others credits his girlfriend, wife, or partner for making him <"You make me want to be a *better man*." –JACK NICHOLSON to Helen Hunt in *As Good as It Gets*, 1997,

dir James Brooks; "Any man who has a great girlfriend or wife will tell you that she makes him want to be a *better man*." –CRAIGSLIST>

betty \'be-tē\ *n* [retro slang] a cool, sexy woman – see *THE BETTY BEST pp. 40–41*

bibe \'bīb\ *n* a bisexual vibration given off by a male or female <"I'm telling you, I get a definite *bibe* from Bebe.">

biceps \'bī-,seps\ *n* **a** : a 2-headed muscle of the upper arm that real men like to flex as a display of strength or to show off their tats and when executed with a facial grimace can cause ladies to faint or swoon <*as in* "Ohhhh, Bobby...."> **b** : biceps emerged as a symbol of masculine sexuality in the post–World War II era, when men rolled up the sleeves of their short-sleeved shirts and wore tight black T-shirts – see *MARLON BRANDO*

bicurious \'bī-'kyŭr-ē-əs\ *adj* used to describe a heterosexual male or female who would like to try having sex with a person of the same gender <"Charles isn't gay – he's *bicurious*."> – see *CAN BE HAD*

bikini \bə-'kē-nē\ *n* a 2-piece bathing suit that was invented by French engineer Louis Reard and fashion designer Jacques Heim in Paris in 1946 and which Brigitte Bardot showed off in the 1957 film *And God Created Woman* (*dir* Roger Vadim) to a shocked America <"It's hardly necessary to waste words on the so-called *bikini* since it is inconceivable that any girl with tact and decency would ever wear such a thing." –*Modern Girl* magazine, 1957>; following the release of the 1963 pop ditty "Itsy-Bitsy Teenie-Weenie Yellow Polka-Dot Bikini," sung by Brian Hyland and written by Paul Vance and Lee Pockriss, U.S. bikini sales soared **string bikini** \'striŋ-bə-'kē-nē\ *n* more of less of a good thing

BIKINI

billow \'bi-(,)lō\ *vb* the sensuous and ritualistic cascading of a woman's undone hair from the top of her head to her shoulders and sometimes down her back that takes

place before she goes to sleep at night and often as she gazes from her window at the moon overhead <"I'd like to wear my hair unfastened so it *billows* to the floor." –THE FANTASTICKS, "Much More," Tom Jones/ Harvey Schmidt>

binge-shopping \'binj-'shä-piŋ\ *n* **a :** out-of-control, impulse shopping that people who are alone, insecure, unfulfilled in a relationship, or have just broken up with somebody may in-dulge in and which provides them with an initial high fol-lowed by a guilt-ridden crash **b :** whereas women bingers tend to buy clothes, shoes, jewelry, and other accessories, men go for electronics

BINGE-SHOPPING

and sports equipment ***source*** Tom Horvath, Ph.D.

binoculars \bə-'nä-kyə-lərz\ *n* a handheld optical instrument composed of 2 tele-scopes and a focusing device, which is a must-have item in any bachelor's or peeping Tom's household

bird \'bərd\ *n* a warm-blooded master mu-sician of the Class Aves that has a body covered with feathers, spindly legs, wings, and a beak and that likes to perch on high tree branches so that everyone can enjoy its rep-ertoire of complex love songs **bird**

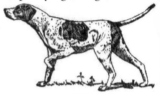

BIRD DOG

dog \'bərd-'dȯg\ *n* a male who goes after an-other man's girl <"Hey *bird dog* get away from my quail. Hey *bird dog* you're on the wrong trail." –EVERLY BROTHERS, "Bird Dog," Boudleaux and Felice Bryant>

birthday \'bərth-ˌdā\ *n* **a :** the day when a person honors one's boyfriend, girlfriend, husband, wife, or lover for turning another year older and that one must always make a huge deal out of, ignoring any requests to do otherwise **b :** the day on which one must surprise his or her lover with a special gift that he or she has always wanted <*as in* "A Hello Kitty diamond pendant with spar-kling ruby accents! How did you know?">

THE BETTY BEST

Bette Davis (1908–1989) One of the best screen actresses of all time, whose on-screen dialog, from "What a dump!" to "Fasten your seatbelts – it's going to be a bumpy night," has inspired countless impersonators and whose real-life dialog wasn't so bad, either <*as in* "An affair now and then is good for a marriage. It adds spice, stops it from getting boring…I ought to know.">

Bette Midler (b. 1945) Brassy, radiantly warm actress, singer, and all-around entertainer who got her start performing in a New York bathhouse with Barry Manilow on the piano, tells raunchy Sophie Tucker jokes, and won an Emmy for crooning "One for the Road" to Johnny Carson on his next-to-last show

Bettie Page (b. 1923) Saucy but enigmatic cult model and pinup girl of the 1950s who posed for a number of fetish and S&M photographs and is the subject of Mary Harron's 2005 screen bio *The Notorious Bettie Page*, starring Gretchen Mol

Betty (Lauren) Bacall (b. 1924) Slinky, sultry, smoky screen and Broadway stage

performer who was married to Humphrey Bogart, to whom she coolly remarked in *To Have and Have Not* after kissing him twice, "It's even better when you help."

Betty Boop Jazz-singing 1930s cartoon character who was the first animated figure to fully represent a sexual woman; a flapper, she wore a garter belt and short dresses with cleavage, and even though lecherous men were always trying to sneak a peek of her undressing or taking a bath, she had class and wasn't about, in her words, to let someone "take my boop-oop-a-doop away!"

Betty Buckley (b. 1947) Actress and singer who played Abby in TV's *Eight Is Enough*, was Sissy Spacek's gym teacher in *Carrie*,

starred with Robert Duvall in *Tender Mercies,* and in 1982 won a Tony Award for her portrayal of Grizabella in *Cats*, where her soaring voice belted "Memory" <*as in* "If you touch me, you'll understand what happiness is.">

Betty Coed A 1920s flapper as drawn by American illustrator John Held (1889–1958) and whose popular likeness appeared in magazines of the era, including the fledgling *New Yorker*; Betty Coed was the successor to the Gibson Girl <see *CHARLES DANA GIBSON*> and the personification of America's post–World War I flaming youth

Betty Cooper Quintessential girl next door; blond-haired daughter of Hal and Alice Cooper and sometime love interest of Archie Anderson of *Archie* comics

Betty Davis (b. 1945) Sexually liberated American funk and soul singer who as Miles Davis's second wife greatly influenced his musicianship by introducing him to psychedelic rock guitarist Jimi Hendrix; the result was jazz fusion; in the 1970s Ms. Davis recorded three cult albums, including *Nasty Gal*

Betty Grable (1916–1973) Actress, singer, dancer, and undisputed pinup queen of World War II, said to have the appeal of a "hash-house waitress" (in the best sense of the words) in that she reminded the boys in uniform of every good-looking gal they had ever known or wanted to date

Betty Suarez Character played by America Ferrera on the TV comedy series *Ugly Betty*, who works for a Manhattan fashion magazine called *Mode* that's staffed by fatuous, mean-spirited divas; although Betty is an outsider in this ultraglamorous environment – short, wears frumpy clothes, has braces, and lives with her family in Queens – she is the beautiful one; based on the Columbian telenovela *Yo Soy Betty, la Fea*, the series premiered in the fall of 2006 on ABC

bisocial \'bī-'sō-shəl\ *n* a boyfriend or girl-friend who is comfortable in his or her partner's social world <"I didn't know Abdul was *bisocial* until I took him to my stitch 'n' bitch group."> *syn* bicomfy

bistro \'bēs-(,)trō\ *n* [French] a European neighborhood-style restaurant where lovers can dine for hours on earthy cuisine *such as* mussels, roast chicken, steak au poivre, and sexy French fries called pommes frite

black \'blak\ *n* the color one wears to look sultry, powerful, sophisticated, mysterious, understated, and confident and can be used to identify witches, monks, nuns, and New Yorkers <"New Yorkers always wear *black*, and that's only until something darker comes along." –CHRISTINE BARANSKI in the comedy series *Cybill,* CBS, 1995–1998>

blackboard \'blak-,bȯrd\ *n* the night sky as described in the 1953 song "Teach Me Tonight," written by Sammy Cahn and Gene de Paul <"The sky's a *blackboard* high about you, and if a shooting star goes by, I'll use that star to write I love you a thousand times across the sky.">

black bra \'blak-'brä\ *n* a lace push-up bra that men find irresistibly sexy – see *ELIZABETH TAYLOR*

BLACK BRA AND...

black coffee \'blak-'kȯ-fē\ *n* a beverage prepared from the roasted seeds of the coffee plant (genus *Caffea*), which is served without milk or cream and drunk or downed in copious quantities by a person whose heart is breaking <"I'm feeling mighty lonesome. I haven't slept a wink. I walk the floor and watch the door and in between I drink *black coffee.*" –SONNY BURKE/PAUL FRANCIS WEBSTER, "Black Coffee">

black-eyed pea \'blak-'īd-'pē\ *n* another name for the cowpea *(Vigna unguiculata)* that is eaten on New Year's Day in S regions of the U.S. to bring good luck, prosperity, and love **Black Eyed Peas** \'blak-'īd-'pēz\ *n* popular Los Angeles–based hip-hop group whose members are called will.i.am, apl.de.ap, Taboo, and Fergie and who had the 2006 hit single "My Humps," which asks the musical question, "Can I mix your milk wit' my cocoa puff?"

BIRTHDAY TABLE			
MONTH	**COLOR**	**FLOWER**	**BIRTHSTONE**
January	White	Carnation	Garnet
February	Dark Blue	Violet	Amethyst
March	Silver	Jonquil	Aquamarine
April	Yellow	Sweet Pea	Diamond
May	Lilac	Lily-of-the-Valley	Emerald
June	Pink	Rose	Pearl
July	Sky Blue	Larkspur	Ruby
August	Dark Green	Gladiola	Peridot
September	Gold	Aster	Sapphire
October	Brown	Calendula	Opal
November	Purple	Chrysanthemum	Topaz
December	Red	Narcissus	Turquoise

blindfold \'blīnd-'fōld\ *n* a comfortable swathe of fabric or other enveloping medium that lovers put over their eyes when having sex to heighten the anticipation of what's coming next

blowsy \'blaū-zē\ *adj* used to describe a frumpy bottled blond or one whose roots need retouching <"Growing up I was crazy about Mae West...she was very funny, she was very risqué, and she was also very beautiful in a kind of *blowsy* way." –BETTE MIDLER>

MAE WEST

blue \'blü\ *n* **a :** the world's most beloved color, as seen in the sky <"Oh! 'darkly, deeply, beautifully *blue*,' as someone somewhere sings about the sky." –LORD BYRON>, in the ocean <"Far out at sea the water is as *blue* as the petals of the loveliest cornflower, and as clear as the purest glass." –HANS CHRISTIAN ANDERSEN, *The Little Mermaid*>, and the eyes <"...and I'll be buried at sea...into an ocean as *blue* as

43

my first lover's eyes." –TENNESSEE WILLIAMS, *A Streetcar Named Desire*> **b :** the color of airport runway lights that signify a tearful reunion or a tearful parting **Blue Heaven** \'blü-'he-vən\ *n* Fats Domino's 1956 hit song that describes a loving home <"Just Molly and me and baby makes three. We're happy in my *blue heaven.*"> **blue moon** \'blü-'mün\ *n* a long time between lovers <"*Blue moon*, you saw me standing alone, without a dream in my heart, without a love of my own." –LORENZ HART/RICHARD RODGERS, "Blue Moon"> **blue whale** \'blü-'whāl\ *n* a migratory baleen whale of the southern hemisphere that is the largest mammal on Earth and whose female of the species has the world's largest vagina, at 6–8 ft. **Baby Blue Eyes** \bā-bē-'blu-'īs\ *n* a spring wildflower *(Nemophila phacelioides)* that grows in prairies and open woods **the blues** \thə-'blüs\ *n* the hurtful despair amd depression one feels when love's gone bad

boast \'bōst\ *vb* the act of bragging that a male uses to impress a female date but which invariably turns her off

Bocelli, Andrea \bȯ-'che-lē-'änd-rä-ä\ (b. 1958) Italian tenor who sports stubble and has become a pop singing star with his renditions of international ballads *such as* "Besame Mucho" and "Les Feuilles Mortes" and who proves Chaucer's axiom that "love is blynd"

body \'bä-dē\ *n* a person's head, neck, torso, arms, and legs, which can provide a playground of infinite pleasures **Body and Soul** \'bä-dē-ən(d)-'sōl\ *n* smoldering jazz standard written in 1930 by Edward Heyman, Robert Sour, Frank Eyton, and Johnny Green that has been recorded by the likes of Billie Holiday, Tony Bennett, Mel Tormé, and others and whose torchy lyrics proclaim, "I'd gladly surrender myself to you *body and soul.*" **body language** \'bä-dē-'laŋ-gwij\ *n* unconscious communication through postures, gestures, and facial expressions <*as in* "Raz's lips may be saying no-no, but her dilating pupils are saying she's ready to do the funky monkey."> **body-lift** \'bä-dē-'lift\ *n* a tummy-tuck that includes a resculpturing of the hips, thighs, and buttocks – called also *belt lipectomy* **body shot** \'bä-dē-'shät\ *n* a drinking game between 2 people who are on (very) good terms with each other

Bolero \bə-ˈler-(ˌ)ō\ *n* **a :** orchestral work composed by Maurice Ravel in 1928 for the Paris Opera, which was featured in the 1979 Bo Derek film *10* and whose mounting rhythms, raucous glissandi, and symbol-crashing crescendo provide a perfect soundtrack for getting it on – see *SCORES TO SCORE BY p. 246* **b :** the only time a pair of ice dancers received a perfect 10 from every judge was at the 1984 Winter Olympics, when Torvill and Dean skated to "Bolero"

bonding \ˈbän-diŋ\ *n* **1 :** feelings of emotional attachment that develop between 2 people who are dating, due to the release of the hormone oxytocin by the posterior pituitary gland **2 :** composite veneers that dentists glue over people's teeth to make their smiles more inviting

Bond, James \ˈbänd-ˈjāmz\ *n* author Ian Fleming's suavely countenanced Super Agent 007 who saves the world from apocalyptic madmen while performing death-defying stunts, driving customized cars, drinking dry martinis, and bedding voluptuous women who fall instantly

SEAN CONNERY AS BOND

in love with him <*as in* Sean Connery, George Lazenby, Roger Moore, Timothy Dalton, Pierce Brosnan, Daniel Craig>

Bonnie and Clyde \ˈbä-nē-ənd-klīd\ (Bonnie Parker, 1910-1934, and Clyde Barrow,

1909-1934) sexy, gun-toting Romeo and Juliet of the Depression era whose derring-do exploits throughout the central U.S. captivated the nation

bonobo \'bə-nō-bō\ *n* the last "great ape" to be identified, in 1926; lives in the rainforests of Zaire and is considered to be the most swinging mammal on Earth, engaging in acts *such as* male-to-male tongue kissing and female-to-female genital rubbing; animal behaviorists theorize that bonobos use promiscuity as a way to relieve tension and create bonding in their crowded social settings <*as in* "It's scandalous, they'll have sex with anyone, never mind the sex or age." –ROBIN DUNBAR, British primatologist> - called also *pygmy chimpanzee*

boo-hoo canal \'bü-hü-kə-'nal\ *n* a term to describe the continuous flow of tears that fall when feelings are hurt <"Every time I bring up the subject, Kayley turns on the *boo-hoo canal*.">

boost \'büst\ *n* a pumping up or reviving of one's self-esteem that occurs when one finally leaves a bad relationship **booster shot** \'bü-stər-'shät\ *n* a term used by a man

BOO-HOO CANAL

to describe a 1-night stand that has increased his confidence <"It's been a while. I needed that *booster shot*.">

booty \'bü-tē\ *n* buttocks **bootylicious** \'bü-tē-'li-shəs\ *adj* an attractive woman with a hot booty <"I don't think you ready for this 'cause my body too *bootylicious* for ya babe." –DESTINY'S CHILD, "Bootylicious">

BOOTYLICIOUS

bossa nova \bä-sə-'nō-və\ *n* a samba- and jazz-infused music style that was started in Rio de Janeiro by Joäo Gilberto in the 1950s and whose sexy, complacent rhythms captivated U.S. musicians, singers, and the American public in the 1960s and whose songs are still being performed, sung, and put on the CD player to make love to <*as in* "Desafinato," "One Note Samba," "How

46

Insensitive," and "The Girl from Ipanema," *as in* "Everyone she passes goes a-a-ahh....">

Botox \'bō-ˌtäks\ *n* a trade name for a neurotoxic protein produced by the bacterium *Clostridium botulinum* that when injected in small doses to the human face reduces wrinkles and character lines <*as in* "I think Brenda's happy but I can't tell by her expression."> - see *TROUT POUT*

bougainvillea \ˌbü-gən-'vil-yə\ *n* a vine (genus *Bougainvillea*) that is native to the rain forest of South America and whose paper-thin foliage of yellow, pink, red, apricot, purple, and white adorns garden trellises, iron balconies, and courtyard walls; conjures up images of dashing caballeros scaling stucco walls to woo beautiful senoritas with black fans

bougie \'bü-ˌzhē\ *adj* used to describe a person who has polite, bourgeois taste <"Danny's idea of swank is the Olive Garden. He's so *bougie*.">

boulangerie \bü-lən-jə-rē\ *n* [French *bakery*] where one goes shopping to get the good bread when making a special dinner for a date

bouncebackability \'baún(t)s-'bak-ə-'bi-lə-tē\ *n* the aptitude for getting over a sports injury, recovering from a job setback, or getting past a failed relationship <"Dumped on Sunday and on Match.com on Monday. You've got to admire Tiffini's *bouncebackability*.">

boundary \'baún-d(ə-)rē\ *n* a protective wall or dividing line that allows one to own his or her feelings and speak the truth while letting go of the outcome so that one can claim full responsibility for how one is treated and not be in crappy relationships anymore - see *I FEEL*, *INNER-CHILD HEALING PROCESS*

Boundary Waters \'baún-d(ə-)rē-'wȯ-tərz\ *n* the 1-million-acre nature preserve in N Minnesota that has 1,200 mi. of canoe routes for lovers to explore and that is home to trout, beavers, and loons - see *MOSQUITO*

boxer shorts \'bäk-sər-'shȯrts\ *n* a type of men's underwear that resembles pugilist

trunks, is made of cotton, has an elastic waistband, often comes in zany colors and patterns, and is worn by men who wish their penis to hang unencumbered and like the idea that if something comes up they can get out of them quickly

BOXER SHORTS

(the) boys \thə-'bȯiz\ *n* **1 :** an endearing term for men and lesbians <"We invited *the boys* to dinner."> **2 :** testicles <"We suspect there is some skin-colored Spandex beneath the loincloth to keep his *boys* in check, but not having seen the show yet ourselves, we can always dream." –QUEER-TY, a daily gay blog>

brain \'brān\ *n* **a :** the control center of the central nervous system, which oversees the heart **b :** initially the brain decides the

BRAIN

where, the when, and the who one is going to meet and be attracted to **c :** after a consultation with the heart, the brain proceeds to dispense feel-good chemicals from its well-stocked pharmacy that requires no doctor's prescription or prior patient consent *such as* dopamine, norepinephrine, serotonin, testosterone, and estrogen, which have the capability to increase energy, improve memory, focus attention, boost sexual stamina, and produce feelings of exhilarating joy **d :** side effects of these potent chemicals may include sleeplessness, loss of appetite, increased heart rate and blood pressure, sweating, obsessive thinking, daydreaming, fantasizing, and inability to multitask *note of warning* if the brain overdispenses these chemicals, feelings of dependency and attachment for another person may occur; should these symptoms continue for a prolonged period of time, one may want to consult a priest, pastor, rabbi, or justice of the peace – see *HEART*

brakes \'brāks\ *n* a device for arresting or preventing the forward motion of a relationship, which men are always applying <"As she's telling me about this Cancun package, I put on the *brakes*.">

Brando, Marlon \'bran-dō-'mär-lən\ (1924–2004) anti-star who brought an earthy

48

brilliance to acting that changed the medium forever and, whether wearing blue jeans, tight T-shirts, motorcycle leathers, a Roman toga, or a sombrero, exuded an irresistible sexuality that said, "I don't give a damn." – see *PHEROMONES*

MARLON BRANDO

Brazilian \brə-'zil-yən\ *n* **1** : a person born in Brazil, which makes him or her automatically sexy by birth **2** : a physically uncomfortable procedure to remove hair from a woman's genital region that is intended to get rid of a bikini line or make a woman more desirable for oral sex <*as in* "The pain isn't bad at all, but I become alarmed when she grabs my labia, folds them back, and spreads wax on them. *Riiiiiiip*. I gasp and my eyes bug out. *Owwwwww*." –CHRISTINA VALHOULI, travel and lifestyle writer>

breakdown lane \'brāk-ˌdaùn-'lān\ *n* a state of ineffectiveness, confusion, pain, and overall feelings of "I can't take any more" that one experiences after a relationship ends <"They just broke up. Montana's OK, but Jason's in the *breakdown lane*.">

breasts \'brests\ *n* the 2 masses of mammary glands that include and surround a woman's nipples and that throughout history have been symbols of fertility, nature, spirituality, and nourishment, esp. as depicted in Renaissance paintings and sculptures and objects of eroticism and particularly as photographed in glossy men's magazines of the mid-to-late 20th c. – see *SYNONYMS FOR BREASTS p. 50* **breast or leg man** \'brest-ər-'leg-'man\ *n* an either/or type decision that heterosexual men make <Paper or plastic? Debit or credit? Ranch or thousand island? *Breast or leg?*>

bridezilla \'brīd-'zi-lə\ *n* a soon-to-wed woman whose demanding and self-centered behavior and actions are likened to Godzilla, the mutant dinosaur created by U.S. hydrogen bomb testing in the Pacific in films of the 1950s and 1960s; bridezillas are known for terrorizing their bridal party and family members by walking over everyone in the belief that they are the most

important person on the planet from the moment they are engaged *syn* going bridal **brideslaves** \'brīd-'slāvz\ and **brideslave of honor** \'brīd-'slāv-əf-'ä-nər\ *n* bridezilla's emotionally battered wedding attendants

Brief Encounter \'brēf-in-'kaùn-tər\ *n* 1945 neo-realistic British tearjerker (*dir* David Lean) that tells the story of a married doctor and a bored housewife who upon meeting in a train station are issued 2 1-way tickets to unrequited love <*as in* "I've fallen in love. I'm an ordinary woman. I didn't think such violent things could happen to ordinary people." –CELIA JOHNSON to Trevor Howard>

brink \'briŋk\ *n* a place or point of momentary pause that precedes an exhilarating release of unstoppable pleasure and force <*as in* the dip of a roller coaster, jumping from an airplane, blasting into orbit> **brink of ejaculation** \'briŋk-əv-,i-'ja-kyə-'lā-shən\ *n* the point of no return, when a man is about to surrender to orgasm *note* to prolong and stimulate ejaculation, the man or his partner can gently squeeze the penis, where the head meets the shaft, just as he is about to experience orgasm

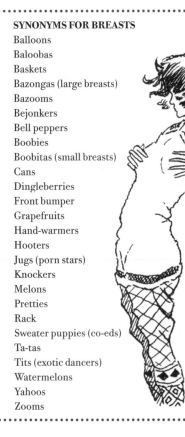

SYNONYMS FOR BREASTS
Balloons
Baloobas
Baskets
Bazongas (large breasts)
Bazooms
Bejonkers
Bell peppers
Boobies
Boobitas (small breasts)
Cans
Dingleberries
Front bumper
Grapefruits
Hand-warmers
Hooters
Jugs (porn stars)
Knockers
Melons
Pretties
Rack
Sweater puppies (co-eds)
Ta-tas
Tits (exotic dancers)
Watermelons
Yahoos
Zooms

broad \'bròd\ *n* 1940s underwold slang for a woman who puts her heart and soul into whatever she does, be it smoking, cussing, boozing,

BARBARA STANWYCK

getting dolled up, making love, or cold cocking a wise guy <*as in* Ida Lupino, Tallulah Bankhead, and Barbara Stanwyck> – called also *one of the boys*

Broca's area \'brō-käz-er-ē-ə\ *n* a section of the human brain that began to take shape approximately 1.8 million years ago and is involved in language processing and speech so that one can have no excuse for not expressing his or her feelings to another person

brokebacking \'brōk-'ba-kiŋ\ *n* a situation in which a man tells his wife or girlfriend that he and a buddy are going fishing, to play ball, or participate in some other activity but are really going off to have sex with each other <*as in* "Talk about absentminded – every time Mike goes bowling with Jerry he forgets to take his ball.">

(The) Brownings \thə-'braù-niŋz\ (Robert, 1812-1889, and Elizabeth, 1806-1861) English poets who, after writing each other nearly 600 love letters and poems over a 20-month period, were secretly wed in London on September 12, 1846, and to avoid the wrath of her tyrannical father ran off to Italy, where they lived for the rest of their lives; on the day of their wedding Robert wrote of her, "You have given me the highest completest proof of love that ever one human being gave another," while she, shortly before her death, said of him, "How do I love thee? Let me count the ways...." – compare *ABELARD AND HELOISE* – see *LOVE LETTER*

bubble \'bə-bəl\ **1** : *vb* to completely zone out from a group of friends by engaging in a one-on-one conversation with one's date to the exclusion of everybody else <"Jen and Randy *bubbled* most of the night."> **2** : *n* a small body of gas in a liquid that can make one feel clean <*as in* soap *bubble*> or giddy <*as in* champagne *bubble*> **Michael Bublé** \'mī-kəl-'bü-blā\ (b. 1975) Canadian retro crooner whose romantic songs have proved appealing to young audiences

buff \\'bəf\\ **1 :** *n* a color between brown and burgundy that smart gay couples who live in condos and lofts love *syns* bay leaf, café au lait, chalk, cumin, flesh, khaki, nut, sand, shortbread, stone, tan, toast **2 :** *adj* used to describe the muscled physique of either sex **in the buff** \\'in-t͟hə-'bəf\\ *adj* to be naked **buffet in the buff** \\'bə-fət-'in-t͟hə-'bəf\\ *n* a weekend nudist brunch option at Miami's Haulover Beach

bumper sticker \\'bəm-pər-'sti-kər\\ *n* a tattoo on a woman's lower back – called also *back tat*

bunny horny \\'bə-nē-'hȯr-nē\\ *adj* a condition in which one's sexual drive and performance are like that of a rabbit <"President Clinton wouldn't have been impeached if he hadn't been so *bunny horny* all the time.">

HORNY BUNNY

Burton, Richard \\'bər-tᵊn-'ri-chərd\\ (1925–1984) British stage and screen actor and son of a Welsh coal miner, who was married 5 times, twice to Elizabeth Taylor, with whom he made 9 movies, including the epic *Cleopatra* (1963, *dir* Joseph L. Mankiewicz) and *Who's Afraid of Virginia Woolf* (1966, *dir* Mike Nichols)

Burton, Richard Francis (Sir) \\'bər-tᵊn-'ri-chərd-'fran(t)-səs-sər\\ (1821–1890) British explorer, Asian scholar, and soldier who mastered some 40 languages and dialects, esp. the language of love, having translated the fiery sonnets of Portuguese poet Luis de Camões (1880), the epic *Arabian Nights* (1885), and 2 quasi-sex manuals, the *Kama Sutra* (1883) and *The Perfumed Garden* (1886)

business \\'biz-nəs\\ *n* (taking care of) a precautionary act in which a male who is about to go on a 1ˢᵗ date masturbates so that he will appear as a gentleman

bustier \\͵büs-tē-'ā\\ *n* an undergarment originally worn as a foundation but that is now considered outerwear <see *FERNANDO SANCHEZ*> and comes in various fabrics *such as* silk, nylon, rayon, and leather <*as in* "In olden days a glimpse of stocking was looked upon as something shocking." –COLE PORTER, "Anything Goes"> – called also *merry widow*

52

but \ˈbət\ **1 :** *conj* an exception to a fact that one usu. doesn't want to hear and that sometimes comes in mid-sentence to soften a blow <"I'd leave my wife for you, *but*...."> **2 :** *adv* used to stress positive emphasis <"We made love last night *but* good."> **But Beautiful** \ˈbət-ˈbyü-ti-fəl\ *n* 1947 ballad by Johnny Burke and James van Heusen popularized by Billie Holiday <"Love is funny or it's sad, or it's quiet or it's mad. It's a good thing or it's bad *but beautiful*.">

butter \ˈbə-tər\ *n* a solid emulsion of fat globules, air, and water that is made by the churning of milk or cream and that was used by Marlon Brando to sodomize Maria Schneider in Bernardo Bertolucci's 1973 film *Last Tango In Paris*

MONARCH BUTTERFLY *(Danaus plexippus)*

butterfly \ˈbə-tər-ˌflī\ *n* an insect of the order Lepidoptera that starts off as a caterpillar and is proof that life can have a

HUMAN BUTTERFLY EFFECT

1. A woman in a diner asks the man at the adjoining booth if she can borrow his Sweet'N Low
2. This leads to a conversation and the exchanging of names
3. He asks her out, and they begin dating
4. They fall in love
5. They get married
6. They have a daughter
7. The daughter goes to Harvard
8. The daugher graduates with a degree in medicine
9. The daughter becomes a distinguished researcher and scientist
10. The daugher is awarded the Nobel Prize for curing cancer

prettier 2nd act ***note*** a butterfly brushing against a person's skin means that someone desirable is going to be flirting with that person in the near future ***source*** *The Encyclopedia of Magickal Ingredients* **butterfly effect** \ˈbə-tər-ˌflī-i-ˈfekt\ *n* the scientific theory that a minute variation in the initial condition of a dynamic system may produce much larger variations *as in*

53

a butterfly flapping its wings may eventually cause a tornado **flick the butterfly** \'flik-<u>th</u>ə-'bə-tər-,flī\ *vb* a sexual act adapted from the *Kama Sutra*, in which one lightly flicks one's tongue along the ridge on the underside of the penis **Julia Butterfly Hill** \'ju-lē-ä-'bə-tər-,flī-'hil\ environmental activist who loves trees so much that she committed herself to saving a 600-year-old California redwood tree from being cut down by living in it for 738 days **Madama Butterfly** \,mə-'dä-mə-'bə-tər-,flī\ *n* 1904 opera by Italian Giocomo Puccini that's set in Nagasaki, Japan, and whose storyline is butterfly meets boy, butterfly loses boy, butterfly commits hara-kiri

butterscotch blondie \'bə-tər-,skäch-'blän-dē\ *n* a brownie's more decadent cousin – called also *manbait* – see NACHOS

buttocks \'bə-təks\ *n* **a :** the 2 fleshy protuberances located below the lower part of the back that both men and women find pleasing to look at either fully exposed or covered by tight clothing **b :** buttocks are paid homage to in many hip-hop and R&B songs and are a trademark physical feature of actress-singer-dancer Jennifer Lopez

BUTTERSCOTCH BLONDIES
(about 36 bars)

Ingredients
¾ cup (1½ sticks) butter, softened
¾ cup packed light brown sugar
½ cup granulated sugar
2 eggs
2 cups all-purpose flour
1 tsp. baking soda
½ tsp. salt
1¾ cups (11-oz. package) Hershey's butterscotch chips
1 cup chopped nuts (optional)

Directions
1. Heat oven to 350° F. Grease 13 X 9 X 2-in. baking pan.
2. Beat butter, brown sugar, and granulated sugar in large bowl until creamy. Add eggs and beat well. Stir together flour, baking soda, and salt. Gradually add to butter mixture, beating until well blended. Stir in butterscotch chips and nuts, if desired. Spread into prepared pan.
3. Bake 30–35 mins. or until top is golden brown and center is set. Cool completely in pan on wire rack. Cut into bars.

c : can be used for sitting, strutting, inserting into, and occasionally grabbing or even slapping in sexual foreplay – see *KAMA SUTRA* – called also *bon bons, booty, backend, bonhunkus, bubblegum, bunghole, buttendski, caboose, cashmerian togas, hottentots, keister, khyber pass, rusty dusty, tushie* **butt cleavage** \'bət-'klē-vij\ *n* the vertical, gluteus crease that is exposed when a male worker <*as in* plumber> bends over or crouches while doing his job *var* b'leavage \'ble-vəj\ *n* a contraction of butt and cleavage that is applied to women who show butt cleavage through hip-hugger pants **butt dial** \'bət-'dī(ə)l\ to accidentally call someone on your cell phone **butt floss** \'bət-'fläs\ *n* a thonglike bathing suit **butt ugly** \'bət-'ə-glē\ *adj* extremely unattractive **butty** \'bə-tē\ *n* an over-the-hill betty <"She was a real betty until she had all of those kids. Now she's a *butty*.">

Byron, George Noel Gordon (Lord) \'bī-rən-'jȯrj-nō-'el-'gȯr-dᵊn\ (1788–1824) **a :** English poet and leading figure in Romanticism known for his good looks and prolific sexual adventures with women and young men and who was described by Lady Caroline Lamb, with whom he had a well-publicized, adulterous affair, as being "mad, bad, and dangerous to know" **b :** is best remembered artistically for his epic poems *Childe Harold's Pilgrimage* and his magnum opus, the 17-canto *Don Juan* **c :** more than men and women he loved his dog, for whom he wrote the following epitaph

LORD BYRON

Near this spot Are deposited the
 Remains of one
Who possessed
Beauty without Vanity,
Strength without Insolence,
Courage without Ferocity,
And all the Virtues of Man
Without his Vices.
This Praise, which would be
 unmeaning flattery
If inscribed over Human Ashes,
Is but a just tribute to the Memory of
"Boatswain," a Dog
Who was born at Newfoundland,
May, 1803,
And died at Newstead Abbey
Nov. 18, 1808.

cab \'kab\ *n* **1** : a vehicle with a light on top that people hail to take them to and from a date or to come get them in the middle of a bad one – called also *taxi* **2** : a bold, full-flavored red wine (Cabernet Sauvignon) **Cab Calloway** \'kab-'ka-lə-wā\ (1907–1994) jazz singer and bandleader dubbed the "Hi-De-Ho Man" in reference to the chorus of his hit song "Minnie the Moocher" about "a low-down hoochie-coocher"

CAB CALLOWAY

callipygian \ˌka-lə-ˈpi-jən\ *adj* having perfectly proportioned buttocks <"I finally met my *callipygian* ideal!">

Camille \ˌka-ˈmēl\ *n* (1936, *dir* George Cukor) romantically atmospheric film version of the novel by Alexander Dumas fils that tells the doomed love story of a tubercular courtesan (Greta Garbo) who falls for a French nobleman (Robert Taylor) and whose dying words to him are "Perhaps it's better if I live in your heart, where the world can't see me." – see *LA TRAVIATA*

57

camping \'kam-'piŋ\ *n* a roughing-it experience that involves a tent, a campfire, and a cooler and can strengthen the bonds between a couple or end the relationship

can be had \kən-'bē-'had\ *vb* a sly, ego-boosting observation one makes to oneself or under one's breath to a friend about someone who one doesn't stand a chance with but needs to believe otherwise <"Lea? Hey, she *can be had*."> – see *AS IF*

candelabra \'kan-də-'lä-brə\ *n* a branched candleholder that sits atop a grand piano, which one lights when sitting down to play Chopin's études to one's lover and, if one's ceilings are high enough, is carried down the hallway afterward to the bedroom

candle \'kan-dᵊl\ *n* **a :** a long, slender piece of tallow, or wax, with an embedded wick that when set aflame is used for romantic lighting at intimate dinners **b :** the most popular artificial device that women use for pleasuring themselves – see *SHERE HITE*
candlelit dinner \'kan-dᵊl-,(l)it-'di-nər\ *n* an elegant meal that one prepares for a romantic partner during which the light is kept to a minimum so that one's pupils will dilate naturally, making one look even more appealing

candy \'kan-dē\ *n* a box of chocolates or other confectionary that a gentleman always sends to a woman he is courting and that she is thrilled to receive but angry at getting because it's so fattening

CANTALOUPE

cantaloupe \'kan-tə-,lōp\ *n* **a :** a muskmelon *(Cucumis melo reticulatus)* with a pale-orange interior that is exceptionally sweet and juicy and when split in half makes a sensual breakfast for 2 **b :** according to folklore, a cantaloupe can test one's love: if one tosses a whole cantaloupe out to sea from the shore and it comes back, then the intended object of one's desire feels the same way

Can't Take My Eyes Off You \'kant-'tāk-'mī-'īz-'òf-'yü\ *n* written by Bob Crewe and Robert Gaudio, the quintessential lounge ballad made famous by Frankie Valli and inspiring couples to sway their arms in the air and sing along <*as in* "You're just too good to be true....">

Cape Cod \'kāp-'käd\ *n* historic Massachusetts peninsula located between the Atlantic Ocean and Cape Cod Bay known for cranberries, shellfish, lobsters, lighthouses, whale-watching expeditions, shingled cottages, and miles of beaches where lovers can walk barefoot and used to go swimming before the 1975 release of *Jaws* (*dir* Steven Spielberg)

Caribbean \ˌker-ə-'bē-ən\ *n* an arm of the Atlantic Ocean 1,063,000 sq. mi. in size lying on the Caribbean plate south of North America, east of Central America, and north and west of South America, on whose 7,000 islands, islets, and reefs thousands of honeymooners annually make lifelong memories that many in later years wish they could forget

Carmen \'kär-men\ *n* a French opera by Georges Bizet (1838-1875) that debuted in 1875 and tells the story of a fiery gypsy named Carmen who works in a cigarette factory in Seville, Spain, and who is stabbed to death by her lover after 86-ing him for a toreador **Carmen Electra** \'kär-men-iˈlek-trə\ (b. 1972, née Tara Leigh Patrick) singer, model *(Playboy)*, actress

CARMEN ELECTRA

(Baywatch), and breast-implanted sex symbol who was married to Dennis Rodman for 9 days <see *CELEBRITY QUICKIE MARRIAGES pp. 226–227*>, had an affair with *Baywatch* co-star Pamela Anderson's ex-husband Tommy Lee, and whose marriage to musician Dave Navarro was a reality TV show

carousel \ˈker-ə-'sel\ *n* **a** : an amusement park ride with painted horses that appear to be galloping as they mechanically go up and down on a rotating platform to the musical strains of a calliope **b** : unlike British carousels that revolve clockwise, American carousels revolve counterclockwise to allow riders to reach for the brass ring with their right hand instead of their left, which is where another kind of ring be-

CAROUSEL

longs – called also *merry-go-round* **Carousel** *n* 1945 Rodgers and Hammerstein musical about a New England carousel barker named Billy Bigelow who falls in love with a mill worker named Julie Jordan to beautiful songs and tragic results

carpal tunnel syndrome \'kär-pəl-'tən-ᵉl-'sin-ˌdrōm\ *n* a painful disorder of the wrist and hand characterized by tingling, burning, and muscular weakness and caused by typing too many e-mails to one's beloved

carpenter \'kär-pən-tər\ *n* a boyfriend who knows how to really please a woman by constructing kitchen cabinets or built-in bookshelves **The Carpenters** \thə-'kär-pən-tərz\ *n* (Richard, b. 1946; Karen, 1950–1983) **a :**

CARPENTER

mega-selling brother-and-sister recording artists of the 1970s who established the "easy listening adult contemporary" music genre with their ballads and midtempo pop songs *such as* "Close to You," "We've Only Just Begun," "Rainy Days and Mondays," and "Top of the World" **b :** Karen's sorrowful contralto lent even the most fatuous of their songs a rich emotional undercurrent

carry-on \'ka-rē-'ȯn\ *n* a small overnight bag that doesn't have to be checked in at the airport so that upon arrival lovers can have more time to carry on

Casablanca \ˌka-sə-'blaŋ-kə\ *n* (*dir* Michael Curtiz) 1942 Oscar-winning film in which a cynical Humphrey Bogart, owner of Rick's Café in the Vichy-con-

HUMPHREY BOGART

trolled Moroccan city of Casablanca, finds his dopamine levels soaring when ex-lover Ingrid Bergman unexpectedly shows up; the last words of the film suggest that Rick may not have been all that unhappy losing Bergman, as he tells the local police captain (Claude Rains): "Louis, I think this could be the beginning of a beautiful friendship." – see *BICURIOUS* **note** voted by the American Film Institute as the most romantic movie ever made

Casanova \,ka-zə-'nō-və\ (1725–1798, né Giovanni Giacomo) **a :** history's most notorious lover whose resume also lists playwright, spy, dualist, soldier, translator, clergyman, diplomat, extortionist, magician, director of state lotteries in Paris, freemason, Catholic knight, impostor, violinist, and fugitive – proof that when you've got it, flaunt it, as he was Europe's favorite dinner guest

CASANOVA

b : although his name has become synonymous with "womanizer," he did not partake in the fashionable orgies of his era and recalled in his 12-volume autobiography that he really only had 1 true love, a mysterious French woman, about whom he said, "People who believe that a woman is not enough to make a man equally happy all the twenty-four hours of a day have never known a Henrietta." **c :** died at age 73 in Venice, where it all began

castanets \,kas-tə-'nets\ *n* a percussion instrument that consists of 2 concave shells tied together by a string and is clicked in the palm of the hand to produce a sound that can cause listeners to involuntarily jump up and shout "Olé! " – see *FLAMENCO*

cat \'kat\ *n* **a :** a domesticated pet *(Felis catus)* that communicates feelings of attachment through various actions *such as* nuzzling, purring, rolling on back, and demanding attention when its owner is otherwise occupied <*as in* working on computer, talking on phone, paying bills> **b :** whereas dogs have masters, it is said that cats have staff

ceiling \'sē-liŋ\ *n* the overhead interior surface of a room that one sees a lot of when one is in love

Central Park \'sen-trəl-'pärk\ *n* an urban outdoor paradise of 843 acres located in the heart of New York City and containing everything a boy and girl could ask for when falling in love <*as in* miles upon miles of walking paths, art nouveau iron bridges, a 1908 carousel with hand-carved horses, 2 ice rinks, a Great Lawn for picnicking, a castle, an outdoor café on a lake, rental boats, a zoo, a band shell, wooden benches, playgrounds with swings, and horse-drawn carriages that are best rid-

CHAISE LOUNGE

den at night when the cars and most of the visitors have cleared out>

certifiable \ˌsər-tə-ˈfī(-ə)-bəl\ *adj* a polite way of saying that one's boyfriend or girlfriend is crazy <"Marsha can't take Enrique to any more parties – he's *certifiable*."> – called also *doesn't play well with others, whack job*

chairlift \ˈcher-ˌlift\ *n* chairs suspended from an endless cable that carries skiers up or down a mountainside and which breaks down or is halted every so often so that lovers can nestle while enjoying the view

chaise lounge \ˈshāz-ˈlaůnj\ *n* [French] an upholstered chair that's shaped like a couch to support one's legs and that femme fatales and other women of experience like to be reclining on when receiving suitors – see COUGAR, MAE WEST

champagne \sham-ˈpān\ *n* **a :** sparkling, dry white wine from the Champagne region of France that has been compared to drinking the stars and whose effervescent bubbles are said to represent one's overflowing love for another **b :** the popping of a champagne cork and the clinking of glasses is a familiar sound at celebrations *such as* anniversaries, birthdays, engagements, and weddings and is a must-serve at romantic candlelit dinners for 2 <"My only regret in life is that I did not drink more *champagne*." –JOHN MAYNARD KEYNES, 1883–1946>

Chapel of Love \ˈcha-pəl-əv-ˈləv\ *n* infectious hit song of 1964 that was sung by the Dixie Cups, written by Jeff Barry, Ellie Greenwich, and Phil Spector, also covered by Bette Midler on her debut album *The Divine Miss M*, and celebrates 2 people tying the knot <"Gee, I really love you, and

we're goin' to get married, goin' to the *chapel of love*....">

ChapStick \\'chap-'stik\\ *n* **a :** a lip balm that contains ingredients *such as* camphor, beeswax, and menthol and is applied to one's lips by lovers to protect them from the drying-out effects of over-smooching **b :** invented by Dr. Charles Browne Fleet of Lynchburg, Virginia, in the early 1880s

cheeks \\'chēks\\ *n* the fleshy areas of the face located below the eyes and on each side of the nose and designated for air kisses

cherry \\'cher-ē\\ *n* **1 : a :** a small, early-summer fruit (genus *Prunus*) that symbolizes female sexuality and fertility and whose shape is simi-

CHERRY

lar to that of the human heart **b :** throughout the ages the cherry's sweet juice, firm texture, and lustful hues (gold, pale-pink, deep-red, mahogany, purplish-black) have been likened by poets and writers to every erogenous part of a woman's fully ripe body <*as in* lips, breasts, hymen> **c :** sweet cher-ries *such as* Bing, Lambert, Tartarian, and Royal Ann are usually eaten out of hand or fed to one's lover, while sour cherries *such as* Early Richmond, Montmorency, and English Morello make the fairest of pies **2 : 3** red cherries in a row mean one has hit the jackpot

chest \\'chest\\ *n* **a :** in hominids the area between the neck and the abdomen that is supported by the ribcage, spine, and shoulder girdle and that in both males and females is ogled over **b :** in males a hairy chest is seen as an object of atavistic virility linked to the club-wielding caveman **chest thrust** \\'chest-'thrəst\\ *n* postural message throughout the animal kingdom in which a male shows his dominance and makes others shrink in his presence by standing tall and thrusting out his chest – see *THREAT RE-SPONSE* **Chesty Morgan** \\'ches-tē-'mòr-gən\\ (b. 1928, Poland, née Llana Wilczkowsky) stripper of the 1960s and 1970s who starred in 2 Doris Wishman sexploitation films, *Deadly Weapons* (1973) and *Double Agent 73* (1974), had a bit part in Federico Fellini's *Casanova* (1976), and was billed as "the world's largest naturally occurring bosom" <*as in* 73-32-36>

CHEW TOY

chew toy \'chü-ˌtȯi\ *n* a person one is having discreet sex with on the side – see *FRIEND WITH BENEFITS*

Chia Pet \'chē-ä-ˌpet\ *n* **a :** a hollow clay pot in which herbs are grown to simulate the fur or hair of an animal, which lovers give to one another to express their feelings of devotion **b :** Chia Pets have been sold since 1982 by Joseph Enterprises of San Francisco, which also holds the patent for the Smart Clapper light switch <*as in* "Clap on! Clap off!"> that is used by people who have difficulty getting out of bed and by lovers who don't like wasting a second

chiaroscuro \kē-ˌär-ə-ˈskyu̇r-(ˌ)ō\ *n* [Italian] **a :** a dramatic shaft of light from an unseen source that creates 3-dimensional highlights and shadows on a motionless subject *such as* one's boyfriend or girlfriend whom one encounters either dozing or reading in a chair by a window **b :** chiaroscuro flourished in Italian and Flemish paintings of the 15th and 16th c., notably in works by Caravaggio, Giovanni Baglione, and Ugo da Carpi

Child, Julia \ˈchī(-ə)ld-ˈjul-ē-ä\ (1912–2004) gourmet cook who so loved French food that she made its preparation accessible to Americans via TV and cookbooks, and though her recipes are time consuming and labor intensive to prepare <*as in* coq au vin, beef bourguignon, duck a l'orange>, they say to a

JULIA CHILD

boyfriend or girlfriend that the relationship has progressed to a more serious stage – see *FOOD PROCESSOR*

chiliburger \ˈchi-lē-ˈbər-gər\ *n* an open-faced hamburger sandwich topped with chili con carne, which, when ordered by a female on a date, lets a guy know that she is neither stuck up nor has an eating disorder <*as in* cool chick>

chips and salsa \ˈchips-ən(d)-ˈsȯl-sə\ *n* man-bait that's left on a kitchen counter or coffee table – see *NACHOS*

chiropractor \ˈkī-rə-ˌprak-tər\ *n* a health care professional who specializes in treating back injuries caused by rigorous sex

64

chlorine bleach \'klȯr-ˌrēn-'blēch\ *n* sodium hypochlorite, a cleaning agent used by unfaithful lovers to remove stains from bedsheets

chocolate \'chä-k(ə-)lət\ *n* **a :** a lover's best friend, there in the good times, giving one energy and boosting sexual stamina, and there in the bad times, helping to comfort and lift depression **b :** chocolate's sensuous melt-in-the-mouth temperature point is slightly below the human body's <"Hold me and control me and then melt me slowly down like *chocolate*." –Kylie Minogue, "Chocolate"> – see *CANDY*

choreophobia \'kȯr-ē-ə-'fō-bə-ä\ *n* the irrational fear of dancing that most men possess <*as in* "I won't dance, don't ask me. I won't dance, Madame, with you. My heart won't let my feet do the things that they should do." –Fred Astaire to Ginger Rogers in *Roberta*, 1935, *dir* William A. Seiter>

Chrysler Building \'krī-slər-'bil-diŋ\ *n* **a :** the queen of New York skyscrapers, located at 42nd Street and Lexington Avenue **b :** a beloved mas-

CHRYSLER BUILDING

terwork of Art Deco design that features replicas of the 1929 Chrysler automobile on its exterior <*as in* eagle hood ornaments and radiator caps>, a marble lobby with Egyptian motifs, and a stainless steel spire that is illuminated at night **c :** designed by William van Alen (1883–1954), it opened in 1930 and was the world's tallest structure until the Empire State Building was completed a year later

chubba bubba \'chə-bē-'bə-bə\ *n* an overweight good old boy

chubby chaser \'chə-bē-'chā-sər\ *n* a person who seeks out overweight sex partners – see *BBW* **Chubby Checker** \'chə-bē-'che-kər\ (b. 1941, né Ernest Evans) American singer who attended South Philadelphia High School with Frankie Avalon and Fabian and who put an end to partner dancing with his 1960 hit song "The Twist" **Chubby Hubby** \'chə-bē-'hə-bē\ *n* Ben & Jerry's ice cream flavor that was introduced in

CHUBBY

1995 and contains chunks of chocolate-covered, peanut butter–filled pretzels in vanilla malt with deep ripples of fudge and peanut butter

ciggie-poo \\'si-gē-ˌpü\\ *n* a cigarette that is smoked after a martooni and is usu. bummed

Cinderella \\ˌsin-də-'re-lə\\ *n* classic allegory of love triumphing over social class as a non-salaried domestic receives a gratis redo from a fairy godmother so that she can attend the town's biggest ball where she snags a handsome prince with a podophilia disorder – see *FETISH EXAMPLES pp. 100–101*

circuit party \\'sər-kət-'pär-tē\\ *n* a year-round series of staged party events held in cities and beach resorts on the gay circuit across the U.S. <*as in* Palm Springs, South Beach, Chicago>, during which thousands of (mostly) young men spend a few days in a kind of disco Twilight Zone, dancing to throbbing, DJ-programmed music with their shirts off **circuit queen** \\'sər-kət-'kwēn\\ *n* a gay male who spends lots of money attending circuit parties

city lights \\'si-tē-'līts\\ *n* the spine-tingling view of the Manhattan skyline from the Brooklyn Heights promenade, esp. at night **City Lights** *n* 1931 film by Charlie Chaplin that's considered his masterpiece and tells the story of the Little Tramp's heartbreaking love for a blind girl who sells flowers and thinks he's her rich benefactor *note* voted by the American Film Institute as the tenth most romantic movie ever made

CHARLIE CHAPLIN

clandestine \\klan-'des-tən\\ *adj* used to describe an amorous or sexual relationship between 2 consenting and sometimes deceptive adults, which is fast-moving, unstructured, shadowy, and ambiguous <"I think Monica may be having a *clandestine* affair with the CEO.">

climax \\'klī-ˌmaks\\ *n* **1** : see *HUMAN SEXUAL RESPONSE, ORGASM* **2** : the high point of a story <"President Clinton's career *climaxed* in the Oval Office."> **Climax** *n* the name of a town in Polk County, Minnesota

(pop. 242), where, in 2004, the superintendent of schools forbade students to wear T-shirts to class bearing the town's motto of "Climax – More Than A Feeling," which had been voted on in a contest and had won out over entries *such as* "No End to Climax" and "Bring a Friend to Climax"

Cline, Patsy \'klīn-'pat-sē\ (1932–1963) crossover country star whose honey-voiced incantations on the heartbreak and longing of love <*as in* "Crazy," "I Fall to Pieces," and "Sweet Dreams"> turned country music haters into country music lovers and who broke the nation's heart when she died at age 30 in a plane crash in Tennessee

Clinton, William Jefferson \'klin-tᵉn-'wil-yəm-'je-fər-sən\ (b. 1946) 42ⁿᵈ president of the U.S. and husband of Senator Hillary Rodham Clinton, who in 1999 sparked a national dialog and congressional investigation as to whether a blow job falls under foreplay or coitus <*as in* "I did not

WILLIAM JEFFERSON CLINTON

have sex with that woman."> – see *BUNNY HORNY*

clitoris /'kli-tə-rəs/ *n* **a :** the most excitable part of a woman's body, whose sole purpose is sexual stimulation **b :** located in the anterior region of the vagina between the labia minora, any man who can find it without having to ask for directions is considered a good lover – called also *clit, eighth wonder of the world, emerald city, secret garden*

cock \'käk\ *n* a tilt of the head that implies curiosity and that occurs when someone of interest catches one's eye <"When a certain pair of nylon walking sticks took a seat at the lunch counter, he looked up from his BLT and *cocked* his head."> **cock-a-doodle-don't** \'kä-kä-dü-dᵊl-'dont\ *n* a condom **cockblock** \'käk-'bläk\ *vb* to physically come between 2 people who are attracted to each other at a party or bar <"We were about to go home together until you *cockblocked* us."> **cockpit** \'käk-,pit\ *n* an enclosed space in the front fuselage of an airplane where the captain, copilot, navigator, and other flight crew members assemble before take-off to de-

cide on which romantic destination to take their passengers **cocksman** \'käks-'man\ *n* picaresque term to describe a man who enjoys sex (as opposed to a female who enjoys sex and is called a whore) **cocksure** \'käk-'shŭr\ *adj* masculine overconfidence <"He's so damn *cocksure* of himself."> **cocky** \'ka̤-kə\ *adj* an arrogant male swagger based on an overinflated ego

coinkydink \kō-'əŋ-kə-diŋk\ *n* fate; kismet <"We ran into each other at the Red Lobster. Tell me that ain't a *coinkydink*.">

Cole, Nat King \'kōl-'nat-'kiŋ\ (1919–1965) groundbreaking African American jazz pianist and singer with a laid-back style and smoky, mellifluous voice, whose plethora of hits include "Sweet Lorraine," "Nature Boy," "Mona Lisa," "Smile," "When I Fall in Love," and 2 renditions of "Unforgettable," 1 in 1951 and a re-mastered duet with his daughter, Natalie, in 1991

NAT KING COLE

commando \kə-'man-(,)dō\ *adj* the act of a woman not wearing underwear when going to a party or out clubbing <"Our insider told us that Paris loves the fact that Britney gets turned on by going *commando*." –YEEEAH.COM> – called also *free-buffing **var*** free-balling (male)

compliment \'käm-plə-mənt\ *vb* to casually express respect or esteem <"*Compliment* a woman at the age of 20, and she will blush. *Compliment* a woman of 30, and she thinks you're clever. *Compliment* a woman of 40, and she'll wonder what you want." –ANON.>

compute \kəm-'pyüt\ *vb* to determine the state of a relationship by mathematical logistics <"Why's she seeing Griffin? I mean, it don't *compute*.">

conditional love song \'kən-'dish-nəl-'ləv-'sóŋ\ *n* a ballad or duet sung in the 1st act of a musical, whose lyrics are in the conditional tense as the romantic leads have yet to know each other or fall in love; a standard device in Broadway shows by Rodgers and Hammerstein <*as in* "People Will Say We're in Love," "Some Enchanted Evening," and "If I Loved You">

68

Coney Island \'kō-nē-'ī-lənd\ *n* a recreational, oceanfront area of S Brooklyn where, since 1897, generations of New York couples have ventured in the summer months to breathe the ocean air, lie on the beach, stroll the 3-mi. boardwalk, eat Nathan's hot dogs, and get their adrenalin levels up by riding the Cyclone, a rollercoaster built in 1927 and still going <*as in* "I can hear the Atlantic echo back rollercoaster screams from summers past." –Death Cab for Cutie, "Coney Island">

confidence \'kän-fə-dən(t)s\ *n* feeling secure enough with one's lover to walk around naked with the lights on

conflict \'kän-ˌflikt\ *n* an antagonistic state of priorities that a couple in love must experience and get past in order to be truly intimate with each other – see *MAKE-UP SEX*

Connie \'kän-ē\ *n* loving nickname for the Constellation, a dolphin-shaped, 3-tailed, propeller-driven, 54-passenger aircraft that represented the luxurious pinnacle of pre-jet air travel and on which Marilyn Monroe met the seatmate of her dreams in the 1953 film *How to Marry a Millionaire* (*dir* Jean Negulesco) **Connie Francis** \'kän-ē-'fran(t)-səs\ (b.1938, née Concetta Rosa Maria Franconero) hugely successful recording artist of the 1950s and 1960s whose lachrymose voice expressed teen longing of a repressed era <*as in* "Where the Boys Are">

CONNIE FRANCIS,

continent \'kän-tə-nənt\ *n* an enormous landmass *such as* Asia or Africa or North America that features physical obstacles *such as* mountains, deserts, and rivers that have never stood in the way of people in love

CONVERTIBLE

convertible \kən-'vər-tə-bəl\ *n* **1** : a 2-door automobile that has windup windows and a retractable roof and allows its occupants to arrive at their destination with suntans and sexy, windswept hair **2** : an uncircumcised penis <"I traded in my boyfriend for a Swedish *convertible*."> – called also *cut*

Coolidge Effect \ˈkü-lij-i-ˈfekt\ *n* a condition of continual rearousal observed by scientists in male rats and other mammals when new females were introduced; according to the Coolidge Effect, sex or flirting with an unfamiliar partner provides a bigger dopamine rush

copulatory gaze \ˈkä-pyə-lə-tə-rē-ˈgāz\ *n* an intense and animalistic look of love that a person gives to someone he or she is sexually interested in and that forces that person to respond, either positively <*as in* smiling back, making small talk, or offering to buy drinks> or negatively <*as in* making a rude remark, shifting about nervously, or checking the time>

coriander \ˈkȯr-ē-ˌan-dər\ *n (Coriandum sativum)* **a :** a relative of the parsley family known for its seeds and lacy, dark-green leaves **b :** when the herb presents itself in a dream, it means a vagina is eager for penetration *source The Perfumed Garden*, by Sheik Nefzaoui (written in the 16th c. and translated into English by Sir Richard Francis Burton in 1886) *note* the following excerpt is a poet's interpretation of a dream that a sheik had in which his wife sent him a bowl of coriander

CORIANDER

••

> She has sent you coriander
> White as sugar;
> I have placed it in my palm,
> And concentrated all my thoughts upon it,
> In order to find out its meaning;
> And I have seized it.
> O my master, what she wants to say,
> Is, "My vulva is restored to health."

••

cortisol \ˈkȯr-tə-ˌsȯl\ *n* a hormone that is produced in the adrenal gland and released when lovers are quarreling or breaking up and causes one to eat increased amounts of foods that are higher in carbohydrates *such as* cookies, potato chips, and lasagna – see *BEN & JERRY'S*

cougar \ˈkü-gər\ *n* a hot older woman who is on the prowl for young lovers <*as in* "It's not a stigma, it's a sophisticated species of female who seeks the pleasure of younger males. She avoids the entanglements of a 'relationship' in favor of the freedom of

COUGAR

the hunt. She has overcome the taboos related to her sexual identity and embraced her true self and now lives life to its fullest. Always one for adventure, she knows what she wants and isn't afraid to get it!" –Urbancougar.com>

couple \'kə-pəl\ *n* 2 individuals in a relationship, whose values, thoughts, and tastes have melded together over a period of time so that they present themselves to the world as a unit <*as in* "We loved it, didn't we Billy?">

courtly love \'kȯrt-lē-'ləv\ *n* a late-medieval conventionalized code that prescribed the proper conduct for the ladies of court and their lovers and inspired romance literature featuring a handsome knight <see *KNIGHT IN SHINING ARMOR*>, who typically offers his obedience and submission to an older lady <see *COUGAR*> who is in control of the relationship and whose love he tries to earn by doing noble deeds <*as in* hoisting his petard>

cowpoke stance \'kau̇-ˌpōk-'stan(t)s\ *n* a mating pose in which a dude wearing a cowboy hat and boots stands around a saloon with his thumbs hooked in the belt loops of his jeans while nonchalantly staring at his genitals

Craigslist \'krāgz-list\ *n* **a :** a centralized network of on-line communities that offers among its services free personals, message boards, and discussion groups for people who are looking for love with the proper or improper stranger **b :** begun in San Francisco in 1995 by Internet entrepeneur Craig Newmark, now has people of all sexual persuasions and curiosities connecting to each other in 450 cities worldwide – compare *MATCH.COM*

cramp \'kramp\ *n* a painful, involuntary, spasmodic contraction of a muscle that occurs when one is attempting a new or unusual sexual position and that is a cause of coitus interruptus – compare *DOUBLE-JOINTED* **cramp one's style** \'kramp-'wənz-'stīl\ *vb* to restrain a lover from his or her free expression <"Maybe you should move out – you're *cramping my style*.">

71

credit card \\'kre-dit-'kärd\\ *n* a small rectangular piece of plastic issued by large financial institutions so that no one can have an excuse for not going on romantic trips or buying engagement or wedding rings

cremaster \\ˌkri-'mäs-tər\\ *n* a muscle that covers the male testes and whose function is to raise and lower the scrotum in order to regulate the temperature of the testes and promote spermatogenesis **cremaster effect** \\ˌkri-'mäs-tər-'i-'fekt\\ *n* penis shrinkage that occurs as the cremaster muscle draws the testes closer to the body to prevent heat loss when they are exposed to a cool environment *such as* a swimming pool – called also *cocksickle* <*as in Seinfeld*, Season Five, "The Hamptons">

CRY

cry \\'krī\\ *n* a vocal exaltation ranging from soft to loud that is a visceral response to hurt feelings, a quarrel, or a breakup; lasts on average 1–2 mins. and is 5 times more common in females than in males who are 5 times more likely to cause the tears <"No guy is worth your tears, and the one who is won't make you *cry*." –Anon.>

cryptic sigh \\'krip-tik-'sī\\ *n* a barely perceptible, cunning exhalation of air from the throat that is ripe with conscious or unconscious meaning and is intended for one's partner to decode and is often released at dinner parties where others remain unaware of the interpersonal dynamics taking place <"And the evenings of martyred looks, *cryptic sighs*, sullen stares from those injured eyes...." –Stephen Sondheim, "Could I Leave You?">

crystallization \\'kris-tə-ˌlī-zā-shən\\ *n* a scientific metaphor linking crystals to love that was introduced by French writer Stendhal in 1822; he came upon it after visiting a salt mine in S France, where miners would throw leafless wintry boughs into abandoned areas of the mine and would return 3 months later to find them unrecognizably covered with "perceptual diamonds of shimmering beauty" through the effects of salt water <"I call *'crystallization'* that action of the mind that discov-

ers fresh perfections in its beloved at every turn of events." –STENDHAL, 1783–1842>

Cupid \'kyü-pəd\ *n* the god of erotic love who in Western art is portrayed as a mischievous boy or young man with wings and a quiver who shoots arrows into the hearts of mortals; gold-tipped arrows are for love and lead-tipped, for hate

custody \'kəs-tə-dē\ *n* the dividing up of shared or combined friends when a relationship ends

Cythera \ˌsi-thə-'rē-ə\ *n* **a** : a flowering island located at the metaphorical conjunction of landscape and desire and home to the Greek and Roman goddesses of love, Aphrodite and Venus **b** : in Jean-Antoine Watteau's *A Pilgrimage To Cythera* (1717), beautifully dressed aristocrats, accompanied by cherubs, pay a visit to this voluptuous, dreamily painted paradise that resembles Donald Trump's Mar-A-Lago Club in W Palm Beach, Florida, while in Sandro Botticelli's *The Birth of Venus* (ca. 1484), the Divine Miss V is seen emerging naked from her half-shell on the island's shore

CUPID

daDUM-daDUM-daDUM \ˌdä-ˈdəm-ˌdä-ˈdəm-ˌdä-ˈdəm\ *n* the sound of a normal heart beating ***daDUMdaDUMdaDUM!!!*** \ˌdä-ˈdəm-ˌdä-ˈdəm-ˌdä-ˈdəm\ *n* the sound one's heart makes before asking someone out for the first time

damaged goods \ˈda-mijd-gu̇dz\ *n* a term for anyone over 40 who is looking for a relationship

damn! \ˈdam\ *interj* **1 :** a 1-word superlative that's used when all other words fail to properly register the magnitude of one's first impression of another's physique <"Check out her body...*damn!*"> **2 :** a stage of being overweight <"Plump...heavy...chunky...*damn!*">

d'Antigny, Blanche \ˌdan-ˈtēn-ˌyä-ˈblänch\ (1840–1874) **a :** French courtesan who loved bedecking herself in diamonds and driving through Paris in open carriages and who made sure she was always the talk of the town by appearing in theatrical productions with not much on but her bling **b :** despite affairs with industrialists, bankers, sultans, shahs,

and crowned heads, including a Russian prince with whom she lived for 4 years in St. Petersburg, she died broke and alone at age 34 after giving up her demimonde existence for the true affections of a stout, not very handsome tenor she met in a play, who died shortly afterward **c :** she was the inspiration for Emile Zola's novel *Nana*

dark continent \'därk-'kän-tə-nənt\ *n* Sigmund Freud's term for the largely unexplored and difficult to comprehend female psyche <*as in* "Honey, you should wear that dress more often – it looks great on you!" "So you do think I'm fat?">

Dark Lady \'därk-'lā-dē\ *n* the mysterious lover William Shakespeare wrote about in *Sonnets 127–152*, who is driving him mad with her infidelities <*as in* "For I have sworn thee fair and thought thee bright, who art as black as hell, as dark as night."> – see *FAIR YOUTH*

date \'dāt\ *n* a social engagement between 2 people that can lead to love and marriage or end up being a pointless waste of time and a hair appointment

deal breaker \'dēl-'brā-kər\ *n* the straw that breaks a lover's back; a negative quality that ends a relationship <"Calling her life coach during foreplay was the *deal breaker*.">

death spiral \'deth-'spī-rəl\ *n* the winding down of a relationship from which recovery is nearly impossible

December \di-'sem-bər\ *n* **a :** the 12th month of the Gregorian calendar **b :** a period when fatty, guilt-inducing foods and beverages are served, making one feel unattractive and hesitant to date for many months afterward **c :** a time of year when Hollywood releases its Oscar-winning movies, making it one of the best dating seasons

decider \di-'sī-dər\ *n* the person in a relationship who is primarily responsible for making the big decisions *such as* what consumer products to buy, where to go on vacation, and how many children to have, which, according to psychologists, is not so much about making the right choices as it is about being the boss <"Doesn't everyone…secretly believe that in interpersonal dealings he or she wears the '*decider* badge'?" –*The New York Times*>

decline \di-'klīn\ **1 :** *vb* a civilized way of saying "no chance in hell" <"As much as I'd love to meet you for drinks, I'm afraid I'll have to *decline*."> **2 :** *vb* to be rejected and humiliated on a dinner date <"I'm sorry, sir, but your credit card has been *declined*."> **3 :** *n* an economic condition in romance novels <"With her family's fortune in *decline*, Desiree bid adieu to the rubber plantation and all it meant to her.">

DELILAH

Delilah \di-'lī-lə\ *n* **1 :** biblical temptress, schemer, betrayer, and lover of Samson, a Herculean Israelite whose hair she whacks off and sells to the conquering Philistines after learning it's the source of his manliness **2 :** 1968 hit song by Tom Jones about the murder of an unfaithful woman **Samson and Delilah** \sam(p)-sən-ən(d)-di-'lī-lə\ *n* **1 :** 1890 French opera by Camille Saint-Saëns (1835–1921), which features Delilah's scorching aria of love and sensuality "Mon coeur s'ouvre à ta voix" ("My heart opens to your voice") **2 :** 1949 spectacle-filled film by Cecil B. DeMille starring Hollywood's then hottest bodies, Victor Mature and Hedy Lamarr <"*Delilah*, what a dimpled dragon you can be, flashing fire and smoke." –MATURE to Lamarr>

dependent \di-'pen-dənt\ *adj* reliant on a boyfriend, girlfriend, or spouse or on a substance *such as* alcohol or drugs to get by or die <"Eye cream seems so expensive. I can't believe it really works. Then I feel like if I start using it, I will grow *dependent* on it, and if I stop, my eyes will stretch out." –ANDERSON COOPER, in *People* magazine>

Depp, Johnny \'dep-'jä-nē\ (b. 1962) **a :** American actor and musician who compensates for being too good looking <see *DOUBLE BOMB*> by sporting scrubby facial hair, pirate's teeth, and bad haircuts

JOHNNY DEPP

b : of Cherokee, Irish, and German descent, he is publicly low-key, moderately tattooed, only does films he finds to his liking, lives in a villa in France, and has the greatest sexual attribute of all: mystery

deride \di-'rīd\ *vb* to mean-spiritedly ridicule someone whose heart is breaking <"Now laughing friends *deride* tears I cannot hide." –OTTO HARBACH/JEROME KERN, "Smoke Gets In Your Eyes">

desperation \,des-pə-'rā-shən\ *n* a potent, indescribable odor that permeates a singles' bar 15–20 mins. before closing

destiny \'des-tə-nē\ *n* the belief that everything is predetermined and by lucky accident the "right person" or "love of one's life" lives in one's century, is of one's generation, is not related, and may even share the same zip code or yoga studio <"There's no such thing as chance; and what to us seems merest accident springs from the deepest source of *destiny*." –JOHANN CHRISTOPH FRIEDRICH VON SCHILLER, 1759–1805>

diamond \'dī-(ə-)mənd\ *n* a precious stone possessing superlative physical qualities; composed of carbon, it may be the hardest thing a man can give the woman he loves **diamond in the rough** \'dī-(ə-)mənd-'in-thə-'rəf\ *n* a boyfriend who with lots of polishing goes from gooftard to Prince Charming **Diamond Lil** \'dī-(ə-)mənd-'lil\

DIAMOND

n man-loving character played by Mae West on stage and in film and who is famous for her double entendres *such as* "Is that a gun in your pocket or are you just glad to see me?" **Neil Diamond** \'nēl-'dī-(ə-)mənd\ (b. 1941) American singer-songwriter whose iconic love songs include "Song Sung Blue," "You Don't Bring Me Flowers," and "Love on the Rocks"

diaphanous \dī-'a-fə-nəs\ *adj* a breathy, sensual sounding word to describe women's sleepwear that is of such fineness of texture as to be able to see through it <"Miranda bade me to her boudoir wearing a flowing, *diaphanous* robe."> *syns* cobwebby, gauzy, gossamer, sheer, transparent, vaporous

dickbrain \dik-'brān\ *n* a fool; a guy who screws up a really good relationship <"Way to go, *dickbrain*."> – called also *dickface, dickhead* **dick pokers** \'dik-'pō-kərz\ *n* close-fitting, revealing, nylon swim trunks

diet plate \'dī-ət-'plāt\ *n* a classic lunch order for people who are dating and want

78

to stay slim that usu. consists of cottage cheese and fresh fruit or tuna served on a bed of iceberg lettuce

difficult years \'di-fi-(,)kəlt-'yirz\ *n* an age, usu. between 30 and 40, when one is too old to wear a bikini or thong and too young for a caftan or muumuu

digital imaging \'di-jə-t°l-'i-mi-jiŋ\ *n* a process in which one uses Photoshop or other advanced computer skill to enhance one's photograph on an Internet dating service

dilate \'dī,lāt\ *vb* the widening of the pupil of the eye in response to less light – see *CANDLELIT DINNER*

dildo \'dil-(,)dó\ *n* **a** : a non-vibrating sex toy made of silicone and other modern materials, shaped like a penis, and used for sexual gratification **b** : stone dildos have been found in archaeological digs, causing much speculation about what cavewomen did when their husbands were off hunting woolly mammoths **strap-on dildo** \'strap-òn-'dil-(,)dó\ *n* a dildo designed to be worn by one partner and used to penetrate the other vaginally, anally, or orally

dimmer switch \'di-mər-'swich\ *n* a wall device necessary for regulating the intensity of a lighting unit *such as* a lamp or overhead fixture when one is having a romantic evening at home

dimples \'dəm-p(°)lz\ *n* small, natural indentations of the human face that form in the cheeks when a person smiles and are a turn-on; most babies have dimples, as do babes *such as* Mario Lopez, Kurt Russell, and Jennifer Garner

DIRECTIONS

directions \də-'rek-shənz\ *n* the way to a destination that men's brains are hardwired not to ask for, which evolutionary scientists think may be nature's way of giving men more time to spend in the car with their girlfriend

discretion \dis-'kre-shən\ *n* the art of being cautious and not sending one's lover erotic e-mails at his or her workplace

dissolve \də-'zälv\ *vb* to end a marriage; under most U.S. laws divorce is now de-

79

fined as a "dissolution of marriage" and is nobody's fault <"Len's twice *dissolved*."> by the American Film Institute as the seventh most romantic movie ever made

D-minor chord \'dē-'mī-nər-'kȯrd\ *n* considered by many to be the most melancholy key in music; featured in Bach's "The Art of the Fugue," Beethoven's "Symphony No. 9," Rachmaninoff's "Piano Concerto No. 3," Carl Orff's "Carmina Burana," Madonna's "Like a Prayer," Abba's "Lay All Your Love on Me," and Jimi Hendrix's "The Wind Cries Mary"

DOG

dog \'dȯg\ *n* a domesticated 4-legged animal *(Canis familiaris)* with bad breath and a tail and who is always up for taking walks, cuddling on the couch, and sleeping with its owner; never holds a grudge, has a snit, or calls with excuses <"To err is human, to forgive canine." –ANON.> *vars* dawg, dogg – see *GEORGE NOEL GORDON BYRON*

Doctor Zhivago \'däk-tər-ˌzhə-'vä-gō\ *n* 1965 epic film (*dir* David Lean) based on Boris Pasternak's 1957 novel in which Omar Sharif plays a doctor and poet who carries on an adulterous affair with a mysterious nurse named Lara (Julie Christie); their paths keep crossing throughout the harsh years of the Bolshevik Revolution as Maurice Jarre's Oscar-winning "Lara's Theme" plays again and again and again, and yet again; Lean is a master of illicit love stories – see *BRIEF ENCOUNTER **note*** voted

JULIE CHRISTIE IN DOCTOR ZHIVAGO

Dole, Bob \'dōl-'bäb\ (b. 1923) Republican senator from 1969–1996 and husband of Republican Senator Elizabeth Dole; ran for the presidency in 1996 and after being defeated by Democratic Senator Clinton, went on to do erectile dysfunction TV commercials for Viagra, a product his opponent would have no need for **Dole Food Company** \'dōl-'füd-'kəmp-nē\ *n* agricultural corporation that

BOB DOLE

in 1925, when it was called the Hawaiian Pineapple Company, held a reader recipe contest that produced the American pineapple upside-down cake, a classic that women have been baking and men drooling over ever since

dolphin \\'däl-fən\\ *n* a marine mammal (family Delphinidae) known for its intelligence, compassion, joy, and uninhibited love of sex – see *FLIPPER* **Dolphin** *n* a popular line of vibrators that come in various dolphin-shaped sizes

dominatrix \\'dä-mi-'nā-triks\\ *n* a woman who dresses in black leather, fishnet stockings, and stilettos, carries a whip or paddle, and is paid by CEOs to spank them as punishment for their willful role in corporate fraud **domme** \\'däm\\ *n* shortened form of dominatrix <"Sub boy here needs *domme* to make him obey." –CRAIGSLIST>

Don Juan \\'dän-'(h)wän\\ *n* **1 :** a lady's man who has a "hump 'em and dump 'em" reputation and who gets his name from the legendary Spanish nobleman and libertine **2 :** the title of a 1926 Warner Brothers film (*dir* Alan Crosland) that stars John Barrymore and features the most on-screen kisses ever: 191, or 1 every 53 secs.

Donne, John \\'dä-nə-'jän\\ (1572–1631) English writer and master of romantic love whose passionate poems <*as in* "The Dream" and "The Ecstasy"> and elegies <*as in* "To His Mistress Going to Bed" and "Love's Progress"> glitter with eroticism and whose later works attempt to deal with the death of his wife, Anne More, who he was married to for 15 years

JOHN DONNE

Don'tdatehimgirl.com \\'dōnt-dāt-həm-gərl-dät-cam\\ *n* an on-line community where women from all around the world can post names and photographs of boyfriends who allegedly have cheated on them; to date more than 27,000 photos have been submitted

don't go there \\'dōnt-'gō-'*ther*\\ *interj* a warning issued by lovers during a fight to indicate that a dangerous line is about to be crossed and what is said may not be able to be taken back *var* don't push it

doo dee doo dee \\'dü-'dē-'dü-'dē\ *n* **a :** the theme to *The Twilight Zone*, an offbeat TV series written and hosted by Rod Serling that premiered on CBS in October 1958 **b :** used to describe a boyfriend or girlfriend who seems to live in another dimension <"Jerry, when I said to come by at six, I meant after work, not before...*doo dee doo dee*.">

doodly-squat \\'düd-lā-'skwät\ *n* the remains, or least amount; what one is left with after a breakup <"She got the house and the kids, and I got *doodly-squat*."> – called also *diddly-squat*

DOORMAN

doorman \\'dòr-ˌman\ *n* a uniformed employee of a residential building who keeps track of everyone who comes and goes and, if he wants a decent Christmas tip, knows how to keep his mouth shut

doors closing \\'dòrz-'klō-ziŋ\ *n* said by a female to her lover to signify the sex act is completed, and it is time for him to go home, now

dopamine \\'dō-pə-ˌmēn\ *n* a chemical and neurotransmitter found in the brain and other areas of the body that makes one feel good for feeling good – often for doing something one maybe shouldn't *such as* going on a Jimmy Choo shopping spree, having a 3-martini lunch, or even habitually falling in love; because dopamine stimulates the release of the sexual hormone testosterone, it has been dubbed by anthropologist Helen Fisher as "the liquor that fuels romance" **dope** \\'dōp\ *adj* really cool <"Man, she's *dope*.">

double bomb \\'də-bəl-'bäm\ *n* someone who is almost too good looking <"How'd Big Tito score that *double bomb*?"> – called also *bombdiggity* – see *JOHNNY DEPP*

double-jointed \\'də-bəl-'jòin-təd\ *adj* **a :** the condition known medically as hyper-

mobility, in which a person's joints can stretch further than is normal **b** : a rare phenomenon that men don't go looking for but are certainly delighted to discover <"Lordy, Inga is bi and *double-jointed*."> – see *JACKPOT*

down-aging \'daủn-'ā-jiŋ\ *n* a term coined by trend-watcher Faith Popcorn to describe nostalgia-crazed members of an older generation who relive their courting days by wearing fashions of the period *such as* boogie shoes or listening to songs of their era by the original artists on PBS pledge drives <*as in* "Oh that's the way, uh-huh uh-huh, we like it, uh-huh uh-huh."> – see *HARLEY-DAVIDSON*

downcast \'daủn-'kast\ *n* a slow downward movement of the eyes followed by a slow upward moment, which is how a woman lets a man who is hitting on her know she is interested

down comforter \'daủn-'kəm(p)-fə(r)-tər\ *n* a quilt stuffed with soft, fluffy feathers that is warming in winter and cooling in summer and makes one want to never get out of bed, lover or not *note* cruelty-free stores on the Internet offer organic, lightweight alternatives to feathers

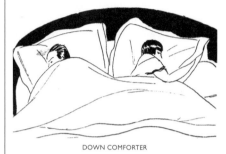

DOWN COMFORTER

downshifting \'daủn-'shif-tiŋ\ *vb* to quit a high-stress job in order to have more time with the person one loves <"Honey, it's a crossing-guard vest. I'm *downshifting*.">

dream \'drēm\ *n* a very sexy or unusually attractive person who sometimes appears before one's eyes when one least expects it and requires one to pinch oneself to make sure one isn't in an REM or Level 3 sleep stage **dreamboat** \'drēm-'bōt\ *n* the "perfect" boyfriend or girlfriend who sometimes turns out to be the *Titanic* **Dream Cream** \'drēm-'krēm\ *n* an orgasm facilitator invented by Jed Kaminetsky, a urologist at New York University's School of

Medicine, which helps women have more pleasurable, forceful orgasms; contains off-label combinations of vasodilators, or blood flow enhancers, and is applied to the clitoris and labia before intercourse – called also *the female Viagra* **dream kitchen** \\'drēm-'ki-chən\ *n* an expensive fantasy that has an island in the middle for having sex **dreamland** \\'drēm-'land\ *n* a place where one spends 6 years, or 2 hours a night, of one's life **dream on** \\'drēm-'än\ *vb* to mistakenly think someone has the hots for oneself **dreamy** \\'drē-mē\ *adj* a low-level form of consciousness in which one is oblivious to his or her co-workers, which means either he or she is in love or enjoying a Xanax

drinks \\'driŋks\ *n* **a :** alcoholic refreshments that relax one's body and bring 2 people together <"Can we meet for *drinks*?"> or settle a lovers' quarrel <"Can we discuss this over *drinks*?"> **b :** too many drinks can result in the failure to get a relationship off the launch pad <*as in* "It [drink] provokes the desire, but it takes away the performance." –WILLIAM SHAKESPEARE, *Macbeth*> **d-runk** \\'dē-rəŋk\ *adj* past tense of d-rink <"I don't know what we did after that. I was *d-runk*.">

drip \\'drip\ **1 :** *vb* to ooze or let out copiously <"I was transfixed by [Rita] Hayworth – her glow, her hair, her audacity, and by the very idea that a movie could so *drip* with

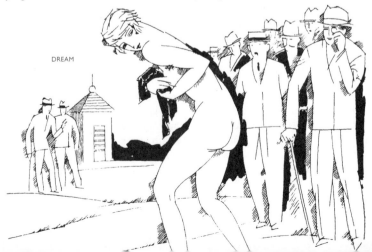

DREAM

sex and innuendo." –JAMI BERNARD, author, *The X List*> **2** : *n* a retro nerd

drive-in \'drīv-'in\ *n* **a** : a fixture of the 1940s–1960s where, for an admission price, people could park their cars in front of a large screen to watch a movie and young couples who needed a place to smooch could go **b** : today drive-in theaters are a rarity, though the remains of their structures can sometimes be seen in asphalt lots overgrown with weeds and memories

drizzle \'dri-zəl\ *vb* a sensuous cooking term that means to make wet with minute drops and usu. applies to precious food items <"She *drizzled* the melted chocolate atop the pears," or "He *drizzled* the macadamia nut oil over her alabaster thighs.">

drop cloth \'dräp-'klóth\ *n* a sheet made of canvas or other material that is placed over furniture for protection <"A girl's best friend is her *drop cloth*. Before you embark on your madcap erotic adventure, dig up an old heavy quilt to drape over your expensive and easily soiled sheets. It's like birth control; you'll be glad you thought of it in advance." –CRAIGSLIST>

dumbbells \'dəm-ˌbelz\ *n* exercise weights that people who no longer have time to go to the health club because they're in a relationship keep in their homes to try and maintain some muscle tone

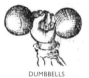
DUMBBELLS

dump \'dəmp\ *n* a surreal, Dali-esque landscape located on the outskirts of a city or town, where the jilted go to rid themselves of their lover's possessions after finally accepting the reality that he or she is never coming back

duty free \'dü-te-'frē\ *adj* a tax-free, last-minute gift that one buys at an airport, having forgotten to get one's lover or spouse something special from far away

Dyngus Day \'diŋ-gəs-dā\ *n* a Polish tradition celebrated annually in Buffalo, New York, and South Bend, Indiana, on the first Monday after Easter, during which singles congregate in a reception room or dance hall, and if a guy is interested in a girl, he sprays her with a squirt gun, and if she likes him back, she hands him a pussy willow

ears \\'irz\ *n* **a :** organs located on each side of the head that are used for gathering and processing romantic sounds *such as* "Would you like to have dinner?"or "Will you marry me?" **b :** can also be an erogenous zone, as when blown into

Earth \\'ərth\ *n* the 5th-largest planet in the solar system, where 6.5 billion people share its 57.5 million sq. mi. of landmass <*as in* someone for everyone>

easy \\'ē-zē\ *adv* love that is not hard <"She bid me take love *easy* as the leaves grow on the tree; but I, being young and foolish, with her would not agree." –WILLIAM BUTLER YEATS, 1865–1939> **I'm Easy** \\'īm-'ē-zē\ *n* Oscar-winning song from Robert Altman's 1975 movie *Nashville*, written and sung by Keith Carradine <"Take my hand and pull me down. I won't put up any fight, because *I'm easy*."> **Nice 'n' Easy** \\'nīs-ən-'ē-zē\ *n* a Frank Sinatra hit that warns, "To rush would be a crime, 'cause *nice 'n' easy* does it every time." –ALAN BERGMAN/ MARILYN BERGMAN/LEW SPENCE

BILLY ECKSTINE

Eckstine, Billy \'ek-stēn-'bi-lē\ (1914–1993) American jazz singer whose hits include "Everything I have Is Yours" (Harold Adamson/Burton Lane), "My Foolish Heart" (Ned Washington/Victor Young), and "Blue Moon" (Lorenz Hart/Richard Rodgers); when he crooned, they swooned <"*Eckstine* in particular shaded his plunges into the well of Eros with husky vocal edges that evoked a cool, manipulative sincerity. It was all about being the laid-back cock of the walk, so elegant and in control that women would fall all over each other for a taste of the honey." –STEPHEN HOLDEN, *The New York Times*>

ecology \i-'kä-lə-jē\ *n* the branch of biology that teaches one to be a better custodian of one's planet by cleaning up after a romantic picnic

Edison, Thomas Alva \'e-də-sən-'tä-məs-al-vä\ (1847–1931) American inventor who thought up the phonograph so that lovers could have mood music at home

THOMAS ALVA
EDISON

Edward VIII \'ed-wərd-thə-'ā-(t)th\ (1894–1972) king of the U.K. from January to December 1936 who, after meeting an older, twice-divorced, American-born commoner named Wallis Simpson, became so lovesick that he abdicated the throne in order to marry her; known as the Duke and Duchess of Windsor, they were married in Monts, France, and buried at Windsor Castle, England

EDWARD

Eiffel Tower \'ī-fəl-'taù(-ə)r\ *n* **a :** the world's most celebrated phallic symbol, made of iron and located alongside the River Seine in Paris **b :** *La Tour Eiffel* (named for its architect, Gustave Eiffel) was opened in 1889 for the Exposition Universelle marking the centennial of the French Revolution, and at 986 ft. (75 stories), or 1,058 ft. including antenna, was the world's tallest structure until the completion of the Chrysler Building in New York in 1930 **c :** lovers no longer need a passport to enjoy it as scaled-down replicas exist in various locations across the U.S., including the Las Vegas strip, Walt Disney's Epcot theme park in Flor-

ida, and downtown Paris, Texas, where a red cowboy hat hangs from the top

Eisenstaedt, Alfred \'īz-ən-stat-'al-frəd\ (1898–1995, b. W Prussia) *Life* magazine photographer who took the iconic photograph of a delirious sailor kissing a back-bending nurse in New York's Times Square on V-J Day, 1945

ejaculatory inevitability \i-'ja-kyə-lə-ˌtȯr-ē-i-'ne-və-tə-'bil-itē\ *n* the point at which a man is about to experience orgasm, when blood pressure, heart rate, and breathing are at elevated levels <*as in* "Keep going, keep going...," "Oh, baby, oh, baby, oh, yeah...," "Almost there, almost there...," "Hang on, stop, don't move...," "Oh *shiiii*-it!">

electrician \i-ˌlek-'tri-shən\ *n* a hot boyfriend who knows how to rewire a woman's toaster – compare *PLUMBER*

electricity \i-ˌlek-'tri-sə-tē\ *n* harnessed energy that lovers rely upon to create mood lighting, prepare blended drinks, and make coffee the next morning **electric kiss** \i-ˌlek-'trik-'kis\ *n* see *KINDS OF KISSES pp. 148–151*

elevator \'e-lə-ˌvā-tər\ *n* a moving, rectangular platform designed to take lovers to exalted, romantic places *such as* observation decks, penthouses, and rooftop restaurants and whose operating design was perfected in 1853 by Elisha Otis of Yonkers, New York, who founded the Otis Elevator Co., which is still the world's largest manufacturer of vertical transportation systems *var* [British] lift **elevator operator** \'e-lə-ˌvā-tər-'ä-pə-ˌrā-tər\ *n* a uniformed person who operates an elevator and gives riders the option of going up or going down

ELEVATOR

El Paso \el-'pa-(ˌ)sō\ *n* seat of El Paso County, W Texas, and port on the Rio Grande opposite Ciudad Juarez, Mexico, that is the Wild West setting for Marty Robbins's 1959 eponymous ballad about a gun-toting cowboy who dies for a Mexican maiden named Feleena who dances every night in Rosa's Cantina

embrace \im-'brās\ *vb*
a : to encircle a person with one's arms while lightly hugging him or her in a warm and loving way *<as in* "Upon waking the next morning

EMBRACE

about daylight, I found Queequeg's arm thrown over me in the most affectionate manner. You had almost thought I had been his wife." –HERMAN MELVILLE, author, *Moby Dick>* **b :** in 2007 archaeologists near Mantua, Italy, unearthed the 5,000–6,000-year-old remains of a couple who had been buried together face to face with their arms wrapped around each other in an enduring embrace; the Stone Age squeezes were dubbed the Lovers of Valdaro, after the Mantua suburb of industrial farmland where they were found

emotional-needs pets \i-'mō-shən-nᵊl-'nēdz-'pets\ *n* pets that people who are lonely or have incapacitating fears

EMOTIONAL-NEEDS PETS

such as agoraphobia take with them to public places *such as* restaurants, offices, health spas, and airplanes in order to feel secure and comforted *<*"When I travel, I tell hotels up front that 'Alexander Dog Cohen' is coming, and he is my *emotional-needs* dog." –APHRODITE CLAMAR-COHEN, *The New York Times>* – called also *emotional-service pets, emotional-support pets*

empathy \'em-pə-thē\ *n* understanding feelings for another's desperate need for love and attention *<as in* "Mom, I *do* like the tongue stud.">

endowed \in-'daùd\ *adj* **a :** a woman who has large breasts **b :** a man with large genitals; although "endowed" is correct usage, "equipped" is preferable when referring

ERECTION SYNONYMS
Artful dodger
Baloney pony
Beaver cleaver
Blue-veiner
Boner
Boneroni
Breakfast burrito
Captain's log
Charles the bold
Diamond cutter

BONER

to men <"No one could tell from Sven's thong that he was so well *equipped*.">

ensorcell \in-'sȯr-səl\ *vb* to bewitch, or enchant <"When she wore blue jeans, men were *ensorcelled* by her bonhunkus." – see *BUTTOCKS*>

erection \i-'rek-shən\ *n* **a :** a state of rigidity in which the penis becomes enlarged and elevated when its tissues fill with blood as a result of sexual arousal or watching new car ads – see *NITRIC OXIDE* **b :** man is the only mammal that does not have a bone in his penis, which makes the word "boner" a misnomer

EROS

Eros \'er-ä\ *n* **a :** god of male lust, love, and sex whose name is the root word for "erotic"; in ancient Greek mythology, Eros was the son of Aphrodite and Ares (goddess of love and god of war) and husband of Psyche **b :** called Cupid by the ancient Romans and Stupid Cupid by Connie Francis in her 1958 hit song of the same name **c :** a palindrome, "eros" spelled backward is "sore" <*as in* too much of a good thing>

erotogenic zones \i-ˌrō-tə-'je-nik-'zōnz\ *n* areas of the human body identified by Sig-

Honker
Irish toothache
Love pole
Morning glory
Nazi salute
Old hornington
One-eyed monster
Piccolo
Placenta poker
Pogo stick
Proud Mary

PICCOLO

Purple-headed womb ferret
Rock python
Sporting a sequoia
Steely Dan
Stiffy
Tallywhacker
Telescope
Texas longhorn
Throbber
Yogurt rifle

PYTHON

EYE EXPRESSIONS

BEDROOM

CLOSED

CROSS

GOLDDIGGER

GOO-GOO

JEALOUS

LOVING

LYING

SATISFIED

ILLUSTRATION: RAJ BHARADIA

mund Freud as the genitals, anus, mouth, and ears and whose definition has been expanded to include any part of the body that can be aroused

ESP (extrasensory perception) *n* a psychic ability people experience during the rush of falling in love that makes them think they were fated for one another *<as in "No way! I was just thinking of calling you when the phone rang!">*

Europe \'yu̇-rəp\ *n* a landmass between the Atlantic Ocean and Asia, where people smoke cigarettes, drink wine, and have sexy accents

ew \'ē-ü\ *interj* **a :** shortened version of "ewwwww" **b :** used to register a jolt of disgust or ickiness <"Jayson told you that's his fantasy? *Ew.*"> *syns* too much information, thank you for sharing

excuse me? \ik-'skyüz-'mē\ *interj* a comeback; a point of contentious disbelief said during an argument between lovers <"*Excuse me?* It's my fault?">

92

exercise \'ek-sər-ˌsīz\ *n* bodily exertion one engages in except when trying to maintain a relationship <"I don't have time to *exercise*. I'm seeing someone.">

EXERCISE

exotic \ig-'zä-tik\ *adj* used to describe a woman who has esp. dramatic facial features *such as* a Roman nose or a unibrow <"Larry, have I got a date for you." "Is she pretty?" "She's *exotic*.">

extension \ik-'sten(t)-shən\ *n* a movement in the body's sagittal plane that allows a woman to bend her head back from a standing upright position in order to be kissed

eye-hump \'ī-'həmp\ *vb* to seduce someone with one's eyes as he or she walks innocently by <"I do know how I feel when those fat slobs at the pizza place *eye-hump* every female that passes through their lazy-eyed visual field." –Craigslist> – see *GAZE*

eyes \'īz\ *n* organs of sight that are located in bony sockets at the front of the skull and considered the windows to the soul

EXTENSION

93

fabric softener \'fa-brik-'sò-fə-nər\ *n* a laundry product *such as* Downy or Bounce that is added to a load of wash to make clothes softer and fluffier and that if found atop a man's washing machine means a woman is marking her territory

FABRIC SOFTENER

fado \'fä-(ˌ)thü\ *n* [Portuguese] **a :** a folk song with heartsick lyrics that is performed in Lisbon taverns by women who are dressed in black and accompanied by guitar **b :** fado is to Portugal what tango is to Argentina or flamenco to Spain **Queen of Fado** \'kwēn-əv-'fä-(ˌ)thü\ *n* the title bestowed upon Amália Rodrigues (1920–1999), considered the greatest fado singer of all time

Fair Youth \'fer-'yüth\ *n* a mysterious young man whom William Shakespeare dedicated *Sonnets 18–126* to, in which he expresses his love for him; what expressing one's love meant to a Renaissance man is a subject of scholarly debate – see *DARK LADY*

SONNET TWENTY

A woman's face with Nature's own hand painted
Hast thou, the master-mistress of my passion;
A woman's gentle heart, but not acquainted
With shifting change, as is false women's fashion;
An eye more bright than theirs, less false in rolling,
Gilding the object whereupon it gazeth;
A man in hue, all 'hues' in his controlling,
Much steals men's eyes and women's souls amazeth.
And for a woman wert thou first created;
Till Nature, as she wrought thee, fell a-doting,
And by addition me of thee defeated,
By adding one thing to my purpose nothing.
But since she pick'd thee out for women's pleasure,
Mine be thy love and thy love's use their treasure.

faith \'fāth\ *n* a belief not based on any truth that one should dry one's hair and try to look one's best when running to the store as one never knows who one will run into or get asked out by

Fallopius, Gabriello \,fə-'lō-pē-əs-'gab-ri-'elō\ (1523–1562) **a :** Italian anatomist who discovered the eponymous fallopian tubes and who also named the vagina, placenta, and clitoris, among other body parts **b :** credited with having invented the proto-type of the modern condom – a linen bag doused in salt and herbs that was tied to the penis with a pink ribbon; it was not for birth control but to help prevent STDs (sexually transmitted diseases)

GABRIELLO FALLOPIUS

fare-beater \'fer-'bē-tər\ *n* a person who is afraid of missing the last train to his girlfriend's or boyfriend's place and has to leap over the turnstile in order to make it on board in time

fascination \,fa-sə-'nā-shən\ *n* a romantic crush that occurs in the first 3 months or so of a relationship and is marked by increased levels of dopamine and other feel-good chemicals in the brain, which causes a person to temporarily exhibit strange and uncharacteristic behaviors *such as* volunteering for home improvement projects, quitting one's job, or needing emotional support after listening to Hawaiian music

Fatal Attraction \'fā-tᵊl-ə-'trak-shən\ *n* 1987 thriller starring Michael Douglas and Glenn Close (*dir* Adrian Lyne), in which a

96

married man pays a high price for having a one-night stand with a woman who has too little serotonin and too much frizz

feather duster \'fe-<u>th</u>ər-'dəs-tər\ *n* a short-handled device consisting of soft feathers that is sold at hardware stores and is used to arouse one's partner during sexual foreplay – see *PARESTHESIA*

FEATHER DUSTER

February \'fe-b(y)ə-ˌwer-ē\ *n* the 2nd month of the Gregorian calendar, which, with 28 days (29 in leap years), is the shortest of the year but can sometimes feel like the longest <"The nights were long and cold and scary. Can we live through *February*?" –DAR WILLIAMS, "February">; the month when crocuses bloom, Super Bowl Sunday and the Academy Awards take place <see *NESTING*>, Cupid is celebrated <see *VALENTINE'S DAY*>, and winter finally loses its icy grip <*as in* "Wishing and wanting to see you, I step on thin ice." –MADOKA MAYUZUMI, poet>

female hysteria \'fē-māl-his-'ter-ē-ə\ *n* a medical condition that Victorian women were commonly misdiagnosed with and whose symptoms included faintness, insomnia, and anxiety; treatment involved a pelvic massage <see *QUOTE UNQUOTE*>, in which the doctor manually stimulated the woman's genitalia until she achieved hysterical paroxysm <*as in* "Father, is Mother home from the doctor yet? "No, son, she went for a second opinion.">

feminism \'fe-mə-ˌni-zəm\ *n* a sociopolitical movement in which women split the dinner check with their dates

femmebox \'fem-bäks\ *n* a curvaceous woman who turns heads because she dresses so glamorously <"Portia's quite the *femmebox* in her gold-sequined Elie Saab knock-off."> – called also *fashion plate*

femme d'une certain age \'fem-dœⁿ-ser-ten-äzh\ *n* [French] polite expression for a woman over 40 <*as in* "French women bloom at 40! I can't wait!" –JULIETTE BINOCHE, actress> – called also *Helen Mirren*

HELEN MIRREN

femme fatale \,fem-fə-'tal\ *n* [French *disastrous woman*] an irresistibly attractive woman who a man would do anything to please, including kill her husband

fender bender \'fen-dər-'ben-dər\ *n* a minor collision between automobiles that allows 2 strangers to fatefully meet and exchange names and phone numbers

feng shui \'fəŋ-'shwē\ *n* [Chinese *wind water*] the Asian practice of creating harmonious surroundings through the placement of furniture and choice of room color; for a bedroom to be a passionate environment it needs to be decorated in warm colors *such as* pink or earth tones and never cold blues, grays, or white; for an energy flow that encourages lovemaking and fertility, the bedroom should be located in the back of the house, on the left side

Fern, Fanny \'fərn-'fa-nē\ pseudonym of U.S. writer and newspaper columnist Sarah Payson Willis Parton (1811–1872), who wrote the immortal words, "The way to a man's heart is through his stomach."

Ferris wheel \'fer-əs-'hwēl\ *n* an amusement park structure consisting of an upright wheel from which passenger seats are suspended in which lovers on dates have been cuddling since 1893, when George Washington Gale Ferris Jr. (1859–1896) designed the wheel for the World's Columbian Exposition in Chicago as a rival to the Eiffel Tower; the original Ferris wheel was 250 ft. tall (26 stories) and featured 36 bus-size cars that held 60 people each, 20 seated and 40 standing, and took 20 mins. to make 1 revolution – see *CONEY ISLAND*

FERRIS WHEEL

fetish \'fe-tish\ *n* **a :** an inordinate fascination with something **b :** although the most common fetishes involve clothing and body parts, there is no end to the number of unusual fixations that can get a person all hot and bothered, most too unsuitable for publication – called also *paraphilia* – see *FETISH EXAMPLES pp. 100–101*

fever \'fē-vər\ *n* **a :** a rise in body temperature caused by passionate feelings for an-

other for which there is no preventative measure or cure **b :** can cause headaches, chills, loss of appetite, attention deficit disorder, malaise, and delirium <"Love is like a *fever* that comes and goes, quite independently of the will." –STENDHAL, 1783-1842> **Fever** *n* a jazzy 1956 song by Eddie Cooley and John Davenport made famous in 1958 by Peggy Lee <"You give me *fever* when you kiss me, *fever* when you hold me tight.">

fifties \'fif-tēz\ *n* the last era in which people waited until they were married to have sexual intercourse

film noir \'film-'nwär\ *n* [French *black film*] a 1940s and 1950s genre of seedy Hollywood crime dramas filmed in somber black and white and featuring detectives, saps, and femme fatales and whose gritty, smoldering dialog was written by the literary likes of Dashiell Hammett, James M. Cain, and Raymond Chandler and mouthed by stars *such as* Humphrey Bogart, John Garfield, Robert Mitchum, Fred MacMurray, Barbara Stanwyck, Veronica Lake, Lauren Bacall, and Ida Lupino

• •

FILM NOIR DIALOG
• "When we get home, Frank, then there'll be kisses, kisses with dreams in them. Kisses that come from life, not death." –Lana Turner to John Garfield, *The Postman Always Rings Twice* (1946, *dir* Tay Garnett)
• "Do you always go around leaving your fingerprints on a girl's shoulder?" –Rhonda Fleming to Robert Mitchum, *Out of the Past* (1947, *dir* Jacques Tourneur)
• "I'm hard to get, Steve. All you have to do is ask me." –Lauren Bacall to Humphrey Bogart, *To Have and Have Not* (1944, *dir* Howard Hawks)
• She: "I look good in a mink coat, honey." He: "You look good in a shower curtain." –Virginia Mayo and James Cagney, *White Heat* (1949, *dir* Raoul Walsh)

• •

fine \'fīn\ *adv* **a :** very well; alright **b :** said by an angry woman to her husband or boyfriend before she leaves the room. <"Then *fine*, have it your way.">; implies the discussion is closed but it isn't

fire \'fi(-ə)r\ *n* **a :** a combustion of hazardous elements *such as* lust and attachment that causes one to overheat – see *JEALOUSY*

FETISH EXAMPLES

andromimetophilia sexually aroused by a female impersonating a male

autagonistophilia liking to be watched while having sex

autassassinophilia sexual arousal from thinking one is going to die

autonepiophilia sexual arousal from wearing diapers and being humiliated

DIAPER

choreolaperectus sexually aroused by lap dancers

choreophilia sexual arousal through dancing

chrematisophilia sexually aroused by having to pay for it

MUSIC

cotophilia sexually aroused by darkness

dendrophilia sexually aroused by trees

TREE

formicophilia sexual arousal from having ants crawl on one's genitals

gerontophilia sexually attracted to older people

gynemimetophilia turned on by transvestites

ANT

homilophilia sexual arousal from giving speeches

homoerotiphobia fear of men turning each other on by touching one another except in sports

hybristophilia sexually aroused by people who commit crimes

hyphephilia turned on by touching certain objects

100

kleptophilia turned on by stealing

klismaphilia sexually aroused by enemas

maiesiophilia sexually aroused by pregnant women

mixophilia turned on by having sex with one's partner in front of a mirror

MIRROR

morphophilia obsession for certain body types

mysophilia turned on by dirty clothes

narratophilia sexually aroused by dirty stories

olfactophilia sexually aroused by smells

pictophilia inability to be sexually aroused except by pornographic images

plushophilia sexual attraction to stuffed toys

STUFFED TOY

podophilia sexual attraction to feet

raptophilia desire to be sexually ravaged by force

scoptophilia sexual arousal from watching others have sex

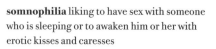
FEET

somnophilia liking to have sex with someone who is sleeping or to awaken him or her with erotic kisses and caresses

sositophilia sexually aroused by food

stigmatophilia a hankering for people who have tattoos and body piercings, esp. in the area of the genitals

symphorphilia sexually aroused by natural disasters

xylophilia sexually attracted to wood

fire drill \'fi(-ə)r-'dril\ *n* an impromptu exercise that takes place in office buildings at undisclosed times of the year in which employees must drop whatever they're doing and immediately leave the premises and gather in small groups on the sidewalk so that they can meet and ask each other out **firehouse dog** \'fi(-ə)r-'haùs-däg\ *n* **a :** a fireman's beloved buddy and station mascot that has traditionally been a dalmatian **b :** in the days of horse-drawn fire wagons, firehouse dogs fended off other dogs that would try to nip at the horses' hooves and ran ahead of the wagons to clear the way

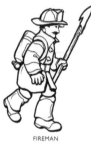

for the horses **fireman** \'fi(-ə)r-'mən\ *n* a sexy public servant who poses for calendars and rescues people from burning buildings **fireworks** \'fi(-ə)r-'wərks\ *n* a combustible display of explosive devices

FIREMAN

that produces a phantasmagorical array of light, color, and sound and is reserved for monumental events *such as* historical anniversaries, inaugurations, and the consummation of relationships in movies

first impression \'fərst-im-'pre-shən\ *n* the immediate effect one has on the feelings, intellect, and consciousness of another person, which is based 55% on one's appearance and body language, 38% on one's style of speaking, and 7% on what one actually says *source* Social Issues Research Centre, Oxford, England

Fisher, Helen \'fi-shər-'he-lən\ **a :** professor of anthropology at Rutgers University and best-selling author *(Why We Love)* who has gained international recognition in her ongoing scientific attempts to solve Cole Porter's poignant question, "What Is This Thing Called Love?" **b :** identified love's chemically driven stages as: 1. lust; 2. attraction; 3. attachment

Fitzgerald, F. Scott \fits-'jer-əld-ef-'skät\ (1896-1940) **a :** a chronicler of the jazz age and its excesses who wrote that "the rich are different from you and me" **b :** in 1920 he married glamorous Zelda Sayre,

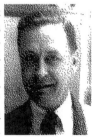

F. SCOTT FITZGERALD

who died in a mental institution in 1948; they are buried together in Saint Mary's Cemetery in Rockville, Maryland <"His heart beat faster as Daisy's white face came up to his own. He knew that when he kissed this girl, and forever wed his unutterable visions to her perishable breath, his mind would never romp again like the mind of God." –*The Great Gatsby*, considered by many to be Fitzgerald's masterwork>

flamenco \flə-'meŋ-(ˌ)kō\ *n* **a :** a passionate and sensual musical art form of Spain that includes the *cante* (song), the *baile* (dance), and the *guitarra* (guitar) and whose roots are traced to Andalusian Gypsy cultures **b :** *juergas* are flamenco gatherings that begin at midnight, when there is nothing around but the voice, the guitar, and the body of a dancer moving in the moonlight

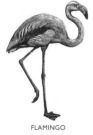

flamingo \flə-'miŋ-(ˌ)gō\ *n* an aquatic bird (family Phoenicopteridae) whose pinkish coloring, drooped beak, and skinny legs are rendered in garden ornaments and swizzle sticks and whose

FLAMINGO

recognizable shape says boom-shaka-laka; flamingos live in colonies that can have thousands of members, and when ready to breed, they pair up for a sequence of synchronized mating gestures that include head turning, calling, preening, and marching <*as in* "A-five, six, seven, eight, turn, kick...">

FLAMENCO

103

flapjack \'flap-ˌjak\ *n* a circular, flat cake cooked on a griddle and served hot with butter and maple syrup and eaten for breakfast by lumberjacks who stay the night

FLAPJACK

flashback \'flash-ˌbak\ *n* the vivid recollection of a traumatic event from a past relationship that is brought about by a date who says or does something that is spookily reminiscent of one's ex and sets off an alarm <*as in* "Abort, abort relationship now!">

FLIGHT
ATTENDANT

flight attendant \'flīt-ə-'ten-dənt\ *n* an airline employee who makes sure everyone's fastened their seat belts before take-off and whose airborne duties include serving beverages, passing out pillows, and knocking on the bathroom door when the "Occupied" sign has been on too long – see *MILE-HIGH CLUB*

Flipper \'fli-pər\ *n* **a :** beloved dolphin crossover star whose eponymous Sunday night TV show (1964–1968) was set in the Florida Keys **b :** though supposedly a

FLORIDA

TAVERNIER

KEY LARGO

BIG PINE KEY

PLANTATION KEY

KEY WEST

LAYTON

MARATHON

ISLAMORADA

FLORIDA KEYS

male <*as in* "They call him *Flipper*, *Flipper*, faster than lightning...."> in real life the animal was a female named Mitzi that relied on a stunt dolphin (Mr. Gipper) to do her tail-walking **c :** playful, intelligent, and in full command of the English language, Flipper was the Lassie of the deep, the best friend every kid wanted **d :** Mitzi (1958-1972) is buried at the Dolphin Research Center in Grassy Key, Florida

DOLPHIN

floor \'flȯr\ *n* the lower enclosing surface of a room of a house that lovers do it on after they've signed the mortgage papers and before they've moved in

Florida \'flȯr-ə-də\ *n* SE U.S. state (pop. 16 million) where love is blind and still driving **Florida Keys** \'flȯr-ə-də-'kēs\ *n* **a :** an archipelago of 1,700 subtropical islands that begins off the southernmost tip of the Florida peninsula and extends westward in an arc, dividing the Atlantic Ocean and the Gulf of Mexico **b :** Florida's romantic history includes Ernest Hemingway, Tennessee Williams, Jimmy Buffett, and key lime pie and was the setting for the classic 1948 film *Key Largo* (*dir* John Huston), which starred Humphrey Bogart, Lauren Bacall, Edward G. Robinson, Claire Trevor, and Lionel Barrymore and was set against the backdrop of an oncoming hurricane – see *FILM NOIR*

HUMPHREY BOGART
AND LAUREN BACALL
IN KEY LARGO

fondue \fän-'dü\ *n* [French] a classic dish of Swiss heritage, which consists of a savory mixture of melted cheeses *such as* Gruyère or Emmentaler, white wine, kirsch, and seasonings and is served *au table* in an earthenware fondue pot (or *caquelon*) into which bite-size pieces of French bread attached to a long fork are dipped; tradition dictates that whoever loses his or her piece of bread in the pot is to be kissed

food processor \'füd-'prä-ˌses-ər\ *n* a kitchen appliance with interchangeable blades

105

and an enclosed food container invented in the early 1970s so that singles could invite a date over for dinner and wow him or her with a French meal they wouldn't otherwise have had time to prepare – see *JULIA CHILD*

foot language \'fu̇t-'laŋ-gwij\ *n* **a** : the unconscious act of positioning one's feet in a certain direction when meeting potential mates **b** : a person will angle his or her feet toward someone he or she is interested in and away from him or her if not <*as in* toward the nearest exit>

foot massage \'fu̇t-mə-'säzh\ *n* the act of kneading the feet of one's lover, which can trigger the release of the attachment hormone oxytocin in his or her brain and serve as foreplay to sex

foreplay \'fȯr-ˌplā\ *n* intimate acts performed by couples to build up sexual arousal so they can experience orgasm and that can include kissing, massaging, licking, biting, groping, grinding, getting undressed, and wrestling; can also involve objects *such as* chocolate syrup, feather dusters, ice cubes, soap, swings, and whipped cream – see *TOYS*

......................................

HOW TO GIVE A FOOT MASSAGE
Be sure to dim the lights or light candles and put on soft music.

1. Have partner sit in chair and soak his or her feet in warm water and Epson salts.
2. Place partner's feet on towel-covered pillow in one's lap and pat dry.
3. Rub scented lotion into palms of one's hands to warm it up, and then slowly rub lotion into partner's feet, applying more lotion as needed.
4. Use thumbs to put pressure on partner's insteps and balls of feet.
5. Gently twist each foot by rotating both hands around it, each going in opposite directions.
6. Caress each toe individually.
7. Use dry towel to remove excess lotion from partner's feet.
8. Be prepared to go to bed early.

......................................

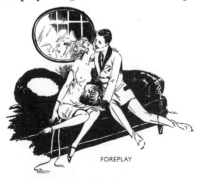

FOREPLAY

four years \fŏr-ˈyirz\ *n* the period of time it takes for a president to serve a term in the White House, a college student to graduate, and, according to statistics, first marriages to last

frankenboobies \ˈfraŋ-kən-ˈbü-bēz\ *n* surgically enhanced breasts <"Can you believe all the *frankenboobies* on South Beach?">

freckles \ˈfre-kəlz\ *n* small brown or tan discolorations on the skin that are associated with people who have red hair and light complexions and that give a face personality <"A girl without *freckles* is like a night without stars." –Anon.>

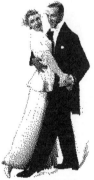

Fred and Ginger \ˈfred-ən(d)-ˈjin-jər\ **a :** Hollywood's most famous dance partners who made 9 films together in the 1930s **b :** while Astaire (1899–1987) was the debonair man-about-town, Rogers (1911–1995) was sassy, smart, and suspicious, a combina-

FRED AND GINGER

tion as intoxicating as a gin and tonic – see *ZINGIBERACEOUS*

Freud, Sigmund \ˈfróid-ˈsig-mənd\ (1856–1939) Austrian neurologist and father of psychoanalysis who perpetuated the no-

SIGMUND FREUD

tion that every woman wanted to secretly cut off her husband's penis and every man was secretly afraid this his wife's vagina held a ferocious array of fangs ready to devour his genitals

friend \ˈfrend\ *n* what one hopes ex-lovers can remain but rarely do <"Love takes hostages. It gets inside you. It eats you out and leaves you crying in the darkness, so a simple phrase like 'Maybe we should just be *friends*' turns into a glass splinter working its way into your heart." –Neil Gaiman, author, *The Sandman*> **friend with benefits** \ˈfrend-ˈwith-ˈbe-nə-ˌfits\ *n* a term for a person one can have occasional sex with *syn* fuck buddy

Frisbee \ˈfriz-bē\ *n* **a :** an aerodynamic plastic disc invented in 1948 by Los Angeles

building inspector Walter Frederick Morrison and his partner, Warren Franscioni, that provides hours of entertainment to college students who take it to parks and beaches to toss to their boyfriend or girlfriend or dog **b :** its design is based on a pie tin sold by the extinct Frisbie Baking Company of Bridgeport, Connecticut

frisson \frē-ˈsōⁿ\ *n* **a :** a chill or tingly shock that one experiences when one's arm or hand accidentally touches another's **b :** a homoerotic feeling a man experiences

when a tailor is measuring his slacks for alteration

frog kisser \ˈfròg-ˈki-sər\ *n* a woman who dates losers hoping that one will become her prince

FROG

frot \ˈfrät\ *n* **a :** a shortened version of the French verb *frottage*, meaning "to rub" **b :** can mean sexual foreplay between a man and a woman <*as in* rubbing their naked bodies together under a sheet) or 2 males <*as in* rubbing their penises together, a same-sex practice observed in bull manatees, bottlenose dolphins, and bonobos *syns* bone-on-bone, cockrubbin', dick2dick, grind, wrestling

frumpy \ˈfrəm-pē\ *adj* **a :** looking like one's mother (usu. unintentionally) **b :** wearing clothing that emphasizes comfort over sex appeal <"I am told that on the road to *frumpy* Dansko clogs are a gateway drug." –Because the Medium Is the Message blog>

fuck-me shoes \ˈfək-ˈmē-ˈshüz\ *n* close-fitting women's dress shoes in red or black with 4-6-in. stiletto heels **fuck-you shoes** \ˈfək-ˈyü-ˈshüz\ *n* sensible shoes *such as* Birkenstocks, Dansko clogs, Doc Martens, L.L. Bean Duckboots, or Tevas

full-length mirror \ˈfül-ˈleŋ(k)th-ˈmir-ər\ *n* **a :** a total-body reflective surface that distorts a woman's view of herself so that no matter how in shape she is she still always sees a fat butt **b :** a total-body reflective surface that distorts a man's view of himself

FULL-LENGTH MIRROR

so that no matter how out of shape he is he still always sees a toned, muscular god

full-mast \'fül-'mast\ *adj* used to describe a fully aroused penis **var** half-mast

fun \'fən\ *n* an Internet dating term that people who post personal adds are fond of; can be used to describe themselves <"I'm a *fun*-loving brunette."> or the person they are seeking <"I'm looking for someone to have *fun* with."> or what they like to do in their free time <"I like to watch DVDs, walk on the beach, hang out, and have *fun*.">

futz \'fəts\ *vb* to spend a day preparing dinner for someone <*as in* shopping, cleaning, buying flowers> only to get blown off or not have it appreciated <"This sucks. I've been *futzing* all day.">

fuzz \'fəz\ *n* short-cropped hair on a man's head that feels deliciously abrasive when rubbed during lovemaking **fuzzy math** *n* someone whose age doesn't add up <*as in* "That would make her an embryo at Woodstock.">

fwap \'fwȯp\ *n* the sound made when swatting one's lover's rear end as he or she gets out of a hot tub

FUCK-ME SHOES

109

Gabor, Zsa Zsa \'gä-(ˌ)bȯr-zä-zä\ (b. 1917, Hungary) **a :** Hollywood star with the most husbands and none of them repeats: Burham Belge, Conrad Hilton, George Sanders, Herbert Hutner, Joshua S. Cosden, Jack Ryan, Michael O'Hara, Felipe de Alba, and Frédéric Prinz von Anhalt **b :** most memorable quote: "I'm a marvelous housekeeper. Every time I leave a man, I keep his house." **c :** her late famous sisters, Magda and Eva, had 6 and 5 husbands, respectively, for a grand total of 20 marriages among the 3 women

gag reflex \'gag-'rē-ˌfleks\ *n* **a :** a normal retching reaction produced when a boyfriend forces his girlfriend to hear one of his corny jokes and makes her laugh so hard she regurgitates her Diet Coke or other soft drink **b :** normal part of deep-throating <"The only thing you can do is practice. The more you do it, the less you will *gag*. Try practicing on bananas, zucchinis, anything." –Fox SALCHI, sex adviser, Allexperts.com> – called also *pharyngeal reflex*

111

gap tooth \\'gap-'tüth\\ *n* a space between the central incisor teeth that makes for a very sexy smile <*as in* Lauren Hutton, Sandra Day O'Connor, Madonna, and Oliver Stone> – called also *diastema*

garage time \\'gə-'räzh-'tīm\\ *n* a metaphor for a period of time a guy needs to be by himself after a romantic breakup <"For now I'm through with love. I need some *garage time*.">

AVA GARDNER

Gardner, Ava \\'gärd-nər-'ä-və\\ (1922–1990) **a :** raven-haired screen siren who was born in a farming community in Johnson County, North Carolina, and who was so smolderingly beautiful that it didn't matter if she could act or not **b :** films include *Mogambo* (1953, *dir* John Ford) and *The Barefoot Contessa* (1954, *dir* Joseph L. Mankiewicz) **c :** according to film historian David Shipman: "Perhaps she always belonged to the nether side of men's desires – smoking, booze, late nights, strange ladies in faraway places; never quite a lady but never cheap; warm and sympathetic but not immediately attainable." – see *FRANK SINATRA*

garlic bread \\'gär-lik-'bred\\ *n* an Italian or French bread that

GARLIC BREAD

is slathered with garlic butter and heated and should not be ordered by people who are on a date and counting on getting laid

garnish \\'gär-nish\\ *n* a decorative, edible accompaniment to a dish <*as in* a simple sprig of parsley or a more complicated tomato-skin rose> that people who are trying to impress a date by having him or her to dinner make sure to include but rarely add once a date becomes old hat

gates of heaven \\'gāts-əv-'he-vən\\ *n* the vagina **gates of paradise** \\'gāts-əv-'per-ə-ˌdīs\\ *n* the frenulum, which is located on the underside of the penis, near the head, and is extra-sensitive to the touch <*as in* "Oh, yeah."> **Gates, William Henry III** (Bill) \\'gāts-'wil-yəm-'hen-rē\\ (b. 1955) billionaire founder and former CEO of Microsoft, whose development of computer software has helped billions of people find dates, get laid, and download adult imagery

gawn \\'gä-òn\\ *vb* to date someone in the southernmost region of the U.S. <"Dwayne's *gawn* out with Trinket agin.">

gaydar \\'gā-,där\\ *n* a detection device that is hard-wired in the limbic region of the homosexual male brain and alerts him whenever another homosexual male is within cruising range – see *BEEP*

gaze \\'gāz\\ *vb* **a :** to sexually objectify someone by checking him or her out with one's eyes **b :** traditionally men are the gazers and women the gazees <*as in* peep shows, beauty pageants, advertising, centerfolds, and even in the manufacture of furniture, where a woman's chair has traditionally been designed without arms so that she could sit up and be admired> **c :** feminist theory calls gazing a show of asymmetrical male power – see *EYE-HUMP*

general store \\'jen-rəl-'stòr\\ *n* a small, charming, non-departmental market that lovers visit when vacationing in remote places for its selection of canned goods, local produce, plastic eating ware, and hardware supplies *such as* flashlights and batteries *ant* Wal-Mart

generous \\'jen-rəs\\ *adj* a trait that implies financial benevolence, which is what some people who place Internet personal ads are looking for in others <"Looking to meet up with a *generous* guy," *as in* one who will pay for sex>

Gershwin, George \\'gər-shwən-'jòrj\\ (1898-1937) **a :** Brooklyn-born son of Russian immigrants who started his composing career in Tin Pan Alley and who, along with his lyricist brother Ira (1896-1983), wrote Broadway and movie scores that introduced standards *such as* "I Got Rhythm," "Embraceable You," "Love Is Here to Stay," and "But Not for Me," and who composed innovative jazz and classical

GEORGE GERSHWIN fusions *such as* "Rhapsody In Blue," the tone poem "An American in Paris," and the opera "Porgy and Bess," and who died of a brain tumor at age 38 while working in Hollywood; **b :** when George's sophisticated sounds and Ira's elegant lyrics are interpreted by singers *such as* Frank Sinatra, Billie Holiday, Judy Garland, Ella Fitzgerald, Mel Tormé, Vic Damone, Tony Bennett, Peggy Lee, and

Billy Eckstine, lovers agree: "S'wonderful, s'marvelous"

get \'get\ *vb* to score, or have sexual intercourse **getaroom** \'get-ə-'rüm\ *interj* said to overheated lovers who are offending community standards **get it up** \'get-'it-,əp\ *vb* to sport a boneroni – see *ERECTION SYNONYMS pp. 90–91* **getting any?** \'ge-tiŋ-'e-nə\ *n* standard greeting among men in their 20s

ghost \'gōst\ *n* the lingering emotional presence of an ex-lover in one's living quarters **Ghost** *n* (1990, *dir* Jerry Zucker) the quintessential chick flick in which Patrick Swayze's dead spirit makes love and pottery with wife Demi Moore in their New York loft while the Righteous Brothers serenade them

Gibson, Charles Dana \'gib-sən-'chär-(-ə)lz-'dā-,nə\ (1867-1944) **1 : a :** American illustrator and *Life* magazine editor who created the Gibson girl, the pre–World War I picture of the idealized American woman who was both beautiful and independent **b :** in 1895 Gibson married his muse, Virginia socialite Irene Langhorne, who died in 1954; they are interred together in the same jar in Mount Auburn Cemetery outside Boston, Massachusetts **2 :** named after the Gibson girl, a Gibson is a martini garnished with a spirited cocktail onion in place of an olive

ginchy \'gin-chē\ *adj* retro 1950s term meaning the most pleasing or fashionable <"Baby, you're the *ginchiest*." –Edd "Kookie" Byrnes, "Kookie, Kookie, Lend Me Your Comb">

ginger \'jin-jər\ *n* a spicy, pungent rhizome (genus *Zingiber*) grown in tropical and subtropical regions whose ability to stimulate and promote circulation makes it a natural aphrodisiac

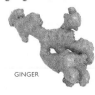

GINGER

– see *ZINGIBERACEOUS* **Ginger Grant** \'jin-jər-'grant\ *n* fictional, aphrodisiacal movie star shipwrecked on *Gilligan's Island* and played by Tina Louise

girlfriend experience \'gər(-ə)l-,frend-ik-'spir-ē-ən(t)s\ *n* a service provided by some female prostitutes in which they agree to foreplay, cuddling, and mutual kissing

with a client so that he feels like she's his girlfriend – see *LOSER*

gladiator \'gla-dē-ˌā-tər\ *n* ancient Roman professional fighter who engaged in brutal, bloody, death-defying rough-housing and swordplay at the Colosseum and other amphitheater bookings and whose leather outfits and metal-studded armbands predated today's S&M look <"Joey, do you like movies about *gladiators*?" –PILOT PETER GRAVES to young passenger Rossie Harris in *Airplane!*>

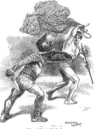
GLADIATOR

glimpse \'glim(p)s\ *n* **a :** a brief look **b :** the most a woman should allow a man to see on a first date in order to retain her mystery, which applies to her personality as well as her body

go ahead \'gō-ə-'hed\ *interj* a phrase lovers say with raised eyebrows that implies "I dare you" <"You want to go to California without me, *go ahead...,*" and may be followed by "...see if I care."> – see *FINE*

golf \'gälf\ *n* **a :** a popular competitive game invented in Scotland and played on a large grassy course **b :** the one sport men will jump out of bed before dawn to play, preferring teeing off to getting it off

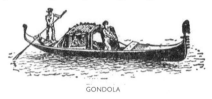
GONDOLA

gondola \'gän-də-lə\ *n* **a :** the world's most romantic form of transportation, which for centuries has been the chief means of getting around Venice, Italy **b :** by law these long and narrow flat-bottomed boats, with ornamental stems and sterns and small passenger cabins, must be painted black **gondolier** \gän-də-'lir\ *n* the man who poles a gondola, dressed in smart black pants, waist-cut jacket, straw hat with red scarf, and balletlike shoes; he may even sing

Gone With the Wind \'gȯn-'with-<u>th</u>ē-'wind\ *n* (*dir* Victor Fleming) **a :** 1939 Oscar-winning film starring Vivien Leigh and Clark Gable that takes place during the Civil War and tells the story of a Southern belle

named Scarlett O'Hara whose narcissistic behavior drives away her lovers, including Rhett Butler, who once said to her, "You should be kissed, and often, and by someone who knows how." **b :** based on the 1936 Pulitzer Prize–winning novel by Margaret Mitchell ***note*** voted by the American Film Institute as the second most romantic movie ever made

∙∙

SCARLETT O'HARA

2 oz. Southern Comfort Peach Liqueur
6 oz. cranberry juice
1 lime wedge
Pour Southern Comfort Peach Liqueur over ice in an 8-oz. glass. Fill with cranberry juice. Squeeze lime into drink. Stir and serve.

∙∙

good night's sleep \ˈgu̇d-ˈnīts-ˈslēp\ *n* a state of unconsciousness that as one gets older one finds is more satisfying than staying out late or even getting laid

goose bumps \ˈgüs-ˈbəmps\ *n* a skin reaction that occurs when one gets kissed by one's lover on the back of the neck – see *NAPE, PARESTHESIA*

gorilla \gə-ˈri-lə\ *n* **1 :** a boyfriend who thinks being macho is jumping around, thrusting his chest, and bullying people **2 :** a large anthropoid ape found in equatorial W Africa that jumps around, thrusts its chest, and has a 2-in. penis

gossamer \ˈgä-sə-mər\ *n* **a :** a film of cobwebs that floats in air **b :** in 1935 songwriter Cole Porter used the image in "Just One of Those Things," which many feel is the most romantic image ever written <"It was just one of those nights, just one of those fabulous flights, a trip to the moon on *gossamer* wings." >

gossip \ˈgä-səp\ *n* **a :** a practice engaged in by humans both male and female that involves activities *such as* gathering around the water cooler, instant messaging, or speed dialing to find out who's seeing who <"I am not *gossiping*. I'm networking."> **b :** recommended by doc-

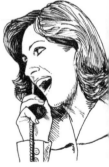

GOSSIP

tors as a healthful activity because the juicier the information, the more stress-reducing endorphins get stimulated and released in one's brain

Gottlieb, Bill \\'gät-lēb-'bil\ **a :** 27-year-old Manhattan lawyer who convinced *The New York Times* crossword editor Will Shortz to construct a puzzle that would include a marriage proposal to his girlfriend, 24-year-old Emily Mindel, a Brooklyn Law School student and crossword devotee **b :** on January 3, 1998, over brunch at an Upper West Side restaurant, Gottlieb sat across the table from Mindel as she unsuspectingly filled in the grid, which included both of their first names, the proposal, and the word "Yes" <*as in* 57 Down>

Grant, Cary \\'grant-'ka-rē\ (1904–1986) **a :** never-aging movie star whose looks resembled the plastic groom atop a wedding cake and who, despite a limited acting range, set the high bar for all leading men **b :** of all his leading ladies, including Doris Day, Katharine Hepburn, Rosalind Russell, and Mae West, Audrey Hepburn summed him up best, in *Charade* <*as in* Hepburn: "You know what's wrong with you?" Grant: "No, what?" Hepburn: "Nothing."> **syns** dapper, debonair, elegant, stylish, suave

grape \\'grāp\ *n* a berry of the family Vitaceae that grows in clusters in temperate zones throughout the world and that lovers like to feed to each other while reclining – see *CHAISE LOUNGE*

GRAPE

grapefruit \\'grāp-ˌfrüt\ *n* a yellow or pink, plump, tart-tasting citrus fruit *(Citrus paradisi)* eaten in the morning by health conscious people who want to look trim and fit for their lovers or the dating scene

grass \\'gras\ *n* any plant of the Poaceae or Gramineae family that is cultivated in lawns or used as pasture and serves to soften hard ground so couples can be comfortable when picnicking or making love <"Breathless, we flung us on the windy hill, laughed in the sun, and kissed the lovely *grass*." –RUPERT BROOKE, 1887-1915, "The Hill"">

Great White Way \\'grāt-'hwīt-'wā\ *n* the midtown theater district of New York City located between 42nd and 53rd streets and

illuminated by millions of lights on marquees that proclaim the greatest love stories ever acted, danced, or sung

greyhound \\'grā-ˌhaùnd\ *n* **a :** a quiet, gentle

canine of Art Deco form whose breed goes back to ancient Egypt **b :** frequently adopted by animal lovers, who find that by taking them out for walks they meet other animal lovers

GREYHOUND

who sometimes become their lovers **Greyhound Lines** \\'grā-ˌhaùnd-ˈlīns\ *n* **a :** America's largest common carrier of passengers founded in 1914 in Hibbing, Minnesota **b :** currently headquartered in Dallas, Texas, provides inexpensive bus service to 2,200 U.S. locations so that lovers who live far apart and don't have a lot of money to spend on transportation can still see each other and remain faithful

group \\'grüp\ *n* a gathering of strangers who agree to have anonymous sex – see *SWINGERS* **group hug** \\'grüp-həg\ *n* a communal embrace – called also *huddle*

grrrrrr \\'grrrrrr\ *interj* **1 :** strong primitive sounds unleashed during the sex act *such as* moans, sighs, cries, whimpers, hisses, and screams of ecstasy **2 :** used to emphasize a hot body <"He's got that whole David Hasselhoff thing going on. *Grrrrrr*.">

..

G-SPOT DIRECTIONAL MAP

Because the G-spot is difficult for women to find, it is best if her partner does the driving.

After arousing wife or girlfriend, have her lie down. If she is on her back, turn the palm of one's hand downward. If she is lying on her stomach, turn the palm of one's hand upward. Insert 2 fingers *such as* the index and middle finger into the vagina approximately 1.5–3 in. The G-spot can be felt atop the wall of the vagina. Stimulate the G-spot by making circular motions with one's fingers, or a coochie-coo, here kitty-kitty motion. Look for facial expressions or listen for vocal sounds to confirm that one has reached one's destination.

..

118

G-spot \'jē-'spät\ *n* **a :** a source of vaginal orgasm first identified by a German doctor named Ernst Gräfenberg who, amid speculation of its existence, was the first scientist to put his finger on it in an article in *The International Journal of Sexology* in 1950 **b :** in 1983 the G-spot was rediscovered in a book called *The G-Spot and Other Recent Discoveries About Human Sexuality*, by John Perry, Alice Kahn Ladas, and Beverly Whipple, which gave instructions on how to find it **c :** the G-spot lies between a woman's urethra and the front wall of the upper vagina and when aroused swells to the size of a quarter **d :** its stimulation causes orgasm that many women describe as being deeper and more intense than a standard vaginal orgasm **e :** because the nerves that support the G-spot are different from those that support the clitoris and vulva, it is believed by some experts that the G-spot is a totally separate pathway for orgasm and may be a learned experience or pleasure – see *G SPOT DIRECTIONAL MAP* (not yet available on MapQuest or GPS tracking systems)

Guide to Getting It On! \'gīd-tə-'ge-tiŋ-'it-'ȯn\ *n* 782-page sex guide written by research analyst Paul Joannides and illustrated by Daerick Gross that was first published in 1998 and is the American equivalent of the *Kama Sutra*; the illustrated guide tells college kids everything they didn't learn from their sex ed teacher, from the Zen of thrusting to penis dyslexia

GUIDE TO GETTING IT ON

guilt \'gilt\ *n* always being made to feel one is hurtful or disappointing <"Lakeesha doesn't just give *guilt* trips – she runs the travel agency.">

guy \'gī\ *n* a regular dude, average Joe, or unpretentious boyfriend <"No handsome face could ever take the place of my *guy*." –MARY WELLS, "*My Guy*"> – see *MENSCH*

ha! \\'hä\ *interj* a pithy outburst one makes to one's lover or steady to express disbelief just before turning on one's heels and walking away <"No, really – that girl you saw me with was my cousin." "*Ha!*">

hair \\'her\ *n* **a :** threadlike appendages on human skin that grow on every part of the body (except the palms, soles, and lips) and get stuck in shower drains <see *PLUMBER*> and teeth <see *LATERAL INCISOR*> **b :** throughout history authors and poets have paid homage to its alluring colors and hues – see *HAIR AND LOVE p. 122*

Hair *n* American tribal love rock musical that opened at the Biltmore Theater on Broadway <see *GREAT WHITE WAY*> on April 29, 1968, and whose eponymous title song featured the lyrics "Gimme a head with hair, long beautiful hair, shining, gleaming, steaming, flaxen, waxen hair!" –JEROME RAGNI/ JAMES RADO/GALT MACDERMOT **hairstylist** \\'her-stī-list\

HAIR

HAIRY WOODPECKER

n a licensed professional one sees at least once a month in order to talk about one's love life and obtain problem-solving advice **hairy eyeball** \'her-e-'ī-ˌbȯl\ *n* the usu. not subtle sizing-up of a former lover's romantic replacement <"When we walked into the party, Sienna gave my new date the *hairy eyeball*."> **hairy woodpecker** \'her-ē-wu̇d-ˌpe-kər\ *n* **a :** a black-and-white North American bird *(Picoides villosus)* whose noisy mating ritual consists of extended bouts of drumming on trees **b :** distinguished

HAIR AND LOVE

"And yonder sits a maiden,
 the fairest of the fair, with gold in her
 garment glittering, and she combs
 her golden hair."
 –Heinrich Heine (1797–1856)

"I dream of Jeannie with the light
 brown hair, floating on a vapor like the
 soft summer air."
 –Stephen Collins Foster (1826–1864)

"It was a blonde. A blonde to make a bishop
 kick a hole in a stained-glass window."
 –Raymond Chandler (1888–1959)

"Gentlemen prefer blondes...
 but marry brunettes."
 –Anita Loos (1893–1981)

"Such a morning it is when love leans
 through geranium windows and calls
 with a cockerel's tongue,
 when red-haired girls scamper like roses
 over the rain-green grass,
 and the sun drips honey."
 –Laurie Lee (1914–1997)

"Black, black, black, is the color
 of my true love's hair.
 Her face is something truly rare.
 Oh I do love my love and so well
 she knows
 I love the ground whereon she goes.
 She with the wondrous hair."
 –Appalachian folk ballad

from similar-looking birds of its species by its longer, more active pecker *source* National Audubon Society

happy \\'ha-pē\ *adj* the state of being joyous, blithe, contented, cheerful, merry, gay, satisfied, recently engaged **happy hunting ground** \\'ha-pē-'hun-tiŋ-'graúnd\ *n* a singles' bar **happy rails** \\'ha-pē-'trālz\ *n* a sexy line of hair that extends from a man's belly to his genital region (considered less sexy on a woman) **Happy Trails** *n* **a :** song written by Dale Evans and performed by Roy Rogers and Dale as their theme song **b :** crooned by a lover (usu. under his or her breath) to a parting ex that he or she is glad to see go <"*Happy trails* to you, until we meet again."> – see *ROY ROGERS*

Harley-Davidson \\'här-lē-'dā-vəd-sən\ *n* **a :** a heavy, chopper-style motorcycle that

HARLEY-DAVIDSON

is known for its distinctive exhaust noise **b :** the chariot of choice for the Echo Generation's parents who are attempting to reclaim their youth and rebond with each other – see *DOWN-AGING*

ELVIS PRESLEY

Hawaii \hə-'wä-yē\ *n* **a :** the 50th U.S. state and honeymooners' paradise consisting of 8 main islands in the Pacific Ocean **b :** where Elvis Presley sang "Hawaiian Wedding Song" as he married Joan Blackman in the 1961 film *Blue Hawaii* (*dir* Norman Taurog) and where Deborah Kerr rolled in the surf with Burt Lancaster in the 1953 movie *From Here to Eternity* (*dir* Fred Zinnemann), saying to him afterward, "I never knew it could be like this."

hay fever \\'hā-'fē-vər\ *n* an assortment of eye-burning, nose-running, chest-coughing, pollen-induced symptoms that arrive in April, May, and June and that unless one has a prescription for Allegra-D, Claritin-D, or Zyrtec-D can ruin a walk

in the park with one's lover <"Spring brings roses to people you see, but it brings *hay fever* to me." -LORENZ HART/RICHARD RODGERS, "Where's That Rainbow?">

Hayworth, Rita \'hā-ˌwərth-'rē-tä\ (1918-1987) **a :** red-haired, Brooklyn-born actress/dancer who in 1946 took her place in the pantheon of cinema love goddesses when in *Gilda* (*dir* Charles Vidor) she crooned "Put the Blame on Mame"

RITA HAYWORTH while doing a mock striptease in a clinging black satin dress and elbow-length gloves **b :** racked up 5 husbands, including Orson Welles and Prince Aly Khan

headache \'hed-ˌāk\ *n* **1 :** a pain that can rage in the head and that women traditionally claim to suffer from when they're not in the mood, which usually means their partners aren't skilled enough to put them in the mood **2 :** a difficult boyfriend or girlfriend <"You might have been a *headache* but you never were a bore." -RALPH RAINGER/ LEO ROBIN, "Thanks for the Memory"> **ice**

HEADACHE

cream headache \ˌīs-'krēm-'hed-ˌāk\ *n* a temporary, painful condition that occurs when the coldness of an ice cream sundae or frappucino that one is sharing with one's sweetheart comes in contact with the roof of one's mouth, which irritates nerves in the region of the sphenopalatine ganglions, which causes them to spasm and in turn causes blood vessels in the brain to dilate – called also *brain freeze*

headlights \'hed-ˌlīts\ *n* **1 :** lights on the front of a car that allow people to go on dates after dark and find their way there and back **2 :** a woman's nipples when seen through a tight sweater or blouse <"Yowzah! Carrie left her *headlights* on again!"> – called also *high beams*

heart \'härt\ *n* **a :** the body's most vital organ for survival that its owners are always giving away despite the likelihood of it being broken, discarded, and not returned in the same condition **b :**

124

HEART

although communication between the heart and brain is a dynamic, ongoing, 2-way dialog, neither really hears or listens to the other, with the heart usu. doing what it pleases **c :** in an average lifetime the human heart beats 2½ billion times, puzzling scientists <see *HELEN FISHER*>, poets, songwriters, artists, authors, and psychoanalysts as to why it never seems to learn <"Pity me that the *heart* is slow to learn / What the swift mind beholds at every turn." -EDNA ST. VINCENT MILLAY, 1892-1950> **heart chakra** \'härt-'chä-krə\ *n* **a :** located at the middle of the breastbone

HEART CHAKRA

and green in color, the heart chakra is the center for kindness, compassion, appreciation, gratitude, and inner peace, connecting one to oneself and all of humanity **b :** a person whose heart chakra is imbalanced may seem cold-hearted, have a fear of intimacy, be narcissistic, lack intimacy, and have trouble expressing love – called also *Fourth Chakra* – see *AURA*

..

HEART CHAKRA MEDITATION
To help get energy flowing to
the Fourth Chakra, practice this
exercise.

1. Sit comfortably in a chair or in a
 cross-legged position.
2. Close eyes. Breathe deeply into the
 center of chest. Roll shoulders up
 toward ears, then back and down.
3. Draw shoulder blades toward
 each other.
4. While inhaling, be aware of sensa-
 tions of the heart chakra.
5. Exhale with a long sigh, inviting
 heart to relax and open.
6. Continue breathing deeply for
 1-3 mins.
7. Rest hands, palms down, on one's
 heart chakra.

125

8. Continue to breathe and feel deep inside one's heart.
9. Affirm that one is a loving person and deserving of love.

......................................

heat \ˈhēt\ *n* a period of sexual receptiveness in household pets and other animals that sets time parameters as to when they can and cannot do it and, unlike humans, who are always up for a good time, allows them the freedom to focus on and pursue other areas of interest *such as* sleeping and begging for food

heather \ˈhe-<u>th</u>ər\ *n* a low-lying evergreen shrub *(Calluna vulgaris)* with purplish-pink flowers that grows on the romantically desolate and windy moors of Scotland and N England and that figures prominently in Emily Brontë's 1847 tragic saga, *Wuthering Heights* <"Smell the *heather*, Heathcliff. Fill my arms with *heather*. All they can hold." –MERLE OBERON to Laurence Olivier in the 1939 film version, *dir* William Wyler>

HEATHER

HEIGHT-WEIGHT PROPORTIONATE

HEATING PAD

heating pad \'hē-tiŋ-'pad\ *n* a fabric-covered pad with electrical heating elements inside that one keeps in one's bed in the winter months and is one of the first items one gives to the Goodwill or Salvation Army when a lover moves in

height-weight proportionate \'hīt-'wāt-prə-'pȯr-sh(ə-)nət\ *n* a frequent requirement in Internet dating ads <"Age, race, and size don't matter; just be *HWP*.">

hello \hə-'lō\ *n* **a :** an introductory phrase or impromptu interjection said at a bar or other social gathering <"You had me at *hello*." -RENÉE ZELLWEGER to Tom Cruise in *Jerry Maguire*, 1996, *dir* Cameron Crowe> **b :** anthropologists warn that a person who uses this word must be extremely cautious about his or her voice inflection to ensure that the right message is sent <"A high-pitched, gentle, mellifluous '*hello*' is often a sign of sexual interest, whereas a clipped, low, matter-of-fact or perfunctory 'hi' rarely leads to love. If a prospective mate laughs somewhat more than the situation calls for, she or he is probably flirting, too." -HELEN FISHER, author, *Anatomy of Love*>

herculean \ˌhər-kyə-'lē-ən\ *adj* a task requiring enormous strength that a lover believes he or she can do for his or her part- ner and that usu.occurs during the courtship period of a relationship when one's brain is producing higher levels of adrenaline <*as in* "What is it you want,

HERCULEAN

Mary? What do you want? You...you want the moon? Just say the word, and I'll throw a lasso around it and pull it down." -JAMES STEWART to Donna Reed in *It's a Wonderful Life*, 1946, *dir* Frank Capra>

heredity \hə-'re-də-tē\ *n* a process by which specific characteristics are transmitted from parents to offspring through genes, which is nature's way of giving young couples sneak previews of what their little darlings are going to look like down the road, for better or worse

herniated disc \'hər-nē-ˌā-təd-'disk\ *n* a rupture of fibrocartilage of the disc between vertebrae of the spinal column that often occurs in the lumbar region of the lower back and can be brought about by a person attempting to hoist a heavy object *such as* a bride over a threshold – see *BBW*

HERNIATED DISC

he-spot \'hē-ˌspät\ *n* a muscular gland surrounding the urethra at the base of the bladder in the male that produces erotic sensations when stimulated by a dildo, erect penis, or rubber glove <*as in* physical examination>

Hey, Stella! \'hā-'ste-lə\ *interj* Stanley Kowalski's Neanderthal-like calling of his wife in Tennessee Williams's *A Streetcar Named Desire* – see *YO, ADRIAN!*

hi \'hī(-ē)\ *interj* a casual acknowledgment of recognition that men make to their wives between the time they walk in the door after work, plunk on the couch, grab the remote, and turn on the TV

Hitchcock, Alfred \'al-frəd-'hich-ˌkäk\ (1899-1980) British-born film producer/director who loved cool blondes and reveled in putting them in jeopardous situations that brought out their inner passions, sensuality, and sometimes a dark criminal side *such as* Madeleine Carroll in *The 39 Steps* (1935), Grace Kelly in *To Catch a Thief* (1955), Kim Novak in *Vertigo* (1958), Janet Leigh in *Psycho* (1960), and Tippi Hedren in *The Birds* (1963)

ALFRED HITCHCOCK

Hite, Shere \'hīt-'sher\ (b. 1942) controversial sex researcher and author of the 1976 "Hite Report: A Nationwide Survey of Female Sexuality," who found that 70% of women who couldn't experience orgasm through intercourse could achieve it through masturbation – see *CANDLE*

homeostasis \ˌhō-mē-ō-'stā-səs\ *n* a steady state in the body's internal environment that includes one's heart rate, temperature, and electrolyte balance, all of which are shot to hell when one falls in love

homo depot \\'hō-mō-'dē-pō\\ *n* [slang] Home Depot, a large American-based retailer of home-improvement and construction supplies whose headquarters are in Atlanta, Georgia, and where gay men and lesbians can meet other same-sex do-it-yourselfers

honey \\'hə-nē\\ *n* a term of endearment people in love often use with each other that derives from a viscous fluid made by bees from regurgitated nectar

HONEY

Honey, I'm home early! \\'hə-nē-'īm-'hōm-'ər-lē\\ *interj* heart-stopping words to an unfaithful husband, wife, or lover – see *IN FLAGRANTE DELICTO*

honeymoon \\'hə-nē-'mün\\ *n* a traditional trip that newlyweds embark upon following their marriage so they can have seclusion and intimacy; can last well beyond the initial trip but is generally considered over when they can stay at home and keep their clothes on for more than an hour or fall asleep together at night watching Netflix

honeysuckle \\'hə-nē-'sə-kəl\\ *n* a shrub (genus *Lonicera*) with fragrant tubular flowers rich in nectar

Honeysuckle Rose \\'hə-nē-'sə-kəl-rōz\\ *n* famous song of 1928 by Fats Waller and Andy Razaf about a sweet young thing whose sexuality is in full bloom <"When I'm takin' sips from your tasty lips, seems the honey fairly drips. You're confection, goodness knows, *Honeysuckle Rose*.">

BOB HOPE

Hope, Bob \\'hōp-,bäb\\ (1903–2003) legendary stand-up comedian and film star whose marriage to Dolores DeFina in 1934 broke all Hollywood records, lasting 69 years

horndog \\'hórn-'dóg\\ *n* a really, really horny guy <"Get off my leg, you *horndog*.">

hospital \\'häs-(,)pi-tᵊl\\ *n* a large medical facility that's located in a building with elevators and a parking annex, where one can go if one is sick, in pain, has incurred serious injury or if one's Cialis has produced an erection lasting more than 4 hours

hot monkey love \'hät-'mən-kē-'ləv\ *n* wild, passionate sex with somebody one has just met and might not even exchange names with <"I know that girl. We once made *hot monkey love* at the Doubletree.">

human sexual response \'hyü-mən-'sek-sh(ə-)wəl-ri-'spän(t)s\ *n* **a :** the 4 physiological stages of sex that lovers experience on their way to the "Big O" <see *ORGASM*> **b :** deconstructed and identified by William H. Masters and Virginia E. Johnson in their 1966 book *Human Sexual Response:* Excitement Phase <*as in* fire down below>, Plateau Phase <*as in* all systems ready>, Orgasmic Phase <*as in* Tiger just sank that putt>, and Resolution Phase

humpback whale \'həmp-,bak-'hwāl\ *n* **a :** a baleen whale (*Megaptera novaeangliae*) that has a wide tail, long slender flippers, and is known for its habit of arching deeply as it dives; possesses a repertoire of complex "songs" to help it lure a mate, though sporting a 10-ft. erect penis, nature's largest, helps, too

hung \'həŋ\ *adj* **1 :** a man with a long or large penis <"You won't be disappointed. I am well *hung*." –CRAIGSLIST> – see *HUMPBACK WHALE* **2 :** a decorating term <"Who put your drapes up? They are certainly well *hung*."> **3 :** a hangover <"Boy, am I *hung* from last night.">

HUSTLE

hustle \'hə-səl\ *n* a Latin swing-dance craze popularized by John Travolta in the 1977 film *Saturday Night Fever* (*dir* John Badham), in which couples perform complicated turns and loops while moving their hips in a Cuban sideways motion but which didn't last long because very few heterosexual American males could put it all together

hymen \'hī-mən\ *n* a fold of tissue at the opening of the vagina – see *POPPED CHERRY* **Hymen** *n* in Greek and Roman mythology the god of marriage and son of Aphrodite, typically depicted with a burning torch in his hand and to whom ancient wedding-goers would sing that old standby, "O Hymen Hymenaee"

hyperamnesia \ˌhī-(ˌ)pər-am-ˈnē-zh(ē-)ə\ *n* **a** : a neurological condition in which a person has increased memory and vivid recall **b** : usu. found in females, esp. in girlfriends and wives – see *AMMUNITION*

hypnosis \hip-ˈnō-səs\ *n* a temporary, trancelike state that usu. occurs in the early stages of love, when suggestibility causes one to obediently carry out a boyfriend's or girlfriend's wishes <*as in* "Oh, dear, I forgot to pick up the dry cleaning." "No problem, baby. I'm out the door.">

HUMAN SEXUAL RESPONSE: RESOLUTION PHASE

identity release donor \ī-ˈden-tə-tē-ri-ˈlēs-ˈdō-nər\ *n* a sperm donor who is willing to be contacted by any of his offspring when they reach the age of 18 <"Can I call you Dad, or do you prefer *Identity Release Donor*?"> – called also *open donor, yes donor*

I feel \ˈī-ˈfēl\ a declaration one makes to one's lover that says he or she has estab-

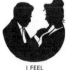

I FEEL

lished internal communication with his or her emotions and is in ownership of them <*as in* "*I feel* hurt by that comment," "*I feel* that

I lack spousal validation," or "*I feel* you haven't been contributing to our joint love bank account.">

Ikea \ī-ˈkē-ä\ *n* a Swedish home-furnishing retailer with giant blue boxlike stores in which couples often spend a day before getting married to see if their tastes are compatible – see *ALLEN WRENCH*

I love you \ˈī-ˈləv-ˈyü\ an expression that exists in every language but doesn't need to be spoken to be communicated - see *p. 134*

I LOVE YOU

Afrikaans	Ek is lief vir jou
American Sign	👍
Braille	⠿ ⠿ ⠿ ⠿ ⠿ ⠿ ⠿ ⠿
Creole	Mi aime jou
Estonian	Mina armastan sind
Farsi	Tora dost daram
Filipino	Iniibig kita
French	Je t'aime
German	Ich liebe dich
Greek (Ancient)	Se erotao
Hawaiian	Aloha i`a au oe; Aloha au la o`e
Hindi	Mai tumaha pyar karta hu
Irish Gaelic	Tá grá agam dhuit
Italian	Ti amo
Japanese	Ai shite imasu
Mandarin	Wo ai ni
Morse Code	../.−..−−−/−.−−−−−.−
Pig Latin	Iway ovelay ouyay
Russian	Ya tebya lyublyu
Sanskrit	Twayi snihyaami
Spanish	Te amo
Swahili	Nakupenda
Tagalog	Iniibig kita; Mahal kita
T-shirt	I ♥ you
Vulcan	Wani ra yana ro aisha
Zulu	Ngiya kuthanda

impetuous \im-'pech-wəs\ *adj* spirited; a kind way of saying that one's boyfriend, girlfriend, or lover is prone to unpredictable or manic behavior and may even be tampering with his or her meds <"You never know what Orianna will do, she's so *impetuous*."> – see *INSANIAC*

impulse \'im-ˌpəls\ *n* a spontaneous or irrational act one performs when in love <*as in* "I sent her flowers for no reason."> **impulse control** \im-ˌpəls-kən-'trōl\ *n* the ability to refrain from acting irrationally when in love <*as in* "Jilted, diapered astronaut planned to kidnap rival." –BoingBoing.net>

in bed \in-'bed\ *adj* a phrase one adds to the saying inside a fortune cookie when reading it aloud at the table <"Your ability to juggle many tasks

FORTUNE COOKIE will take you far in life...*in bed*," "Your confidence will hand you many victories...*in bed*," or "Your lucky number is 7...*in bed*.">

incommunicado \'in-ˌkə-ˌmyü-nə-'kä(ˌ)dō\ *adj* to not answer one's cell phone or e-mails – see *SNIT*

134

infantilism \\'in-fən-ˌtī-ˌli-zəm\\ *n* a desire to wear diapers, be fussed over, and act helpless in front of one's lover or partner – see *BABY TALK*

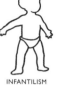

INFANTILISM

infatuation \\in-ˌfa-chə-'wā-shən\\ *n* a temporary glue composed of adrenaline, testosterone, and dopamine that holds people together until they are permanently stuck on each other

in flagrante delicto *adj* [Latin *while the crime is blazing*] a phrase meaning "Honey, I'm home!" <*as in* caught with one's pants down>

informed voter \\in-'förmd-'vo-tər\\ *n* an attractive quality in a potential mate that shows he or she is concerned about the future of the country and is especially appealing on a local level where he or she has taken time to understand the propositions

inner-child healing process \\'i-nər-'chī(-ə)-ld-'hēlŋ-'prä-ˌses\\ *n* an emotional recovery process for codependents whose repressed anger at their parents prohibits them from having healthy, meaningful relationships in their adult lives <*as in* "It is necessary to own and honor the child who we were in order to Love the person we are. And the only way to do that is to own that child's experiences, honor that child's feelings, and release the emotional grief energy that we are still carrying around." –ROBERT BURNEY, author, *Codependence: The Dance of Wounded Souls*>

innit \\'in-it\\ a contraction of "isn't it" that lovers frequently use <"Wow, Debbi, what a gorgeous sunset." "*Innit*.">

insaniac \\in-'sā-nē-ˌak\\ *n* a crazed lover – see *FATAL ATTRACTION*

insect \\'in-ˌsekt\\ *n* an arthropod whose behaviors, manners, and mating rituals can be ascribed to one's ex-lover so that after a breakup one refers to him or her

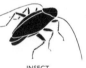

INSECT

as that cockroach, louse, praying mantis, slug, termite, stinkbug, etc.

intercourse \\'in-tər-ˌkörs\\ *n* insertion of the penis into the vagina followed by orgasm (usu.) **Intercourse, Pennsylvania** \\'in-

tər-ˌkȯrs-ˌpen(t)-səl-ˈvā-nyə\ *n* Amish village in Lancaster County founded in 1754 (pop. 300), where tourists mail postcards to friends in order to have the cards stamped "Intercourse, PA"

Interstate Highway System \ˌin-tər-ˈstāt-ˈhī-ˌwā-ˈsis-təm\ *n* **a :** a network of U.S. freeways that was begun under the Federal-Aid Highway Act of 1956 and completed in 1991 so that singles and divorced and widowed people could expand their dating ranges and possibilities **b :** on its 46,726 mi. there are no stoplights, and in some rural areas speed limits are as high as 85 mph *note* when driving, as when making love, it's better to take it slow

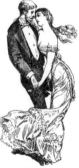

intimacy \ˈin-tə-mə-sē\ *n* **a :** the state of lovers being close to each other <"His voice was as *intimate* as the rustle of sheets." –DOROTHY PARKER, 1893-1967> **b :** intimacy can be physical <*as in* holding hands, hugging, kissing, playing Twister, and getting to third base> or emotional <*as in* 2 people sharing their feelings to gain mutual support, trust, and understanding> **c :** for a man, intimacy can be sitting alongside a girlfriend at a sporting event or taking a hand-in-hand walk in the woods, as neither activity requires eye contact **d :** for a woman, intimacy can be having a conversation with a boyfriend while sitting across the table from him at dinner or gazing at him while making love, as both activities require eye contact – see *AWARENESS EXERCISE p. 27*

INTIMACY

into \ˈin-(ˌ)tü\ *prep* **a :** to be involved with or interested in a person, or not <"Give it up, girl, he's just not *into* you."> **b :** to declare one's sexual proclivities <"So, what are you *into*?">

invidious \ˌin-ˈvi-dē-əs\ *adj* said of a malicious person who likes to cause trouble among lovers or generally stir things up <"I swear I saw Marla's fiancé on TV last night – something called "To Catch a Predator.'"> – see *MOTHER-IN-LAW*

invitation \ˌin-və-ˈtā-shən\ *n* **a :** the 1st of the 3 stages to orgasm **b :** involves come-ons that are meant as clues of desirability *such as* intruding upon another's personal

INVITATION

space, overlong glances, the fluttering of one's eyelashes, the paying of compliments, the licking of one's lips, the unconscious touching of one's genitals, or the use of double entendres <*as in* "Lenny, how does your external hard drive function?">

issues \'i-(ˌ)shüz\ *n* **a :** all the causes, concerns, difficulties, disagreements, baggage, factors, hang-ups, problems, situations, things, and uncertainties that lovers bring to a relationship <"We keep Sunday mornings as our special time to talk about our *issues*."> **b :** of all the issues in a relationship, surveys show that money is the number-one point of contention <*as in* "Honey, you've got some 'splainin' to do," *as in* new shoes>

it's all good \its-ˈȯl-ˈgu̇d\ *adv* a response to "Wuz up?" that says everything's under control, even if it isn't <"Nah, man. *It's all good. It's all good.*" –KEVIN FEDERLINE (*aka* K-Fed), on being asked about his relationship with Britney Spears> – called also *it's all love, it's all gravy, suckin' diesel*

It's a Wonderful Life \ˈits-ˈā-ˈwən-dər-fəl-ˈlīf\ *n* 1946 film (*dir* Frank Capra) in which James Stewart plays a small-town banker who finds himself on the verge of suicide after his repressed anger over marrying Donna Reed is allowed to surface; he is saved by an aspiring angel named Clarence who shows him what the town would have looked like if Stewart hadn't been born or if FEMA were in charge *note* voted by the American Film Institute as the eighth most romantic movie ever made

IT'S A WONDERFUL LIFE

I've had her \ˈīv-həd-ˈhər\ *interj* blasé comeback to someone who says he or she would give anything to have sex with a famous person <"I think Halle Berry is sooo hot!" "Really? *I've had her.*"> *var* I've had him

137

jackpot \'jak-ˌpät\ *n* the unlikely odds of getting 3 in a row with a new boyfriend or girlfriend <*as in* he's employed, dresses well, is straight; she's beautiful, likes sports, is bisexual>

Jacob, Mary Phelps \'jā-kəb-'mer-ē-'felps\ (1891–1970) thrice-married, scandal-ridden New York/Boston socialite who in an effort to liberate women from the corset invented the backless brassiere, or modern bra, which she patented in 1914; she later went on to become an ex-patriot literary publisher in Paris, a heroin addict in Morocco, and a confidante to Henry Miller, who lived in her New York townhouse

January \'jan-yə-ˌwer-ē\ *n* **a :** named for Janus, the ancient Roman god of beginnings, and the 1st month of the Gregorian calendar, when days are short, and nights are long, and not much happens, except between the sheets **b :** month in which the Annual AVN (*Adult Video News* magazine) Awards are presented in Las Vegas in such categories as Best Oral-Themed Release and Best Anal Sex Scene, as well as Best Actor, Actress, and Transsexual

139

Performer **c** : hotties born in January include Kate Bosworth (1/2/83), Orlando Bloom (1/13/77), and Justin Timberlake (1/31/81)

jaws \ˈjoz\ *n* the upper and lower bones of the mouth that allow the teeth to bite down on hard objects <*as in* "Easy, baby.">

jaw dropper \ˈjȯ-ˈdrä-pər\ *n* a shocking revelation or development in a relationship <*as in* "Brandy's a virgin? No way!">

jawsome \ˈjȯ-səm\ *adj* combined form of "jaw dropper" and "awesome" <"Check out her rack – *jawsome!*">

jazz \ˈjaz\ *n* a rhythmic, improvisatory music born of African American musicians in New Orleans in the 2nd decade of the 20th c.; prior to its invention, lovers depended on musical forms *such as* minuets, Irish folk ballads, and mariners' jigs to put them in the mood

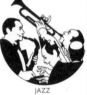

JAZZ

jealousy \ˈje-lə-sē\ *n* **a** : the Krazy Glue of love **b** : in its simplest terms, jealousy is a feeling of protective resentment toward one who threatens a relationship **c** : throughout history, authors and artists have attempted to interpret this ferment of emotions in countless poems, paintings, plays, books, and songs <"O, beware, my lord of *jealousy*! / It is the green-eyed monster / Which doth mock / The meat it feeds on." –WILLIAM SHAKESPEARE, *Othello*> **syns** anxiety, envy, fear, hatred, hope, low self-esteem, pride, rage, shame suspicion, revenge, vengeance

jet engine \ˈjet-ˈen-jən\ *n* **a** : an engine developed in the 1930s that accelerates fluid into its surrounding environment to generate thrust and speed **b** : began replacing propellers on commercial aircraft in the late 1950s, opening the way for bicoastal relationships **jet lag** \ˈjet-ˈlag\ *n* a condition marked by unpleasant mental and physical conditions brought about by the fatigue of crossing several time zones in a jet plane, which can ruin a romantic rendezvous

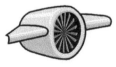

JET ENGINE

jiggy \ˈji-gē\ *adj* stylish; hot; fashionable <"Wow, Candy, that *jiggy* strapless really shows off your tats.">

JM (jealousy mechanism) *n* **a** : an evolutionary psychoanalytic theory that says jealousy comes in different shades of green: for a woman, jealousy has to do with her mate's emotional betrayal, while for a man it has to do with his mate's physical betrayal **b** : according to the theory, the jealousy mechanism is activated in a woman by evidence that her mate is falling in love with someone else, meaning she will be abandoned and will lose his parenting assistance; in a man, it is triggered by the fear of a mate's infidelity because this reduces his opportunity to reproduce and he will be responsible for caring for genetically unrelated offspring

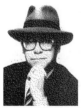
ELTON JOHN

John, Elton \'jän-'el-tən\ (b. 1947) **a** : Grammy- and Oscar-winning British singer-pianist-songwriter known for his flamboyant dress and over-the-top concert performances, who's battled drug addiction, bulemia, and depression, and who, on December 21, 2005, surrendered to love by entering into a civil partnership with David Furnish, an advertising director turned filmmaker **b** : born Reginald Kenneth Dwight, Elton is nicknamed Sharon by his friend, Rod Stewart, whom he calls Phyllis

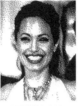
ANGELINA JOLIE

Jolie, Angelina \jō-lē-ˌan-jə-'lē-nə\ (b. 1975) actress and beauty who, despite being the other woman in the bust-up of Jennifer Aniston's marriage to Brad Pitt, has only become more loved by the public, largely because of her United Nations humanitarian work for refugees

Jorgensen, Christine \'jȯr-gən-sən-krēs-tēn\ (1926–1989) one of the first and the most famous of persons to undergo sex reassignment surgery, prompting the *New York Daily News* in 1952 to run a headline proclaiming: "Ex-GI Becomes Blonde Beauty"; George William Jorgensen chose the name Christina in honor of her surgeon, Christian Hamburger, who performed the procedure in Denmark

(The) Joy of Sex \thə-'jȯi-əv-'seks\ *n* **a** : a bestselling sex manual by the appropriate-

ly named Dr. Alex Comfort that was published in 1972 and takes an instructional, illustrated approach to performing sexual acts, as if one were planning a meal à la *Joy of Cooking*, on whose title and structure it is modeled **b** : spawned a sequel from Dr. Comfort, *More Joy of Sex*, and

THE JOY OF SEX

inspired Dr. Charles Silverstein and Felice Picano to write the *Joy of Gay Sex*, all of which have been revised over the years to account for changing times <*as in* AIDS and safe sex> **c** : in the original, Dr. Comfort offers a version of advanced footsies in which a man stimulates a woman with his big toe at a restaurant while keeping his hands on the table <*as in* "I'll have what she's having." -*When Harry Met Sally*, 1989, *dir* Rob Reiner>

jukebox \ˈjük-ˌbäks\ *n* a coin-operated phonograph whose roots go back to the Edison Cylinder of 1889 and that is best defined by the mass-produced 1946 Wurlitzer (Model #1015) that came in a gaudy cabinet with rounded lines and illuminated plastics; post–World War II teenagers in poodle

JUKEBOX

skirts and rayon shirts rock 'n' rolled to it in malt shops and dance halls across America <"You don't dig Latin like ya dig that crazy sound. *Jukebox* baby you're the swingin'est doll in town." -PERRY COMO, "Jukebox Baby," Joe and Noel Sherman>

Jules et Jim \ˈjüls-ˌā-ˈjəm\ *n* (*dir* François Truffaut) 1962 ménage à trois love story that encapsulates the French New Wave and made a star out of Jeanne Moreau (with Oskar Werner and Henri Serre as her impassioned suitors) – see *FEMME FATALE*

Juliet's balcony \ˈjül-yəts-ˈbal-kə-nē\ *n* a vine-tendriled balcony overlooking a plaza at La Casa di Giulietta (27 via Capello) in Verona, Italy, which legend says is where Shakespeare's fictional heroine Juliet stood while Romeo, eyeing her from below, remarked, "See how she leans her cheek upon her hand! O, that I were a glove upon that hand / That I might touch that cheek!" **letters to Juliet** \ˈle-tərz-tə-ˈjül-yət\ *n* every week hundreds of letters from the lovelorn seeking advice are mailed to the office of

JULIET'S BALCONY

the Club di Giulietta (the postman knows where to deliver those simply addressed "To Juliet, Verona"), all of which are answered by the club's volunteers

July \jů-'lī\ *n* **a** : named for Julius Caesar, the 7th month of the Gregorian calendar, when lazy, crazy, hazy days are perfect for picnics, barbecues, ball games, going to the beach, and watching fireworks go off in a park or one's bedroom **b** : designated National Ice Cream Month by President Ronald Reagan **c** : on July 22, 1963, *Introducing the Beatles* was released, and on July 3, 1971, singer Jim Morrison of The Doors died in Paris, at age 27

jumping the broom \'jəm-piŋ-<u>th</u>ə-'brüm\ *vb* a ritual that some scholars believe evolved from the days of U.S. slavery, when slave couples, who were not allowed to marry, would honor their union by jumping over a broom that was laid on the ground to symbolize the sweeping away of the past; today, this ritual has regained popularity among African American couples

jumping the couch \'jəm-piŋ-<u>th</u>ə-'kaůch\ *vb* **a** : to be so crazy for someone that one makes a public ass of oneself in expressing that love **b** : the term is derived from a bizarre incident on the *Oprah Winfrey Show* (May 23, 2005), when actor Tom Cruise, when asked about his feelings for then girlfriend (now wife) Katie Holmes, hopped on a couch and began jumping up and down in excitement

JUMPING THE COUCH

June \'jün\ *n* the 6th month of the Gregorian calendar, when summer begins and every hotel, yacht club, and park has a wedding reception **June Cleaver** \'jün-'clē-vər\ *n* quintessential boomer mom on TV's *Leave It to Beaver* (1957-1963), who cleaned and gardened in pearls; if the post–World war II suburbs were America's Garden of Eden, she was its Eve; played by Barbara Billingsley

Jurassic \jů-'ra-sik\ *adj* a geological term that refers to a period of the Mesozoic era, when dinosaurs ruled the Earth <"I know Ty digs older women but this one's *Jurassic*.">

143

K

kahooga \ˌkə-ˈhü-gä\ *vb* to cry and carry on like a baby <"Jack *kahooga*'d for a week after Sheri dumped him.">

Kalamazoo \ˌka-lə-mə-ˈzü\ *n* a city in SW Michigan that during World War II was home to "a real pipperoo" <"I've got a gal in *Kalamazoo*. Don't want to boast, but I know she's the toast of *Kalamazoo*, zoo, zoo, zoo, zoo." –GLENN MILLER ORCHESTRA>

Kama Sutra \kä-mə-ˈsü-trə\ *n* **a :** an ancient Indian text by a mysterious Brahmin and religious scholar named Vatsyayana that lets a guy know if he wants to score with a woman he'd better master the science of love, which includes knowing how to dress, buying off her servants, and playing sick to get her attention **b :** divided into 7 parts containing a total of 36 chapters, it is Part Two that most readers turn to as it contains detailed instructions and artistic illustrations for 64 different sexual positions - see *LINGAM, PENIS, YONI, VAGINA* **c :** although the *Kama Sutra* regards making love as a divine union, it also advocates scratching, biting, spanking, toys, and oral sex **d :** translated from Sanskrit

145

to English by Sir Richard Francis Burton in 1883 – see *ANIMAL POSITIONS p. 17*

Kansas City \'kan-zəs-'si-tē\ *n* a port city on the S bank of the Missouri River, in Jackson County, W Missouri, which, according to the eponymous song, has "a lot of crazy women there, and I'm gonna get me some."

GRETA GARBO AS ANNA KARENINA

Karenina, Anna \ˌkär-ə-'nē-nə-'ä-nə\ *n* **a :** aristocratic protagonist of Leo Tolstoy's 1877 novel of the same name who leaves her husband for a military officer named Count Vronsky and who after having his baby yada yada yada train platform **b :** although Karenina has been played by numerous actresses, the part is owned by Greta Garbo, who starred opposite Fredric March in the 1935 movie version (*dir* Clarence Brown)

karma bus \'kär-mə-'bəs\ *n* a cosmic vehicle that delivers karmic retribution <"Do not ask for whom the *karma bus* stops – it stops for you, heartbreaker."> **karma kick** \'kär-mə-'kik\ *n* **a :** cause and effect

b : Hindu-based belief that what one does to others comes back to him or her, meaning if one breaks enough hearts, he or she will in time have his or her heart ripped open and left on the sidewalk for the vultures to devour **karma tripping** \'kär-mə-'tri-piŋ\ *vb* comforting someone just to get good karma points <"Look at those phonies consoling Matty 'cause he got dumped. They're just *karma tripping*.">

Ken doll \'ken-'däl\ *n* a boyfriend who is athletic, blond haired, blue eyed, and a trendy dresser but has plastic values and little personality <"Becky's got herself a *Ken doll*. Like yawn.">

killer bod \'ki-lər-'bäd\ *n* an amazing physique <"If I spent all my time at the health club like Chandra, I'd have a *killer bod*, too.">

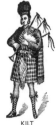

kilt \'kilt\ *n* a tartan, wraparound, pleated skirt worn by men in Scotland to show off their legs and bagpipes

KILT

kind \'kīnd\ **1 :** *adj* tender, compassionate, and generous *as in* desired traits in a lover

<"How *kind* of you to let me come." –ELIZA DOLITTLE, *My Fair Lady*> **2** : *n* a specific variety *as in* dating within one's social rank <"Stick to your own *kind*." –ANITA, *West Side Story*> **kindly** \'kīn(d)-lē\ *adv* helpfully, charitably, and courteously <"Can you *kindly* help me carry my groceries to the car?" *as in* cute bag boy>

••••••••••••••••••••••••••••••••••••

BE KIND

So many Gods,
So many creeds,
So many paths
That wind and
Wind and wind,
While but the art
Of being *kind*,
Is all this sad world
Needs.

　　　–ANON.

••••••••••••••••••••••••••••••••••••

King Kong \'kiŋ-ˌkȯŋ\ *n* **a** : the classic 1933 movie (*dirs* Merian Cooper/Ernest Schoedsack) about a giant testosterone-pumped gorilla who takes his urban squeeze (Fay Wray) to the top of the Empire State Building, where he literally falls head over heels for her **b** : the film's famous last line, as said by a reporter: "Oh, no. It wasn't the airplanes. It was beauty that killed the beast." **c** : remade in 1976 with Jessica Lange (*dir* John Guillermin) and in 2005 with Naomi Watts (*dir* Peter Jackson)

kinkalicious \'kiŋ-kə-'lish-əs\ *adj* good enough to eat <"Baby, I could devour you in that *kinkalicious* teddy.">

kinky \'kiŋ-kē\ *adj* forbidden fun – see *ALFRED CHARLES KINSEY* **Kinky Friedman** \'kiŋ-kē-'frēd-mən\ (b. 1944) American singer, songwriter, novelist, and politician whose hit songs include "Get Your Biscuits In the Oven and Your Buns In the Bed" and "Asshole from El Paso" and who lives on a spread outside Medina, Texas, where he runs the Utopia Animal Rescue Ranch for abused and elderly pets

Kinsey, Alfred Charles \'kin-sē-'al-frəd 'chär(-ə)lz\ (1894–1956) **a** : American zoologist and father of "sexology," whose studies of the evolution of gall wasps led him to explore the taboo sexual practices of average Americans **b** : Kinsey's 2 groundbreaking books, *Sexual Behavior in the Human*

Male (1948) and *Sexual Behavior in the Human Female* (1953), settled the debate once and for all that most men and women masturbate **Kinsey Scale** \'kin-sē-'skāl\ *n* the scale from 1 to 7 that Dr. Kinsey used in his reports to rate a man on how homosexual he is or isn't, in which 1 represents extremely heterosexual and 7 represents florist, organist, or priest

kiss \'kis\ *n* an expression of affection between 2 people that traditionally involves the pressing of one pair of lips against another <"The most eloquent sentence; that of two mouths meeting in a *kiss*." –ANON.> – called also *tongue hockey* **(The) Kiss** \thə-'kis\ *n* **1 a :** the name of 2 European Art Nouveau masterpieces, one by Auguste Rodin and the other by Gustav

KINDS OF KISSES

"There are as many kinds of kisses as kinds of love; the paternal kiss on the forehead, the kiss on the eyes full of peace, the amusing kiss on the nose, the friendly kiss on the cheek. All of these are somewhat anodyne, but they could be taken as tempting invitations to more perfidious ones, such as the indiscreet kiss on the throat, or the coaxing kiss in the ear which is like being told a secret. And finally there is the kiss on the lips. 'A kiss means nothing,' say the thoughtless. Perhaps not, if you are cold as ice and your companion, lacking in ardor, lets you escape easily from his embrace. But if that kiss has filled you with delight, bear in mind that it has moved him even more strongly and awoken all the strengths of his desire." –PEDRO ALMODÓVAR, *Entre Tinieblas (Dark Habits)*, 1983

Air Kiss A pursing of the lips in a pretend kiss on another's cheek or cheeks done during greeting or parting and accompanied by a salutation *such as* "Love ya!" – called also *Hollywood Kiss*

Angel Kiss A kiss in which a person puts his or her cheek against a partner's cheek and moves his or her mouth toward the eyelids while executing gentle kisses

Butterfly Kiss A kiss that follows a regular kiss as 2 people put their eyelashes together and quickly flutter them

148

Klimt, whose subjects need to get a room **b :** in ca. 1886 Rodin sculpted his marble statue depicting 2 lovers entwined in an impassioned embrace, of which he later made hundreds of smaller bronzes **c :** in 1907 Klimt unveiled his oil on canvas of lip-locked lovers, which art historians say represents the loss of self that couples experience when embraced in the golden utopia of passionate surrender – see *ORGASM* **2 :** the title of an 1896 nickelodeon film that lasted only 30 secs. but is famous for having featured the world's first on-screen kiss, between John Rice and May Irwin

klingons \'kliŋ-ȯnz\ *n* a couple who are disgustingly lovey-dovey, esp. in front of other people

••

Candy Kiss A game in which one person puts a piece of hard candy in his or her mouth and challenges the other person to try and steal it away using only his or her lips and tongue

Continental Kiss A double-cheeked kiss that Europeans bestow upon others as a greeting or farewell; similar to the *Air Kiss* only it is slightly more sincere

Cordial Kiss A kiss in which both partners take a sip of their favorite liqueur before bringing their lips together, at which point they slightly open their mouths to exchange liquids

Cup Kiss Often performed in movies, a very romantic lead-up to a kiss, in which a person cups his or her partner's face in his or hands

Electric Kiss A kiss in which 2 people lower the lights then shuffle across the carpet until each is in a sufficiently charged state, at which point they kiss and sparks fly

Eskimo Kiss A non-mouth kiss in which partners stand a breath apart from each other and slowly rub their noses together

French Kiss An open-mouthed kiss involving tongues – called also *Soul Kiss*

Hickey Kiss A kiss in which a person puts his or her mouth against the side of a partner's neck and with mouth slightly open sucks gently on the skin for no more than 30 secs.

149

klutz \'kləts\ *n* a clumsy boyfriend or girl-friend one can't take to antiques shops because they break things but whose awkwardness gives them an irresistible vulnerability

knee \'nē\ *n* a joint fronted by the kneecap at which the thighbone and lower leg connect and used primarily by a man for kneeling in front of a woman when asking for her

KNEE

hand in marriage **knee buckler** \'nē-'bə-klər\ *n* a person who is so hot that one's knees give way when one is in close proximity to him or her **kneesies** \'nē-zēz\ *n* advanced form of footsies in which 2 people rub their knees together under a table while attempting to maintain their composure

- -

KINDS OF KISSES *(continued)*

Hot/Cold Kiss A kiss in which one partner puts a hot drink in his or her mouth and the other partner puts a cold drink in his or her mouth and then while kissing both partners open their mouths a bit and move their tongues inside each other's mouths in an effort to produce steam

Kiss of Death Similar to the *Continental Kiss*, a double-cheeked kiss performed by Italian mob members when saying goodbye

Neck Kiss A kiss in which a person licks the back of his or her partner's neck a few times and then uses his or her lips to brush the back of the partner's neck *var* substitute brushing the neck with nibbling, or do both

Shoulder Kiss A kiss that starts with a person embracing his or her partner and then kissing his or her shoulder and then moving on to the neck and eventually the mouth

Sigh Kiss A prelude to a kiss in which a person gently licks his or her partner's lips with the tip of his or her tongue to produce a tingling feeling that intensifies the main kiss

Snake Kiss A kiss that is done on its own or as part of a *French Kiss* in which both partners stick out their tongues and quickly flick them together

knight \\'nīt\ *n* a member of English nobility who lived during the Middle Ages and was bound by a code of chivalry to uphold virtuous causes, champion the innocent, and protect the weak, esp. beautiful damsels in distress who were looking to have a dragon slain, a tower scaled, or the lock on their chastity belt WD-40'd <"Listen to me, mister. You're my *knight* in shining armor."

- -

Surprise Kiss A gentle kiss that one performs on one's partner's lips as he or she is napping or sleeping and that intensifies in passion as partner comes to

Tickle Kiss A kiss that takes place during a *French Kiss* in which a person tickles the highly sensitive roof of his or her partner's mouth with his or her tongue

Underwater Kiss A kiss in which a person puts his or her head under water in a swimming pool and then taps his or her partner to come down and give him or her air

KISS

–KATHARINE HEPBURN to Henry Fonda in *On Golden Pond*, 1982, *dir* Mark Rydell> **knighting** /'nī-tiŋ/ *vb* a mating ritual among lobsters, during which the female places her claws on the chosen male's head;

KNIGHT

scientists speculate that she is not dubbing her lover "Sir Red" but secreting a protective hormone that reduces his aggressive tendencies *such as* eating her alive **Gladys Knight** \\'gla-dis-'nīt\ legendary performer (b. 1944, Atlanta, Georgia) who, with her backup singers, The Pips, had a string of hits in the late 1960s and early 1970s, including the sexy R&B album *Imagination*, which included "Midnight Train to Georgia" <*as in* "I'd rather live in his world than be without him in mine.">

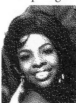

GLADYS KNIGHT

151

La Belle Otero \'lä-'bel-ō-'te-rō\ *n* (1868–1965) **a** : singer-dancer-courtesan (née Agustina Otero Iglesias) who was born into poverty in N Spain and who, after reinventing herself as an Andalusian gypsy (La Belle Otero), became a star

LA BELLE OTERO

in the Folies Bergère in Paris and the personification of *la belle époque* **b** : despite romantic entanglements with the likes of King Edward VII and Russian Grand Dukes Peter and Nicholas, she died in poverty in Nice, France, after gambling away her fortune **c** : legend holds that the twin cupolas of the Hotel Carlton in Cannes were modeled after her lustrous *belle poitrine*

La Bohème \'lä-bō-em\ *n* (1896) the world's most beloved opera, by Giacomo Puccini, that tells the simple story of 4 struggling artists living in Paris, one of whom, Mimi, dies of tuberculosis at the end in the arms of her grieving lover, Rodolfo, causing audiences to cry, including Cher – see *MOONSTRUCK*

lackadaisical \ˌla-kə-ˈdā-zi-kəl\ *adj* semi-drained or jaded from playing the game of love - *syns* downhearted, laconic, spiritless, zestless **lackaday** \ˈla-kə-ˌdā\ *interj* <"I was a fool to fall and get this way; heigh-ho, alas, and *lackaday*."–GEORGE & IRA GERSHWIN, "But Not for Me">

la-dee-dah la-dee-dah \ˈlä-dē-dä-ˈlä-dē-dä\ *interj* **a** : a mindless utterance popularized by Diane Keaton in Woody Allen's romantic comedy *Annie Hall* (1977), which expresses her character's inability to express herself **b** : has since become a term used to describe a female who is scatterbrained or out to lunch <"I called Elaunda and she's at the wrong restaurant - *la-dee-dah la-dee-dah*.">

ANNIE HALL

laffy taffy \ˈla-fē-ˈta-fē\ *n* **1** : [slang] the female buttocks <"Girl, shake dat *laffy taffy*." –D4L, "Laffy Taffy"> **2** : the labia minora of the female genitalia - see *LIPS* **Laffy Taffy** *n* a brand of taffy that comes in small, individually wrapped packages, manufactured by Nestlé in assorted fruit flavors and sold under its Willy Wonka Candy Factory label

lagoon \lə-ˈgün\ *n* a shallow area of water connecting to a larger body of water that connotes a romantic image of lovers lazily canoeing on a warm summer's evening <"A tropical moon, a sleepy *lagoon*, and you." –JACK LAWRENCE/ERIC COATES, "Sleepy Lagoon"> - see *MOSQUITO*

la la \ˈlä-lä\ *n* a state of feeling lighter than air that occurs during infatuation <"Ah, *la la*, and again *la la!* And never enough *la las!*"–COLETTE, 1873-1954, on the early days of her affair with Maurice Goudeket>

land mine \ˈland-ˈmīn\ *n* an emotionally charged device that one can't foresee on the road to love and that if stepped on can severely wound, cripple, or destroy a relationship <*as in* "All I said was - - -, and he blew up."> *var* hand grenade

Lassie \ˈla-sē\ *n* **a** : the beloved TV collie (CBS, 1954–1974) that was an iconic figure of devotion, loyalty, and maternal love for America's post–World War II children **b** : lived with and protected several differ-

154

LASSIE

ent families on Midwest farmland that had varying topographies, including a swamp, a dry desert, and a saltwater lake where a seal lived **c :** today she lives on in reruns and every baby boomer's heart

last month \\'last-'mən(t)th\ *adj* ex-boyfriend or ex-girlfriend of someone who doesn't stay long in a relationship <"Yo, where's Kiki?" "Man, she's so *last month.*">

Las Vegas \läs-'vā-gəs\ *n* a city located in SE Nevada (pop. 480,000) and dubbed the "wedding capital of the world," where 100,000 couples a year have said their "I do's" *such as* Elvis Presley, Joan Collins, Michael Jordan, Clint Eastwood, Bette Midler, and Britney Spears – see *QUICKIE MARRIAGE*

lateral incisor \'la-tə-rəl-in-'sī-zər\ *n* 1 of 2 upper teeth in the front of the mouth alongside the canine teeth, where spinach gets stuck when one is on a dinner date – compare *GAP TOOTH*

La Traviata \'lä-trä-vē-'ä-tä\ *n* Giuseppe Verdi's 1853 opera based on the novel *La Dame aux Camélias* by Alexander Dumas fils in which a beautiful courtesan named Violetta Valery coughs her way into every opera-lover's heart, and though many prima donnas have played the role, it is owned by diva Maria Callas – see *CAMILLE*

Laundromat \'lòn-drə-ˌmat\ *n* a brightly lit commercial estab-

LAUNDROMAT

lishment where singles can get to know each other over timed cycles *such as* presoak, wash, rinse, spin, dry, fluff, and cool down

laundry hamper \'lòn-drē-'ham-pər\ *n* an aerated container for storing soiled bedsheets until they can be washed

Lava Lamp \'lä-və-'lamp\ *n* **1 : a :** a coneshaped light fixture invented in England in the 1960s for the love generation, which presents shifting, psychedelic patterns caused by the breaking apart of oily fluids **b :** rights to the lamp were bought by an American manufacturer in 1965 who

155

renamed it the Lava Lite; today 400,000 a year are sold worldwide by Haggerty Enterprises of Chicago, Illinois **2** : a person who is fun to look at but obtuse <"Arturo's handsome but talk about a *Lava Lamp*.">

lavender \'la-vən-dər\ *n* **1** : **a** : a flowering plant *(Lavandula angustifolia)* of the mint family that has long been revered in art and literature as an herb of love and whose earthy aromatic essence appeals equally to men and women **b** : the leaves of the plant are cultivated for their oils, which are used

in perfumes, body lotions, and other toiletries, while the lilac-purple flowers are dried and pressed for use in sachets and gourmet treats *such as* chocolate bars, teas, and cookies **c** : used by the ancient Romans and Greeks in their soaps and bathwater,

LAVENDER

its name is thought to derive from the Latin verb *lavare*, "to wash" **2** : a color associated with gay pride **lavender marriage** \'la-vən-dər-'mer-ij\ *n* [archaic] a Hollywood term to describe a marriage in which 1 or more partners is homosexual but is pretending to be heterosexual *such as* Rock Hudson and Phyllis Gates, Cole Porter and Linda Lee Thomas, and Liza Minnelli et al

••••••••••••••••••••••••••••••••••••

LAVENDER BATH

Use a handkerchief, a piece of thin cotton, or cheesecloth approximately 6–8 in. sq. Place ¼ cup dried lavender blooms in center of fabric and gather corners together to secure bundle with a piece of 12-in. ribbon tied in a knot. Tie ends of ribbon together to form a loop by which to hang bag. Slip this over bathtub faucet, positioned so water will run through it as tub fills. Can be used for several baths before replacing lavender.

••••••••••••••••••••••••••••••••••••

la vida lowbrow \lä-'vē-dä-'lō-bràu\ *n* a particular look and lifestyle that emulates low social status *such as* wearing designer-label tattered clothing or too much makeup and jewelry, sporting tattoos, swearing, smoking, drinking, and partying late; role models include Paris Hilton, Nicole Richie, and Britney Spears – see *COMMANDO*

L-bomb \'el-'bäm\ *n* an explosive figure of speech that denotes the explicit declaration "I love you" and is open to being dropped sometime after the 3rd or 4th

156

date; once dropped, its initial shock and impending fallout cannot be taken back or easily contained

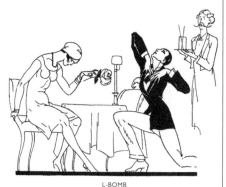

L-BOMB

leather \'le-thər\ *n* tanned animal skin that is both comfortable and stylish and is used for items *such as* shoes, couches, car seats, jackets, and toys **leather spinster** \'le-thər-'spin(t)-stər\ *n* a happily unmarried woman who is usu. heterosexual and who sees her life as meaningful and complete without a man <"My Auntie Sara lives alone. She's a *leather spinster*.">

lekking ground \'le-kiŋ-'graund\ *n* a place where certain males of a species gather for the purpose of competitive mating dis-

plays to win over females – called also *karaoke bar, jousting arena*

Lennon, John \'le-nən-'jän\ (1940–1980) founding member of the Beatles, songwriter, poet, artist, and peace activist who, following his marriage to Yoko Ono on March 20, 1969, held 2 honeymoon "bed-ins" for peace, in Amsterdam and Montreal, and who wrote unashamedly romantic ballads <*as in* "I Want to Hold Your Hand," "The Long and Winding Road," and "All You Need Is Love">

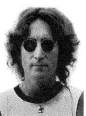

JOHN LENNON

Leonardo da Vinci \,lē-ə-'nar-dō-də-'vin-chē\ (1452-1516) painter who is most famous for his portrait of *La Giaconda* (*aka* the *Mona Lisa*), whose enigmatic smile can be seen at Paris's Louvre Museum <*as in* "Do you smile to tempt a lover, Mona Lisa, or is this your way to hide a broken heart?" –RAY EVANS/JAY LIVINGSTON, "Mona Lisa">

lesbian seagull \'lez-bē-ən-'sē-,gəl\ *n* a typically gray-and-white seabird that sets

157

up nest-keeping with other female gulls, a lifestyle choice practiced by an estimated 8–14% of the seagulls on the Santa Barbara islands off the California coast

Fly with Me, Lesbian Seagull \\'flī-wəth-mē-'lez-bē-ən-'sē-gəl\\ *n* a romantic ballad recorded by pop singer Engelbert Humperdinck for the 1996 movie *Beavis and Butt-Head Do America* (*dirs* Mike Judge/Yvette Kaplan)

level \\'le-vəl\\ *n* the next step in a relationship, which can mean whatever a couple agrees upon *such as* exclusivity, moving in together, marriage, etc. <"I think it's time we took it to the next *level*."> **level off** \\'le-vəl-'òf\\ *vb* to start sleeping through the night <"At first the sex thing was all the time, but lately it's *leveled off*."> – see *GOOD NIGHT'S SLEEP*

liaison \\'lē-ə-ˌzän\\ *n* [French] a discreet sexual agreement between 2 adults that is carried out in expensive settings *such as* hotel suites, yachts, or weekend estates <*as in* "When things got a little touchy, he deeded me a duchy." –Stephen Sondheim, "Liaisons">

library \\'lī-ˌbrer-ē\\ *n* a safe, well-lit building where books, reference materials, and periodicals are kept and where people must speak in sexy, hushed tones, which is perfect for picking up dates esp. since one need never be at a loss for an opening line <*as in* "I couldn't help noticing that you're reading Rambeau. I love Sly Stallone.">

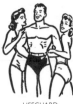

lifeguard \\'līf-ˌgärd\\ *n* a tanned, Adonis-like male figure who can be found at the beach during the summer months wearing a Speedo and who is skilled at giving mouth-to-mouth respiration while remaining emotionally not there

LIFEGUARD

lighthouse \\'līt-ˌhaůs\\ *n* a tall cylindrical structure with a powerful light that warns lovers who are at sea of imminent danger and offers them assistance past the rocks and into safe harbor – see *BEACH, PHALLIC SYMBOL*

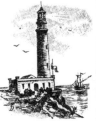

LIGHTHOUSE

158

likee \'lī-kē\ *vb* used to describe one's first feelings of attraction for another person <"Tell me, Dylan, what do you think of Sandra, our new office manager?" "Mmm, me *likee*."> *var* like

lilac \'lī-läk\ *n* **a** : a hardy deciduous shrub *(Syringa vulgaris)* with heart-shaped leaves and showy flowers that blooms in spring in the NE region of the U.S. and that puts anyone who comes within 10 ft. of it, including stoic New Englanders, into a Shakespearean-like love trance **b** : purple lilacs symbolize first love and white lilacs youthful romance; picking them symbolizes the humility of inexperience

LILAC

limbic system \'lim-bik-'sis-təm\ *n* **a** : a group of structures in the brain, which includes the hippocampus, cingulated gyrus, and amygdala and is associated with feelings *such as* anger, fear, pleasure, and sexual arousal **b** : it is the seat of long-term memory, so that a person detecting a certain familiar smell <*such as* a particular brand of perfume a woman is wearing or the smell of tobacco on a man's breath>

can become sexually aroused – see *FETISH EXAMPLES pp. 100–101*

limbo \'lim-(,)bō\ *n* **1** : a voidlike state of emotional emptiness and social retreat that lovers are condemned to for an indefinite period of time after a relationship ends and before another begins <"I'd love to go the the Cheesecake Factory, but I'm still in *limbo*."> **2** : a Jamaican party dance in which rum-induced participants gyrate to a Caribbean beat as they lean backward and dance their way under a horizontal stick that is continually being lowered – see *CHIROPRACTOR*

limp \'limp\ *n* a layman's term for erectile dysfunction <"I don't get it. I've gone *limp*."> – called also *"This has never happened before."* **limp dick** \'limp-'dik\ **a** : *n* an ineffectual male <"He can't get anything right. He's such a *limp dick*.") **b** : *adj* tepid reply to a question or problem <"He thinks he loves her but isn't sure. That's a *limp-dick* answer if ever I heard one.">

lingam \'liŋ-əm\ *n* [Sanskrit *penis*] in the *Kama Sutra*, a man is classified as either

a hare, a bull, or a horse according to the size of his lingam

linger \'liŋ-gər\ *vb* **a :** to be slow in leaving a party or social event after most of the guests have gone in hopes of having some private time with the host or hostess **b :** to pause during lovemaking to share an intimate moment or observation <*as in* "Judith, you really are a blond!">

lips \'lips\ *n* **a :** the soft, fleshy, tactile, movable external structures that surround the mouth and whose functions include

the wearing of lipstick, whistling, playing the saxophone, and kissing – see *ZYGOMATIC MAJOR MUSCLE* **b :** because of their high number of

LIPS

nerve endings, the upper lip (labium superioris) and lower lip (labium inferioris) make a highly erogenous zone that poets, artists, songwriters, and lovers have long cherished <"If you press a beautiful breast and beautiful arms, they may not return your caresses; but kiss the mouth, and it answers with the soul. The soul flies to those ruby *lips*; the two make but one, and

it is a paradise." –VOLTAIRE, 1694-1778> **c :** because the lip skin does not have sweat glands, lips are susceptible to becoming chapped from weather, pathogens, or over-smooching; lip balms, lipstick, lollipops, and all-day suckers can help them retain moisture and stay smooth **inner lips** \'i-nər-'lips\ (labia minora) *n* the 2 folds of skin that form the inner, smaller lips of the female genitalia - see *CLITORIS* **outer lips** \'aú-tər-'lips\ (labia majora) *n* the 2 folds of skin that form the outer and larger lips of the female genitalia

lipstick \'lip-ˌstik\ *n* a waxy, solid cosmetic that comes in stick form and is applied by women to their lips and linked by some anthropologists to the attention-getting bright pink sexual swellings exhibited by female baboons during estrus – see *HEAT*

LIPSTICK

listen \'li-sᵊn\ *vb* **a :** the art of being able to stay focused and actively interested in what a date or partner has to say <"The first duty of love is to *listen*." –PAUL TILLICH, 1886-1965> **b :** "Men have a tendency to want to provide solutions when someone

talks to them about problems or concerns. Women, however, very often talk about their problems just to unload. They aren't necessarily seeking advice; the simple act of letting it out is therapeutic enough for them." –JANET O'NEAL, author, *The Complete Idiot's Guide to the Art of Seduction* **c :** "Women always think that guys don't *listen*. It's not that we don't *listen*; we just don't understand why you're bringing up your problems if you don't want us to do something about it." –CRAIGSLIST

little death \'li-t°l-'deth\ *n* the translation of the French phrase *la petite mort*, which refers to a woman fainting after experiencing a supercharged orgasm

LOBSTERCARD

lobstercard \'läb-stər-'kärd\ *n* a term for the act of ordering the most expensive item on a restaurant menu <"Our first date, and she pulls the *lobstercard*."> *var* [New England] lobstahcahd

lock \'läk\ *n* **a :** a mechanical device used by lovers over the centuries to securely fasten doors in order to prevent coitus interruptus **b :** used frequently by teenage boys when Web surfing one-handed in their rooms

Lolita \lō-lē-tə\ *n* **a :** controversial tragicomedy by Vladimir Nabokov (1899–1977) that tells the story of a middle-aged intellectual who is obsessed by a sexually precocious 12-year-old girl he dubs Lolita, whose name has since become synonymous with young seductresses **b :** first published in Paris in 1955, the book was finally allowed to be printed in the U.S. in 1958, the same year that a 70-year-old Maurice Chevalier was crooning "Thank Heaven for Little Girls" to Leslie Caron in the Oscar-winning musical film *Gigi* (*dir* Vincente Minnelli)

look \'lùk\ **1 :** *n* an involuntary come-hither glance that involves the slight arching of an eyebrow and communicates immedi-

ate romantic or sexual interest in someone who has just come into view <"Boy, did he give her a *look*."> **2** : *n* a distinct appearance or style of dress <"Dad's got that whole Kenny Rogers *look* going on."> **3** : *vb* to direct one's attention <"To love is not to *look* at one another but to *look* together in the same direction." –ANTOINE DE SAINT-EXUPERY, 1900–1944> **4** : *interj* to level with a friend who's out of his league <"*Look*, dude, you don't stand a chance."> **melting look** \\'mel-tiŋ-'lůk\ *n* an intense, heat-bearing glance that causes a person to go from a solid to a liquid state **The Look of Love** \thə-'lůk-əv-'ləv\ *n* definitive Burt Bacharach/Hal David song recorded by Dusty Springfield, Brasil '66, and Nina Simone <"*The look of love* is saying so much more than just words could ever say.">

lordosis behavior \lór-'dō-səs-bi-'hā-vyər\ *n* **a** : a mammalian courting pose in which an estrous female animal *such as* a cat, dog, or baboon crouches, arches her back, and tips up her buttocks

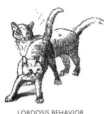

LORDOSIS BEHAVIOR

toward her suitor to advertise sexual availability **b** : a behavioral trait not exclusive to animal members of the primate order <*as in* "Women do this, too. A woman will look coyly over her shoulder at a man as she gracefully arches her back and tips her buttocks in his direction." –HELEN FISHER, author, *Why We Love*>

loser \'lü-zər\ *n* **a** : a person who isn't a winner **b** : one who in the game of love lacks a game plan **c** : one who is unpopular, unstylish, different, hopelessly square, lives at home with his or her parents, is counterintuitively challenged, or has fallen off the social ladder **d** : being a loser is a matter of perception as it can also describe a person who is cool and happy with himself or herself, who doesn't put down others, who is not a slave to trends or fashions, isn't promiscuous, has a high I.Q., is very creative – qualities that often prove irresistible to a romantic partner; famous losers include Bill Gates, Al Gore, Steve Jobs, Madonna, Prince, Steve Wozniak **e** : can be a term of affection between close friends <"C'mon *loser*, we're late for the game."> **Loser** *n* 1993 song co-written and performed by the singer Beck on his first major album,

Mellow Gold, which proved to be his only hit <"I'm a *loser* baby, so why don't you kill me?" –BECK/CARL STEPHENSON>

lovable kook \'lə-və-bəl-kúk\ *n* **a** : retro term to describe a high-spirited woman with quirky ideas and a forgivable personality who was once plentiful in New York's Greenwich Village but whose population has dwindled due to high rents; epitomized by Audrey Hepburn as Holly Golightly in the 1961 film version of Truman Capote's *Breakfast at Tiffany's* **b** : defies social convention by dressing in her own style, befriending social misfits, and saying outrageous things at inappropriate times, often to the consternation of her date; has an easily breakable heart and loves animals esp. cats *note* recent lovable kooks include Cyndi Lauper, Kate Winslet, and Lisa Kudrow

Lovapalooza /'lə-və-pə-'lü-zə/ *n* the world's largest kissing event that took place in the Philippines at midnight on February 10, 2007, during which 6,124 couples simultaneously kissed for 10 secs. in the parking lot of a shopping mall

love \'lƏv\ – see chapters A–Z **love at first sight** \'lƏv-ət-'fərst-'sīt\ *n* **a** : a violent biological and emotional disturbance in which a person who is minding his or her own business <see *LA-DEE-DAH LA-DEE-DAH*> suddenly goes gaga over another person the moment he or she comes into view **b** : neurologists, psychologists, anthropologists, and behaviorists link the phenomenon to a perfect storm of conditions that can involve smells (pheromones), sex hormones (testosterone and estrogen), a need to control, and an unconscious knowing of exactly what one is searching for **c** : writers, poets, and artists have long contended that love at first sight is indeed real <*as in* "I came, I saw, and was undone! / Lightning did thro' my Bones and Marrow run; / A pointed Pain pierc'd deep my Heart / A swift cold Trembling seiz'd on ev'ry Part / My head turn'd round, nor could it bear / The poison that was enter'd there." –ABRAHAM COWLEY, 1618–1667> **love at first text message** \'lƏv-ət-'fərst-tekst-'mes-əj\ *n* a telecommunications phenomenon that occurred in 2002 in London, when then 19-year-old David Brown, after a night of drinking with his buddies, dreamed of a phone number and decided the next day to send a text message to it; in so do-

ing he met his future wife, then 17-year-old Michelle Kitson; Brown asked in his message, "Did I meet you last night?" to which Kitson replied, "Who are you and where are you from?"; after they agreed to meet, they began dating and were married 5 years later **love handles** \ˈləv-ˈhan-dᵊlz\ *n* **a :** fatty bulges that appear on either side of a man's midsection as he approaches middle age, which are there to be grabbed

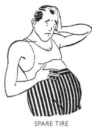

SPARE TIRE

by a partner to prevent neck or sacral injury during a wild ride in the sack **b :** not to be confused with a spare tire, which describes fat that extends all around the abdomen <see *MUFFIN TOP*> **love letter** \ˈləv-ˈle-tər\ *n* **a :** throughout history a popular way for

TYPES OF LOVE

agape unconditional, spiritual, selfless

courtly love romantic, idealized, ennobling

erotic full of sexual desire, passionate

familial sharing a common ancestry, selfless, emotionally filling, reciprocal

free love not married or legally bound to another

ludus love as a game of conquest, unserious

mania low self-esteem, needy, jealous, possessive

philia friendly, affable, loyal, self-serving

platonic restrained, idealized, non-reciprocal

pragma practical, commonsensical, compatible

puppy love adolescent crush

religious devotion to one's deity or theology

romantic love emotional and sexual, a special love between 2 people

storge friendly, committed, little passion or sex

tough love disciplinary, expressing care and concern

unconditional absolute, unqualified love regardless of a person's actions or beliefs

unrequited deeply desired, nonreciprocal

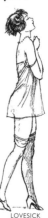

LOVE LETTER

lovers to express their deepest thoughts for one another <*as in* "When your glances dart like arrows from the bow of your eyebrows, millions of hearts are wounded." –ABBAS MIRZA, 1789-1883, crown prince of Persia, in a love letter to a lady friend> **b :** the first known love letters date back some 4,000 years to ancient Sumer <*as in* "My precious caresses are sweeter than honey. Come my bridegroom and let me caress you.">; written on clay tablets, these cuneiform documents are on display at the Istanbul Archaeological Museum in Turkey – called also *billet-doux* [French *sweet letter*] – see *ABELARD AND HELOISE, (THE) BROWNINGS* **lovemaps** \'ləv-'maps\ *n* a term coined by controversial sex researcher John Money (1921-2006) that defines a set of love attachment predispositions, or neurological love templates, that are developed in one's early youth and that could account for certain sexual requests one may make of his or her partner <*as in* "Mommy, I was very, very bad today."> **lover's leap** \'lə-vərz-'lēp\ *n* **a :** *(singular)* a high cliff overlooking a riv-er or ravine where a spurned lover may go to end his or her sorrow <*as in* "Not much you can do when the feeling is gone." –NEIL DIAMOND, "Love on the Rocks"> **b :** *(plural)* a place where 2 lovers who wish to be together in death because they can't be together in life due to family objections or laws preventing their union can go to jump hand in hand **c :** most leaps were named in honor of a mythical lovesick Indian brave or maid or both, which some scholars suggest came from the American desire to romanticize the noble red man in return for taking his land <"Thus they stood a single moment / On that rocky, towering heap; / Then, they named the place forever – / As they made the Lover's Leap." –JESSE EDWARD GRINSTEAD, 1866-1948> **lovesick** \'ləv-'sik\ *adj* a condition of physiological imbalance whose obvious cause <*as in* the dancer who just moved in down the hall> can often go undetected and whose symptoms include sweaty palms, increased heart rate, decreased appetite, and an all-over, achy, flulike countenance **lovesickness** \'ləv-'sik-nəs\ *n* a condition

LOVESICK

diagnosed by Ethel Merman in the 1950 Broadway show *Call Me Madam*: "There is nothing you can take to relieve that pleasant ache; you're not sick, you're just in love." –IRVING BERLIN **Love Story** \'ləv-'stȯr-ē\ *n* 1970 film (*dir* Arthur Hiller) based on Erich Segal's best-selling novel, in which Ryan O'Neal plays Oliver Bar-

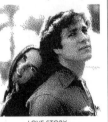

LOVE STORY

rett IV, a rich Harvard preppie, who falls in love with a poor but brilliant Radcliffe girl named Jenny Cavilleri, played by Ali MacGraw, who loves Mozart, Bach, the Beatles, and Oliver, too (though not at first) and who dies at the young age of 25, prompting O'Neal to end the film by telling his stodgy old father, "Love means never having to say you're sorry." *note* voted by the American Film Institute as the ninth most romantic movie ever made **love survey** \'ləv-sər-'vā\ *n* a questionnaire distributed by the Institute of Human Thermodynamics in Chicago, which asked 250 everyday people what the word *love* most meant to them, to which they re-

plied: *life* <*as in* someone or something for which one would give his or her life>, *care* <*as in* someone or something about which one cares more than oneself>, *friendship* <*as in* one's favored interpersonal associations or relationships>, *union* <*as in* a synergistic connection, or the perfect union of 2 souls>, and *family* <*as in* people who are related via common ancestry, religion, or race>

lovotomy \lə-'vȯ-tə-mē\ *n* a psychological phenomenon in which someone is suddenly over the breakup of a relationship <"When our eyes met at the Jiffy Lube, she didn't even recognize me. It's like she's had a *lovotomy*.">

low \'lō\ *adj* a shade of blue; bummed <"She hasn't called, and I'm feeling *low*, man."> **low-hangers** \'lō-'haŋ-ərz\ *n* testicles that dangle lower than average and are shaped like lightbulbs or avocados <*as in* "Big balls in Cowtown, we'll all go down. Big balls in Cowtown, we'll dance around." –GEORGE STRAIT, "Big Balls in Cowtown"> **low-rent** \'lo-'rent\ *adj* used to describe a no-class date <"A guy who keeps Astrolube in his glove compartment is too

low-rent for me."> **low-rider** \'lo-'rī-dər\ *n* a hydraulically pumped car that appears to masturbate at intersections **low-talker** \'lo-'tȯ-kər\ *n* a boyfriend or girlfriend who speaks so softly one doesn't hear what is being said and agrees to do things one shouldn't <*as in* wearing a puffy shirt on the *Today Show* –SEINFELD, Season 5, Episode 66> **low-wattage** \'lo-'wä-tij\ *adj* a term used to describe a lightbulb that casts a soft, flattering glow – compare *DIMMER SWITCH*

lucubrate \,lü-kyə-'brāt\ *vb* to work laboriously at night by candlelight or lantern shine which, be-

LUCUBRATE

cause of the paucity of radiant energy in the room, causes one's pupils to dilate, which is very becoming <"Not tonight, darling, I'm *lucubrating*.">

Lucy and Ricky \'lü-sē-ən(d)-'ri-kē\ *n* **a :** fictional TV characters of the 1950s who were constantly engaging in power struggles that had underpinnings of erotically

LUCY AND RICKY

charged S&M behavior <*as in* "Lucy, come here!" "I don't *wanna*...."> **b :** real-life husband-and-wife stars Lucille Ball and Desi Arnaz, who divorced in 1960 reportedly due to his real-life philandering

lust \'ləst\ *n* **a :** feelings of intense physical yearning that are usu. self-serving in nature <*as in* "As long as she didn't talk, I could do Ann Coulter."> **b :** from a theological standpoint lust began when Adam and Eve were evicted from the Garden of Eden and became conscious of their sexual impulses over which they had no control **c :** from a scientific standpoint lust evolved as a survival technique so that man would want to copulate with whatever came slinking or crawling by

LUST

machete \mə-ˈshe-tē\ *n* a large, heavy knife used for clearing brush, chopping sugarcane, and opening coconuts for girlfriends

machine \mə-ˈshēn\ *n* a person who has long-lasting sexual stamina <"Lord, Meg's a *machine*.">

MACHINE

Madame Bovary \mə-ˈdam-ˈbo-və-rē\ *n* Gustave Flaubert's erotic masterpiece about a farmer's daughter who after finding herself in a dull marriage with a provincial doctor shocks the locals <see *PEYTON PLACE*> by having a passionate affair with a philandering aristocrat, with whom she gets it on while traveling in her coach <see *MILE-HIGH CLUB*>; after the novel was serialized in *La Revue de Paris* in 1856, Flaubert was attacked by public prosecutors for obscenity but acquitted

GUSTAVE FLAUBERT

madness \ˈmad-nəs\ *n* the unexplainable fooling around or leaving a marriage partner that some people are capable of even

169

when they are in a wonderful or committed relationship; such behavior puts them at risk of losing their character, friends, job, health, happiness, and kids *syn* dumb fuck

magic hour \'ma-jik-'aὐ(-ə)r\ *n* a filmmaker's term to describe the time between sundown and dark when the light is warm, the sky deep blue, the shadows long, and one's lover is ready for his or her close-up

MAGIC HOUR

maintenance
\'mānt-nən(t)s\
n the upkeep
of a relationship

MAINTENANCE

high-maintenance \'hī-'mānt-nən(t)s\ *adj* a lover, partner, or spouse who is demanding, self-centered, and complicated **low-maintenance** \'lō-'mānt-nən(t)s\ *adj* opposite of high-maintenance <*as in* keeper> **dose maintenance** \'dōs-mānt-nən(t)s\ *n* appropriate medication levels for high-maintenance lovers

make-up sex \'māk-'əp-'seks\ *n* passionate lovemaking that follows a heated argument between lovers and requires little if any foreplay as the couple's blood is already boiling and their hearts pounding

mancation \'man-'kā-sheñ\ *n* a testosterone-filled vacation where men get together with their buddies for a few days of fun and where no wives or girlfriends are allowed

man crush \'man-'krəsh\ *n* a seemingly nonsexual, adolescentlike crush that a heterosexual adult male can have on another male but not know it <"It would be so cool to hang out with Bill Clinton and listen to some Elvis." "Frank, you have a *man crush*.">

mango \'maŋ-(ˌ)gō\ *n* **a :** a delicate fruit (genus *Mangifera*) that is originally from India and is known for its tough red-and-yellow skin, enormous seed, and exceedingly juicy and exotically sweet golden-orange flesh **b :** in the Hindu *Vedas*, mangos are called the "fruit of the gods" and because of their large size (up to 4 lbs.) and smooth texture are sometimes known as *huevos de toro* [Spanish *bull's balls*] **Mango** *n* sexually ambiguous stripper played by Chris Kattan on *Saturday Night Live*, who proved irresistible to anyone who met him <"Oh, to be *Mango*! Why to be me?!"> **sucking a mango fruit** \'sə-kiŋ-ā-'maŋ-(ˌ)gō-'früt\ *vb* a sexual act adapted from the *Kama Sutra* that involves the vigorous sucking of a penis

MANGO

manscaping \'man-skā-piŋ\ *vb* trimming of the male pubic region <"Dakota suggested I do some *manscaping*.">

man's shirt \'manz-'shərt\ *n* a sexy, oversized, gender-bending garment that a woman wears after making love to her husband or boyfriend

MAN'S SHIRT

maple syrup \'mā-pəl-'sər-əp\ *n* a deliriously rich syrup that is made by partially boiling down the sap of the maple tree and that on Sunday mornings couples pour over pancakes, waffles, and French toast – see *FLAPJACK* **maple tree** \'mā-pəl-'trē\ *n* a large deciduous tree (genus *Acer*) that is abundant in New England and whose leaves in the autumn turn phantasmagorical shades of red, yellow, orange, and gold; every fall, thousands of leaf-peeping lovers go to see their magic

MAPLE TREE

marbles \'mär-bəlz\ *n* a term for a closeted lesbian woman who is married to a man *as in* **mar**(ried) **b**(ut) **les**(bian)

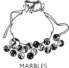
MARBLES

march \'märch\ *vb* to move along steadily *as in* down the aisle to get married **March** *n* the bipolar 3rd month of the Gregorian calendar, which comes in like a lion and goes out like a lamb; named for Mars, the Roman god of war, yet ushers in the 1st day of spring <"With rushing winds and gloomy skies/The dark and stubborn winter dies/Far-off, unseen, Spring

faintly cries / Bidding her earliest child arise / *March!*" –Bayard Taylor, 1825–1878>; celebrates St. Patrick's Day (17th), in honor of the saint who drove all the snakes out of Ireland **wedding march** \ 'we-diŋ-'march\ – see *RICHARD WAGNER*

marriage \'mer-ij\ *n* **a :** the future tense of engaged **b :** a social and legal decision in which 2 people decide to live together as man and wife, which provides an opportunity for a couple to pass on their DNA, have someone to eat with, not have to look their best for, share their finances with, and make love to and is a universal cultural phenomenon that's practiced by 90% of American adults **marriage, my ex, kids** \'mer-ij-'mī-('eks-'kidz\ *n* the top 3 topics not to be discussed on a first date

Martin, Dean \'mär-tᵊn-'dēn\ (1917–1995, né Dino Paul Crocetti) crooner, actor, TV star with his own variety show, nightclub attraction, and "Roast" host, Martin's "don't DEAN MARTIN worry, be happy" public persona was as smooth as a dry martini, of which his last name was only 1 letter shy; after breaking up with Jerry Lewis (of Martin & Lewis fame), he made an art form out of playing a bewildered, womanizing drunk but one that even the most ardent of feminists had to love: cool, hip, and retro to the max

martini \mär-'tē-nē\ *n* **a :** the world's most loved cocktail **b :** a potent combination of

MARRIAGE

172

MARTINI

either gin or vodka and a splash of vermouth served with either an olive or a twist of lemon in an iconic glass; connoisseurs are exacting as to how the drink should be mixed, and although Ian Fleming's James Bond insisted it should be "shaken, not stirred," Somerset Maugham claimed it "should always be stirred, not shaken" - compare *GIBSON*

mask \\'mask\\ *n* a false, distorted, or idealized image that lovers project upon one another when

MASK

they're dating and that often falls away at the 3-month point in the relationship, revealing their true personas <*as in* "What was I thinking?">

Massachusetts \\ˌma-sə-'chü-səts\\ *n* U.S. state (pop. 6,500,000) with the lowest divorce rate in the nation and the 1st to legalize same-sex marriages

massage \\mə-'säzh\\ *vb* the act of kneading the body to relax muscles and relieve tension, which releases feel-good oxytocins and when done by a boyfriend or girlfriend can often lead to sex - see *FOREPLAY*

MARTINI QUOTES

"Why don't you get out of that wet coat and into a dry martini?" –ROBERT BENCHLEY

"You can no more keep a martini in the refrigerator than you can keep a kiss there. The proper union of gin and vermouth is a great and sudden glory; it is one of the happiest marriages on earth and one of the shortest lived." –BERNARD DeVOTO

"I like to have a Martini / Two at the very most / After three I'm under the table / After four I'm under my host." –DOROTHY PARKER

"One martini is all right. Two are too many, and three are not enough." –JAMES THURBER

"I am prepared to believe that a dry martini slightly impairs the palate, but think what it does for the soul." –ALEC WAUGH

masturbation \‚mas-tər-'bā-shən\ *n* **a** : nature's way of allowing one to achieve sexual satisfaction by stimulating one's own genitals in lieu of finding a date <"There's one thing to be said about *masturbation*; you certainly don't have to look your best." –MART CROWLEY, *The Boys in the Band*> **b** : although masturbation is practiced by both men and women <see *CANDLE, SHERE HITE, ALFRED CHARLES KINSEY, TOYS*>, most of its synonyms refer to males

Match.com \'mach-dät-käm\ *n* the world's largest on-line dating service, started in San Francisco in 1995 and listed in the *Guinness Book of World Records* as having more than 42 million registered singles, which is the combined populations of California and New Jersey <*as in* "All the lonely people, where do they all come from?" –THE BEATLES, "Eleanor Rigby">

mate poaching \'māt-'pōch-iŋ\ *vb* **a** : the act of stealing another's boyfriend or girlfriend <"Some friend you are, *mate poacher*!"> **b** : mate poaching was brought to the public's attention by psychology professor David P. Schmitt of Bradley University in Peoria, Illinois, who wrote the article (with David M. Buss), "Human Mate Poaching: Tactics and Temptations for Infiltrating Existing Mateships," that appeared in the *Journal of Personality and Social Psychology*" (summer 2001); in a study of 236

••

MASTURBATION SYNONYMS

Beating the dummy

Beating the meat

Choking the chicken (or gopher)

Dancing with myself

Five-knuckle chuckle

Flogging the dog (or log)

Flogging the poodle

Ham-boning

Jacking off

Jerking (off)

Knob-polishing

Knowing thyself

Peeling the eel (Canadian)

Pounding off

Pounding the pudding

Pulling the pud

Rubbing the magic lantern

Strumming the banjo

Wanking (off)

Whacking off

Whacking the doodle

••

MATE POACHING

Bradley students, 50% admitted to having stolen a partner from another person and 80% said that someone had tried to steal their partner: "Approximately one-fifth of existing romantic relationships are the result of a previous poach," according to Smith, who found a man is more likely to poach a woman for her looks, while a woman is more likely to poach a man for his resources and emotional support

matter \'ma-tər\ *n* **1 :** an approximate amount <"I know she'll come back. It's just a *matter* of time."> **2 :** something of importance <"On this Valentine's Day I knew what grown-up love was, or at least I knew one of the things love does. It tells us what *matters*." –RONALD K. FRIED, "The Day the House Blew Up," *The New York Times* **3 :** the reason for a lover's distress <"C'mon, tell me what's the *matter* with you babe. Baby, what's the *matter* now?" –DIRE STRAITS, "What's the Matter Baby?">

May \'mā\ *n* the 5th month of the Gregorian calendar, whose 1st week marks the official beginning of the summer movie season and whose last week gives the all-clear to wearing white, especially when it comes to wedding gowns – see *JUNE*

MOVIES

maybe \'mā-bē\ *adv* an answer that is neither a yes nor a no, which can put one in a state of romantic uncertainty <"Will you marry me?" "*Maybe*."> and suggest ominous possibilities <"*Maybe* we should start seeing other people."> – see *LIMBO*

maybe baby \'mā-bē-'bā-bē\ popular rhyme in love songs <"*Maybe baby*, I'll have you. *Maybe baby*, you'll be true." –BUDDY HOLLY, "Maybe Baby">

maze \'māz\ *n* **1** : a confusing labyrinth that one must carefully navigate *such as* a singles' bar on a weekend night **2** : an outdoor

game in which lovers try not to get lost as they traverse their way on foot through a complicated, puzzling route lined with

MAZE

hedgerows or cornstalks, the novelty of which can trigger feelings of attachment between them

Mediterranean Sea \ˌme-də-tə-ˈrā-nē-ən-ˈsē\ *n* the world's largest inland sea (970,000 sq. mi.), which lies between Asia, Africa, and Europe and whose warm year-round water and air temperatures enable females to go topless on many beaches and aboard yachts owned by Greek tycoons and French playboys

MEDITERRANEAN SEA

mee-ow! \ˈmē-ˈaů\ *interj* said after someone makes a catty or mean remark about another person <"Tracy looks great for someone who's had no work." *"Mee-ow!"*>

MEE-OW!

mensch \ˈmen(t)sh\ *n* [Yiddish] a good person; a stand-up guy <"The second date, and Quantiko takes me home to meet his mom. Such a *mensch*.">

men's tank \ˈmənz-ˈtaŋk\ *n* a classic, white sleeveless T-shirt that is worn by a man in the summertime, either under a dress shirt or as outerwear around the house, and that gives him toned, Paul Newman pecs <*as in Cat on a Hot Tin Roof* and *Harper*> *var* muscle-T

mental case \ˈmen-tᵊl-ˈkās\ *n* what someone who has finally broken off a relationship with a difficult person calls that person 6 months down the road <"What did I see in that *mental case*?">

men who cook \ˈmən-ˈhü-ˈkůk\ *n* a confident breed of the male species commonplace in Europe and parts of South America and

176

also in certain U.S. cities *such as* New York, San Francisco, and New Orleans; they know how to get a woman excited by making kitchen sounds *such as* a butcher's knife chopping herbs on a wooden board, a peppered steak hitting a hot frying pan, or a blender puréeing basil leaves for a pesto sauce <*as in* "Any poor schlub can take a woman to a swanky restaurant and slap down his credit card. If you really want to impress a woman, you should cook for her." –CANDY SAGON, *Washington Post*> – see APRON

meringue \mə-'raŋ\ *n* a piece of flashy jewelry <"Star needs a sugar daddy to keep her in *meringue*."> **syns** bling, ice **wang meringue** \'wäŋ-mə-'raŋ\ *n* [vulgar] a term for semen

MERINGUE

metaphysical exploration \'mā-tä-'fi-zi-kəl-,ek-splə-'rä-shən\ *n* sexual intercourse between tenured university professors, philosophers, Mensa members, or similar highbrows <"...in sex one also can engage in *metaphysical exploration*, knowing the body and person of another as a map or microcosm of the very deepest reality, a clue to its nature and purpose." –ROBERT NOZICK, author, *The Examined Life*>

meter maid \'mē-tər-mād\ *n* a woman who harbors no personal agenda as she puts tickets on windshields of cars belonging to people who are trying to have a leisurely, romantic lunch

metrosexual \'me-(,)trō-'sek-sh(ə-)wəl\ *n* a guy who is so in love with his superficial self that he risks societal ostracism by putting highlights in his hair, makeup on his face, or cotton balls between his toes – see KEN DOLL

mile-high club \'mī(-ə)l-'hī-'kləb\ *n* a non-dues-paying club that an airline passenger becomes an automatic member of after having sex on an airplane with a person other than himself or herself, which usu. takes place in the restroom – see COCKPIT, FLIGHT ATTENDANT

Milky Way \'mil-kē-'wā\ *n* **1 :** a belt of starlight in the night sky that lovers have been gazing up at since time be-

MILKY WAY

gan **2** : a nougat-filled candy bar that was created in 1923 and is called a Mars Bar outside of the U.S.

Miller, Glenn \\'mi-lər-'glen\\ (1904–1944) U.S. bandleader and trombonist whose theme song was "Moonlight Serenade" and who in 1939 recorded the world's most irresistible dance song, "In the Mood," whose up-tempo swing rhythm still pulls couples out onto the dance floor

mimosa \\mə-'mō-sə\\ *n* **1** : any of a number of plants, shrubs, or trees belonging to the legume family that can be found growing in parks and whose small flowers do their part in bringing lovers closer together by emitting an intoxicating aroma **2** : a brunch cocktail consisting of 3 oz. chilled champagne and 3 oz. freshly squeezed orange juice

mirror \\'mir-ər\\ *n* a smooth surface made of glass that one looks in before going on a date to check for zits and aberrant hairs **mirroring** \\'mir-ə-riŋ\\ *vb* a synchronization of

MIRROR

body movements, voice inflections, and thinking that occurs between lovers over a period of time <*as in* "Your mom and I think that....">

missed connections \\'misd-kə-'nek-shənz\\ *n* a postings section on Craigslist where frustrated people can attempt to connect with someone they recently found attractive and wanted to meet but let their golden chance pass them by <*as in* "To attractive woman in black VW on Mass Pike, Copley exit, me in dark blue SUV, app. 7:30 a.m., our eyes met, wanna chat?">

Miss Otis \\'mis-'ō-təs\\ *n* the properly mannered heroine of Cole Porter's 1934 song "Miss Otis Regrets" who, as she's about to be hanged by an angry mob for shooting her lover dead, gives her regrets that "she's unable to lunch today, madam."

COLE PORTER

moment \\'mō-mənt\\ *n* an indefinitely short period of time that lovers and romantics try to hold on to <"Let's make this *moment*

178

last a lifetime."> **Moments to Remember** \\'mō-mənts-tə-ri-'mem-bər\ *n* the 1955 hit song by the Four Lads that has served as the theme of countless high school and college proms <*as in* "The New Year's Eve we did the town, the night we tore the goalpost down." –ROBERT ALLEN/AL STILLMAN> **fully present in the moment** \\'fu̇(l)-lē-'pre-zᵊnt-'in-t͟hə-'mō-mənt\ *adj* a term used by sex therapists to encourage one to stay awake during sex

money \\'mə-nē\ **1 :** *n* **a :** a medium of exchange that can make ordinary-looking people who have lots of it appear better-looking <*such as* Barry Diller, Aristotle Onassis, Donald Trump> **b :** money can provide one with admiring friends and young lovers but it is no guarantee that one will be loved or even happy <*as in* "You are loved for something else when what you are loved for is a peripheral part of your own self-image or identity." –ROBERT NOZICK, author, *The Examined Life* **2 :** *adj* good or beneficial <"Noah's new girl is *money*.">

monogamy \\mä-nə-'ga-mē\ *n* an until-death-do-us-part pair bonding that is practiced by 3% of the 4,000 mammal species on Earth and that humans swear to when they get married but often forget when they meet an irresistible force <"Bigamy is having one wife too many. *Monogamy* is the same." –OSCAR WILDE, 1854-1900> - see *DISSOLUTION, MONOGAMOUS MATES p. 180*

Monroe, Marilyn \mən-'rō-'mer-ə-lən\ (1926-1962, née Norma Jean Baker) **a :** the world's sexiest female Hollywood star who was adored by both male and female audiences and whose luminous presence and heartfelt vulnerability have never been equaled **b :** of whom Nunnally Johnson, producer of her 1953 film *How to Marry a Millionaire*, said: "Marilyn's a phenomenon of nature, like Niagara Falls and the Grand Canyon. All you can do is stand back and be awed by it."

MARILYN MONROE

moon \\'mün\ *n* **a :** Earth's natural satellite that softly lights the sky and has blessed lovers since the beginning of time **b :** for poets and lyricists, "moon" conveniently

rhymes with "June" <"Honey*moon*, keep a-shinin' in June." –EDWARD MADDEN/GUS EDWARDS, "By the Light of the Silvery Moon"> **blue moon** \'blü-'mün\ *n* the phenomenon wherein a full moon occurs twice in the same calendar month and inspiration for one of the most popular songs

MOON

ever written <"*Blue moon*, now I'm no longer alone, without a dream in my heart, without a love of my own."–LORENZ HART/RICHARD RODGERS, "Blue Moon"> **full moon** \'fül-'mün\ *n* **a :** a lunar phase that occurs every 27.3 days, when the moon's surface is fully illuminated by the sun, causing it to appear big and round **b :** a time when lovers like to take romantic strolls but are wise to avoid foggy bogs and graveyards **c :** an exposing of the buttocks for shock effect **Moondance** \'mün-'dan(t)s\ *n* 1970 hit song by Van Morrison that includes the adjective "fantabulous" **Moonstruck** \'mün-₁strək\ *n* 1987 urban fairy tale directed by Norman Jewison that is set in Brooklyn and whose female stars, Cher and Olympia Dukakis, won Oscars for and whose dialog by John Patrick Stanley is full of cunningly poignant observations about love

MOONSTRUCK

MONOGAMOUS MATES

Anglerfish
Bald eagles
Barn owls
Beavers
Black vultures
Condors
Coyotes
French angel fish
Geese
Golden eagles
Gray wolves
Gibbon apes
Ospreys
Prairie voles
Pigeons
Red-tailed hawks
Sandhill cranes
Swans
Termites

ANGLERFISH

COYOTES

GOLDEN EAGLE

Nicolas Cage to Cher: "But love don't make things nice. It ruins everything. It breaks your heart. It makes things a mess. We aren't here to make things perfect. The snowflake is perfect. The stars are perfect. Not us. Not us. We are here to ruin ourselves and to break our hearts and love the wrong people and die."

Olympia Dukakis to John Mahoney on why men chase women: "I think it's because they fear death."

Cage to Cher: "I'm in love with you." Cher to Cage: "Snap out of it!"

mosquito \mə-'skē-(,)tō\ *n* a member of the Culcidae family

MOSQUITO

of flies, whose females have a long proboscis that enables them to suck the blood of lovers who are trying to enjoy canoe rides at eventide and moonlit walks down country lanes and which are going to breed more extensively due to global warming

mosquito bite \mə-'skē-(,)to-'bīt\ *n* a small annoyance that one shouldn't be bothered by <"I'm so hurt that Porter forgot our four-and-a-half-month anniversary." "Get over it. It's a *mosquito bite*.">

mother-in-law \'mə-thər-'in-'lȯ\ *n* the wife's mother and the butt of jokes since marriage began

"Did you know it's illegal to marry your mother-in-law?" "I didn't, but talk about useless legislation."

The punishment for bigamy is two mothers-in-law.

"What would you do if you found out you had a month to live?" "I'd take my mother-in-law on a cross-country trip, stopping at every Motel 6." "Why would you do that?" "It would be the longest four weeks of my life."

motor trip \'mō-tər-'trip\ *n* an excursion during which lovers escape together for a temporary period of time by getting in a car and driving on highways with no more than 2 lanes, eating at restaurants where

181

MOTOR TRIP

they can twirl on stools, and staying in motels or cabins they haven't booked in advance <"I like potato chips, moonlight, and *motor trips*, how about you?" –Burton Lane/Ralph Freed, "How About You?">

Motown sound \\'mō-taůn-'saůnd\\ *n* **a :** an upbeat, gospel-influenced, rhythm-and-blues style of music that dominated the 1960s and that came out of Detroit, Michigan, under the guidance of songwriter-entrepreneur Berry Gordy, Jr. **b :** had every teen in America dancing, falling in like, and pledging their love forever to hits *such as* "My Guy," "Please Mr. Postman," "The Locomotion," "Ain't No Mountain High Enough," "I Heard It Through the Grapevine," "Ain't Nothing Like the Real Thing," and "How Sweet It Is" **c :** legendary performers include Mary Wells, Diana Ross and the Supremes, Marvin Gaye, Stevie Wonder, Smokey Robinson, and the Jackson 5

DIANA ROSS AND THE SUPREMES

mouse potato \\'maůs-pə-'tā-(ˌ)tō\\ *n* a person whose whole social life occurs while he or she is on-line

mouth \\'maůth\\ *n* an oval cavity of the face that's bounded by the lips and contains the gums, teeth, and tongue and is used for biting, blowing, eating, kissing, masticating, and sucking

Mrs. Robinson \\'mi-sez-'rä-bən-sən\\ *n* the sexually rapacious mother-of-the-bride

who has the hots for her future son-in-law in *The Graduate* (1967, *dir* Mike Nichols) <"*Mrs. Robinson*, you're trying to seduce me." –Dustin Hoffman to Anne Bancroft> – see *COUGAR*

muffin \'məf-ən\ *n* **a :** an endearing name for one's sweetheart <"Awww, is *muffin* still mad?"> **b :** a woman's vagina <"She wouldn't be so uptight if she'd just get her *muffin* buttered more often."> **muffin top** \'məf-ən-'täp\ *n* the exposed flesh that plus-size persons display when wearing low-rider jeans or hip huggers

multiple orgasm \'məl-tə-pəl-'ȯr-ˌga-zəm\ *n* **a :** the ability to experience orgasm 3 times in a row, a skill that 15% of adult females are capable of, according to the Kinsey report "Sexual Behavior in the Human Female" **b :** although few men are capable of multiple orgasm, they have the compensatory ability to urinate standing up

mushroom \'məsh-ˌrüm\ *n* **1 :** a fleshy fungus that comes in a variety of colors, sizes, and shapes and is considered to have healing and aphrodisiacal qualities **2 :** the head of an uncircumcised penis <"Larry has a beautiful *mushroom*."> **cream of mushroom soup** \'krēm-əv-'məsh-ˌrüm-'süp\ *n* a rich, flavorful soup used to make hearty, comfort-food dishes that men love *such as* casseroles and savory potpies

mustang \'məs-ˌtaŋ\ *n* a feral horse of the American plains descended from horses brought by the Spaniards **Mustang** *n* a roadster wannabe manufactured by the Ford Motor Company and introduced to the world in 1964; number 1 car in most boomers' hearts **Mustang Ranch** \'məs-ˌtaŋ-'ranch\ *n* **a :** Nevada's first brothel, licensed in 1971, and located 8 miles E of Reno **b :** forbidden sexual acts included anal intercourse and mouth kissing **c :** closed in 1999 for tax fraud and racketeering **d :** the buildings have been razed, and the property is being transformed into parkland, where lovers can stroll free

mystery \'mis-t(ə-)rē\ *n* something that is not fully known or explained about a person and that keeps a date or potential lover excited, wanting to know more <*as in* "...like a good book I can't wait to finish and have to take to bed." –Cy Coleman/ Carolyn Leigh, "You Fascinate Me So">

nacho \\'nä-(ˌ)chō\\ *n* a crisp tortilla chip topped with melted cheddar cheese and chopped chili peppers that is used as man-bait and left in front of the TV set during a sporting event – see *BUTTERSCOTCH BLOND-IE*, *CHIPS AND SALSA* **nachos** \\'nä-(ˌ)chōz\\ *n* [slang] esp. attractive breasts <"Check out those *nachos*.">

nap \\'nap\\ *n* a short period of dozing off that lovers experience together on afternoons, when they snuggle and hold each other but usu. don't have sex **naptrap** \\'nap-'trap\\ *n* roadside rest area for overheated lovers

power nap \\'paů(ə)r-'nap\\ *n* a snooze lasting 15–20 mins. that a person who has a date that night takes in his or her office or cubicle (usu. sitting upright in a chair) so that he or she can stay up late

nape \\'nāp\\ *n* the back of the neck, which is very sensitive to soft kisses, being blown on, licked, stroked, or lightly massaged – see *PARESTHESIA*

NAPE

narcissism \\'när-ˌsə-ˌsə-zəm\\ *n* **a :** self-love **b :** derived from the Greek myth of Narcis-

NARCISSUS

sus who, as a punishment for spurning the advances of the nymph Echo, was doomed to fall in love with his own reflection in a pool of water and eventually was transformed into the flower called narcissus **narcissist** \'när-sə-sist\ *n* a boyfriend, girlfriend, or significant other who thinks everything's about them **narcissistic personality disorder** \,när-sə-'sis-tik-,per-sə-,na-lə-tē-(,)dis-'ôr-dər\ *n* a psychological condition identified by Freud as a failure to grow up, which makes a person a demanding, attention-starved brat <*as in* ex-boyfriend, ex-girlfriend, ex-lover, ex-husband, ex-wife> – called also *NPD*

Nashville \'nash-,vil\ *n* the capital of Tennessee and since 1925 the home of country music **Nashville sound** \'nash-,vil-'saùnd\ *n* a stylized, more sophisticated form of country music that began in the late 1950s and chronicles the complicated love lives of ordinary, hard-working folk; made crossover stars out of Eddy Arnold, Johnny Cash, Roy Orbison, Jim Reeves, Marty Robbins, and Dottie West – see *PATSY CLINE*

nasty \'nas-tē\ *adj* someone who is sexually hot <"Jewel has a *nasty* body."> **(The) Nasty** \thə-'nas-tē\ *n* the sex act <"Mrs. Jensen caught us doing *The Nasty*."> **nasty-arsed** \'nas-tē-'ärst\ *adj* a cruel boyfriend or girlfriend <"Just because I hate men doesn't make me a *nasty-arsed* bitch."> **get nasty** \'get-'nas-tē\ *vb* to throw some kink into the action – see *SHAGNASTY*

NASTY

National Geographic \'nash-nəl-,jē-ə-'gra-fik\ *n* a magazine that has been published by the National Geographic Society since 1888 and has made many a breast man out of a young boy

national parks \'nash-nəl-'pärks\ *n* **a** : 58 areas of spectacular beauty, wilderness, and historical importance that were set aside throughout the U.S. so that lovers had somewhere to go when told to chill, get out of town, get lost, jump off a cliff, or take a hike **b** : the first park was Yellowstone (1872), where lovers can find Old Faithful **c** : since 1916 the parks have been managed by the National Park Service

Nefertiti \\'ne-ˌfər-'tē-ˌtē\\ Egyptian queen of the 18th dynasty, whose name means "the beauty that has come" and who is remembered in history for her perfectly proportioned bust, which is on display at the Altes Museum in Berlin

nekkid \\'ne-kəd\\ *adj* [Southern] wearing no clothes <"No sooner I walk in the door when Austin says, 'Hot dang, Shirl, let's get *nekkid*.'">

nene \\'nā-(ˌ)nā\\ *n* **a :** the state bird of Hawaii that forms lifelong pairs and sometimes trios with other males or females **b :** smaller than Canada geese, they can live up to 32 years of age **c :** males and females have identical plumage – called also *Hawaiian goose*

Neruda, Pablo \\ˌnā-'rü-dä-'pä-blō\\ (1904–1973) penname of Chilean Nobel prize-winning poet and Communist whose most famous volume of romantic verse *(Twenty Poems of Love and a Song of Despair)* chronicles a doomed love affair and includes lines *such as* "I am no longer in love with her, that's certain, but maybe I love her," and "Love is so short, forgetting so long."

NESTING

nesting \\'nes-tiŋ\\ *vb* **1 :** a trend in which couples strive to make their homes comfortable and cozy so they can stay in on weekends, have dinner together, watch TV and eat popcorn, and go to bed early **2 :** a euphemism for having no money to go out <"Go to Nobu without us. We're *nesting*.">

netspeak \\'net-ˌspēk\\ *n* a shorthand lingo used by people looking for love via the Internet – see *NETSPEAK LINGO pp. 188–189*

neuropeptides \\ˌnùr-ə-'pep-ˌtīdz\\ *n* feel-good compounds *such as* dopamine, serotonin, and adrenaline that are formed of amino acids and released when one is having sex <"Don't nod off now, Louise. The *neuropeptides* just kicked in!">

Nevada \\nə-'va-də\\ *n* W state in which 67% of women report reaching orgasm and not faking it every time they have sex with a man ***source*** *Men's Fitness* "Sex in the U.S.A." study – see *LAS VEGAS*

never \'ne-vər\ *adv* not ever; said by every person who has ever fallen in love <"I *never* thought this would happen to me.">

New Deal \'nü-'dēl\ *n* a federal economic recovery program begun by President Franklin D. Roosevelt in 1933 that included Social Security benefits so that in their golden years retired widows and widowers could have enough money to go on cruises and meet each other

newel post \'nü-əl-'pōst\ *n* a sturdy post that supports a handrail and is used for grabbing while taking a deep breath before charging up the stairs to be with one's lover in the bedroom, or boudoir

NEWEL POST

Newman, Paul \'nü-mən-'pól\ (b. 1925) Oscar-winning movie star and humanitarian with chiseled good looks and Technicolor

NETSPEAK LINGO

Bareback = sex without condoms
BB = bodybuilder
BBW = big beautiful woman
BC = black cock
Bicurious = straight male or female
 wanting to try gay sex
BDSM = bondage discipline or
 domination/sadisim/masochism
BiWM = bisexual white male
BJ = blowjob
CD = cross-dresser
CE = casual encounter
D/DF = drug/disease free
Dom = dominant
DTE = down to earth
DWF = divorced white female

FB = fuck buddy
Generous = looking to be paid
Friends with benefits (FWB) = friends
 who have sex together
FTM = female to male transgender
GHM = gay Hispanic male
Golden shower (GS) = water sports
Het = heterosexual
Host = can meet at one's home
HWP = height-weight proportionate
ISO = in search of
LTR = long term relationship
Must travel = can't meet at one's home
MBM = married black male
MHC = married Hispanic couple
M4CD = man for cross-dresser
M4M = man for man

blue eyes who has been married to another Oscar winner, Joanne Woodward, since 1958 – see *MEN'S TANK*

Niagara \nī-ˈa-g(ə-)rə\ *n* 1953 thriller (*dir* Henry Hathaway) in which Marilyn Monroe's emergence from her honeymoon cabin in a low-cut, tight red dress prompts a male guest to remark, "Hey, get out the fire hose!" **Niagara Falls** \nī-ˈa-g(ə-)rə-ˈfôlz\ *n* a pair of waterfalls, the American Falls

NIAGARA FALLS

and the Canadian Falls (*aka* Horseshoe Falls), located between Lake Erie and Lake Ontario on the U.S.-Canada border,

- -

M4T = male for transvestite
M4W = man for woman
MM4M = male/male couple seeks
 3-way with male
MOTOS = member of the other sex
MW4W = man/woman couple seeks
 3-way with woman
NSA = no strings attached
PNP = party and play
SAF = single Asian female
SF = single female
SJM = single Jewish male
SJPM = single Jewish professional male
SJW = single Jewish woman
SO = significant other
SP = strictly platonic
ST8 = straight

Sub = submissive partner
SWF = single white female
SWNS = sex with no strings
SWPM = single white professional male
Top/Bottom = dominant/passive sex partner
TWG = transsexual with genitalia
T4M = transvestite seeking man
UB2 = you be too
VGL = very good looking
WE = well-endowed
WLTM = would like to meet
WM = white male
W4M = woman seeking man
W4MW = woman seeking man and woman
W4W = woman seeking woman
4-real = not into superficial games
420 = marijuana

- -

whose powerful, surging cascades have long attracted honeymooners <"To *Niagara* in a sleeper, there's no honeymoon that's cheaper." –AL DUBIN/HARRY WARREN, "Shuffle Off to Buffalo">

nice \'nīs\ *adj* **a :** amiable and pleasant; non-argumentative **b :** descriptive of people from Minnesota <"I met a *nice* girl from Bemidji." "That's *nice*."> **Nice** \'nēs\ *n* a resort town in SE France – see *MEDITERRANEAN SEA* **nice as pie** \'nīs-'az-'pī\ *adj* to be sweet to someone to gain his or her favor <"Something's going down. Drake's being *nice as pie* lately.">

night-blooming jasmine \'nīt-'blü-miŋ-'jaz-mən\ *n* a woody, unassuming evergreen *(Cestrum nocturnum)* that grows in S and W portions of the U.S. and that in summer months, after the sun goes down and other plants have folded up their flowers, emits an intense perfume that intoxicates lovers

nightlight \'nit-'lit\ *n* a small, dimly lit light that plugs into a wall socket and that people who don't have anyone to love and protect them turn on before going to bed – see *ROBIN BYRD*

nitric oxide \'nī-trik-'äk-ˌsīd\ *n* **a :** a clear, colorless gas that allows a man to get it up and keep it up **b :** during sexual stimulation, nerves in the penis release nitric oxide, which triggers chemical reactions that cause the penis to fill with blood and become erect; once blood starts flowing into the penis, the source of nitric oxide in the blood vessels is continuously activated so that the more nitric oxide is released, the more tissue relaxes, the more blood comes in, and a sustained erection is achieved; the cycle begins in the brain, when a man thinks erotic thoughts, visits adult Web sites, or experiences certain physical sensations – see *ERECTION*

norepinephrine \'nȯr-ˌe-pə-'ne-frən\ *n* a hormone and neurotransmitter secreted by the adrenal medulla and nerve endings of the sympathetic nervous system that gives lovers energy and causes sleeplessness, loss of appetite, higher blood pressure, and faster breathing <*as in* jacked, turned on, horned up, you're lookin' good hoochie mama>

North Dakota \'nȯrth-də-'kō-tə\ *n* a sparsely populated state in the U.S. Midwest whose

female residents have the nation's highest masturbation rate and whose sex drives go up as they get older **source** *Men's Fitness* "Sex in the U.S.A." study

nose \'nōz\ *n* **a :** a structure of the face that supports one's eyeglasses and serves as a passageway for air into and out of the lungs so that one can smell a woman's perfume or a man's aftershave **b :** a big nose is thought to indicate a large penis

NOSE

••••••••••••••••••••••••••••••••••••••

FAMOUS NOSES

John Barrymore
Cyrano de Bergerac
Adrien Brody
Cleopatra
Gérard Depardieu
Jimmy Durante
King Kong
Laurence Olivier
Pinocchio
Barbra Streisand
Danny Thomas

JIMMY DURANTE

••••••••••••••••••••••••••••••••••••••

nothing \'nə-thiŋ\ *n* **1 :** something that does not exist **2 :** a female's reply that usu. means "plenty" and can signify the onset of a lasting argument that will end with her having the final word <"What's wrong, dear?" "*Nothing.*"> – see *FINE*

novel \'nä-vəl\ **1 :** *adj* used to describe an unusual experience lovers share that creates a unique bond between them and is sometimes forged by fear-induced adrenalin <*as in* skydiving, bungee jumping, dinner at the in-laws'> **2 :** *n* a fictitious prose of considerable length in which 2 people meet, fall in love, and lose each other, only to get back together at the end and have a catered wedding

November \nō-'vem-bər\ *n* **a :** the 11ᵗʰ month of the Gregorian calendar **b :** a gloomy month for poets, who write of its withered trees, sodden pastures, and feelings of impending death, and for songwriters, too, as there are no happy songs about November love <"When I look into your eyes I can see a love restrained, but darlin' when I hold you, don't you know I feel the same. 'Cause nothin' lasts forever and we both know hearts can change, and it's hard to hold a candle in the cold *November* rain." -GUNS N' ROSES, "November Rain">

191

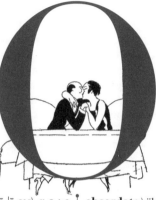

oasis \ō-ˈā-səs\ *n* **a :** a green area in a desert region where in 1974 singer Maria Muldaur sent her camel to bed then proceeded

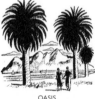
OASIS

to shagnasty with a sheik <*as in* "But you don't need no harem, honey, when I'm by your side, and you won't need no camel, oh no, when I take you for a ride." –DAVID NICHTERN, "Midnight at the Oasis"> **b :** a metaphorical place where lovers go to be alone together <*as in* hot tub, bedroom, corner booth, Best Western>

obcordate \ˌäb-ˈkȯr-ˌdāt\ *adj* heart-shaped

Oberon and Titania \ˈō-bə-ˌrän-ən(d)-tī-ˈtā-nē-ə\ *n* **a :** jealous, promiscuous King and Queen of the Faeries in Shakespeare's *A Midsummer Night's Dream* **b :** after a quarrel, Oberon puts a spell on Titania that causes her to fall madly and passionately in love with an ass

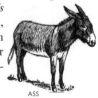
ASS

obstacle \ˈäb-sti-kəl\ *n* an impediment *such as* a large body of water, different social

193

standings, or a spouse that gets in the way of attaining one's object of desire, which only serves to intensify the desire – see *ROMEO AND JULIET EFFECT*

ocean \'ō-shən\ *n* a vast body of salt water that covers nearly ¾ of Earth's surface and can either separate lovers or bring them closer together <*as in* sailing, taking cruises, going to the beach> **oceanfront** \'ō-shən-'frənt\ *adj* a highly desirable location <"All the rooms have *oceanfront* views."> and sexual lure <"You should come with me to Hilton Head – I have an *oceanfront* condo."> **ocean of tears** \'ō-shən-əv-'tirz\ *n* a cathartic flood of saline, the watery fluid secreted by the lacrimal glands after a breakup with one's love

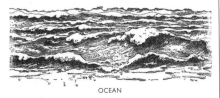

OCEAN

October \äk-'tō-bər\ *n* **a :** the 10th month of the Gregorian calendar, which occurs in what many feel is the most romantic time of year due to its crisp, clean air and brilliantly colored foliage <"There is something in *October* sets the gypsy blood astir." –WILLIAM BLISS CARMAN, 1861–1929> **b :** official start of nesting season <*as in* fireplaces, casseroles, down comforters> **c :** on October 28, 1886, America's most loved woman – the Statue of Liberty – was dedicated by President Grover Cleveland in New York Harbor – see *TORCH SONG*

octopus \'äk-tə-pəs\ *n* a sexually aggressive man found in singles' bars and at parties who is oblivious to women's boundaries and appears to have 8 arms

OCTOPUS

Octopussy \'äk-te-'pu-sē\ *n* the 13th James Bond film (*dir* John Glen) and the 6th to star Roger Moore; involves stolen Fabergé eggs, a plot to destroy the world, and a cult of beautiful babes who have octopuses tattooed on their bottoms

odd couple \'äd-'kəpəl\ *n* a romantic or passionate union that exists between 2 people who appear to be completely mismatched <*as in* "I just don't get it. What in the world

does she [he] see in him [her]?" *as in* James Carville and Mary Matalin, Mel Brooks and Anne Bancroft, Demi Moore and Ashton Kutcher, Kermit the Frog and Miss Piggy, Susan Sontag and Annie Leibovitz>

off \'òf\ *adv* not on; detached <"He's *off* of me," *as in* he's no longer interested; "He turned me *off*," *as in* he did something stupid; "Turn *off* the lights," *as in* going to bed or creating an atmosphere for sex and nudity; "Get *off* of me," *as in* trying to go to sleep> ***ant*** on **Off** *n* a popular insect repellent that lovers spray on themselves when taking romantic walks at dawn or dusk – see *MOSQUITO* **off-and-on** \'òf-ən(d)-'òn\ *adj* a relationship that can't make up its mind **off-shore drilling** \'òf-'shòr-'dri-liŋ\ *vb* adultery <"Susan caught Morey *off-shore drilling* again."> **off the hook** \'òf-thə-'húk\ **1 :** *adj* a lifting of suspicion by a girlfriend or wife usu. for lack of evidence <"OK, you're *off the hook*…for now."> **2 :** [archaic] a pre-caller ID telephone avoidance technique <"She didn't want to talk to him so she left the phone *off the hook*."> **3 :** something unbelievably amazing <"Those Evil Eye ClimaCool's are *off the hook*.">

office \'ä-fəs\ *n* commercial accommodations usu. located downtown or in an office park where one goes to make long-distance phone calls, read the paper, drink coffee, do crosswords, check one's horoscope, have lunch with colleagues, make dinner reservations, surf the Internet, and e-mail one's partner, spouse, or romantic interest **office bike** \'ä-fəs-'bīk\ *n* [Australian slang] a promiscuous female employee who regularly has sex with other employees **office wife** \'ä-fəs-'wīf\

OFFICE WIFE

n a businessman's personal assistant who listens to his problems, laughs at his jokes, and does everything for him that a spouse does, except have sex (usu.)

official \ə-'fi-shəl\ *adj* confirmation of a romantic commitment <"They're seeing each other; it's *official*," or "They're engaged; it's *official*," or "You are now *officially* man and wife.">

O'Keeffe, Georgia \ō-'kēf-'jòr-jə\ (1887–1986) American pioneer of abstract paintings, whose best-known works are her

195

GEORGIA O'KEEFFE

dramatically large, sensual close-ups of flowers, the reproductive parts of which closely resemble those of females; O'Keeffe claimed she was only painting what she saw

old \ˈōld\ *adj* experienced; deep <"He's an *old* soul."> **old age** \ˈōld-ˈāj\ *n* a period of life in which one realizes that Oscar Wilde's observation, "Youth is wasted on the young," was the most brilliant remark ever made **oldie but goodie** \ˈōl-dē-ˈbət-ˈgu̇-dē\ *n* a sexy senior citizen **Old Spice** \ˈōld-spīs\ *n* an aftershave whose smell triggers one's limbic system to evoke barbershops and a square-jawed dad shaving in the bathroom mirror

olive oil \ˈä-liv-ˈȯi(-ə)l\ *n* a flavorful, mono-

OLIVES

unsaturated, heart-healthy oil that is used for cooking, salads, dipping bread into, and rubbing on the bodies of male Turkish athletes who compete in *yağlı güreş* (oil-wrestling competitions), their country's national sport

Olivier, Laurence \ō-ˈli-vē-ˌā-ˈlȯr-ən(t)s\ (1907–1989) classically trained British stage and screen actor whose leading-man looks and countenance made him a Hollywood star and heartthrob and who in his personal life was a better actor than anyone knew; although married to actresses Jill Esmond (1930–1940), Vivien Leigh (1940–1960), and Joan Plowright (1961–1989), it was posthumously revealed (and confirmed by Plowright) that his true love was comic actor Danny Kaye – see *ODD COUPLE*

Olmsted, Frederick Law \ˈōm-ˌsted-ˈfre-drik-ˈlȯ\ (1822–1903) visionary U.S. landscape architect who, to ensure that urban couples would always be able to get back to nature, designed New York's Cen-

FREDERICK LAW OLMSTED

tral Park, Brooklyn's Prospect Park, Chicago's Jackson Park, Montreal's Mount Royal Park, the grounds of the Capitol in Washington, D.C., an extensive system of parks and parkways in Boston and Louisville, and the Niagara Falls Reservation and who was John McLaren's inspiration for San Francisco's Golden Gate Park

om \'ōm\ *n* a mantric Hindu word that a person says before meditating or doing yoga poses or, in a display of passive-aggressive behavior, invokes to tune out a lover <"I can't hear you. *Ommmmmmmm....*">

omelet \'äm-lət\ *n* a sexy breakfast dish containing a mixture of eggs, seasonings, and sometimes a little milk or water and filled with various ingredi-

OMELET

ents *such as* cheese, ham, or mushrooms, which men enjoy whipping up for a girlfriend in the morning as it makes them feel like Gordon Ramsay - compare *POACHED EGGS* - see *APRON, MEN WHO COOK*

Omigod! \'ō-mə-'gäd\ *interj* female expression of surprised joy <"*Omigod!* It's so beautiful," *as in* seeing a girlfriend's engagement ring> *vars* Oh my gawd!, OMG!

omnia vincit amor \'òm-nē-ä-'wiŋ-kit-'ä-,mòr\ [Latin] love conquers all

onanism \'ō-nə-,ni-zəm\ *n* withdrawal of the penis during sexual intercourse so that ejaculation takes place outside of the vagina *syn* [Latin] coitus interruptus - called also *two kids are enough, thank you*

one \'wən\ *adj* special <"She's *one* tasty beverage."> **One** *n* Harry Nilsson song <"*One* is the loneliest number...."> **(The) One** \thē-'wən\ *n* a Mr. or Ms. Right who comes along after a long run of losers <"My heart tells me that Fortuna's *The One*."> **one of a kind** \wən-'əv-'ə-'kīnd\ *adj* unique <"Mona's *one of a kind*."> **one-two punch** \'wən-'tü-'pənch\ *n* sequential blows <*as in* "I'm leaving you for another woman...your sister.">

ONE

oneiric \ō-'nī-rik\ *adj* of or relating to a dream <"Part of *oneiric's* charm is its sonorous similarity to *onanism* (where the reductive intellectual misinterpretation of dreams will lead you), *onerous* (an apt word for a life without a dream), and *oenology* (the study of wine, that great stirrer of dreams).... Wings may let you fly, but *oneiric* wings, like the little ones on Hermes's boots, lift not just the mind and body but the soul and spirit as well. Used carefully,

an *oneiric* modification will lift a leaden thought and instantly lead you somewhere unexpected." –PETER FYFE, playwright>

onion \'ən-yən\ *n* an edible bulb (genus *Allium*) with a pungent flavor that broken-hearted or upset people use to hide their teary feelings <"No, nothing's wrong. I was just chopping an *onion*.">

ONION

on the down low \'òn-<u>th</u>ə-'daùn-'lō\ *n* the act of a closet homosexual male sneaking around to have sex with other men <"She says Skylar's all man, but I swear he's *on the down low*."> – see *BROKEBACKING*

on the rocks \'òn-<u>th</u>ə-'räks\ *adj* **1** : used to describe a relationship that's busted apart <see *LIGHTHOUSE*> **2** : an alcoholic drink served with ice <"Joe, Tamika and I are *on the rocks*. Make that a double, please, and *on the rocks*.">

onto \'òn-tü\ *prep* **a** : used to describe a person who can move quickly from one relationship to another <"She's not even 30 and *onto* her third husband."> **b** : said of a cheating lover <"I'm *onto* Larry.">

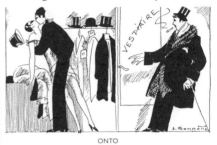

ONTO

oompa-loompa vibe \'üm-'pä-'lüm-'pä-'vīb\ *n* **a** : a creepy feeling a person gets from a stranger, esp. a blind date or someone who is hitting on him or her <"When Paco told me I must never Google him, my *oompa-loompa vibe* went off."> **b** : the vibe is based on the dwarfish Oompa-Loompa factory workers in Roald Dahl's 1964 children's book *Charlie and the Chocolate Factory*

open-mouth kissing \'ō-pən-'maùth-'ki-siŋ\ *n* a type of passionate kiss that has the beneficial side effect of helping young lovers save on dental costs, as the exchange of saliva washes food from the teeth, thereby

reducing the level of acid that causes plaque build-up and tooth decay – see *KINDS OF KISSES pp. 148–151*

opera \\'ä-p(ə-)rə\\ *n* a musical stage work that originated in Florence, Italy, in the 1600s, in which emotions are sung by the highly trained voices of sopranos, mezzos, basses, baritones, and tenors who, when they fall in love, often at first sight, are so blindsided by their lustful feelings that a young warrior can see his 300-lb. lover as a *forma divina* (divine shape) *as in* "Celeste Aida" from Verdi's 1871 opera *Aida*

Opie \\'ō-pē\\ *n* **a :** Sheriff Andy Taylor's tousle-haired, non-precocious son on TV's long-running comedy series *The Andy Griffith Show* (CBS, 1960-1968) **b :** played by naturalistic child-actor turned Oscar-winning director Ron Howard

OPEN-MOUTH KISSING

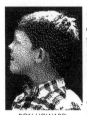

RON HOWARD

(then Ronny Howard) **c** : a lovable, unassuming boyfriend <"Geez, did Sondra find herself an *Opie* or what?">

oral sex \ȯr-əl-'seks\ *n* a form of sexual gratification that involves the mouth, lips, tongue, and sometimes the knees <see SYNOVIAL FLUID> and requires 2 people – called also *cunnilingus, fellatio, going down, little piece of heaven*

orange \'är-inj\ *n* a round fruit (genus *Citrus*) that's grown in Arizona, California, Florida, and Texas and whose fragrant blossoms are used in wedding bouquets **Orange Colored Sky** \'är-inj-'kə-lərd-'skī\ *n* Nat King Cole hit (Milton DeLugg/Willie Stein) about the power of love at first sight<*as in* "Flash! Bam! Alacazam! Wonderful you came by.">

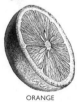

ORANGE

orange safety vest \'är-inj-'sāf-tē-'vest\ *n* a sleeveless mesh vest with silver reflective stripes that is worn by hard hats on hot days with no T-shirt underneath, which exposes their biceps, tats, and sun-bronzed skin **pass the orange** \'pas-the-'är-inj\ *n* a 1960s party game in which a person secures an orange under his or her chin and without using his or her hands passes it on to another person

orbicularis oris \ȯr-'bi-kyə-lä-rəs-'ȯr-əs\ *n* the mouth muscle that inserts itself into the mucous membrane at the margin of the lips and allows one to play a brass instrument *such as* a French horn, trumpet, or tuba or certain woodwind instruments *such as* a saxophone or clarinet or to pucker up and kiss someone

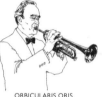

ORBICULARIS ORIS

orchid \'ȯr-kəd\ *n* **a** : the Miss Universe of the plant family that grows almost everywhere, particularly in tropical and subtropical rainforests; in addition to its exotic flowers is known for its complex, Rube Goldberg–like sexual organs that have highly developed pollination mechanisms, some of which can accommodate more than just bees <*as in* frogs and bats> – see *VANILLA* **b** : underworld lingo for a

beautiful dame <"Hey, buddy, keep your mitts off my *orchid*.">

ORCHID

orgasm \ˈȯr-ˌga-zəm\ *n* **a :** the stage in which building passions crescendo, resulting in a volcanolike eruption of extreme pleasure that can leave a person physically and emotionally spent **b :** can be achieved by oneself <see *MASTURBATION*>, with someone with whom one is not emotionally involved, or with a partner one is deeply in love with and with whom one wishes to experience the ultimate in physical and emotional intimacy and trust – called also *climax* – see *HUMAN SEXUAL RESPONSE*

orifice \ˈȯr-ə-fəs\ *n* an opening in the human body *such as* the mouth, vagina, anus, ear canal, or belly button, so that lovers can have options <"Darling, pick an *orifice*.">

Orpheus \ˈȯr-ˌfyüs\ *n* son of the ancient Greek god Apollo and muse Calliope, whose playing of the lyre could tame wild beasts and who, after his bride, Eurydice,

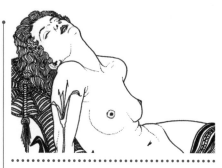

ORGASM CHECKLIST

In order for orgasm to occur, the following conditions need to be confirmed.

	men	women
abnormal breathing	x	x
dilating eyes	x	x
erect nipples		x
erect penis	x	
genital muscular contractions	x	x
increased pulse rate	x	x
muscular tension	x	x
pets off bed	x	x
pounding heart	x	x
pre-ejaculatory fluid	x	
sex flush	x	x
sweating	x	x
vaginal lubrication		x
vocalization	x	x

was killed, ventured to the Underworld to bring her back, convincing death to take a holiday; killed by the maenads (female worshipers of Dionysus, the god of wine), his head, singing, floated to Lesbos; meanwhile, Zeus threw his lyre to the heavens, which became the constellation Lyra, which contains Vega, the 5th-brightest star in the sky **Orpheus Descending** *n* \'òr-ˌfyüs-di-'sen-diŋ\ *n* 1957 Broadway play by Tennessee Williams, which was adapted into the 1959 movie *The Fugitive Kind* (*dir* Sidney Lumet), starring a motorcycle-riding Marlon Brando who, instead of a lyre, played a guitar

Our Town \'är-'taùn\ *n* **a :** the most produced American play ever written (by Thornton Wilder) and first seen by audiences in 1938 **b :** the plot revolves around the marriage of George Gibbs, a physician's son, to Emily Webb, a newspaper editor's daughter, who dies during childbirth; after her death, she is given the chance to live 1 day of her life over again to realize how important every moment of every day is *note* in the 1940 movie version, starring William Holden and Martha Scott (*dir* Sam Wood), Emily doesn't die, at least not for long – she wakes up after having had her baby to proclaim she's had the craziest dream

over \'ō-vər\ *prep* kaput; finis; free again!
Over the Rainbow \'ō-vər-'the-'rān-bō\ *n* **a :** the world's most beloved ballad, written by E. Y. Harburg and Harold Arlen for Judy Garland in the 1939 film *The Wizard of Oz* (*dir* Victor Fleming) **b :** though it became Garland's theme song, it has been successfully revived and reinterpreted by countless singers, most notably Patti LaBelle, the late Eva Cassidy, and the late Hawaiian singer Israel Kamakawiwo'ole **c :** popular song choice among *American Idol* contestants

Ovid \'ä-vəd\ *n* (43 B.C.–17 A.D.) Roman poet whose full Latin name was Publius Ovidius Naso and who was master of the elegiac couplet and author of *Ars Amato-*

ria, a series of 3 volumes in rhyming verse on the art of seduction, which scholars believe got the poet permanently booted out of Rome in 8 B.C. by the family-value-toting ruler Augustus

OVID

owl hoot \'aù(-ə)l-'hüt\ *n* the noise emitted by a nocturnal family of birds that one hears while lying in a sleeping bag at night on a camping trip or on a moonlit walk in the woods and whose haunting sound causes lovers to snuggle closer

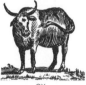

OX

ox \'äks\ *n* sex appeal Soviet style <"You'll like my daughter – she strong like *ox*.">

oxytocin \'äk-sē-'tō-s^ən\ *n* a hormone that's made in the hypothalamus, ovaries, and testes and plays a role in bonding and building trust between lovers <*as in* "Every kiss, every hug, seems to act just like a drug." –AL DUBIN/HARRY WARREN, "You're Getting to Be a Habit with Me.">

oy gevalt \'ói-gə-'vält\ *n* [Yiddish] a lament <"So, how was your date with Keefer?" "*Oy gevalt*, such a schmuck.">

oyster \'óis-tər\ *n* **a :** a bivalved mollusk that can be eaten raw, smoked, baked, grilled, and in soups or cooked with spinach and breadcrumbs for the decadent Oysters Rockefeller invented at Antoine's res-

OY GEVALT

taurant in New Orleans in the late 1890s **b :** traditionally thought of as the most sexually arousing food that lovers can eat <"Before I was born, my mother was in great agony of spirit and in a tragic situation. She could take no food except iced *oysters* and champagne. If people ask me when I began to dance, I reply, 'In my mother's womb, probably as a result of the *oysters* and champagne – the food of Aphrodite.'" –ISA-DORA DUNCAN>

OYSTER

203

Pachelbel, Johann \pä-kel-ˌbel-jō-ˈhän\ (1653–1706) German baroque composer and organist who, unlike Handel, Scarlatti, Telemann, or Bach, no one had ever heard of until the early 1970s, when his "Canon in D Major" became the biggest classical crossover hit ever and continues to be popular, esp. at wedding ceremonies; used as the theme music for Robert Redford's 1980 film *Ordinary People*

package \ˈpa-kij\ *n* a man's genitals, esp. if they are large enough to be obvious when he's wearing clothing <"Now maybe I can help you with your *package*." –SAMANTHA JONES to hunky Worldwide deliveryman, *Sex and the City*, Season 5, Episode 70> – see *WOOF*

PACKAGE

package deal \ˈpa-kij-ˈdēl\ *n* a twofer or other special travel offer that includes various options at a reduced price <"We're going to Bermuda this weekend. It's a *package deal*.">

surprise package \sə(r)-ˈprīz-pa-kij\ *n* a smaller than average penis that becomes large when aroused

P/R

PADDLE

paddle \'pä-d°l\ *n* **1** : a wooden implement that has a long handle and a broad flat blade that a man uses when he rows his girlfriend around a lake or lagoon in a small boat **2** : a leather implement that has a short handle and a broad flat blade that is used in S&M sex – see *DOMINATRIX, FWAP*

paella \pä-'e-lə\ *n* an earthy Spanish dish of saffron-flavored rice combined with a variety of meats, shellfish, and vegetables cooked in a wide, shallow pan that is brought to the table, which is outside, overlooking the Costa del Sol, where one sits with one's lover and a pitcher of sangria

Pandora \pan-'dòr-ə\ *n* a curious girl who opened a box that the Greek god Epimetheus told her not to go near; she thought it contained her wedding dowry but instead it held all the evils of the world, which were unleashed on mankind **Pandora's Box** \pan-'dòr-əz-bäx\ *n* (1922, *dir* G. W. Pabst) silent film in which Louise Brooks plays the amoral femme fatale Lulu

panic \'pa-nik\ *n* an overwhelming fear of abandonment that consumes codependent lovers when an e-mail or phone call is not immediately returned

PANIC

paper \'pā-pər\ *n* a 2nd-c. Chinese invention of material in sheet form that has been

PAPER

used ever since for a wide range of purposes *such as* drawing, printing, packaging, and writing love letters – see *ABELARD AND HELOISE, (THE) BROWNINGS*

paradise \'per-ə-ˌdīs\ *n* **1** : sexual union **2** : a popular euphemism in song lyrics <"Her kiss, each fond caress, they lead the way to happiness. She takes me to *paradise*." –NACIO HERB BROWN/GORDON CLIFFORD, "Paradise" >

PARADISE

paralysis \pə-'ra-lə-səs\ *n* a temporary lack of movement brought about after being hit on at a party by the most beautiful woman, or the most handsome man, or both

paranoia \‚per-ə-'nȯi-ə\ *n* obsessive suspicions that occur when one is falling in love and getting to know someone *such as* "When is she going to break my heart?" or "What could she see in me?" or "Why is God setting me up for a fall?"

paresthesia \‚par-əs-'thē-zhə\ *n* a tingling sensation of the skin that feels as if one is being brushed by a peacock feather and is usually associated with partial damage to a peripheral nerve; common in the ears, making one think someone is blowing in them

Paris \'pa-rəs\ *n* **a :** the capital of France, on the River Seine, with a reputation for being the world's most romantic city based on its beauty, culture, art, fashion, gardens, food, and love of love <"Ninotchka, it's midnight. One half of *Paris* is making love to the other half." –MELVYN DOUGLAS to Greta Garbo in *Ninotchka*, 1939, *dir* Ernst Lubitsch> **b :** of all the cities in the world, Paris is believed to have received the most valentines, from songs <"The last time I saw *Paris* her heart was young and gay." –OSCAR HAMMERSTEIN II> to books <"*Paris* is a moveable feast." –ERNEST HEMINGWAY>

to movies <"We'll always have *Paris*." –HUMPHREY BOGART in *Casablanca*> **Paris and Helen** \'pa-rəs-ən(d)-‚he-lən\ *n* **a :** the pulchritudinous Greek gods who became lovers and who by running off together to Troy started the Trojan War (she having the face that launched 1,000 ships) **b :** their story was made into a 1956 film, *Helen of Troy* (*dir* Robert Wise), starring Jacques Sernas as Paris, Rossana Podesta as Helen, and Brigitte Bardot as Helen's handmaiden Andraste

DOROTHY PARKER

Parker, Dorothy \'pär-kər-'dä-rä-thē\ (1893–1967) American satirist, critic, short story writer, poet, and one of the founding wits of the Algonquin Round Table who is best remembered for her caustic observations on love, including "Men seldom make passes at girls who wear glasses," and "Oh, life is a glorious cycle of song, a medley of extemporanea; and love is a thing that can never go wrong, and I am Marie of Romania."

parting \'pär-tiŋ\ *n* a painful separation of ways that lovers endure either temporarily

207

<"Good night, good night! *Parting* is such sweet sorrow, that I shall say goodnight till it be morrow." –JULIET to Romeo> or forever <"*Parting* is all we know of heaven, and all we need of hell." –EMILY DICKINSON, 1830–1886>

PARTING

passion \\'pa-shən\ *n* a red-hot sexual fire that starts in the id and, if not extinguished <see *FIREMAN*>, can consume one's reasoning, setting off a virtual Fourth of July fireworks display of emotions and feelings *such as* jealousy, paranoia, disgust, remorse, and obsession, before cooling <"I began as a *passion* and ended as a habit, like all husbands." – GEORGE BERNARD SHAW, 1856–1950>

PASSION

Pavarotti, Luciano \\pä-vä-'rä-tē-'lü-sē-'ä-nō\ (b. 1935) ursine Italian tenor whose mellifluous, spine-tingling vocals brought opera to the masses and masses to his bank account – called also *King of the High C's*

peach \\'pēch\ *n* **1** : a person who is exceptionally attractive <"Boy, did you pick a *peach*."> **2** : a sensuous stone fruit with soft, juicy flesh that one eats in the summer months and whose velvety skin ranges in color from pink-blushed creamy white to red-blushed yellow *note* peaches bruise easily and, like lovers, must be handled gently

PEACH

pegging \\'pe-gən\ *vb* the practice by which a male is anally penetrated by a woman wearing a strap-on dildo – called also *bend over boyfriend*, or *BOB* **Peg of My Heart** \\'peg-əv-mī-hart\ *n* popular song written in 1913 by Alfred Bryan and Fred Fisher about a sweet Irish lass <*as in* "Sweeter than the rose of Erin are your winning smiles endearin'.">

Pelléas et Mélisande \\pə-'lā-,as-ā-'mā-lə-sȯnd\ *n* Claude Debussy's realistic dreamlike opera of 1902, in which Pelléas, the handsome grandson of a king, happens upon Mélisande, a beautiful, mysterious young woman, who he falls in love with, and she with him, and that's it, until they die 5 acts later

penis \'pē-nəs\ *n* the male external reproductive organ that contains the urethra, through which urine and semen pass, and where some women think men's brains are located – called also *artful dodger, big Jim and the twins, cock robin, cream stick, dangler, dickory dock, ding dong, doggie, hang down, honker, John Thomas, love pole, love rocket, love sausage, larrydoodle, meat puppet, pajama python, putz, schlong, schmuck, tally whacker, ting-a-ling, trouser trout, trouser snake, willy, Wyatt Earp* – see *ERECTION* **penis envy** \'pē-nəs-'en-vē\ *n* **a :** a condition identified by Sigmund Freud in which girls age 3½–6 think their mothers took away their penis **b :** Carl Jung dubbed this condition the "Electra Complex," after the Greek myth of Electra, who avenges the death of her father (King Agamednon) by arranging the murder of her mother (Clytemnestra) **penis perception** \'pē-nəs-pər-'sep-shən\ *n* the belief that one can tell the size of a man's penis by the size of his nose or feet

perfidy \'pər-fə-dē\ *n* unfaithfulness; a deliberate breach of trust by a lover *note* the noun is the inspiration for the 1939 Mexican song "Perfidia" (Alfred Bryan/Fred Fisher) about an unfaithful female lover <"To you my heart cries, '*Perfidia*,' for I find you, the love of my life, in somebody else's arms.">

perhaps \pər-'häps\ *adv* neither yes nor no; maybe <"I asked if she was free on Saturday night, and she said, '*Perhaps*.'">

perineum \per-ə-'nē-əm\ *n* **a :** the Australia, or Down Under, of the body **b :** an area of skin rich in nerve endings that is located below the anus and in women extends to the vaginal opening and in men to the base of the testicles and is very sensitive to the touch – called also *million dollar point*

permatan \'per-mə-tan\ *n* a year-round bronzed look acquired in a tanning booth <"Is Carrie Latino?" "No, she's *permatanned*."> – called also *tanorexia*

petrichor \'pet-rə-kor\ *n* the pleasant scent that accompanies the first rain after an extended dry spell <"After a long drought in the desert of love, I found Shirley, my reviving *petrichor*.">

PETRICHOR

Petruchio and Katharina \pə-'tru-chē-ō-'ənd-'kathə-'rē-nə\ *n* Shakespeare's embattled lovers in *The Taming of the Shrew* whose banter shows just how low the bard could go <*as in* Petruchio: "Who knows not where a wasp does wear his sting? In his tail." Katharine: "In his tongue?" P: "Whose tongue?" K: "Yours, if you talk of tales: and so farewell." P: "What! with my tongue in your tail? Nay, come again, Good Kate; I am a gentleman.">

Peyton Place \'pā-tən-'plās\ *n* **a :** 1956 novel by Grace Metalious (1924–1964) that spills the steamy secrets of a fictional New England town and whose name has become a synonym for any scandal-ridden environment <"This office has become a *Peyton Place*.">; Metalious died of alcoholism at age 39 **b :** inspired the modern soap opera genre and was made into a Hollywood film and TV series and also referenced in Jeannie C. Riley's hit country-and-western

PHALLIC SYMBOLS

1950s SPORTS CAR

CLOCK TOWER

EIFFEL TOWER

REDWOOD TREE

NECKTIE

CIGAR

GIANT CACTUS

TELESCOPE

PHAT

phenylethylamine \ˌfe-nᵊl-ˌe-thəl-ˈa-ˌmēn\ *n* a naturally occurring amphetamine that floods the brain when romance occurs, allowing lovers to stay up late together in order to bond and get to know each other while they're still interested

pheromones \ˈfe-rō-mōnz\ *n* a chemical substances emitted by certain animals and insects to lure others of their species for copulation; there is no scientific proof that humans emit natural pheromones, only empirical evidence <*as in* "Hi, Clarissa, I was in the vicinity....">

Piaf, Edith \pē-ˈaf-ˈē-dəth\ (1915–1963) France's most famous female singer, whose

EDITH PIAF

powerful, poignant voice spoke to the people and whose popularity outside of France, esp. in the U.S., makes a case for love being purely aesthetic, as the words she sang needed no translation to be deeply felt; signature songs include "La Vie en Rose," "Non, Je Ne Regrette Rien," and "L'hymne à l'Amour"

song "Harper Valley PTA" <"This is just a little *Peyton Place*, and you're all Harper Valley hypocrites.">

phallic symbol \ˈfa-lik-ˈsim-bəl\ *n* a symbol that consciously or unconsciously relates to an erect phallus, or penis, and symbolizes male power

phat \ˈfat\ *adj* acronym for "pretty hot and tempting" <"She's one *phat* mama.">

211

piano \pē-'ä-(ˌ)nō\ *n* a popular recital instrument that was invented in Florence, Italy, in the 17th c. and since then has put

PIANO

millions of lovers in a romantic state <"A tinkling *piano* in the next apartment, these foolish things remind me of you." –HOLT MARVELL/JACK STACHEY/HARRY LINK, "These Foolish Things">

pick-up line \'pik-ˌəp-'līn\ *n* a suave, rehearsed greeting that a guy uses at singles' bars to lure women to his charms but which usu. turns them off <*as in* "I couldn't help noticing the label on the back of your dress – it says, 'Made in Heaven.'">

pillow \'pi-(ˌ)lō\ *n* a soft cushion on which to leave one's lover little gifts and love notes **Pillow Talk** \'pi-(ˌ)lo-'tȯk\ *n* (1959, *dir* Michael Gordon) 1st of 3 bedroom farces starring Rock Hudson and Doris Day, who were magically matched romantic adversaries **Cum Stains On the Pillow (Where Your Sweet**

PILLOW

Head Used to Be) \'kum-stānz-'ȯn-'thȯ-'pi-(ˌ)lō-'hwer-'yur-'swēt-'hed-'yüzd-'tə-'bē\ *n* country-and-western ballad by Chinga Chavin that was featured on his mid-1970s cult album, *Country Porn*

Pincus, Gregory Goodwin \'piŋ-kəs'greg(e-)re-'gu̇d-win\ (1903–1967) New Jersey-born biologist who studied at Cambridge, Cornell, and Harvard and who was inspired by birth control advocate Margaret Sanger (1883–1966) to perform research that would lead to the development of an oral contraceptive for women, which gave birth to the Pill; after being tested on women in Puerto Rico, it was approved for American women by the FDA on May 11, 1960, prompting the Sexual Revolution

GREGORY GOODWIN PINCUS

pineal gland \'pī-nē-əl-'gland\ *n* **a :** a small cone-shaped gland in the brain that secretes melatonin and is thought to regulate mood-elevating body rhythms **b :** triggered by sunlight, it's a free tonic for the broken-hearted or depressed of spirit

pinup \\'pin-ˌəp\\ *n* **a :** a large mass-produced photograph that was popular in the late 1940s and 1950s and featured a curvy, carefully posed woman who often had rolled hair, muted eye shadow, and a ruby-red pout, which men hung in their lock-

PINUP

er or garage **b :** the pinup look is enjoying a retro revival, esp. in the underground rockabilly scene <*as in* "I feel like that's why it remains a classic style. It was born of the everyday woman. You didn't have to be a starlet to look like this." –ADINA HEPWORTH, stylist> – see *THE BETTY BEST pp. 40–41*

PISTOL

pistol \\'pis-tᵊl\\ *n* age-old word for penis, likely because pistols and penises both go bang <"Here, *Pistol*, I charge you with a cup of sack. Do you discharge upon mine hostess." –FALSTAFF speaking in Shakespeare's *Henry IV*>

player \\'plā-ər\\ *n* an admiring term for a promiscuous man that implies the use of strategy and skill to get laid <"...there is no pejorative equivalent to suggest that a man has sullied himself with too many sexual partners. Men are *players*, women are sluts, just the way men are tough and women are bitchy." –MAUREEN DOWD, *The New York Times*>

plebeian \\pli-'bē-ən\\ **1 : a :** *adj* coarse or vulgar **b :** used in a bluesy torch song that made sultry Julie London famous <"You told me love was too *plebeian*, told me you were through with me...." –ARTHUR HAMILTON, "Cry Me a River"> *note* despite being recorded by dozens of major artists since it was written in 1954, it remains Hamilton's only hit song **2 :** *n* an uncouth person <"Rudy took me to Hot Dog On a Stick for dinner. He's such a *plebeian*.">

plop \\'pläp\\ *n* the sound an unappreciative husband or boyfriend makes as he lands on the couch for the evening – see *HI*

plumber \\'plə-mər\\ *n* a hot boyfriend who can fix leaky faucets, keep pipes open, and isn't timid about crawling around in dark places

PLUMBER

plummet \\'plə-mət\ *vb* a sudden decrease in one's sex drive from hot 'n' bothered to not in the mood; can be brought about by many forces *such as* an insensitive remark, unbrushed teeth, a phone ringing, or "Mommy, can I have a glass of water?"

poached eggs \\'pōcht-'egz\ *n* a sensuous way to prepare eggs for one's lover in the morning, by first breaking them into a bowl, then dropping them into a vortex of boiling water, which leaves the whites firm and the yolks runny; used in eggs Benedict and eggs Florentine, which lovers order at champagne brunches – compare *OMELET*

Pochahontas \\pō-kə-'hän-təs\ (ca. 1595–1617) American Indian princess who saved the life of English colonist and Jamestown founder Captain John Smith because "He gives me fever with his kisses; fever when he holds me tight."

poet \\'pō-ət\ *n* anyone who is in love <*as in* "Without love no bard can be." –PHILIP JAMES BAILEY, 1816–1902> **poetry** \\'pō-ə-trē\ *n* heartfelt, expressive writings that people who are in love send to each other and that often invoke a teary reaction

UNTITLED LOVE POEM

Like warmth held in cupped hands;
The sweet, sweaty smell of promise
Seeping through thirsty lips.
Insides glowing
Pour out spilling over the scenery.
Every sensation alive.... Aware.
Colors, thoughts and sounds
Swirling through the clear mist.
The dizzying bliss of bittersweet dependence.
 –ANON.

polyamory \\pä-lē-'a-mə-rə\ *n* a lifestyle in which people who are happily married or in committed relationships agree that it's OK to have sex with others <*as in* "Honey, I'm seeing Natasha tonight so I won't be home until after 10 o'clock." "Oh, don't give me that. I know you're working late at the office again."> – called also *open marriage, polygamy*

pon farr \\'pän-'fär\ *n* Vulcan mating period that occurs every 7 years; in its final stages, called "plak tow," a Vulcan is unable to think or speak clearly, becomes combative, and will fight to win his or her mate – see *STAR TREK*

PONTE VECCHIO

Ponte Vecchio \\'pon-tə-'vek-ē-ō\ *n* [Italian *old bridge*] Europe's oldest segmental arch bridge, which spans the Arno River in Florence, Italy, and from which, in Puccini's one-act opera *Gianni Schicchi*, Lauretta, the daughter of the eponymous title character, threatens to throw herself in the heart-melting aria, "O Mio Babbino Caro," unless her father lets her be with the man she loves

POOL

pool \\'pül\ *n* an artificial basin for swimming and sunning that's located in backyards and apartment complexes and allows a person who might be interested in another to see what he or she looks like in a bathing suit before taking action **pocket pool** \\'pä-kət-'pül\ *n* a solitary and often unconscious game that men play in which they fondle their genitals while their hands are in their pockets

pop \\'päp\ *n* **1** : an ice-cold bottled soda that lovers swig on hot summer days at the beach <"Would you like another cherry *pop*?"> **2** : the sound a champagne bottle makes when it is uncorked **popped cherry** \\'päpt-'cher-ē\ *n* a broken hymen **pop the question** \\'päp-thə-'kwes-chən\ *vb* to propose marriage

POP

Porgy and Bess \\'por-gē-ən(d)-'bes\ *n* the lovers in George Gershwin's folk opera who express their love for each other in the hauntingly beautiful arias, "Bess, You Is My Woman" and "I Loves You, Porgy"

positive assortive mating \\'pä-zə-tiv-ə-'sor-tiv-'mā-tiŋ\ *n* an anthropological term

215

for people of similar backgrounds, ethnic groups, or physical types being attracted to each other – called also *PAM*

PAM FORMULA

Good ol' boy + mountain mama
 = shacking up
Catholic (boy) + Catholic (girl)
 = big wedding
Nerd + nerdette
 = monogamous relationship
Calvin Klein model + nerdette
 = no, no, nerdette

postman *n* \'pōs(t)-mən\ a U.S. Postal Service employee who delivers birthday cards, Valentine's Day cards, and wedding invitations

POSTMAN

posture \'päs-chər\ *n* the bearing of the body that when straight and erect makes one look younger and more confident

potty train \'pä-tē-'trān\ *vb* to teach a new boyfriend how to use the toilet *as in* shooting straight and putting the seat back down

POSTURE AWARENESS EXERCISE

1. Place feet under hips, with toes pointing straight ahead.
2. Balance over feet – front to back and left to right.
3. Relax knees.
4. Rotate pelvis, tucking coccyx under. Tighten butt with pelvic muscles.
5. Breathe normally as lumbar spine lengthens.
6. Broaden chest by elevating sternum.
7. Extend fingers toward floor, lengthening arms, neck, and shoulders.
8. Look straight ahead, with chin down, and lift back of head as if a hook from the ceiling were lifting it.

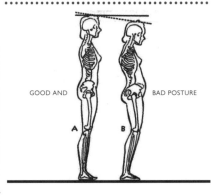
GOOD AND BAD POSTURE

A B

216

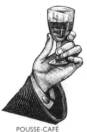

POUSSE-CAFÉ

pousse-café \ˌpüs-(ˌ)ka-ˈfā\ *n* **a :** in France, a brandy or cordial that lovers have after coffee **b :** U.S. version is a drink made by layering various liqueurs on top of each other, starting with the sweetest: ¼ shot each of grenadine, yellow Chartreuse, crème de cassis, white crème de menthe, and green Chartreuse <"After dinner, Babette asked if I'd like to come up for some *pousse-café*.">

power couple \ˈpaů(-ə)r-ˈkə-pəl\ *n* a high-voltage pairing *such as* Ben Bradlee and Sally Quinn, Mike Nichols and Diane Sawyer, Arnold Schwarzenegger and Maria Shriver, and Bill and Hillary Clinton – see *BONNIE AND CLYDE*

prayer \ˈprer\ *n* turning to God in speech or silent concentration when things are really bad and one needs help <*as in* "Please, God, make her call me," or "Please, God, let her be there to-

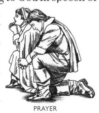

PRAYER

night," or "Please, God, don't let her go," *as in* to the Cineplex with Jamal>

preemptive breakup \ˌprē-ˈem(p)-tiv-ˈbrāk-ˌəp\ *n* retaining one's power by ending a relationship before the other person gets the chance

preening behaviors \ˈprē-niŋ-bi-ˈhā-vyərz\ *n* grooming and other actions observed in singles trying to diffuse anxiety or nervous energy when talking to a potential mate and often exaggerated for effect <*as*

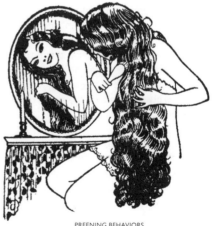

PREENING BEHAVIORS

in a man straightening his tie, arranging his package, or thrusting out his chest; a woman fidgeting with her hair, batting her eyelashes, or performing an impromptu pole dance>

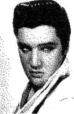
ELVIS PRESLEY

Presley, Elvis \'prez-lē-'el-vis\ (1935–1977) lip-curling, hip-swirling singer, movie star, pop phenomenon, and the everlasting King of Rock 'n' Roll

priapism \'prī-ə-ˌpi-zəm\ *n* a painful medical condition in which a man's penis stays erect and won't become flaccid and can require treatment at a hospital emergency room **Priapus** \prī-'ā-pəs\ *n* a minor Greek fertility god who had a humongous penis that was always depicted as erect in sculptures of his likeness

prince \'prin(t)s\ *n* an idealized male suitor <"Some Day My *Prince* Will Come" –FRANK CHURCHILL> **princess** \'prin(t)-səs\ *n* a spoiled girlfriend who thinks the world revolves around her <*as in* "Lisa, I heard you knocked over a Ming vase at the museum." "It's true, but I'm OK."> **Prince Albert** \'prin(t)s-'al-bərt\ *n* **a :** a metal ring that pierces the penis from outside of the frenulum and into the urethra and is named after Queen Victoria's

PRINCE ALBERT

husband, Prince Albert, who, along with other fashionably hung gents of the era, supposedly wore it to fix his member inside his trousers – see *ARRANGE* **b :** today Prince Alberts are a common form of male genital piercing done for the purpose of sexual stimulation, though men who wear them often have to sit down to urinate as the ring can disrupt a steady flow

Prius \'prī-əs\ *n* a babe magnet for girlie men that gets 60 mpg and has an emissions-free engine

proboscis \prə-'bäs-kəs\ *n* a prominent trunk, snout, or nose <*as in* "You don't realize how big it is until Jim turns sideways.">

PROBOSCIS

218

prolactin \prō-'lak-tən\ *n* a hormone that acts to repress the effect of dopamine after orgasm so that one isn't bunny horny 24/7 and can get on with one's life – see *REFRACTORY PERIOD*

proxemics \präk-'sē-miks\ *n* **a :** the science of what brings people together **b :** the term was coined in the 1950s by researcher Edward Hall, whose study was broken into 2 areas, physical territory <*as in* the placement of office desks> and personal territory <*as in* how much space people put between each other when having conversations or otherwise interacting>

PROXEMICS

⋯⋯⋯⋯⋯⋯⋯⋯⋯⋯⋯⋯⋯⋯⋯

PROXEMICS OF PERSONAL TERRITORY
- **Public Space** (*e.g.,* the distance between a speaker and his or her audience): 12-25 ft.
- **Social Space** (*e.g.,* business associates and strangers at bus stops or other public places): 4-10 ft.
- **Personal Space** (*e.g.,* friends and family members or people waiting at ATMS): 2-4 ft.
- **Intimate Space** (*e.g.,* whispering, embracing, getting to first base): 0 in.-1 ft.

⋯⋯⋯⋯⋯⋯⋯⋯⋯⋯⋯⋯⋯⋯⋯⋯⋯

P-spot \'pē-,spät\ – see *HE-SPOT*

public proposal \'pə-blik-prə-'pō-zəl\ *n* a popular trend in which a man, thinking he's being imaginative or original, surprises a woman while he's on live TV by falling to his knees, pulling out a ring, and asking her to marry him – see *OMIGOD!*

PUBLIC PROPOSAL

published \'pəb-lisht\ *v* a word used to impress a date <"I'm 35 and *published*.">

pubococcygeus muscle \'pyü-bo-,käk-'sə-jē-us-'mə-səl\ *n* **a :** a muscle that in both

219

men and women stretches from the pubic bone to the coccyx, or tailbone, forming the floor of the pelvic cavity and supporting the pelvic organs; contracts during orgasm to cut off urine flow **b** : the muscle can be strengthened for better orgasms through Kegel exercises, which are very subtle contractions that can be done almost anywhere without anyone being aware <*such as* when sitting at one's desk, driving, or giving a Power Point presentation> – called also *PC muscle*, *pelvic flex muscle* – see *TOYS*

pulchritude \'pəl-krə-ˌtüd\ *n* physical beauty <"You must have been Miss Pennsylvania with all this *pulchritude*." –MICHAEL FRANKS/DAVID FRISHBERG, "Popsicle Toes">

pulse \'pəls\ *n* **a** : the regular, rhythmic beating of an artery resulting from the pumping action of the heart, which speeds up when a beautiful woman or handsome man comes into view and esp. during foreplay as one rounds 3rd base **b** : easily detected on the radial artery of the wrist, the average pulse at rest is 60–80 bpm (beats per minute)

TAKING THE PULSE

TAKING THE PULSE

1. Touch one's thumb lightly on either side of the wrist until one feels the pulse.
2. Count the number of beats for 15 seconds and multiply by 4.

purr \'pər\ **1** : *n* the low vibratory sound a cat <called also *pussy*> makes when it is being loved **2** : *vb* to speak maliciously of a rival <"I can't believe Brenda got married in a white dress," she *purred*.> – see *MEE-OW*

pushbutton panic \'pùsh-ˈbə-tᵊn-ˈpa-nik\ *n* the fear one has of making an initial phone call to ask someone out <"Kayla, get over your *pushbutton panic* and call him now.">

pusillanimous \ˌpyü-sə-ˈla-nə-məs\ *adj* petty; timid; small-minded <"If he weren't so

pulchritudinous, I wouldn't tolerate his *pusillanimous* behavior.">

pussy \'pù-sē\ *n* [slang] vagina – called also *pussycat* **Pussy Galore** \'pù-sē-gə-lōr\ *n* bicurious sex bomb played by British actress Honor Blackman in the 1965 film *Goldfinger* (*dir* Guy Hamilton) <"My name is *Pussy Galore*." 007: "I must be dreaming.">; in the 1997 film *Austin Powers: International Man of Mystery* (*dir* Jay Roach) her name was parodied as Alotta Fagina – see *JAMES BOND* **pussy willow** \'pù-sē-'wi-lō\ *n* a beloved small tree (genus *Salix*) that is native to North America and is a harbinger of spring; its branches have soft buds (or catkins), which suitors give to their girlfriend to put in vases – see *DYNGUS DAY*

Pygmalion \pig-'māl-yən\ *n* **1 :** the sculp-

AUDREY HEPBURN

tor in Ovid's *Metamorphoses* who creates a statue of a woman that is so realistic he falls in love with it and Aphrodite brings it to life **2 : a :** a 1912 stage play by Irish playwright George Bernard Shaw, based on Ovid's story and introducing the characters Professor Henry Higgins and Eliza Doolittle **b :** adapted into a 1938 movie, with Leslie Howard and Wendy Hiller (*dirs* Anthony Asquith/Leslie Howard), and into the 1956 stage musical *My Fair Lady*, with Rex Harrison and Julie Andrews, and into the 1964 movie version starring Rex Harrison and Audrey Hepburn (*dir* George Cukor)

PUSSY

221

quadragenerian \'kwä-drə-jə-ner-ē-ən\ *n* a person in the prime of his or her life, somewhere between the ages of 40 and 50 <*as in* Julia Roberts, George Clooney, Teri Hatcher, Harry Connick, Jr.>

quads \'kwädz\ *n* **a :** the extensor muscle at the front of the thigh that allows one to bend one's knees and support someone sitting in one's lap **b :** can be strengthened

QUADS

through weight-bearing exercises *such as* squats, dead-lifts, the clean-and-jerk, and the snatch

quaff \'kwäf\ *vb* to drink with relish and passion; to drink copiously of <"They *quaffed* champagne as if it were water.">

QUAFF

Quant, Mary \'kwänt-'mer-ē\ (b. 1934) British fashion designer who set the stage for

223

the swinging, free-loving mod scene when in 1965 she sold the first miniskirt, in her store on Kings Road in London's Chelsea district, naming it after her favorite car, the French Mini; not to rest on her laurels, she went on to design hot pants and the micromini

quantum leap \'kwän-təm-'lēp\ *n* an electromagnetic reaction in which a normally shy person becomes so highly charged by the presence of another person that he or she jumps up and introduces himself or herself

QUANTUM LEAP

quarrel \'kwȯr(ə)l\ *n* a frictional condition between partners that can become habit-forming <*as in* bickering>; according to Dr. Phil, follow certain rules when quarreling *such as* discuss issues and not topics, don't fight in front of the kids, negotiate compromises, and don't make ultimatums

quasi-breakup \'kwā-ˌzī-'brāk-ˌəp\ *n* a cooling off period between lovers <"This is not goodbye, Katelan. It's a *quasi-breakup*.">

Queen \'kwēn\ *n* British rock group whose lead singer and pianist Freddie Mercury (1946-1991) had a powerful, 4-octave range that he used to full effect in songs *such as* "Bohemian Rhapsody" and "Crazy Little Thing Called Love"; Mercury died of AIDS at age 45 wearing the wedding band given to him by his lover, Jim Hutton, who he called his husband **(RMS) Queen Elizabeth** *n* **a :** one of the last great ocean liners, which began service in 1969 and is named for Queen Elizabeth I **b :** Cunard's flagship until the 2004 launching of the behemoth *RMS Queen Mary 2*, which is named after Mary of Teck, Queen Consort of George V and grandmother of Elizabeth II **queens** \'kwēnz\ *n* affectionate term for an elderly homosexual couple <"Look at those old *queens*, still holding hands."> **Queens** *n* the borough of New York City where Edith and Archie Bunker lived in *All in the Family* and the site of La Guardia Airport, from where New Yorkers depart for romantic getaways to Florida **drama queen** \'drä-mə-'kwēn\ *n* a male or female whose brain is so overloaded with dopamine and norepineph-

QUEENS

rine that every little problem becomes a crisis <*as in* "Marcy, he only kissed you on the cheek. You are not with child.">

queer-eye \\'kwēr-ī\\ *vb* when a gay person improves a male heterosexual's taste or lifestyle <*as in* decor, wardrobe, cooking skills, manners> in order that he can impress a girlfriend <"Dwayne, the place looks great. Who *queer-eyed* you?">

quenelle \\kə-'nel\\ *n* a delicate dumpling that's filled with fish, poultry, or other meat, poached in a stock, served with a rich sauce, and the height of gourmet dining in a French restaurant; if successfully prepared at home, will wow any suitor <"You may have had her body, but I've had her *quenelles*." –ROBERT MORLEY talking about Jacqueline Bisset in the 1978 film *Who Is Killing the Great Chefs of Europe?*, *dir* Ted Kotcheff> – see *JULIA CHILD*

question \\'kwes-chən\\ *vb* to ask for someone's hand in marriage – see *POP THE QUESTION, TROTHPLIGHT*

quickie \\'kwi-kē\\ *n* a fast-forward sex act between 2 people who have busy sched-

QUICKIE

ules and work long hours that is sometimes performed standing up <*as in* "Darling, that was great. What time do you have?"> **quickie marriage** \\'kwi-kē-'mer-ij\\ *n* an impulsive tying of the knot that often involves a hangover and an annulment and, in the case of celebrities, a statement from their publicist – see *CELEBRITY QUICKIE MARRIAGES pp. 226–227, LAS VEGAS*

quiet \\'kwī-ət\\ **a :** *n* tranquility; peacefulness; freedom from noise <"...where the *quiet*-colored end of evening smiles." –ROBERT BROWNING, 1812-1899> **b :** *adv* in a secretive manner <"They plan to get married but are keeping it *quiet*."> **c :** *interj* <"*Quiet!* Some of us would like to get some sleep," *as in* overhearing lovers having sex in a B&B> **(The) Quiet Man** \\thə-'kwī-ət-'män\\ *n* classic 1952 film (*dir* John Ford) in which an adrenaline-pumped John Wayne pursues a feisty Maureen O'Hara through the lush Irish countryside

quilt \\'kwilt\\ *n* a thick, stitched cover that makes a bed so invitingly cozy that on win-

CELEBRITY QUICKIE MARRIAGES

ETHEL MERMAN
AND ERNEST BORGNINE
34 DAYS (1964)

CARMEN ELECTRA
AND DENNIS RODMA
9 DAYS (1998)

MICHELLE PHILLIPS
AND DENNIS HOPPER
8 DAYS (1970)

ZSA ZSA GABOR
AND FELIPE DE ALBA
1 DAY (1982)

BRITNEY SPEARS AND
JASON ALLEN ALEXAND
2 DAYS (2004)

JENNIFER LOPEZ
AND CRIS JUDD
9 MONTHS (2001)

DREW BARRYMORE
AND JEREMY THOMAS
19 DAYS (1994)

CATHERINE OXENBERG
AND ROBERT EVANS
12 DAYS (1998)

DREW BARRYMORE
AND TOM GREEN
5 MONTHS (2001)

227

ter mornings one's lover will not want to leave it <*as in* "'Tis very warm weather when one's in bed." –JONATHAN SWIFT, 1667–1745> – see *DOWN COMFORTER*

quinquagenarian\\'kwin-'kwə-jə-nā-rē-ən\ *n* a person who is in his or her fifties <*as in* "I saw my girl's driver's license, dude, and she's in her fifties!" – see *scary potatoes!*> – called also *the new forties* **quinquagenary** \\'kwin-'kwə-jə-nə-rē\ *n* a 50th-year celebration – called also *golden anniversary* – see *ANNIVERSARY ELEMENTS p. 18*

quintessence \kwin-'te-sᵊn(t)s\ *n* the most perfect embodiment of something or someone <"Looking at you, I'm filled with the essence of the *quintessence* of joy." –COLE PORTER, "Looking At You">

quit \'kwit\ *vb* to end a relationship <"I don't know how to *quit* you." –JAKE GYLLENHAAL to Heath Ledger in *Brokeback Mountain*, 2005, *dir* Ang Lee> – see *APPLE Q*

quiver \'kwi-vər\ **1 :** *vb* to physically tremble in the proximity of another person – see *LOVE AT FIRST SIGHT* **2 :** *n* the pouch in which Cupid carries his arrows

Quixote, Don \'kē-hō-tä-dän\ *n* the title character in Miguel de Cervantes's epic, picaresque novel that recounts the adventures of a delusional minor landowner who believes he is a chivalrous knight in shining armor

DON QUIXOTE (LEFT)

quixotic \kwik-'sä-tik\ *adj* used to describe an average Joe who has lofty romantic ideals and is willing to march into hell for a heavenly cause

quote \'kwōt\ *n* a message of love from a usu. unknown source that people send each other over the Internet **quote unquote** \'kwōt-ᵊn-ˌkwōt\ *interj* a qualifier used to let others know one has just made an ironic observation; usu. accompanied by the index and middle fingers of both hands drawing quotation marks in the air <"Sean and Craig are *quote unquote* roommates.">

quotidian \kwō-'ti-dē-ən\ *adj* daily; ordinary <*as in* "How do you keep the song from fading too fast? How do you not run out of new things to say?" –MICHEL LEGRAND/ALAN BERGMAN/MARILYN BERGMAN, "How Do You Keep the Music Playing?">

QUOTES TO LOVE BY

The following quotes about love are by unknown authors and can be used to heal, inspire, or express one's deep feelings for another. They can also be embroidered on cushions.

- The spaces between your fingers were created so that another could fill them.
- Never frown because you never know who might be falling in love with your smile.
- I love you not because of who you are but because of who I am when I am with you.
- True love cannot be found when it does not exist and cannot be hidden where it does.
- You know it's love when forever is not long enough.
- Love does not consist of gazing at each other but in looking outward in the same direction.
- It's true we don't know what we've got until it's gone, but we don't know what we've been missing until it arrives.
- Love is the shortest distance between hearts.
- It takes a second to say I love you but a lifetime to show it.
- When I miss you I just have to look inside my heart because that's where I'll find you.
- You need to trust love but first you need to love in order to trust.

- You don't love a woman because she is beautiful. She is beautiful because you love her.
- Trying to forget someone you love is like trying to remember someone you never met.
- I thought I forgot you, but I guess I forgot to.
- Love needs no map for it can find its way blindfolded.
- If you think missing me is hard, you should try being me missing you.
- A hundred hearts would be too few to carry all my love for you.
- Trip over love and you can get up, but fall in love and you fall forever.
- Happiness is falling asleep next to you and waking up thinking I'm still in my dreams.
- Love is like an hourglass with the heart filling up as the brain empties.
- Showing someone you're in love with them is just as important as loving them.
- If love is the best healer, then pain is the best teacher.
- I dropped a tear in the ocean and whenever they find it I will stop loving you.
- Just because someone doesn't love you the way you want them to doesn't mean they don't love you with everything they've got.
- People need to be loved the most when they deserve it the least.

229

Rabelais, François \ra-bə-ˌlā-ˈfrän-ˈswä\ (ca. 1494–1553) **a :** French Renaissance writer, medical doctor, and friar whose writings satirized society and politics and whose books, filled with FRANÇOIS RABELAIS sexual double entendres, were banned for advocating a lifestyle of "eat, drink, and be merry" **b :** referenced by the ladies of River City in Meredith Willson's *The Music Man*: "You know she [Marian, the librarian] advocates dirty books...Chaucer! *Rabelais!* Balzac!"

Rabbit, Jessica \ˈra-bət-ˈje-ˌsi-kə\ *n* the sultry, animated femme fatale of the 1988 movie *Who Framed Roger Rabbit* (*dir* Robert Zemeckis) about a jealous bunny who hires a detective to tail his wife (Jessica), a Veronica Lake look-alike whom he suspects of playing patty-cake with another guy <*as in* "I'm not bad. I'm just drawn that way." –JESSICA RABBIT>; Jessica's singing voice was dubbed by Amy Irving and her speaking voice by Kathleen Turner

Rachmaninoff, Sergei \räk-ˈmä-nə-ˌnȯf-ˈsyir-gā\ (1873–1943) Russian composer,

pianist, conductor, and U.S. immigrant whose *Piano Concerto No. 2* (1900) has been used to convey longing and romance between screen lovers *such as* Greta Garbo and John Barrymore in *Grand Hotel* (1932), Trevor Howard and Celia Johnson in *Brief Encounter* (1945), Joseph Cotten and Joan Fontaine in *September Affair* (1950), Elizabeth Taylor and John Ericson in *Rhapsody* (1954), Christopher Reeve and Jane Seymour in *Somewhere in Time* (1980), and (to comic effect) Marilyn Monroe and Tom Ewell in *The Seven Year Itch* (1955); the melody has been used as the basis for 2 pop love songs, "Full Moon and Empty Arms" (1945) and "All By Myself" (1976), which is lip synched by Renée Zellweger in the opening credits of *Bridget Jones's Diary* (2001)

radio \'rā-dē-ˌō\ *n* wireless telegraphy that has been an everyday item in American homes since the 1920s, broadcasting the world's greatest love songs by the top artists of each decade **Radio City Music Hall** \'rā-dē-ˌō-'si-tē-'myü-zik-'hól\ *n* Art Deco masterpiece stage and movie theater built in 1932 at New York's Rockefeller Center and home to the high-kicking Rockettes who, for 50 years, have performed every day

CHARLOTTE RAMPLING

Rampling, Charlotte \'ram-p(ə-)liŋ-'shär-lət\ (b. 1946) **a** : smoldering, British-born actress who works mostly in France and who specializes in reckless, dark characters and who can still do full-frontal nude scenes (*Swimming Pool*, 2003, *dir* François Ozo) or be pursued by a Haitian beachboy (*Heading South*, 2006, *dir* Laurent Cantet) **b** : her last name has become a verb meaning "to ensorcell with an enigmatic gaze" –THE NEW YORKER – see *FEMME D'UNE CERTAIN AGE*

rattlesnake \'ra-tᵊl-ˌsnāk\ *n* a lover one thinks is really nice but who never fails to show his or her true self RATTLESNAKE with a venomous bite <*as in* "Over dinner, Richard tells me he's made plans for Christmas that don't include me."\>

rayon vert \'rā-ˌän-'vərt\ *n* [French *green ray*] **a** : an optical illusion that occurs at

sunset in which a green spot or flash appears for no more than 2 secs. just above the sun as it sets, and according to French author Jules Verne, who wrote a book called *Le Rayon-Vert* (1882), he who sees this illusive occurrence will be incapable of being "deceived in matters of sentiment" and will be able to see into his or her own heart and to read the thoughts of others **b :** *Le Rayon Vert* is a 1986 film by French *dir* Eric Rohmer that tells the story of a lonely Parisian secretary who, while going in pursuit of Verne's green flash, meets a man who may be the love of her life

red \'red\ *adj* the color of lust, passion, sex, deep abiding love, roses, the Valentine's Day heart, blushing cheeks, wine, sunsets, and the sexual swellings of mandrills – see *LIPSTICK* <"O, my luve is like a *red, red* rose that's newly sprung in June." –ROBERT BURNS, 1759–1796> **red-cyc** \'red-'ī\ *n* an overnight, coast-to-coast airplane flight that long-distance lovers take to get back home so they can be at work the next day **red eyes** \'red-'īz\ *n* a sign that some-

RED

body is suffering from a broken heart or allergies

Redford, Robert \'red-'fōrd-'rä-bərt\ (b. 1936) **a :** California-born actor who is proof that one can be beautiful *and* have talent, brains, taste, and a social conscience **b :** became a superstar in 1969 opposite Paul Newman in *Butch Cassidy and the Sundance Kid*, won an Oscar for directing *Ordinary People* (1980), founded the Sundance Film Festival and Sundance TV channel as showcases for independent filmmakers, campaigns passionately for the environment and Native American rights, keeps his personal life personal, and always makes sure his leading ladies shine <*as in* Mia Farrow *(The Great Gatsby)*, Jane Fonda *(Barefoot in the Park)*, and Barbra Streisand *(The Way We Were)*> – called also *ADONIS*

ROBERT REDFORD

red-hot chili peppers \'red-'hät-'chi-lē-'pe-pərz\ *n* pungent pods of the *Capsicum* genus that are found in spicy foods from south of the border *such as* salsas, tacos,

enchiladas, and guacamole and contain the chemical compound capsaicin, which studies show releases feel-good endorphins in the brain <*as in* "Whenever Jenna and I have a tiff, we go for Tex-Mex.">

red light \'red-'līt\ *n* an automated stoplight that's put up at busy intersections so drivers can check each other out

red lipstick \'red-'lip-,stik\ *n* a brightly colored cosmetic for women's lips that is always sexy, esp. with blond hair <*as in* Christina Aguilera, Marilyn Monroe, Gwen Stefani>

refractory period \ri-'frak-t(ə-)rē-'pir-ē-əd\ *n* down time needed for a penis to respond to stimuli after orgasm <*as in* "Honey, you'll just have to wait.">

regift \ri-'gift\ *vb* to rewrap an unwanted wedding present to give to somebody else

regret \ri-'gret\ *n* a feeling of melancholy remorse that people experience in later life when thinking about who they might have chosen and that can usu. be cured by attending their high school reunion <*as in*

"Andrea, I can't believe the airline charged you for two seats!"> **Non, je ne regrette rien** \'nȯ-zhə-nə-rə-gret-ryaⁿ\ [French *No, I regret nothing*] – see *EDITH PIAF*

rejection \ri-'jek-shən\ *n* a painful, often devastating emotion that comes after being told by the person one loves that he or she is no longer interested in continuing the relationship; a person who has been rejected can take some comfort, if not eventual satisfaction, in knowing that what comes around goes around – see *KARMA BUS*

REM (rapid eye movement) *n* a period of sleep during which one has vivid dreams about one's lover or about someone one wishes were one's lover <"I *REM'd* last night about Daniel Craig.">

REM

renovate \'re-nə-vāt\ *vb* to redo one's kitchen, bathroom, or house; a project that starts out as a bonding experience but as costs, delays, and frustrations increase can serve to test a relationship's durability

RENTAL

rental \'ren-t°l\ *n* a small truck that a person rents for a day shortly after agreeing to move in with a lover – see *U-HAUL*

reproduction \ˌrē-prə-'dək-shən\ *n* from a biological standpoint, the whole and only reason romantic love with its infinite complexities exists

reptilian \rep-'ti-lē-ən\ *adj* used to describe a cold-blooded, slimy person <*as in* snake, toad, crocodile, heartbreaker> **reptilian brain** \rep-'ti-lē-ən-'brān\ *n* **a :** the oldest and most primitive section of the human brain, which resembles the brain of present-day reptiles and governs instinctual behaviors *such as* breathing and survival of the species *such a*s physical maintenance, hoarding, dominance, preening, flirting, and mating, as well as basic emotions *such as* love, hate, rage, fear, and lust **b :** millions of years of evolution have added layers of complex rational thought to the reptilian brain so that one doesn't act violently or lose control

REPTILE

when a lover forgets his or her birthday but instead takes a deep breath, puts it in perspective, and moves on, sort of

restaurant \'res-t(ə-)ränt\ *n* an establishment featuring a dining area, kitchen, wait staff, and valet parking where a man takes a woman as part of a courting ritual that he hopes will lead to sexual favors, if not that night, then soon, but that can have the opposite effect should he display jerklike traits *such as* insulting the help, talking only about himself, under-tipping, sending back the wine, or splitting the bill

RESTAURANT

retrosexual \'re-trō-'sek-sh(ə)wel\ *n* a regular guy or "real man" <"After dating too many metrosexuals, Norberta's decided to try a *retrosexual*.">

return gaze \ri-'tərn-'gāz\ *n* a coy look one gives someone who is checking him or her

out that sends a message of mutual interest and that usu. provokes a smile from the gazer, which provokes a return smile from the re-gazer, which prompts an approach, introductions, etc. – compare *EYE HUMP*

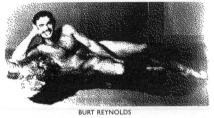
BURT REYNOLDS

Reynolds, Burt \\'re-nᵊl(d)z-bərt\ (b. 1936) popular actor who posed for *Cosmopolitan* magazine (April 1972), becoming the first nude male centerfold

rice \\'rīs\ *n* the starchy grain of an annual marsh grass that is grown in warm climates and used for throwing at newlyweds as they leave the church – see *WEDDING*

right \\'rīt\ **1** : *adv* by a 2-1 margin, the direction in which lovers turn their face when being kissed **2** : *adj* something men are always trying to get <"I told her she always looks good in that dress and she got pissed. I just can't get it *right*.">

ring finger \\'riŋ-'fiŋ-gər\ *n* counting from the forefinger, the 3ʳᵈ finger of the left hand, where an engagement ring is worn – see *VOWS*

Rio \\'rē-(ˌ)ō\ (Rio de Janeiro) *n* **a** : sexy SE port city of Brazil whose attractions include Copacabana and Ipanema beaches **b** : famous for its music, which includes the samba, rumba, and bossa nova, carnival celebrations and parades, and iconic bombshell movie star Carmen Miranda (1909–1955), who sang and danced in plat-

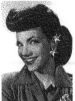
CARMEN MIRANDA

form heels with an orchard of fruit on her head <*as in* "Aye-aye-aye I like you very much."> – see *BRAZILIAN* **Flying Down to Rio** \\'flī-iŋ-'daùn-tə-'rē-(ˌ)ō\ *n* 1933 movie (*dir* Thornton Freeland) that first paired Fred Astaire and Ginger Rogers

ripped /'ript/ *adj* **1** : used to describe a man or woman who has little body fat and whose muscles are very well defined <"That guy at the gym is *ripped*."> **2** : very drunk <"That guy at the bar is *ripped*."> **ripped-shit** /'ript-'shit/ *adj* really ripped

road erection \\rōd-i-'rek-shən\ *n* **a :** an unconscious physical reaction that occurs in males when driving in cars (esp. on gravel roads) or while taking public transportation **b :** the condition is caused by the combination of vibrations (which send extra blood to the penis) and sitting (which can shut veins carrying blood out of the penis)

robe \\rōb\ *n* a loose, tantalizing garment made of cloth, velvet, or silk that a person sensuously slips on with little or nothing underneath and whose front is barely held shut by a sash <"No beauty she doth miss/When all her *robes* are on/But Beauty's self she is/When all her *robes* are gone." –ANON.>

robin \\rä-bən\ *(Turdus migratorius) n* **a :** North American member of the thrush family that reappears each spring with its motivational song, "Cheer up, cheer up, cheer up" **b :** a symbol of hope for singles who've stayed in all winter because they couldn't find a date **Robin Byrd** \\rä-bən-'bərd\ a fixture on New York City's late-night public-access TV since 1977 who, as host of her eponymous show, always tells viewers not to be sad if they're all alone, "be-

cause you always have me" <*as in* "Cheer up, cheer up, cheer up.">; dressed in signature black crocheted bikini and wearing white fingernail polish, she

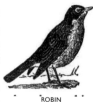
ROBIN

always invites her guests, male and female stripteasers, to join her at the end of her show in a rousing dance rendition of the 1950s R&B song, "Baby Let Me Bang Your Box" **Robin Hood** \\rä-bən-'húd\ *n* legendary medieval English outlaw whose romantic target was Maid Marian **Robin and Marian** \\ra-bən-ən(d)-'mer-ē-ən\ *n* 1976 movie (*dir* Richard Lester) in which Sean Connery and Audrey Hepburn play the long-separated lovers who are reunited on her deathbed <*as in* "Where this [arrow] falls, John, put us close, and leave us there." –ROBIN to Little John, on where Marian and he should be buried as he shoots an arrow out her bedroom window

Robinson, Jackie \\rä-bən-sən-'ja-kē\ (1919–1972) first African American baseball player in the major leagues (Brooklyn Dodgers); in his autobiography, he recalls being told by Branch Rickey, manager of

the Dodgers, that as he crossed the color line he would need a good woman at his side, and this he found in Rachel Isum (b. 1922), a UCLA nursing student, whom he married in 1946 and remained married to until his untimely fatal heart attack; despite death threats, harassment, and physical abuse from players and fans, he told *People* magazine, "When they try to destroy me, it's Rachel who keeps me sane."

rocket \'rä-kət\ *n* a car; a motorcycle; a penis **rocket scientist** \'rä-kət-'sī-ən-tist\ *n* something a boyfriend, girlfriend, or lover with a low I.Q. isn't <"I don't mean to sound unkind, but Erin's new boyfriend is no *rocket scientist*.">

roller coaster \'rō-lər-'kōs-tər\ *n* an elevated amusement park ride constructed with steep inclines and sharp curves and a track

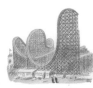

carrying small, open-air cars in which couples spend 2–3 mins. clinging to each other while traveling at breakneck speeds – see *CONEY ISLAND*

ROLLER COASTER

HEPBURN & PECK

Roman Holiday \rō-'män-'hä-lə-,dā\ *n* (*dir* William Wyler) 1953 film starring Audrey Hepburn (who won the Oscar for Best Actress) that tells the fairy-tale story of a rebellious young princess who goes AWOL for 24 hours in Rome, where she falls in love with a newspaperman (Gregory Peck), but who soon comes to her fiscal senses and resumes her royal duties of smiling and waving to crowds *note* voted by the American Film Institute as the fourth most romantic movie ever made

Romeo and Juliet effect \'rō-mē-,ō-ən(d)-'jül-yət-i-'fekt\ *n* a condition in which social or physical barriers serve only to kindle passion and the subject of countless angst-ridden ballads *such as* Frankie Valli's "Dawn" <"I want you to think what your family would say, think what you're throwing away," *as in* class differences), Nat King Cole's "Too Young to Go Steady"<"They say that love's a word, a word we've only heard," *as in* age>, and Gene Pitney's "Town Without Pity" <"If we stop to gaze

upon a star, people talk about how bad we are," *as in* social ostracism>

Rooney, Mickey \\'rü-nē-'mi-kē\ (b. 1920) diminutive Hollywood child star turned character actor who's a giant in the marriage department, having walked down the aisle with 8 brides <*as in* Ava Gardner, Betty Jane

MICKEY ROONEY

Rase, Martha Vickers, Elaine Devry, Barbara Ann Thomason (*aka* Carolyn Mitchell), Marge Lane, Carolyn Hockett, and Jan Chamberlin>

roses \\'rōzəz\ *n* **a** : thorny, showy flowers (genus *Rosa*) traditionally sent to lovers to mark special occasions *such as* birthdays, anniversaries, Valentine's Days, or great sex **b** : prized for centuries for their beauty and source of perfume, roses are the world's most cultivated ornamental plant, with more than 20,000 named cultivars **c** : roses symbolize warmth, affection, and quality of life <"A life with love will have some thorns, but a life without love will have no *roses*." –ANON.> **rosebud** \\'rōz-ˌbəd\ *n* **1** :

symbol of youth and innocence <"Gather ye *rosebuds* while ye may, / Old Time is still a-flying, / And this same flower that smiles today, / Tomorrow will be dying." –ROBERT HERRICK, 1591–1674> **2** : [slang] a pink anus **rose-colored glasses** \\'rōz-ˈkə-lərd-ˈgla-səz\ *n* metaphorical spectacles that people wear when in love

· ·

THE MEANING OF ROSES

Black: death
Blue: hope, new possibilities
Coral: desire
Lavender: love at first sight
Orange: pride, enthusiasm
Peach: appreciation
Pink: gentility, fun
Pink (dark): thank you
Pink (pale): friendship, joy
Purple: enchantment
Red: romance, passion
Red-and-pink: strong passion
Red-and-white: unity
Red-and-yellow: happiness
White: loyalty, young love, spiritual love;
 can be mixed with other colors to
 strengthen a message
Yellow: apology, sympathy

ROSE

Single rose: You are the only one
Six roses: I miss you
Seven roses: Infatuation
Dozen roses: I love you; gratitude
Eighteen roses: I'm sorry
Twenty-five roses: Congratulations
Fifty roses: Unconditional love
Withered roses: It's over

..

Roto-Rooter \\'rō-(,)to-'rüt-ər\ *vb* to deep kiss <"I wish Nicholas and Kara would stop *Roto-Rootering* in front of everyone.">

R&R (rest and relaxation) *n* a period apart from one's lover, partner, or spouse, during which one can take a break from too much sex <"Amy's on a business trip, and so I can finally get some *R&R*.">

Rubenesque \\'rü-bə-nesk\ *adj* a woman of ample proportions based on the sensual, fleshy females featured in the paintings of Flemish artist Peter Paul Rubens (1557–1640) <"A humor broad to

RUBENESQUE

match the body, / far too exuberant to be bawdy. / ...A bust no bra could hope to capture. / Let Peter *Rubens* paint the picture." –ROBERT FRANCIS, "Alma Natura">

Rubirosa, Porfirio \\'rü-bə-rō-sä-pōr-'fə-rē-ō\ **1 :** (1909–1965) suave international playboy, polo player, diplomat, and Formula One race car driver who was born in the Dominican Republic and who dat-

PORFIRIO RUBIROSA

ed and married the world's most desirable women; his 5 wives were, in order of succession: daughter of Dominican dictator Rafael Leónidas Trujillo, Flor de Oro; legendary French actress and beauty Danielle Darrieux; tobacco heiress Doris Duke; Woolworth heiress Barbara Hutton (a union that lasted only 53 days); and French actress and then teenager Odile Rodin; his paramours included Dolores Del Rio, Eartha Kitt, Zsa Zsa Gabor, Ava Gardner, Veronica Lake, Eva Peron, and Kim Novak; it's said

that in addition to his rugged good looks he was notoriously well endowed and not just financially; Truman Capote described Rubirosa's sexual organ as "an 11-in. café au lait sinker as thick as a man's wrist"; died in Paris when coming home from a party he crashed his Ferrari into a tree **2** : *n* [slang] a large, wooden peppermill

ruby \'rü-bē\ *n* a deep-red gemstone that maharajas give to maharanis <see *TAJ MA-HAL*> and that is mentioned in the *Bible* <"A virtuous wife is worth more than *rubies*." –PROVERBS 31> **RUBIES** \'rü-bēz\ *n* acronym for "rich urban bikers" – see *HARLEY-DAVIDSON*

rugged features \'rə-gəd-'fē-chərz\ *n* a male trait that studies show women are attracted to as it suggests a large reserve of testosterone ***ant*** pretty boy – compare *KEN DOLL*

rum \'rəm\ *n* a potent spirit made from sugarcane and used in tropical drinks with umbrellas *such as* mai tais, daiquiris, and blue Hawaiians

Rumi \'rü-mē\ (Jalal ad-Din Ar-Rumi) **a** : the world's greatest mystic Sufi poet

WHIRLING DERVISHES

(1207–1273), who believed in the universality of love and whose inspirational poems can be found everywhere today, esp. at Amazon.com, which lists more than 6,400 "Rumi" hits **b** : founded the Whirling Dervishes, who used music and dance to put a whole new spin on worshiping

rusticate \'rəs-ti-ˌkāt\ *vb* to get out of town with one's lover and spend some time in the country <"Ruby, pack a bag. We need to *rusticate*."> – see *GENERAL STORE*

rut \'rət\ *n* a state of sexual excitement among animals *such as* goats, sheep, deer, and pigs **rutting** \'rə-tiŋ\ *vb* to make crude sexual sounds that people overhear <*as in* "I don't mind that you have sex in your hot tub. But I DO mind it when I am in the middle of a much-needed gardening project." –CRAIGSLIST>

sags \'sagz\ *n* condition that occurs during the body's aging process as muscles lose their fleeting tautness <"If you want to be a sexual person, you've gotta really make a commitment to it, you've got to really say, 'I'm gonna love my *sags*.'" –JOAN PRICE, author, *Better Than I Ever Expected: Straight Talk About Sex After Sixty*>

SAGS

salt-and-pepper \'sòlt-ən(d)-'pe-pər\ *adj* used to describe a man's hair that is both dark and light and says he is neither young nor old but just about right

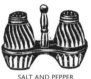

SALT AND PEPPER

samatta? \sə-'ma-tə\ *interj* a male response to a sharp look or physical dig from a girlfriend or wife to express his confusion over what he said or did that irked her <"*Samatta?* What'd I say?"">

Sanchez, Fernando \'sän-chez-fər-'nän-(ˌ)dō\ (1935–2006) Belgian fashion pioneer who captured the naughty side of couture

S/T

243

by introducing dressmaking techniques *such as* finished seams and linings to innerwear *such as* slips and camisoles so that women could wear them as sexy outerwear beyond the boudoir – see *BUSTIER*

SAPPHO

Sappho \'sa-(ˌ)fō\ (ca. 610–580 B.C.) female poet from the Greek isle of Lesbos who is considered to be the greatest poet of the classical era and whose messages of erotic love and worship of pagans so upset radical Christians that they destroyed most of her work; because she ran a school for girls and wrote love poems to women, many think she may have been gay, or bicurious, though anyone who lives on the isle of Lesbos, be it a man, woman, or goat, would be called a Lesbian

sassy tuna \'sa-sē-'tü-nə\ *n* a woman who is exceptionally flirty and brazen <"That *sassy tuna* patted my ass!">

satisfy \'sa-təs-ˌfī\ *vb* to afford sexual gratification to one's partner by leaving nothing to be desired except rolling over and getting some sleep

SAXOPHONE

saxophone \'sak-sə-ˌfōn\ *n* one of a group of single-reed woodwind instruments ranging from soprano to bass that when heard on a sultry night produces a sound of unbearable loneliness and longing

scary potatoes! \'sker-ē-pə-'tā-(ˌ)tōs\ *interj* used to describe a creepy first impression of a blind date <"He asked to use the bathroom and didn't come out for 30 minutes – *scary potatoes!*">

SCENERY

scenery \'sē-nə-rē\ *n* an attractive person that one is romantically interested in but can't have because he or she is of the wrong sexual orientation so that all one can do is sit back and enjoy the view

schadenfreude \'shä-dᵊn-ˌfrȯi-də\ *n* [German *damage + joy*] a term meaning pleasure taken from another's misfortunes

such as a broken engagement or rained-out honeymoon <"When Jan found out that her ex-husband's girlfriend had left him, she shivered with *schadenfreude*.">

schoolmarm \\'skül-'marm\\ *n* in old TV Westerns a prim woman whose love could tame gunslingers and cattlemen

SCHOOLMARM

schwaggle \\'shwa-gəl\\ *vb* to hang out with one's significant other to the complete exclusion of one's friends <"I never see Chris anymore – he's always off *schwaggling* with Deirdre.">

score \\'skȯr\\ **1 :** *vb* to get to 4th base *as in* having sexual intercourse <"I *scored* with Madison last night during *Dancing with the Stars*."> **2 :** *n* a lush movie soundtrack that prompts a guy to put his arm around his date's shoulder – see *SCORES TO SCORE BY p. 246*

Scotch whisky \\'skäch-'hwis-kē\\ *n* **a :** a potent, mature, smoky-tasting liquor produced in distilleries in Scotland from water, yeast, and fermented cereals, esp. malted barley **b :** considered a man's drink, which is why a woman who is in the dating scene keeps a supply in her liquor cabinet; when ordered by a woman on a first date, it immediately establishes her as a player [archaic *broad*] **c :** unlike Irish or U.S. whiskey, Scotch whisky is always spelled without the "e" and comes from the Scots Gaelic *uisge beatha* (water of life) **d :** famous Scotch drinkers include Winston Churchill, George Burns, James Stewart, Oliver Reed, Dylan Thomas, William Faulkner, George Bernard Shaw, and Robert Burns <"I like my *whisky* old and my women young." –ERROL FLYNN, 1909-1959>

scruffmuffin \\'skrəf-'mə-fən\\ *n* a hot guy with long hair and a beard who also takes regular showers and clips his nails

seagull \\'sē-'gəl\\ *n* a large aquatic bird (genus *Larus*) with blue-gray back, yellow beak, and flesh-colored legs that is found on both U.S. coasts as well as inland lakes and waterways and whose

SEAGULL

245

SCORES TO SCORE BY

Around the World in 80 Days (1956)	Victor Young
A Summer Place (1959)	Max Steiner
Body Heat (1981)	John Barry
Breakfast at Tiffany's (1961)	Henry Mancini
Casablanca (1942)	Herman Hupfield/Max Steiner
Dirty Dancing (1987)	Various artists
Doctor Zhivago (1965)	Maurice Jarre
Friendly Persuasion (1956)	Dimitri Tiomkin
Gigi (1958)	Frederick Loewe/Alan Jay Lerner
Goldfinger (1964)	John Barry
Gone with the Wind (1939)	Max Steiner
Laura (1944)	David Raskin
Never on Sunday (1960)	Manos Hadjidakis
Out of Africa (1985)	John Barry
Picnic (1955)	Robert Earl Keen
Romeo and Juliet (1996)	Nino Rota
Summer of '42 (1971)	Michel Legrand
Ten (1979)	Henry Mancini
The English Patient (1996)	Gabriel Yared
The Mambo Kings (1992)	Tito Puente and others
The Umbrellas of Cherbourg (1964)	Michel Legrand
The Way We Were (1973)	Marvin Hamlisch
Titanic (1997)	James Horner
West Side Story (1961)	Leonard Bernstein/Stephen Sondheim
Written on the Wind (1956)	Dimitri Tiomkin

piercing cry is used to convey longing in movies when heartbroken lovers take solitary walks along the shore

seamed stockings \\ˈsēmd-ˈstä-kiŋz\ *n* gossamer leg hosiery that comes in black or flesh tones, has a back seam, and makes a woman or cross-dresser look sexy, chic, and cosmopolitan *var* fishnet stockings *note* on the Internet one can still buy retro-style "fully fashioned" seamed stockings tailored to fit and defined by a finishing loop at the top

SEPTEMBER

secret code \\ˈsē-krət-ˈkōd\ *n* a conspiring, ESP-like communication that men believe women share

sensitive guy \\ˈsen(t)-sə-tiv-ˈgī\ *n* a boyfriend who is environmentally aware, recycles, rides a bike, doesn't wear animal skins, and is the kind of man most women say they want until he cries, can't change a tire, or freaks out at a bug

September \sep-ˈtem-bər\ *n* the 9th month of the Gregorian calendar, when school begins and lovers can reclaim their turfs *such as* parks, movie theaters, and beaches

serotonin \ˌsir-ə-ˈtō-nən\ *n* **a :** a chemical widely distributed in the body, esp. the brain, where it acts as a neurotransmitter and needs to be balanced with other neurotransmitters and hormones in order for a healthy love affair to ensue

7-Eleven \\ˈse-vən-ˈi-ˈle-vən\ *n* a convenience-store chain open 24 hours a day, 7 days a week, so that people en route to dates 7-ELEVEN can get Tic Tacs and people who can't sleep because they have broken hearts can get ice cream or a Big Gulp to see them through until morning

247

seven-year itch \'se-vən-'yir-'ich\ *n* a condition in which a partner in a marriage

MARILYN MONROE

or union becomes sexually bored and feels the urge to fool around *var* [gay] *seven-week itch* **(The) Seven Year Itch** \thə-'se-vən-'yir-'ich\ *n dir* Billy Wilder's 1955 adulterous film comedy that features the iconic image of Marilyn Monroe standing over a subway vent as her dress is blown skyward

sex \'seks\ *n* a non-prescriptive restorative for mild depression that produces a sense of euphoria and well-being by releasing feel-good endorphins into the bloodstream *syns* balling, banging, getting laid, having at it, hiding the weenie, screwing **sexcapade** \'sek-skə-ˌpād\ *n* a love triangle that usu. involves a politician, an ambitious young woman, and a tabloid **sex on the beach** \'seks-'ón-thə-'bēch\ *n* a cocktail that contains 1½ oz. peach schnapps, 1½ oz. vodka, 2 oz. cranberry juice, 2 oz. orange juice, and 2 oz. pineapple juice

Sexiest Man Alive \'sek-si-est-'man-ə-'līv\ *n* annual *People* magazine honor when middle-aged editors choose the hottest male celebrity on the planet, most of whom have also been middle aged *such as* Pierce Brosnan, George Clooney, Sean Connery, Harrison Ford, Richard Gere, and Nick Nolte

sexual Alcatraz \'sek-sh(ə-)wəl-'al-kə-ˌtraz\ *n* a marriage or relationship in which a man or woman feels sexually unsatisfied but can't do anything about it <"I'd like to have an affair, but there's no escaping this *sexual Alcatraz*." –CRAIGSLIST>

SEXUAL ALCATRAZ

shag \'shag\ *vb* to have sexual intercourse **shagnasty** \'shag-'nas-tē\ *n* kinky sex that can involve bondage or other S&M activities <"Few girls can do the *shagnasty* like Mary Alice.">

shed \'shed\ *n* a man's beer gut or extended middle-aged stomach that provides shelter from the elements to the person who is pleasuring him orally out of doors

248

shirtless \'shərt-'les\ *adj* **a :** without a shirt; topless **b :** shirtless U.S. males can be observed in their jogging shorts on the first warm days of spring or earlier in USDA-designated Hardiness Zones 7-11, which include Albuquerque, New Mexico (7), Washington, D.C. (8), Las Vegas, Nevada (9), Los Angeles, California (10), and Miami, Florida (11) **c :** famous shirtless males in U.S. iconography include Johnny Weissmuller (*Tarzan the Ape Man,* 1932, *dir* W. S. Van Dyke*)*, Clark Gable (*It Happened One Night,* 1934, *dir* Frank Capra), William Holden (*Picnic,* 1956, *dir* Joshua Logan), and Sean Connery (*Goldfinger,* 1964, *dir* Guy Hamilton)

SHOCK

shock \'shäk\ *n* an abnormal physical state associated with inadequate oxygen delivery to the metabolic apparatus of the mitochondrion and brought about by an unexpected occurrence *such as* finding one's lover in bed with one's best friend **shockarooni** \shä-kə-'rü-nē\ *n* **1 :** a bigger shock <*as in* "My Granny's a tranny!"> **2 :** a sudden shaking of the ground that is neither volcanic nor tectonic in origin

but brought about by the realization that one has fallen in love <"Is it an earthquake or simply a *shock*? Is it real turtle soup or merely the mock? Is it a cocktail this feeling of joy? Or is what I feel the real McCoy?" –COLE PORTER, "At Long Last Love">

SHOOT

shoot \'shüt\ *vb* **1 :** to experience ejaculation <"Don't move, baby – I'm gonna *shoot*."> **2 :** to take a photograph of one's lover <"Don't move, baby – I'm gonna *shoot*."> **shooting star** \'shü-tiŋ-'stär\ *n* the ionization trail of a meteoroid as it enters Earth's upper atmosphere, which never fails to thrill those who see it, esp. lovers <*as in* "It's a sign."> **shot** \'shät\ *adj* to be worn out from being out late <"Get some sleep, dude. You look *shot*."> – see *SHAGNASTY* **shot down** \'shät-'daùn\ *vb* to be suddenly rejected <"He didn't even say goodbye. He didn't take the time to lie...bang, bang, my baby *shot* me *down*." –SONNY AND CHER, "Bang Bang">

shoulder \'shōl-dər\ *n* the laterally projecting part of the human body that's composed of the clavicle (collarbone), scapula

249

(shoulder blade), and humerus (upper arm bone), which one willingly invites a heartbroken friend to cry on

show tunes \'shō-'tünz\ *n* euphemism used by heterosexuals to indicate or insinuate that someone is gay <"I'd say Loretta's husband definitely likes *show tunes.*">

shrimping \'shrim-piŋ\ *vb* the act of sucking a person's toes for erotic pleasure <*as in* Kathleen Turner in *Crimes of Passion*, 1984, *dir* Ken Russell>

shrink debt \'shriŋk-'det\ *n* a condition in which one never has enough money to have a life as one is in financial debt to a therapist, who one is seeing in an effort to figure out why one doesn't have a life

shudenoughta\'shü-dən-'ȯtə\ *vb* an expression used by Southern women to express humility and gratitude to a suitor who gives her something unexpected *such as* a kiss <called also *sugar*> or a gift <"Why, Rusty Peter, you *shudenoughta!*">

shysexual \'shī-'sek-sh(ə-)wəl\ *adj* a person who can't get the nerve to ask someout out

sick day\'sik-'dā\ *n* days that employees take off for illness <see *QUOTE UNQUOTE*> that are spent with a lover or spouse in some rare quality time together

SICK DAY

side squeeze \'sīd-'skwēz\ *n* a secondary partner in romance; a lover one has in addition to the object of one's affections – called also *significant 'nother*

sidewalk \'sīd-'wȯk\ *n* a paved public pathway on either side of a street where lovers can be seen strolling hand in hand or with their arms around each other's waists and usu. obstructing other pedestrians who are in a hurry and want to get by

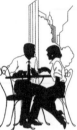

SIDEWALK CAFÉ

sidewalk café \'sīd-'wȯk-ka-'fā\ *n* a laid-back, outdoor spot found in cosmopolitan cities where lovers can go to enjoy a light meal while taking in the sights and sounds of urban life *as in* being panhandled **sidewalk sale** \'sīd-'wȯk-'sāl\ *n* a sale held at the end of the summer when people put their

250

ex-boyfriend's or ex-girlfriend's unclaimed belongings on the street to be sold

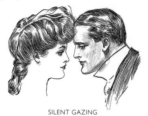

SILENT GAZING

silent gazing \'sī-lənt-'gā-ziŋ\ *n* a method of creating bonds with one's partner that's borrowed from tantric sex, in which 2 people sit opposite one another, face to face, silently gazing into each other's eyes for 5 mins., and then discuss the experience *note* clothing optional **silent pillow gazing** \'sī-lənt-'pi-(ˌ)lō-'gā-ziŋ\ *vb* a variation of silent gazing in which lovers lie in bed, their heads on separate pillows, staring into each other's eyes – see *STUPID ARM*

silly \'si-lē\ *n* a term of endearment used in the early stages of a relationship, when another person's faults are easily forgiven or perceived as charming <"You broke another wine glass, *silly*."> **Silly Putty** \'si-lē-'pu-tē\ *n* a brand name for a form of silicone plastic modeling clay that was accidentally invented in 1943 by James Wright of General Electric while trying to find a substitute for rubber and whose name is used to describe someone head over heels in love <"Rocky is *Silly Putty* in Ashley's hands.">

(The) Simpsons \thə-'sim(p)-sənz\ *n* (Homer and Marge) **a :** animated blue-collar couple from Springfield, USA, who, in their long-running Sunday evening Fox TV show, put the *fun* in dys*fun*ctional <*as in* "It takes two to lie: one to lie and one to listen."–Homer; "You should listen to your heart and not the voices in your head." –Marge> **b :** despite their harrowing predicaments, personality disorders, and ongoing battles, there's one thing that keeps them together: love <*as in* "Doh." –Homer>

Sinatra, Frank \sə-'nä-trə-'fraŋk\ (1915–1998) New Jersey–born crooner blessed by Apollo, the god of music, with vocal chords of divine, ambrosial tones in order that mortals could have a soundtrack to their love lives; in the 1950s he recorded a series of concept LPs for Capitol Records with conductor-arranger Nelson Riddle; *In the Wee Small Hours* (1955), the first

of the albums, features 16 smoky songs of desire and longing that were inspired by Sinatra's failing marriage <*as in* "I know what the cat who wrote the song is trying to say. I've been there – and back."> – see *AVA GARDNER*

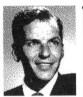

FRANK SINATRA

Singles Awareness Day \'siŋ-glez-ə-'wer-'nes-'dā\ *n* a counter-holiday celebrated on or around Valentine's Day, when singles who do not have valentines get together to commiserate and greet each other by saying, "Happy SAD."

sink \'siŋk\ *n* a free-standing or wall-mounted porcelain basin that is found in bathrooms and whose purpose is to help one prepare for a date <*as in* brushing teeth, applying makeup, shaving>

sinking feeling \'siŋ-kiŋ-'fē-liŋ\ *n* a knot in one's stomach that says one shouldn't have slept with someone so soon

size queen \'sīz-'kwēn\ *n* a person (usu. a homosexual male) who will only date a man who has a large penis and scrotum <called also *cod*, *ballsack* – see *LOW HANGERS*>

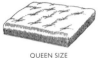

QUEEN SIZE

skin \'skin\ *n* the largest organ of the human body that accounts for 12–15% of bodyweight and has more than 1,000 nerve endings that never, ever, tire of being touched <*as in* "Hold me, thrill me, never, never, never let me go." –HARRY NOBLE, "Hold Me, Thrill Me, Kiss Me"> **skin-tight** \'skin-'tīt\ *adj* body-gripping clothes made of spandex or other stretchable materials worn by athletes for endeavors *such*

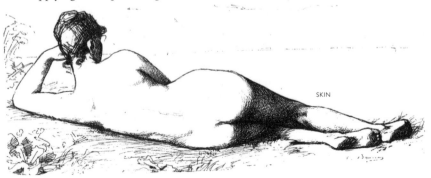

SKIN

as gymnastics, cycling, swimming, diving, and being salivated over by spectators

SKYLARK

skylark \'skī-ˌlärk\ *n* a small songbird *(Alauda arvensis)* whose elaborate and beautiful melodies have inspired romantics of both the Old and New Worlds to muse upon its joyous warbling <*as in* "Hail to thee, blithe spirit! / Bird thou never wert - / That from heaven or near it / Pourest thy full heart / In profuse strains of unpremeditated art." –PERCY BYSSHE SHELLEY, 1792-1822, "To a Skylark"; "*Skylark*, have you anything to say to me, can you tell me where my love can be?" –JOHNNY MERCER/HOAGY CARMICHAEL, "Skylark">

slatternly \'sla-tərn-lē\ *adj* used to describe a woman who is disorderly, disheveled, yet somehow still sexy *as in* Kirstie Alley, Kathleen Turner, and John Travolta (in *Hairspray*) – compare *BLOWSY*

sleeve \'slēv\ *n* the part of a garment that covers one's arm and is used for crying into when one's heart is breaking

sloe-eyed \'slō-ˌīd\ *adj* dark, slanted eyes belonging to a sexy, intelligent woman <"Four years later, baby fat disappeared, her bone structure became evident, and she developed into a sultry, *sloe-eyed* exotic young woman." –BARRIE ROBERTS, author, *Lynn Bari: The Siren Call*> – see *EYE EXPRESSIONS p. 92*

sloe gin \'slō-'jin\ *n* a sweet, gin-based liqueur flavored with blackthorn plums that fraternity boys use to get girls in the mood very quickly and very sick afterward; drinks made with sloe gin include the Alabama Slammer, Bionic Beaver, and Panties Dropper

• •

ALABAMA SLAMMER

½ oz. amaretto almond liqueur
½ oz. Southern Comfort peach liqueur
½ oz. sloe gin
1 splash orange juice
1 splash sweet-and-sour mix
Pour over ice into stainless steel cocktail shaker, strain, and serve in an old-fashioned glass.

• •

slow \'slō\ *adj* **a :** the opposite of fast <"Baby, let's take it *slow*."> **b :** taking it

SLOW

slow during lovemaking requires turning one's mind off to the outside world so that one can focus on minute motions *such as* gently running one's fingertips over a partner's forearm, kissing his or her eyes, or pausing to sigh in appreciation <"To have your particular pleasures known and accepted, to linger in them for as long as you will without any rushing to another stage or another excitement, to receive another's permission and invitation to loll there and play together – *is* there such as thing as sex that is too *slow*?" –ROBERT NOZICK, author, *The Examined Life* **c** : slow is a quality that women look for in men and something that experts say men need to pay better attention to <"I found somebody who will understand, when it comes to love, I want a *slow* hand." –POINTER SISTERS, "Slow Hand"; "Why should I deny that I would die to know a guy what takes his time?" –MAE WEST> **slow motion** \'slō-'mō-shən\ *n* a distorting of time that takes place when...two...lovers...run...toward...each...other...on...the...beach

slutware \'slət-'wer\ *n* **a** : revealing designer clothes that are marketed to pubescent and prepubescent girls *such as* hip-hugger jeans, thong-style underwear, peek-a-boo tanks, and shrunken see-through T-shirts with provocative messages **b** : sold in mainstream department stores *such as* Abercrombie & Fitch to the concern of many parents <*as in* "All [parents] have to do is persuade the kids that it's cool or da bomb or whatever, and we'll have them dressing like the Amish in no time." –FREE REPUBLIC, Internet blog> **slutwitch** \'slət-'wich\ *n* a temptress who leads a man on <"The *slutwitch* was beautiful but taller than I expected and had a deep FM-DJ-type of voice. As I watched her slink away it hit me, my *slutwitch* was a dude." –CRAIGSLIST>

smell \'smel\ *vb* **a** : the primary function of the nose besides holding up one's Ray-Bans **b** : through odor receptors inside one's nose <called also *nosh*, *schnoozle*> a person is able to recognize 10,000 scents, information that the olfactory nerves send on to the brain's limbic system, which is

SMELL

254

where a person's emotions, feelings, sexual arousal, and memory are housed; olfactory neurons live only about 60 days but new ones are constantly being generated; the memory of a scent survives because the axons of neurons that express the same scent receptor always go to the same location in the brain, so that old lovers, for better or worse, never really go away but keep returning through smells that bring back an experience or special moment – see *PHEROMONES*

Smith, Bessie \'smith-'be-sē\ (1894–1937) U.S. Empress of the Blues whose signature songs didn't beat around the bush but went right for it *as in* "I need a little sugar in my bowl, need a little hot dog on my roll" (1931, J. T. Brymn/Dally Small/ Clarence Williams) and "Nobody in town can bake a sweet jelly roll like mine" (1923, Clarence Williams/Spencer Williams)

BESSIE SMITH

snack \'snak\ *n* a light meal one always has before going on a blind date so as not to be too hungry if it

SNACK

doesn't lead to dinner or, if it does, to appear in control of one's body

snail darts \'snāl-'därts\ *n* small (less than ½-in.) calcium darts that mating garden snails shoot at each other to increase the amount of sperm that survives – see *CUPID*

SNAIL

snit \'snit\ *n* the temporary refusal by a lover or partner to speak to his or her other half, which involves a tightening of the lips and sphincter muscle and is usu. brought on by something said or done unintentionally or unknowingly <see *SAMATTA?*>; should the person to whom the snit is directed require specifics, he or she is usu. given minimal information <*as in* "You know what you did."> – called also *snit fit* **syn** somebody needs a diaper change

snookiebear \'snù-kē-'ber\ *n* a term of endearment for a cuddly male lover <"Who's my widdle *snookiebear*?">

Some Enchanted Evening \'səm-in-'chantəd-'ēv-niŋ\ *n* quintessential Rodgers and Hammerstein love ballad that urges

SOME ENCHANTED EVENING

one to take immediate action if one sees an attractive stranger across a crowded room, or else suffer the consequences <*as in* "For all through your life you may dream all alone."> – see *CONDITIONAL LOVE SONG*

soonish \'sü-nish\ *adv* **a :** a word women use with men to buy more time for themselves **b :** infers speediness but could in fact mean several hours from now and is usu. used chiefly as a response to a question *such as* "When will you be done shopping?" or "Are you about done in the bathroom?"

South Dakota \'saùth-də-'kō-tə\ *n* U.S. state in the upper Midwest (pop. 750,000) where

more women receive oral sex than in any other state and where men have the greatest concern over whether or not their partners reach orgasm *source Men's Fitness*, "Sex in the U.S.A." study

South Pacific \'saùth-pə-'si-fik\ *n* **1 :** the area of the world that includes Australia, Bali, Bora-Bora, Fiji, Indonesia, New Zealand, Tahiti, and Tonga, as well as thousands of secluded, paradisiacal islands with white sand beaches to make love on **2 :** a 1949 Broadway musical based on James Michener's *Tales of the South Pacific*, whose themes include racism and washing men out of one's hair

space \spās\ *n* an unlimited 3-dimensional expanse that a person says he or she needs to have when ending a relationship <"Man, I need my *space*.">

spaghetti straps \spə-'ge-tē-'straps\ *n* thin pieces of fabric resembling strips of cooked spaghetti that are found on women's clothing, from sundresses to after-five wear, and are a big turn-on to men, esp. when they slip off a woman's bare shoulder and onto her upper arm

Spanish guitar
\\spa-nish-gə-'tär\ *n* an acoustic, non-ampli-fied wooden instru-

SPANISH GUITAR

ment with a long fretted neck, sound box, and 6 nylon strings that when plucked with a pick or fingers create sounds of such haunting tonal qualities that whoever hears it is instantly in the mood *por amor* – see *CASTANETS, FLAMENCO*

spell check \\spel-'chek\ *n* computer software that people who place personal ads should use so they don't sound illiterate <*as in* "I have alot to offer," "I'm very hansome," "My calender is open," "Let's rendesvous," or "I'm really horney.">

'splainin' \\splā-nin\ *vb* a retro imperative coined by Ricky Ricardo on the *I Love Lucy* TV show <"Luceeeee, you've got some *'splainin'* to do.">

sponsored wedding \\spän(t)s-(ə-)rd-'we-diŋ\ *n* a wedding in which some or all of the products or services are provided in exchange for publicity <*as in* "This is an era of corporate sponsorship. Weddings very much reflect what is going on around us culturally." –Antonia van der Meer, editor-in-chief, *Modern Bride*>

squeak \\skwēk\ *n* a screechy sound made by the bedsprings underneath a mattress when pressure is applied to it

BEDSPRING

standard \\stan-dərd\ *n* an imaginary level of acceptability that one sets when dating and that sometimes has to be lowered, esp. as one ages **standard line** \\stan-dərd-'līn\ *n* an excuse one hears over and over from the same person <*as in* "He says he forgot his cell phone and that's why he couldn't reach me," *as in* "Yeah, yeah.">

stank \\staŋk\ *adj* used to describe a boyfriend or girlfriend who is trashy or has too much 'tude <"I must apologize for acting *stank*, treating you this way." –Gwen Stefani, "Sweet Escape">

stare \\stär\ *vb* a look thrown by a woman to let a man know he doesn't stand a chance of winning

starter marriage \\stär-tər-'mer-ij\ *n* a brief first marriage that ends in a clean divorce

involving no children, property, or acrimony – called also *icebreaker marriage, practice marriage, training marriage*

Star Trek \'stär-'trek\ *n* NBC sci-fi series that ran from 1966–1969 and followed the adventures of a spacecraft and its crew who went places where no man had dared to go before *as in* the first interracial kiss on TV, between Captain Kirk (William Shatner) and Lieutenant Uhura (Nichelle Nichols) – see *PON FARR*

CAPTAIN KIRK

statistic \stə-'tis-tik\ *n* a random variable that a woman feels like after being dumped by a playboy lover <"Just call me another of his *statistics*.">

sticky note \'sti-kē-'nōt\ *n* **a :** a small piece of paper that has an adhesive backing for sticking on objects *such as* refrigerators, car doors, and briefcases and that lovers use as a form of communication <*as in* cutesy messages and smiley faces> **b :** used by spouses as a non-verbal form of nagging

<*as in* "Pick up dry cleaning."> – called also *Post-its*

stiletto \stə-'le-(ˌ)tō\ *n* a very narrow, towering shoe heel introduced in 1953 to make women appear taller, lighter, and capable of inflicting pain

still \'stil\ **1 :** *n* a quiet period in the middle of the night when a person wakes up to obsess about the person he or she loves or desires <"As I gaze out my window at the moon in its flight, my thoughts all stray to you." –COLE PORTER, "In the *Still* of the Night"> **2 :** *adv* used to indicate the continuance of a condition <"You're *still* young," "You're *still* beautiful," or "You're *still* here?" *as in* "I'm late for work – get outta here.">

Stone, Sharon \'stōn-shə-'rōn\ (b. 1958) **a :** film star, feminist, Buddhist, political activist, and human rights crusader with a reported I.Q. of 154 who, after 3 failed marriages, said, "Women might be able to fake orgasms, but men

SHARON STONE

can fake whole relationships." **b** : achieved stardom in the 1992 adventure thriller *Basic Instinct*, when her vagina was exposed to the camera as she uncrossed her legs while being interrogated by the police

stop button \\'stäp-'bə-tᵊn\\ *n* the red button inside an elevator, which is meant to be pushed when 2 lovers need their privacy

strawberry \\'strȯ-ˌber-ē\\ *n* **1** : **a:** a spring berry (genus *Fragaria*) that is grown in every U.S. state and province of Canada and that lovers feed to each other during foreplay as its intense flavor provides an instant burst of excitement to the mouth region while its antioxidants send blood flowing to the testicles **b** : according to legend, if one breaks a double strawberry in half and shares it with another, love will ensue **c** : strawberries lend themselves to many types of sensual food pairings *such as* chocolate, whipped cream, and champagne **d** : many U.S. cities and towns hold strawberry festivals to celebrate the berry's harvest, one of the most famous being in Plant City, Florida, where, besides strawberries, they

STRAWBERRY

pick an annual Strawberry Queen and her court **2** : [slang] a pink anus – see *ROSEBUD*

Strawberry Fields \\'strȯ-ˌber-ē-'fēldz\\ *n* a teardrop-shaped peace garden in New York's Central Park dedicated to John Lennon and named after the Lennon/McCartney song "Strawberry Fields Forever," where "nothing is real and nothing to get hung about."

••••••••••••••••••••••••••••••••••••

STRAWBERRIES AU CHAMPAGNE
(serves 4)

4 cups sliced, fresh strawberries
⅓ cup chilled, dry champagne
20 organic rose petals (make sure they
 were not sprayed with chemicals)
Directions: Toss strawberries and champagne together. Gently toss in rose petals before serving.

••••••••••••••••••••••••••••••••••••

stubble \\'stə-bəl\\ *n* the beard growth that appears on a man's face after 2 days of not shaving and makes him look sexy until it starts turning gray, which makes him look old

stunt \\'stənt\\ *n* a ploy to get the affection of another <"If you ever pull that little *stunt* again...," *as in* running out of gas, reset-

ting a clock, standing one up) **stunt cock** \'stənt-ˈkäk\ *n* a length-to-girth proportionate penis (7¾ in. long but no more than 9 in. erect, according to adult entertainment industry standards) that is brought in during the climactic scene of a sex flick if the lead actor is unable to perform

STUPID ARM

stupid arm \'stü-pəd-ˈärm\ *n* what one experiences when one's arm has gone numb from lying on it while gazing at one's lover – see *AFTERGLOW*

suboccipitals \'sub-äk-ˈsi-pə-tᵊlz\ *n* the group of small neck muscles that do most of the work of turning the head when an attractive person walks by

suck \'sək\ *vb* to use one's mouth for oral gratification <"Lindsay loves to *suck* on fudgesicles."> **it sucks** \'it-ˈsəks\ *adj* crappy; not right <"If you're not in good communication with your partner, *it sucks*." –Tom Cruise, in *GQ* magazine>

suggester \səg-ˈjes-tər\ *n* the person in a relationship who is able to persuade the person who makes the decisions to make mutually beneficial choices <"For us, marriage is more a finesse game than a power game. It requires 'the *suggester*' and 'the discusser' as much as it does 'the decider.'" –Donna Perry Keller, *The New York Times* – see *DECIDER*

suit \'süt\ **1** : *vb* to express tentative approval of a friend's new boyfriend or girlfriend <"She *suits* you well."> **2** : *n* conservative outer clothing of 2 or more pieces that businesspeople wear to the office and that men look sexy in on a date but women don't

SUIT

summer afternoon \'sə-mər-ˌaf-tər-ˈnün\ *n* the part of day between noon and sunset in the season extending astronomically from the June solstice to the September equinox, which American novelist Henry James (1843–1916) called "the two most beautiful words in the English language" **summer hours** \'sə-mər-ˈau̇(-ə)rz\ *n* a policy in which companies allow employees to

leave early on Friday afternoons between Memorial Day and Labor Day in order to enjoy the warmer weather and longer days and to show them, along with profit sharing, stock options, and pensions, how much they are loved – compare *ALOHA FRIDAYS*

Sunday \'sun-dē\ *n* a day of rest that falls between Saturday and Monday, which women who are having affairs with married men usu. spend alone

Super Glue \'sü-pər-ˌglü\ *n* **a** : the brand name of a methyl-2-cyanoacrylate adhesive that was discovered by Harry Coover at Eastman Kodak during World War II and that fiery lovers keep in their homes in order to repair broken household objects *such as* tossed plates or vases **b** : in the early 1990s, it was rumored that actress Sean Young, who was going through a tempestuous breakup with actor James Woods, took revenge on him while he was asleep by supergluing his penis to his thigh, which she denied – see *BONDING*

surrender \sə-'ren-dər\ *vb* **a** : a giving up of power over one's sexual partner during the forceful rush of orgasm **b** : according to psychologists, men who are control freaks can't always let go of their power and as a result can be impotent <*as in* "Mr. Big Wig took me to Acapulco but he couldn't get it up."> – see *LIMP*

survivor guilt \sər-'vī-vər-'gilt\ *n* the guilt one often feels when one's romantic relationship or marriage has outlasted those of all of one's friends

susurrus \su-'sə-rəs\ *n* a soft whispering or murmuring that lovers like to give and receive

swan \'swän\ **1 : a :** *n* a monogamous aquatic bird (genus *Cygnus*) that glides gracefully across ponds alongside its mate, and when the pair put their heads together with their bills pointing downward, a heart shape is formed **b** : the swan has long been a favorite motif of art, literature, music, and mythology: in Wagner's opera *Lohengrin*, the eponymous knight sings the farewell aria to his swan, "Nun sei bedankt, mein lieber Schwan," <"Goodbye, *swan*.">; in Tchaikovsky's ballet *Swan Lake*, a handsome prince named Siegfried and a beautiful swan named Odette drown themselves

rather than live in separate nests; in Greek mythology, Zeus assumes the form of a swan in order to court Leda, with whom he fathers Apollo **2 :** *vb* to glide about <"His dream would be to *swan* around the Deep South going to garden parties and fanning himself off and wearing hoop skirts." –GoFugYourself, fashion blog> – see *GONE WITH THE WIND* **swan boat** \'swän-'bōt\ *n* a boat for children, sightseers, and lovers that is in the shape of a swan and is operated by a foot pedal; the most famous swan boats are in Boston Public Garden's lagoon, where they've been operating from early spring until after Labor Day for more than 130 years

sweat \'swet\ *n* the moisture produced during lovemaking that cleanses the pores and reduces one's chances of suffering from dermatitis and other blemishes of the skin

sweater girl \'swe-tər-'gər(-ə)l\ *n* **a :** a retro species of young women who wore tight cashmere sweaters to emphasize their breasts **b :** the prototype for the style was actress Lana Turner who, in 1937, made her screen debut wearing one as a murdered teenager in *They Won't Forget*, which led

LANA TURNER

to an era of famously endowed sweater girls of the 1940s and 1950s *such as* Jane Russell, Marilyn Monroe, and Jayne Mansfield **c :** cashmere sweaters were esp. popular with sorority girls of the 1950s who liked to pet

sweet \'swēt\ *adj* **a :** pleasing to the senses **b :** often used to modify innumerable words in the vocabulary of love *as in sweet* dreams, *sweet* talk, *sweet* breath, *sweet* sounds, *sweet* pea, sweet *revenge* **c :** can also be used to express a bitter sentiment <"*Sweet* is true love though given in vain." –Lord Alfred Tennyson, 1809-1892> **sweetheart** \'swēt-,härt\ *n* **1 :** either of a pair of lovers <"Some *sweethearts* can become tattooed in the hearts of their lovers forever." –LaMarr Cole, Lovelandia.com **2 :** film noir lingo for an extremely desirable person or thing <"Listen, *sweetheart*....."> **Sweethearts** \'swēt-,härts\ *n* heart-shaped candies that were invented by Necco after the Civil War and carry sweet nothings *such as* "be mine" and "I'm yours" **sweet**

sauce \\'swȯt-'sȯs\ *n* an expression used to describe something that is really good *such as* a compliment, a kiss, or a gift <"Thanks, babe, that's some *sweet sauce*.">

swim upstream \\'swim-'əp-'strēm\ *vb* to travel a long distance in order to get laid <*as in* a fish heading upriver to spawn>

swingers \\'swiŋ-ərz\ *n* couples who enjoy having sex in groups or with another couple <*as in* wife-swapping> – compare *MATE-POACHING*

synovial fluid \sə-'nō-vē-əl-'flü-əd\ *n* the thick, lubricating fluid in the joints that allows them to move smoothly so one can more easily assume sexual positions – compare *CRAMP*

SWINGER TERMINOLOGY

Full Swap Swingers who are OK with partners having sexual intercouse with others

Off-premise Venue A swingers' bar or club that serves alcohol but does not allow intense sexual play

On-premise Venue A bring-your-own-bottle swingers' bar or club that has rooms for sexual play

Playdar Internal barometer swingers use to determine if others are also swingers – compare *GAYDAR*

Soft Swap Swingers whose sexual play is limited to kissing and stroking

SWINGERS

taciturn \ˈta-sə-tərn\ *adj* used to describe a man who doesn't say a lot but has a lot to say – called also *Clint Eastwood*

tadpole \ˈtad-pōl\ *n* a young man whom an older woman is schooling in the ways of love <"Where did Mona catch a *tadpole*? She's practically pre-Columbian.">

taffeta \ˈta-fə-tə\ *n* a high-end silk fabric made mostly in India and used for ball gowns and wedding dresses; so lustrous is its sheen that in *Henry IV*, Part One, Shakespeare compares the "blessed sun" to "a fair hot wench in flame-colored *taffeta*"

Tahiti \tä-ˈhē-tē\ *n* the largest island of French Polynesia, where honeymooners on a bigger budget go instead of Hawaii and that's famous for its orchids, coconuts, and the *'upa'upa*, a traditional couples dance that the European discoverers found indecent – see *SOUTH PACIFIC*

265

tail fin \\'tāl-'fin\ *n* post–World War II automobile design feature that was most prominent in the 1959 Cadillac and whose illuminated, phallic, rocketlike shape said, "The future is here."

TAJ MAHAL

Taj Mahal \\'täzh-mə-'häl\ *n* a bejeweled mausoleum built by the 17th-c. Mogul emperor Shah Jahan for his beloved wife, Mumtaz Mahal, a highborn beauty who bore him 14 children during their 19-year marriage and who died in 1631 giving birth to the last; they are entombed alongside each other in a white marble sarcophagus at the heart of the edifice

talk \\'tȯk\ *vb* to deepen a relationship by communicating and exchanging ideas, which is usu. initiated by the female

but doesn't get very far <"Darling, let's *talk*." "About what?" "Us." "Huh?" "Never mind.">　**(The) Talk** \thə-'tȯk\ *n* a serious discussion about the status or future of a relationship, which requires sitting down – see *WE NEED TO TALK*

TALK

talk in caps \\'tȯk-'in-'kaps\ *vb* what adrenaline-pumped lovers do when describing their new boyfriend or girlfriend <*as in* "DUDE, SHE'S AWESOME!">

tango \\'taŋ-(,)gō\ *n* the world's sexiest dance, which originated in Argentina, where couples do it in the street; though there are various forms of tango, including American-style ballroom, they all require poise, grace, and attitude, as if one has just sniffed a bad smell

TANGO

tantric sex \\'tən-trik-'seks\ *n* an ancient Indian love practice in which couples

honor their bodies for what they *are* and not for what they *aren't* and whose simple but intense sexual practices can rejuvenate erotic fires – see *LINGAM, YONI*

• •

TANTRA EXERCISE

Both partners sit naked facing one another with legs crossed in lotus position. Each partner slowly touches his or her heart while staring intently and longingly into partner's eyes. If painful cramping ensues, get up.

• •

tap dance \'tap-'dans\ *vb* **1 :** to think quickly and creatively in order to dodge one's way out of an embarrassing situation <*as in* "This isn't what it looks like. I'm giving your sister the Heimlich Maneuver."> **2 :** an American form of dancing in which metal is attached to the heels and toes of shoes so that the feet become a percussion instrument; favorite American tap dancers include Fred Astaire, Sammy Davis, Jr., Savion Glover, Gregory Hines, Ann Miller, the Nicholas Brothers, and Bill (Bojangles) Robinson

tar beach \'tär-'bēch\ *n* the roof of an urban building where lovers who can't afford to get out of town on a summer afternoon can enjoy the sun <*as in* "Rudy invited me to the Roofhamptons this weekend.">

Target \'tär-gət\ *n* the retail store that was founded in 1962 in Minneapolis, Minnesota, and sells coolly designed kitchenware, bedding, and other household items at prices that young couples can afford **target date** \'tär-gət-'dāt\ *n* a tentative calendar date that is aimed for <"Our *target date* is June 15," *as in* wedding>

TARGET

Taylor, Elizabeth \'tā-lər-i-'li-zə-bəth\ (b. 1932) **a :** double-Oscar-winning movie star who was wed 8 times, twice to actor Richard Burton <compare *RICHARD FRANCIS BURTON*>, and is famous for her beauty, violet eyes, and being famous; she did for black bras (*Butterfield 8,* 1960, *dir* Daniel Mann) and white slips (*Cat on a Hot Tin Roof*, 1958, *dir* Richard Brooks) what Michelangelo did for high ceilings **b :** "Her wind-blown black hair frames her features like an ebony aureole and her large eyes

ELIZABETH TAYLOR

and red lips glisten warmly in the close-ups on the softly lighted screen." –Bosley Crowther, film critic, in his 1954 review of Taylor's romantic drama *Rhapsody* (*dir* Charles Vidor) – see *RACHMANINOFF*

tea dance \'tē-ˌdan(t)s\ *n* a pulsating disco dance event that occurs at gay resorts and takes its name from the genteel Victorian-era social dances and teas that took place on Sunday afternoons – see *SHIRTLESS*

TEARDROP

teardrop \'tir-ˌdräp\ *n* a watery saline liquid that is secreted by the lacrimal glands and falls from the eyes and down a person's face when one is either overcome with joy <*as in* loved walked in> or sadness <*as in* love walked out> – see *ONION* **Lonely Teardrops** \'lōn-lē-'tir-ˌdräps\ *n* classic 1959 oldie but goodie sung by Jackie Wilson and written by Gwendolyn Gordy-Fuqua

teaspoons \'tē-ˌspünz\ *n* **1 :** a front-to-back sleeping position popular with lovers **2 :** a sexy piece of silverware that lovers use to feed each other ice cream; also used after a meal to slowly stir sugar into one's coffee, espresso, or cappuccino while staring intently across the table at one's lover

telegram \'te-lə-ˌgram\ *n* [archaic] a rectangular piece of yellow paper that people in old movies receive from uniformed messengers and which contains important typed announcements or plot points *such as* "It's a boy stop" or "Wedding's off stop we've eloped stop"; the Western Union Telegraph Company, founded in 1856, sent its last telegram in February 2006 stop

SHIRLEY TEMPLE

Temple, Shirley \'tem-pəl-'shər-lē\ (b. 1928) **1 :** curly-haired, dimpled child star of the silver screen who sang and tapped her way into America's heart in some 29 films by the time she was 11 and who stopped believing in Santa Claus when, she says, "he asked for my autograph"; in her adult life she became a U.S. diplomat **2 :** *n* a non-alcoholic drink made with ginger ale, a dash of grenadine, and a maraschino cherry

268

tequila \tə-'kē-lə\ *n* **a :** a strong liquor made from the blue agave plant *(Agave tequilana)* of Mexico **b :** downed with salt and lemon juice in "tequila shots" or combined with triple sec for margaritas, can cause one to make phone calls to past lovers *<as in* "Ish Shhharon there? Tell her ish me.... She'll remember....">

testes \'tes-ˌtēz\ *n* the male reproductive glands that are oval and suspended in the scrotum – called also *acorns, balls, bernies, cajones, cohangas, cookies, clappers, crown jewels, diamonds, frick and frack, lightbulbs, nuts, tadpole factory, toolbox*

testosterone \tes-'täs-tə-ˌrōn\ *n* the hormone of sexual desire and an anabolic steroid that is produced in the male testes and female ovaries; males produce 20 times more testosterone than females, which may be the reason they'd rather invade other countries than go shopping

therapist \'ther-ə-pist\ *n* a licensed professional one visits when having problems with one's love life for insightful, expensive advice *such as* "Uh, huh," "Go on," and "How does that make you feel?"

thigh \'thī\ *n* a sensuous area between the hip and the knee that borders the genitals and is not to be touched until one is on 3rd base

(The) Thin Man \thə-'thin-'man\ *n* (1934, *dir* W. S. Van Dyke) the first of 6 comic detective films starring William Powell and Myrna Loy as Nick and Nora Charles, a well-off, flirtatious, bantering, carefree married couple who live in Manhattan with their wire-haired fox terrier, Asta, and who, when not downing martinis (up to 6 each in one scene), solve crimes; based on characters by Dashiell Hammett <Nora to Nick: "You got types?" Nick to Nora: "Only you, darling – lanky brunettes with wicked jaws."> **thinner** \'thin-ər\ *adj* a physical condition beyond thin that's fashionable among female celebrities and models

thong \'thȯŋ\ *n* **a :** a skimpy, T-shaped undergarmen that boasts "No visible panty line!" and is worn by women who like skin-tight pants; since its popularity in the late 1990s is responsible for hav-

THONG

ing converted many a breast and leg man to a booty lover <"Baby make your booty go da na, da na. Girl I know you wanna show da na, da na, that *thong thong thong thong thong*." –Sisqo, "Thong Song"> **b :** until the late 20th c. were called G-strings and associated with exotic dancers and strippers; today, worn by more and more women as beachwear <see *FERNANDO SAN-CHEZ*>; few men wear them, except on Mediterranean beaches and gay cruises

threat response \'thret-ri-'spän(t)s\ *n* the unconscious thrusting of the chest exhibited by a man when he's with a date and a potential romantic rival gets too close to the goods

THRONE

throne \'thrōn\ *n* an elevated, canopy-covered seat that kings and queens sit on and have to give up if they fall in love with a commoner – see *EDWARD VIII*

through \'thrü\ *prep* of no further use; get out of here; kaput <"I have given so much in the past for a love I never had. I'm *through* with love, I'm *through* with it, *through* with love." –Destiny's Child, "Through with Love">

throw together \'thrō-tə-'ge-thər\ *vb* to dress with great style or serve a gourmet meal without apparent effort in order to impress a boyfriend or girlfriend <"Oh, you like it? It's just something I *threw together*," *as in* it took all day>

thrust \'thrəst\ *n* a powerful driving force <"Penelope felt a frisson of excitement at the *thrust* of the jet's engines on take-off."> or pushing forward <"Ramiro *thrust* his way through the crowd to claim her.">

thumb \'thəm\ *n* an opposable, thick digit of the human hand that allows a man to grasp a woman and give her a swooping, passionate kiss

tightly wound \'tīt-lē-'wünd\ *adj* used to

TIGHTLY WOUND

describe a person who is so caught up in his or her job that he or she can't relax enough to have sex

tiki party \'tē-kē-'pär-tē\ *n* a retro-style Polynesian house party in which Don Ho and Martin Denny albums are played, pan-Asian hors d'oeuvres are served <*as in* coconut shrimp, sweet 'n' sour spare ribs, curried chicken shish-kebabs>, and cocktails sporting umbrellas are imbibed – see *RUM*; guests traditionally wear brightly colored muumuus, sarongs, Aloha shirts, cut-offs, and plastic leis

TIKI PARTY

time \'tīm\ *n* a continuum of events or conditions that goes by at different speeds <*as in* "When you are courting a nice girl, an hour seems like a second. When you sit on a red-hot candle, a second seems like an hour." –ALBERT EINSTEIN, 1879-1955> **time bomb** \'tīm-'bäm\ *n* a hothead boyfriend **time-share** \'tīm-'sher\ *n* a sexual lure <"Baby, I got a *time-share* in the Poconos."> **Times Square** \'tīmz-'skwer\ *n* an area of New York City that centers on 42nd Street and Broadway, where thousands of people kiss each other on New Year's Eve – see *AULD LANG SYNE*

tiptoe \'tip-'tō\ *vb* to walk softly on the balls of one's feet so as not to wake a sleeping lover **tiptoes** \'tip-'tōz\ *n* the front ends of the feet that are meant to be stood on in order to reach the lips of someone who is taller **Tiptoe Through the Tulips** \'tip-'tō-'thru-<u>th</u>ə-'tü-ləps\ *n* (Al Dubin/Joe Burke) 1929 novelty song that was resurrected by Tiny Tim, making him famous

TIPTOE

TITANIC

titanic \tī-'ta-nik\ **1** : *vb* to go down on a first date *as in* oral sex <"We *titanic'd* shortly after *Jay Leno*."> **titanic 2** : *adj* large <"Check out Diane's breasts. They're *titanic*.">

titivate \'ti-tə-ˌvāt\ *vb* to spruce up <"Marla will be down soon – she's *titivating*.">

271

toast \'tōst\ **1 :** *vb* a salutation of congratulations that a best man makes to newlyweds <"I'd like to *toast* Kevin and Darci as they begin their journey...."> **2 :** *adj* a lover or partner who has been dumped <"Darci, how's Kevin?" "He's *toast*.">

TOBOGGAN

toboggan \tə-'bä-gən\ **1 :** *n* a long, narrow sled designed so riders can secure their arms around the person sitting in front of them and breathe down their neck – see *NAPE* **2 :** *vb* to decline rapidly <"After Roshanda left me, my spirits *tobogganed*.">

toe cleavage \'tō-'klē-vij\ *n* the tops of a woman's toes that can be seen when she's wearing open-fronted shoes and that podophiliacs are esp. turned on by – see *FETISH*

toi \'twä\ *pron* the familiar form of *vous* (you) and more intimate form of *tu* (you) that a person employs when speaking softly or of love to a French man or woman <"*Toi*, quesque-tu pense, ma cherie?"> – see *WHADDYA THINKING?*

TOMATO

tomato \tə-'mā-(ˌ)tō\ *n* a fruit that was incorrectly classified as a vegetable by the U.S. government in 1893 and that because of its supposed aphrodisiacal powers is called *pomme d'amour* (apple of love) by the French *var* [gangster slang] tamata *as in* gorgeous doll

tomcruise \'täm-'krüz\ *n* an all-male gay cruise <"For our vacation this year, Keith and I booked a *tomcruise* out of Ft. Lauderdale.">

Tom Jones \'täm-'jōnz\ **1 :** *n* eponymous title character of Henry Fielding's comic novel of 1749 that tells the tale of a lusty lad of uncertain heritage – called also *bastard* **2 :** *n* 1963 movie (*dir* Tony Richardson) that features what movie critics and gourmands consider the sexiest eating scene ever filmed; won Oscar for Best Picture **3 :** power-voiced Welsh singer (b. 1940) whose hits include "It's Not Unusual," "What's

TOM JONES

New, Pussycat?," and "Delilah" and who is known for his open shirts, gold necklaces, and bulging crotch – see *PACKAGE*

tongue \'təŋ\ *n* a mucous membrane–covered organ that is attached to the floor of the mouth by the frenulum linguae and used for deep kissing, licking, and oral sex; secondary uses include eating and vocalization **tongue vibrator** \'təŋ-'vī₁brā-tər\ *n* a waterproof mini-vibrator that attaches to the lower teeth and makes the tongue vibrate for oral pleasure

top \'täp\ *n* the best <"You're the *top*! You're a Waldorf salad...a Berlin ballad." –COLE PORTER, "You're the Top"> **top and bottom** \'täp-'ən(d)-'bä-təm\ *n* **1** : the 2 loosely fitting components of a pair of pajamas that can be worn as an ensemble or separately when going to bed *note* in the 2006 revival of *The Pajama Game* on Broadway, stars Harry Connick, Jr., and Kelli O'Hara appear in the final scene wearing the same pair of pajamas – he in the top and she in the bottom – to indicate they have become lovers **2** : term used esp. among gay male lovers to describe what position is preferred; the top is the dominant giver, or pitcher, and the bottom is the passive receiver, or catcher – see *ANAL INTERCOURSE* **top secret** \'täp-'sē-krət\ *adj* an affair that no one is supposed to know about but everyone does

torch song \'tȯrch-'sȯŋ\ *n* a pre-feminist ballad whose lyrics express the angst of a woman carrying a flame for someone who often treats her like dirt <*as in* "He isn't true, he beats me too. What can I do?" –JACQUES CHARLES/ALBERT WILLEMETZ/MAURICE YVAIN, "My Man">

toreador pants \'tȯr-ē-ə-'dȯr-'pan(t)s\ *n* sexy, high-waisted, ankle-length trousers for women, styled after the skin-tight pants of matadors, which became a fashion statement in 1954 after Audrey Hepburn wore them in *Sabrina* (*dir* Billy Wilder); in the 1960s a similar looking, rest-on-the-waist version, called Capri pants, became a fashion trend, thanks to Jacqueline

MATADOR

Kennedy and TV's chicest housewife, Laura Petrie, as played by Mary Tyler Moore on *The Dick Van Dyke Show*

Tormé, Mel \'tȯr-'mā-'mel\ – see *(THE) VELVET FOG*

Torvill and Dean \'tȯr-vəl-ən(d)-'dēn\ British ice-skating partners (Christopher and Jayne) who received a perfect 10 from every judge at the 1984 Winter Olympics when they skated to Ravel's "Bolero" – see *SCORES TO SCORE BY p. 246*

toxic \'täk-sik\ *adj* a substance or presence that is detrimental to one's mental or physical health <"I love Tom, but those *toxic* stepchildren....."> **toxic bachelor** \'täk-sik-'bach-lər\ *n* a single man who is self-centered and afraid of commitment

TOYS

toys \'tȯiz\ *n* sexual aids or enhancements that are sold in adult stores and include a vast variety for singular or dual pleasure, ranging from mild to wild *such as* vibrating rubber duckies for the bathtub, flavored body gels, cock rings, plastic vaginas, strap-on dildos, nipple clamps, and hog-tie bondage truss bars – see *VIBRATOR*

trade paperback \'trād-'pā-,pər-bak\ *n* reading material that people who have no one to eat with take to restaurants **trade up** \'trād-,əp\ *vb* to leave one's lover for another who is perceived as being more desirable **trade wind** \'trād-wənd\ *n* a hot tropical current that blows trouble

train whistle \'trān-'hwi-səl\ *n* an everyday sound that never fails to stir one's soul <"A *train whistle* has a reassuring lull to it, conjuring up effortless travel and the timeless romance of the roads." –TOM MILLER, author> – see *ALL ABOARD!*

trapezius \trə-'pē-zē-əs\ *n* a large, flat triangular muscle of each side of the upper back that becomes knotted when a person is working at his or her computer; when rubbed or massaged by a boyfriend, girlfriend, or lover renders the receiver completely helpless, so much so that he or she is unable to say no to any demand or request, be it monetary, sexual, or social

TREVI FOUNTAIN

Trevi Fountain \'tre-vē-'faün-t°n\ *n* **a** : the baroque fountain in the center of Rome, Italy, where people throw coins while making a wish to find love **b** : played an important part in the 1954 movie *Three Coins in the Fountain* (*dir* Jean Negulesco), which featured the Oscar-winning ballad of the same name <*as in* "Just one wish will be granted, one heart will wear a valentine. Make it mine, make it mine, make it mine." –SAMMY CAHN/JULE STYNE>

triboelectric effect \,trī-bō-i-,lek-'trik-i-'fekt\ *n* an electrical charge or spark generated when 2 unlikely materials, properties, or bodies are rubbed together <*as in* silk on glass, hair on a balloon, Barry Diller on Diane von Furstenberg>

Trigger \'tri-gər\ *n* (1932–1965) Roy Rogers's golden palomino that was (and still is) America's most beloved horse and starred alongside and underneath the singing cowboy star in more than 100 films and 2 TV series; along with his pals Buttermilk (Dale Evans's horse) and Bullet (Rogers's German shepherd), Trigger is mounted in a rearing position at the Roy Rogers/Dale Evans Museum in Branson, Missouri, where 200,000 visitors go to see him each year – see *HAPPY TRAILS*

trimming the hedges \'tri-miŋ-<u>th</u>ə-'he-jəz\ – see *MANSCAPING*

tropical splendor \'trä-pi-kəl-'splen-dər\ *n* an exotic, evocative phrase coined by Cole Porter in "Begin the Beguine" <"It brings back a night of *tropical splendor*.">

Tropic of Cancer \'trä-pik-əv-'kan(t)-sər\ *n* **1** : 1936 novel by New York–born author and French ex-patriot Henry Miller <see *MARY PHELPS JACOB*> that was banned in the U.S. for being too sexually explicit and became the focus of a 1964 Supreme

TROPIC OF CANCER

Court decision overriding state obscenity laws, which helped usher in the sexual revolution **2** : the latitude on the terrestrial globe just north of the equator, where all the sunny vacation spots are situated

trothplight \'träth-ˌplīt\ *n* **a** : a proposal of marriage; a betrothal **b** : trothplight is the conjoining of 2 words – *troth* (faithfulness; fidelity) and *plight* (pledge)

∙∙

GROOM: I, Jon, take thee, Mary, to my wedded Wife, to have and to hold from this day forward, for better for worse, for richer for poorer, in sickness and in health, to love and to cherish, till death us do part, according to God's holy ordinance; and thereto I *plight* thee my *troth*.

BRIDE: I, Mary, take thee, Jon, to my wedded Husband, to have and to hold from this day forward, for better for worse, for richer for poorer, in sickness and in health, to love, cherish, and to obey, till death us do part, according to God's holy ordinance; and thereto I give thee my *troth*.

–VOWS OF A TRADITIONAL MARRIAGE
 CEREMONY, CHURCH OF ENGLAND BOOK
 OF COMMON PRAYER, 1662

∙∙

trouble \'trə-bəl\ *n* a predicament that men are always getting into with their wives or girlfriends and often not knowing why – see *SAMATTA?* **troublemaker** \'trə-bəl-ˌmā-kər\ *n* a person who spreads false gossip, esp. about people having affairs <"FYI, Mackenzie is the office *troublemaker*.">

trout pout \'traut-'paut\ *n* a popular S California look that's the result of unnaturally inflated lips from too many collagen injections – called also *collagenus lip inflatus*

Truman, Harry \'trü-mən-'her-ē\ (1884–1972) American Democratic statesman and 33rd president (1945–1953), who was married to his one and only love, Bess, for 53 years

HARRY TRUMAN

trumpet \'trəm-pət\ *n* a brass wind instrument that made headlines in a steamy 1983 divorce trial when Florida hotel and restaurant mogul Herbert Pulitzer accused his wife, Roxanne, of performing an unnatural sex act with one (which she denied but for which she was nicknamed "Strumpet with a Trumpet")

TRUMPET

trust \\'trəst\ *n* reliance on the fidelity, integrity, and honesty of a partner *note* without trust, no relationship can endure <"What loneliness is more lonely than dis*trust*?" –GEORGE ELIOT, 1819–1880> *ant* betrayal

truth \\'trüth\ *n* a state of actuality often denied when one is in love <*as in* "Who you gonna believe? Me, or your lying eyes?" –RICHARD PRYOR, on catching one's partner in bed with another person> **truthiness** \\'trü-thə-nəs\ *n* a term coined by satirist Stephen Colbert to describe things that a person claims to know intuitively and instinctively, with no regard for hard facts or evidence <*as in* "I know damn well Mario's messing around. I just don't know who with."> **truth serum** \\'trüth-'si-rəm\ *n* alcohol, esp. tequila, ouzo, and grappa

tryptophan \\'trip-tə-ˌfan\ *n* **a** : an essential amino acid and serotonin precursor found in protein-rich foods that people who aren't getting enough nookie try to get plenty of as it helps them sleep at night **b** : found in a variety of everyday foods *such as* dairy products, chocolate, bananas, dried dates, meat, fish, turkey, chickpeas, oats, and peanuts *note* also available in supplemental form (take just before bedtime)

T-shirt \\'tē-ˌshərt\ *n* a man's close-fitting inner- and outer-wear garment whose sweaty smell from being worn may be a sexual lure for women – see *CLAUS WEDEKIND*

tugboat \\'təg-ˌbōt\ *n* a short, stocky man with lots of energy and sex appeal

TUGBOAT

tunnel of love \'tən-nᵊl-əv-'ləv\ *n* nearly extinct amusement park ride in which a small boat on a channel of water carries a guy and his girl through a dark tunnel; its purpose is to bring couples closer together either through a romantically themed journey or one filled with scary surprises – see *AMUSEMENT PARK* **Tunnel of Love** *n* songs recorded by both Bruce Springsteen and Dire Straits

turboprop \'tər-bō-ˌpräp\ **a :** *n* a small jet aircraft designed to service minor hubs so non-urban people can have romantic visitors from big cities come and stay **b :** *vb* <"After a short layover at O'Hare, Jeremy *turbopropped* it to North Platte.">

turbulence \'tər-byə-lən(t)s\ *n* atmospheric disturbances that can cause airplanes to unexpectedly bounce about so that passengers can grab the hand of the handsome man or beautiful woman sitting next to them

turkey \'tər-kē\ *n* a loser <"That *turkey* – how'd he get Briana?"> **turkey cock** \'tər-kē-'käk\ *n* a strutting, conceited male <"Look at those *turkey cocks* working the boardwalk."> **turkey drop** \'tər-kē-'dräp\ *n* the period after Thanksgiving when college students dump their boyfriend or girlfriend after taking them home for Thanksgiving

LANA TURNER

Turner, Lana \'tər-nər-'lä-nä\ (1921–1995) blond Hollywood sweater girl turned glamour queen who was married 7 times and whose personal life turned ugly on Good Friday, 1958, when her 14-year-old daughter, Cheryl, stabbed and killed Johnny Stampanato, the star's gangster lover – see *FILM NOIR*

turnpike \'tərn-ˌpīk\ *n* **a :** a highway system in the U.S. that was modeled after the German autobahn, on which drivers pay tolls to ride at high speeds on wide, stoplight-free lanes so they can get to their boyfriend's or girlfriend's house really quickly **b :** the first modern turnpike was the Pennsylvania Turnpike, opened in 1940 **c :** patrolled by hot State Troopers in starched uniforms and specially designed hats

tuxedo \ˌtək-ˈsē-(ˌ)dō\ *n* a man's formal wear suit that is traditionally worn with a ruffled shirt, cuff links, bow tie, and patent leather shoes and transforms any man, esp. a groom, into Cary Grant

TUXEDO

TV light \ˈtē-ˈvē-ˈlīt\ *n* the warm glow that a television screen emits after the networks have signed off and that couples who have fallen asleep on the couch watching the late show wake up to <*as in* "Is it over? What'd I miss?">

Twenty-First Amendment \ˈtwen-tē-ˈfərst-ə-ˈmen(d)-mənt\ *n* U.S. constitutional amendment that repealed the 18th Amendment so that people looking for love could go somewhere, relax, and have a drink

(the) twist \thə-ˈtwist\ *n* a groundbreaking dance craze begun by singer Chubby Checker in 1960 in which couples did not have to have bodily contact with a partner, which led to the solitary self-expression of the disco floor

twisted \ˈtwis-təd\ *adj* crazy or codependent

Twister \ˈtwis-tər\ *n* a game played by 2–4 people that was vociferously dubbed "sex in a box" when it was introduced in 1966 by Milton Bradley; after spinning a dial, players are put in precarious and often suggestive contortions as they try to maneuver their hands and feet about a plastic sheet that's covered with large colored circles – see *ANIMAL POSITIONS, LORDOSIS BEHAVIOR*

CHUBBY CHECKER

tyrosine \ˌtī-ˈrō-sēn\ *n* an amino acid found in protein-rich foods *such as* meat, eggs, and cheese that helps keep lovers focused, energized, in a positive state of mind, and from acting on crazy impulses that could threaten, damage, or end a relationship – see *FATAL ATTRACTION*

279

über \'ü-bər\ *adj* a German word meaning "over" that combines with English words to form new words that exceed the norm <"Marky had an *überdate* with an *überhot* mòdel. They went to an *überchic* restaurant and afterward had *übersex*. Now he's got an *übercrush*. How *übercool* is that ?">

ugh \'əg\ *interj* an expression made when someone opens a picture of someone he or she responded to in a personal ad

ugsome \'əg-səm\ *adj* used to describe a loathsome experience <"How was the tantra sex weekend workshop, Gar?" "*Ugsome*."> – *ant* awesome

U-Haul \'yü-'hòl\ *n* a small moving van that can signify a beginning or an end

uh-oh \'əh-'ōh\ – see *UNEXPECTED*

ululate \'əl-yə-ˌlāt\ *vb* **1** : **a** : to howl like a dog **b** : a sound men sometimes make from their car window when they see a sexy woman **2** : to hoot like an owl <*as in* "Guess who just asked me out?" "Who? Who?"> – see *OWL HOOT*

281

UMBRAGEOUS

umbrageous \\ˌəm-ˈbrā-jəs\ *adj* providing shade for lovers on a picnic <"There's an *umbrageous* spot under that maple."> – see *RUSTICATE*

umbrella \\əm-ˈbre-lə\ *n* a circular cover attached to a ribbed, collapsible frame held up by a slender center pole and used in the rain as a way of meeting people <"Would you like to share my *umbrella*?">

UMBRELLA

Umbria \\ˈəm-brē-ə\ *n* a scenic, hilly, tranquil, historic region of central Italy with Medieval hilltop towns and great vinos and trattorias – called also *il cour verde d'Italia* (the green heart of Italy)

un- \\ən\ a prefix meaning "not," which can be a good thing or a bad thing or both

UN- POSITIVES
unaffected; unassuming; unbuckle; unbutton; unclasp; unclothe; uncritical; undemanding; undo; undress; undying; unfasten; unpin; unprickly; unvolcanic; unzip

UN- NEGATIVES
unaccompanied; unadmired; unavailable; unclassy; uncomfortable; uncommitted; uncool; uncouple; undemonstrative; undistinguished; unfaithful; unfeeling; unhip; uninterested; uninvited; unlucky; untogether

UN- POSITIVES OR NEGATIVES
unaudacious; uncanny; uncatered; uncircumsized (or uncut); unconcerned; unconforming; unconventional; undecided; unfair; unjust; unknightly; unlatch; unlisted; unmarried; unripe; unthankful; untuck; unused

unbelievable together \\ən-ˈblē-və-bəl-tə-ˈge-thər\ *adj* persuasive words that someone who's in the fog of love says to the object of his or her affection to try and convince that person that the 2 of them will be stronger and better off by taking their commitment to the next stage <"I know we'd be *unbelievable together*.">

uncle \\'əŋ-kəl\\ **1** : *n* a term of endearment used by heterosexuals to describe a close gay friend to their children <*"Uncle* Paulie's coming for dinner."> **2** : *vb* to give in to something <"OK, Adora, I say *uncle.* Let's have a baby.">

unctuous \\'əŋ(k)-chə-wəs\\ *adj* a person who is overly smooth and has an oily quality; usu. said by a woman while shivering in disgust at being hit upon <"Ew, he was so *unctuous."*>

UNCTUOUS

under- \\'ən-dər\\ a prefix meaning "less than," which can be a good thing or a bad thing

..

UNDER- POSITIVES

underclothes; underlit; undershirt; undershorts; understood; understated; underthings; underwear

UNDER- NEGATIVES

underage; underbite; undercurrent; underfoot; undermannered; undersized; undervalued; underwhelmed

..

understand \\,ən-dər-'stand\\ *vb* to try and grasp the reasonableness of a lover's irrational decision to end a perfectly good relationship <"Please *understand* that this is about me and not you."> **understanding** \\,ən-dər-'stan-diŋ\\ *n* **a** : the nonjudgmental acceptance of a loved one's desperate need for attention <*as in* "Dad – pierced nipples – cool!"> **b** : an agreement between lovers that it's OK to see other people, which occurs just before the formal breakup <"We have an *understanding.*">

UNDULATE

undulate \\'ən-jə-lāt\\ *vb* to move in a wavelike fashion <"Layla's cosmic, *undulating* energy really opened my chakras.">

unexpected \\,ən-ik-'spek-təd\\ *adj* **a** : to be the recipient of a delightful surprise *such as* a bouquet of flowers or being whisked off to a fancy restaurant after work **b** : to be the recipient of an unpleasant surprise <*as in* "What's Tony doing home so early?">

UNEXPECTED

283

Unforgettable \\'ən-fər-'ge-tə-bəl\\ *n* a love ballad written by Irving Gordon that was a hit for Nat King Cole in 1951 and that more than 40 years later was released as a duet with daughter Natalie

unfuckinbelievable! \\,ən-fə-kin-bə-'lē-və-bəl\\ *adj* used to express astonishment <"When she took her clothes off – *unfuckinbelievable!*">

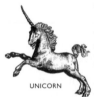
UNICORN

unicorn \\'yü-nə-,körn\\ *n* **a :** a fabulous white mythical beast that resembles a horse, has the hind legs of a stag, the tail of a lion, and a horn – see *PHALLIC SYMBOL* **b :** according to Medieval legend, the only way to catch one is through the beguiling charms of a virgin

unique \\yü-'nēk\\ *adj* a euphemism for an odd personality <"You must meet my cousin." "What's she like?" "She's...well...*unique.*">

unit \\'yü-nət\\ *n* **1 :** how couples who have been together for a long time act and think <*as in* "My Mom and Dad say the same thing about everything. If she likes a movie, he does, too."> **2 :** [slang] **a :** a penis **b :** a vagina

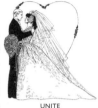
UNITE

unite \\yü-'nīt\\ *vb* to join in marriage <"Love alone is capable of *uniting* living beings in such a way as to complete and fulfill them, for it alone takes them and joins them by what is deepest in themselves." –FATHER PIERRE TEILHARD DE CHARDIN, 1881–1955> **United Airlines** \\yü-'nī-təd-'er-,linz\\ *n* major U.S. carrier founded in 1926 to accommodate newlyweds with daily flights to Hawaii from Los Angeles, San Diego, and San Francisco

unmade \\ən-'mād\\ *adj* **a :** used to describe a bed that lovers have just occupied **b :** can also describe a person's appearance <"Where does Rachel go at night? She always looks like an *unmade* bed.">

unrequited \\ən-ri-'kwī-təd\\ *adj* to be in love with somebody who won't put out <"*Unrequited* love's a bore, and I've got it pretty bad." –LORENZ HART/RICHARD RODGERS, "Glad to Be Unhappy">

284

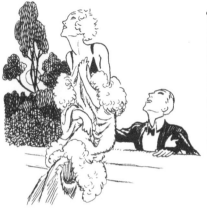

UNREQUITED

unthinkable \ˌən-ˈthiŋ-kə-bəl\ *n* serious cause for a breakup <"Why did you stop seeing Lester?" "Because he did the *unthinkable*.">

upstate \ˌəp-stāt\ *n* **a** : areas of New York state that are N of Manhattan and where city dwellers go for romantic getaways **b** : location of Sing Sing Prison (Ossining) <"Say, Donna, where's loverboy?" "He's sharing a room – *upstate*.">

user-friendly \ˈyü-zər-ˈfren(d)-lē\ *adj* a person who is known to be promiscuous

U.S. Virgin Islands \ˈyü-ˈes-ˈvər-jən-ˈī-ləndz\ *n* a group of islands located in the Lesser Antilles in the Caribbean with the highest marriage rate in the world <*as in* 35.1 per 1,000 people> *source Guinness Book of World Records*

U-turn \ˈyü-ˈtərn\ *n* a screeching turnabout made when the driver of a car comes to his or her senses and realizes that he or she needs to go back and apologize to the person he or she just stormed out on

U2 \ˈyü-ˈtü\ *n* Irish rock band that's as well known for its music as its humanitarian work; in 2005 the band was the recipient of Amnesty International's Ambassador of Conscience Award

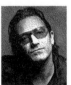

U2'S BONO

UV rays \ˈyü-ˈvē-ˈrāz\ *n* invisible, ultraviolet radiation from the sun that makes people attractive to others by tanning their skin – compare *PERMATAN*

uxorious \ˌək-ˈsȯr-ē-əs\ *adv* to be foolishly fond of one's wife <"Carl's not pussy whipped. He's just *uxorious*.">

285

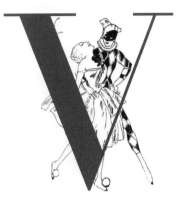

vacancy \ˈvā-kən(t)-sē\ *n* a neon sign that lovers look for on highways – see *ALIAS*

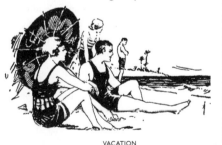

VACATION

vacation \vā-ˈkā-shən\ *n* **a :** a relaxing break from everyday stress that lovers spend in healing environments *such as* beaches, spas, and deserts **b :** time spent in a cosmetic surgeon's office <"Martha, I haven't seen you for a few weeks. You look so relaxed." "Yes, I was on *vacation*," *as in* eye job>

vacuum \va(ˌ)kyüm\ *n* a state of emptiness free from outside influences <"It was Ali's birthday and he didn't even know it. The dude lives in a *vacuum*."> – called also *clueless* **vacuum cleaner** \va(ˌ)kyüm-klē-nər\ *n* a sucking device one manically runs over one's carpet minutes before a date arrives

vagina \və-ˈjī-nə\ *n* a muscular tube lined with mucous membranes that forms the lower part of the female reproductive tract and receives the penis during coitus – called also *black hole, cranny, pink snapper, pookie, sugar dish, tamale, wilma*

(The) Vagina Monologues \thə-və-ˈjī-nə-ˈmä-nə-ˌlȯgz\ *n* 1996 off-Broadway play written and originally performed by Eve Ensler that features women discussing the social, political, and sexual aspects of their vaginas and has since become an international hit **V-Day** \ˈvē-ˈdā\ *n* short for Vagina Day, an annual event established by Ensler that takes place around Valentine's Day, when benefit performances of *The Vagina Monologues* raise money for groups seeking to end domestic and sexual abuse against women

Valentine's Day \ˈva-lən-ˌtīnz-ˈdā\ *n* a day set aside every February 14 to remind scientists and astronomers that it isn't the moon, the sun, or gravity that makes the world go round but love <*as in* "If apples were pears and peaches were plums / And the rose had a different name / If tigers were bears and fingers were thumbs / I'd love you just the same." –Anon.>

Valentino, Rudolph \ˌva-lən-ˈtēˌnō-ˈrü-ˈdälf\ (1895–1926, né Rodolpho Alfonso Raffaelo Pierre Filibert Guglielmi di Valentina d'Antonguolla) born in Italy, slick-haired, dark-eyed, silent-screen star who played exotic leading men in erotically charged classics *such as The Sheik* (*dir* George Melford), *Blood and Sand* (*dir* Fred Niblo), and *Son of the Sheik* (*dir* George Fitzmaurice) and who died at age 31 in a New York City hospital following surgery for a perforated ulcer; the lying-in-state and funeral caused unprecedented riots as thousands of screaming female fans lined the streets <*as in* "Women are not in love with me but with the picture of me on the screen. I am merely the canvas on which women paint their dreams." –R.V.>

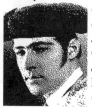

RUDOLPH VALENTINO

vanilla \və-ˈni-lə\ *n* the aphrodisiacal extract of the orchid bean that is used to flavor desserts and specialty drinks **vanilla sex** \və-ˈni-lə-ˈseks\ *n* a synonym for dull or unimaginative sex, which is a misnomer as the

VANILLA

vanilla bean's flavors are so complex that scientists still don't know how many organic compounds they contain, although it's believed to be in the hundreds

vaquero \vä-'ker-(,)ō\ *n* [Spanish] sexy name for a Latin American cowboy

vasopressin \,vā-zō-'pre-sªn\ *n* **a :** a hormone formed in the hypothalamus, which scientists believe may be responsible for causing feelings of attachment to one's partner and children based on animal behavior studies **b :** researchers have found that levels of vasopressin increase in male prairie voles' brains when they ejaculate, at which point they become possessive of their women, kids, and territory **c :** Princeton University researchers found that a reason a marmoset dad may make the best Mr. Mom ever – carrying its newborns in its arms for the first month of life and passing them to the mother only when they need to be fed – may be due to nerve cells in its prefrontal cortex that contain an abundance of receptors for vasopressin

Vatsyayana \'väts-yä-yä-nä\ – see *KAMA SUTRA*

va-va-voom! \vä-vä-'vüm\ *n* a sexy, energetic inner quality of 1950s bombshells, sexpots, and B actresses, who had ample outer qualities <*as in* Mamie Van Doren, Jayne Mansfield, Gina Lollobrigida, and Anita Eckberg> – see *PINUP*

MAMIE VAN DOREN

Velcro \'vel-(,)krō\ *n* a 2-sided nylon fastener made of hooks and loops that was patented in 1955 by French mountaineer and inventor George de Mestral and whose timing helped usher in the sexual revolution – see *ALFRED CHARLES KINSEY* **emotional Velcro** \'i-mō-shə-nəl-'vel-(,)krō\ *n* codependency

(The) Velvet Fog \thə-'vel-vət-'fäg\ *n* **a :** the title bestowed upon Chicago-born jazz and scat singer Mel Tormé (1925-1999) to describe his rich, cool, smooth vocal tones <*as in* "Tormé works with the most beautiful voice a man is allowed to have, and he combines it with a flawless sense of pitch...." –WILL FRIEDWALD, jazz critic> **b :** with longtime collaborator Bob Wells, he wrote "The Christmas Song" <*as in* "Chestnuts roasting on an open fire....">

Venice \'ve-nəs\ *n* **1** : romantic, dream-like Italian city built on a saltwater lagoon in the Adriatic Sea that has canals and a carnival and was home to Marco Polo and Casanova – called also *Bride of the Sea* – see *GONDOLA* **2** : S California city on the Pacific Coast that has canals, roller-bladers, and bodybuilders – see *ADONIS* **Death in Venice** \'deth-'in-'ve-nəs\ *n* 1912 novella by Thomas Mann about an elderly dying novelist named Gustav Aschenbach and his obsession with a handsome youth **(The) Venetian** \thə-və-'nē-shən\ *n* a Las Vegas hotel with a Grand Canal running through it **venetian blind** \və-'nē-shən-'blīnd\ *n* a window covering with overlapping horizontal slats that can be adjusted to allow lovers to be bathed in soft light – compare *CHIAROSCURO*

vent \'vent\ *vb* to rant or complain at length to a best friend, confidante, homie, or gal pal about one's lover or significant other but not really mean it <"Sorry for bending your ear, Chad – I just needed to *vent*.">

ventilate \'ven-tə-ˌlāt\ *vb* to open the bedroom window or turn on the ceiling fan after sex

Venus \'vē-nəs\ *n* **1** : named after the Roman goddess of love and beauty, the 2nd planet from the sun and brightest of all the stars in the heavens **2** : [poetic] a vagina **Hey, Venus** \'hā-'vē-nəs\ *n* 1959 Frankie Avalon hit <"*Venus* if you will, please send a little girl for me to thrill."> **Venus de Milo** \'vē-nəs-'de-'mīlō\ *n* ancient Greek marble statue of Aphrodite that is on display at the Louvre Museum in Paris **Venus's-flytrap** \'vē-nə-səz-'flī-ˌtrap\ *n* **a** : a carnivorous plant

VENUS

(Dionaea muscipula) that can be grown at home and makes a fascinating conversation starter when entertaining a date – see *OOMPA-LOOMPA VIBE* **b** : native to the bogs of N and S Carolina, when an insect lands on a pair of its jawlike leaves, they close up, trapping the bug inside *note* resist the urge to keep touching the leaves as too much stimulation can cause them to clamp permanently shut

versatile \'vər-sə-tᵊl\ *adj* used to describe a person who is capable of a wide range of movement – called also *vers*

verse \\'vərs\\ *n* a line of poetry comprised of metrical feet <*as in* "There was a young girl from Nantucket...." –ANON.>

Vertigo \\'vər-ti-ˌgō\\ *n* 1958 Alfred Hitchcock film about obsessive love in which James Stewart plays a San Francisco detective with a fear of heights who tries to remake Kim Novak into his deceased lover

 <*as in* "Well, I'll wear the darn clothes if you want me to – if – if you'll just like me." –NOVAK to Stewart, who has taken her for a fashion redo at I. Magnin's>

STEWART & NOVAK

vespers \\'ves-pərz\\ *n* church bells that ring at eventide when one is strolling hand in hand with one's lover through the streets of Paris <"I remember when the *vespers* chimed, you loved me once upon a summertime." –EDDIE BARCLAY/MICHEL LEGRAND/EDDIE MARNAY/JOHNNY MERCER, "Once Upon a Summertime"> **vespertine** \\'ves-pər-ˌtīn\\ *n* the time of evening when certain flowers open – see *NIGHT-BLOOMING JASMINE*

via \\'vī-ə\\ *prep* **a :** by way of **b :** the quickest way to a bootie call <"Should I go *via* subway or taxi? *Via* the park or 59th Street?">

Viagra \\vī-'a-grə\\ *n* **a :** a brand name for the chemical compound sildenafil citrate that was synthesized by a group of Pfizer Pharmaceutical chemists in England for the treatment of high blood pressure and heart disease; while testing its safety in volunteers, a surprising side effect was observed, in the form of penile erections <*as in* "Cor blimey, mate. I've got a right stiffy!"> **b :** taken in capsule form, causes long-lasting erections through a physiological process in which the parasympathetic nervous system, feeling very sympathetic toward men over 50, releases nitric oxide (NO) into the erectile tissue of the penis, causing a full salute to occur on command <*as in* "Thank you, Jesus!"> **c :** patented in 1996 and approved by the FDA in 1998 and shortly thereafter by Senator Elizabeth Dole – see *BOB DOLE*

vibrator \\vī-ˌbrā-tər\\ *n* an oscillating device used by women for self sexual stimulation – called also *body massager*, *back massager* – see *WINK-WINK*

vichyssoise \ˌvi-shē-ˈswäz\ *n* a cold leek-and-potato soup from France that women sometimes serve men to see if they're really straight; if they complain that it's cold, or stick it in the microwave, they are definitely heterosexual – see *JULIA CHILD*

Victoria's Secret \vik-ˌtȯr-ē-əz-ˈsē-krət\ *n* Ohio-based chain of lingerie stores and catalogs founded in 1972 by Roy Raymond, a Stanford graduate, who made racy under-wear the stuff of everyday malls; in 1982 he sold the company and in 1993 shocked the world again when, at age 47, he jumped to his death off the Golden Gate Bridge

virtue \ˈvər-(ˌ)chü\ *n* **a :** a set of ethical principles of conduct that a person tries to live up to, of which there are 7 major components: meekness, humility, generosity, tolerance, chastity, moderation, and zeal <"*Virtue* herself is her own fairest reward."

VIBRATORS

Vibrators, or vibes, come in a wide variety of sizes, shapes, and colors and offer a variety of features and pleasures.

Butterfly Effect: Hands-free, strap-on 10-speed designed to stimulate the clitoris and G-spot simultaneously; waterproof; battery powered

Dolphin: Made of silicone and dolphin-shaped, features German-engineered ergonomic controls that enable one to adjust the variable speeds with one's thumb; battery powered

Hitachi Magic Wand: Called the "Cadillac of vibrators," has a tennis ball–size head that is equally good for use on a sore back; electric

Jackrabbit: Shaped like an erect penis, includes a clitoral stimulator, beaded shaft, textured tip; waterproof; battery powered

Japanese Rabbit Pearl: Shaped like an erection, with a rotating midsection to stimulate the vaginal walls and two "rabbit ears" that flutter against the clitoris; battery powered

Laya: Small, extra-quiet, and waterproof with 3 vibration patterns designed to hug the clitoral area; battery powered

Pocket Rockets: Small vibrators for traveling or for G-spot stimulation, which include the Passion Teaser, Essence, Bunny Hopper strap-on, Inner Desire vibrating egg, and Wonder Bullet

-SILIUS ITALICUS, CA. 25-99> **b** : virtue's opposites are called vices and are identified as pride, jealousy, greed, anger, lust, gluttony, and sloth <*as in* "If you want a future, darling, why don't you get a past?" -COLE PORTER, "Let's Misbehave">

Vissi d'arte \vē-sē-'därtə\ *n* bravo-stopping aria that takes place in the second act of Puccini's opera *Tosca* after the heroine, Floria Tosca, hears the screams of her lover being tortured; upon falling to the floor, she sings of having devoted her life to art, love, and Italian food – see *BBW*

vixen \'vik-sən\ *n* a foxy lady <"There is something very sexy and playful about this word. I even like the way it looks written with the X brazenly displayed at its center. I am sure this is all very Freudian. There is a little *vixen* in all of us women." -MYFAVORITEWORD.COM>

vows \'vaúz\ *n* a verbal premarital contract negotiated between 2 parties and entered into in front of no less than 2 witnesses at the altar <*as in* "I do." "I do."> – see *TROTHPLIGHT*

vulva \'vəl-və\ *n* the external female genitalia – called also *artichoke, bank, bearded clam, beaver, beef curtains, box, clam, coochie, cooter, muffin, nookie, pussy, quim, slit, snatch,* [vulgar] *twat* – see *CLITORIS*

Radiant Ring: Opalescent lavender and waterproof with a unique tip for shallow penetration; battery powered

Rock-Chick: U-shaped and made of flexible silicone, stimulates the G-spot and clitoris; battery powered

Sinful Reality: From Germany, this 8-inch "erect penis" has rechargeable internal battery and docking station; includes pronounced head and mini-joystick

Smooth Desire: Extra-thick and shorter, has 2 large "testicles" for added stability and stimulation; battery powered

wabi sabi \\'wä-bē-'sä-bē\\ *n* a Zen-based Japanese design aesthetic that celebrates the beauty of imperfection and honors the wear and tear of old objects; can also apply to humans <"She's had no work done," *as in* wrinkled> – called also *Japanese rustic*

Wagner, Richard \\'väg-nər-'ri-chərd\\ (1813–1883) German opera composer whose most famous work is the "Bridal Chorus" (*aka* "Here Comes the Bride"), from *Lohengrin*

RICHARD WAGNER

wah-wah \\'wä-ˌwä\\ *n* a muted trumpet sound that one hears in one's head after asking somebody out and being turned down

wallboard \\'wȯl-ˌbȯrd\\ *n* a light building material that has become a substitute for wood or plaster and allows people in apartments and condos to know who's sleeping with whom and what they're into

Walnettos \\ˌwȯl-'ne-tȯz\\ *n* **a :** the caramel-and-walnut candy favorite of Tyrone Horneigh (Arte Johnson), a dirty old man with overcoat and cane, which

he regularly offered Gladys Ormphby (Ruth Buzzi), a frumpy old woman with a hairnet, booth of whom appeared regularly on the comedy variety show *Rowan & Martin's Laugh-In* (NBC, 1968–1973); when sitting on a park bench, Tyrone would ask in a gravelly, suggestive voice, "Want a *Walnetto*?" in response to which Gladys would smack him over the head with her purse **b :** discontinued in the 1960s, the individually wrapped caramels were put back on candy shelves in 1984 by new owners, Necco – see *SWEETHEARTS*

WASHINGTON, D.C.

Washington, D.C. \'wȯ-shiŋ-tən-'dē-'sē\ *n* cap. city of the U.S. (pop. 553,000), located in the District of Columbia, named for George Washington, and where male residents masturbate more than men anywhere else in the country, playing with themselves at least every other day **source** *Men's Fitness* "Sex in the U.S.A." study

(The) Way We Were \thə-'wā-'wē-'wer\ *n* 1973 film (*dir* Sydney Pollack) in which Katie Morosky (Barbra Streisand) falls in love with Hubbell Gardner (Robert Redford), only to learn that men are evolutionarily drawn to vacuously beautiful women over brainy ones, and when it comes time to say a final goodbye to Hubbell, Katie tells him, "You'll never find anyone as glad for you as I am, to believe in you as much as I do, or love you as much." *note* voted by the American Film Institute as the sixth most romantic movie ever made

wedding \'we-diŋ\ *n* a public ceremony during which a man (the groom) makes a promise to a woman (the bride) that he will love, honor, and provide for her as long as he shall live, or until a younger woman comes along **weddingmoon** \'we-diŋ-'mün\ *n* a combination wedding and honeymoon in which a couple gets married aboard a ship, at a romantic resort, or barefoot on a tropical beach **wedding ring** \'we-diŋ-'riŋ\ *n* the final stage of a solar eclipse, when the last of the sun's light bursts out from behind the moon's shadow

296

Wedekind, Claus \\'vā-də-kint-'klaus\\ zoologist at the University of Lausanne in Switzerland who conducted a famous experiment in the mid-1990s in which 49 women were asked to smell the T-shirts that 44 men had slept in for 2 nights and to rate the aroma of these garments; women found the odors of T-shirts from men whose genotypes were different from theirs to be pleasant, which could mean that people are sexually attracted to those possessing traits they lack, which could give them healthier offspring

Weinlick, Dave \\'wīn-lək-'dāv\\ a University of Minnesota graduate student who, after years of telling everyone he was going to get married on June 13, 1998, and having no fiancée as the date approached, agreed to let his university buds assemble bridal candidates, and from a list of 28 they voted Elizabeth Runze the bride-to-be; on June 13, 1998, after a 1-hour engagement, the 2 strangers were wed at a ceremony held at the Mall of America in Bloomington, Minnesota, and as of this writing, they have a family and are still happily married

Weissmuller, Johnny \\'wīs-ˌmü-lər-'jä-nē\\ (1904-1984) 5-time Olympic gold-medal-winning swimmer who became a movie star in 1932 when he dried himself off, donned a loincloth, and became the star of *Tarzan the Ape Man*; his leading lady, Maureen O'Sullivan, who played Jane, donned one, too, and together they played tree house in 6 scantily clad films

JOHNNY WEISSMULLER & MAUREEN O'SULLIVAN

we need to talk \\'wē-'nēd-tü-'tók\\ *vb* **a :** an ominous statement that precedes a romantic breakup; usu. implies "I like you, but I can do better." **b :** "The worst four words in the English language." –JERRY SEINFELD, comedian

ALMA MAHLER

Werfel, Alma Mahler Gropius \\'ver-fəl-'al-mə-'mä-lər-'grō-pē-əs\\ (1879-1964) daughter of painter Emil Jakob Schindler who had a thing for creative geniuses, having married 3 of them: com-

poser Gustav Mahler, architect Walter Gropius, and writer Franz Werfel; her lovers included artist Gustav Klimt, opera singer Enrico Caruso, and composers Arnold Schoenberg, Alan Berg, and Alexander Zemlinsky **Alma** \'al-mə\ *n* a song celebrating Werfel's life by Tom Lehrer <"*Alma* tell us. All modern women are jealous. Though you didn't even use Ponds, you got Gustav and Walter and Franz.">

Westheimer, Ruth \'west-ˌhī-mər-'rüth\ (*aka* Dr. Ruth) German sex therapist (b. 1928), author, and media personality whose appeal is largely derived from her vivacious personality, accent, short physical stature (4 ft. 7 in.), and informational, celebratory way of discussing sex as if she were Julia Child on food <*as in* "Buy only items that could be integrated into love play, like whipped cream, chocolate sauce, and maybe a banana or cucumber. Not only will you both be very aroused when you get home, but you'll probably get quite a laugh from the look on the face of the checkout clerk.">

West, Mae \'west-'mā\ (1892–1980) actress, film star, playwright, and queen of the double entendres whose most famous

MAE WEST

observation was "Is that a gun in your pocket, or are you just glad to see me?" and who, at age 85, put on her blond wig and boa to star opposite Timothy Dalton in the 1978 film musical *Sextette* (*dir* Ken Hughes)

West Side Story \'west-'sīd-'stòr-ē\ *n* (*dirs* Robert Wise/Jerome Robbins) 1961 film adaptation of the Broadway musical based loosely on Shakespeare's *Romeo and Juliet*, set in New York City, and starring Richard Beymer as a reluctant American gang member named Tony who falls in love with a Puerto Rican girl named Maria, played by Natalie Wood, and who, when they're alone together on a fire escape, become so adrenalin-pumped that they burst into an operaticlike love duet called "Tonight"; in the end, Tony is mur-

WEST SIDE STORY

dered, and as Maria leans over his lifeless body, she says, "Te adoro, Anton," and the tragedy ends – see *BOO-HOO CANAL*

note voted by the American Film Institute as the third most romantic movie ever made

wet and messy \'wet-ən(d)-'me-sē\ *n* a form of erotic play in which a person gets turned on by seeing his or her partner in a wet T-shirt or other garment or gets aroused by the touch of his or her skin when applying a messy substance to it *such as* custard pudding, shaving foam, whipped cream, or chocolate sauce

whaddya thinking? \'hwä-də-yä-'thiŋ-kiŋ\ – see *AFTERGLOW*

whale \'hwāl\ *n* the world's largest mammal, which lives in the oceans and sings love songs that get recorded on CD – see *HUMPBACK WHALE* **whale-watching** \'hwāl-'wä-chiŋ\ *vb* a perfect dating experience in which couples board a boat that takes them out to sea to look for the gentle behemoths

wharf \'hworf\ *n* a wooden, pierlike structure that projects from a shore into a harbor or other body of water and where abandoned lovers can often be found gazing out to sea, waiting and hoping for their man or woman to return **wharfside** \'hworf-'sīd\ *n* a seaside deck connected to a restaurant where couples can dine and have drinks while enjoying the romantic view esp. at sunset

where \'hwer\ *adv* used frequently by people who are in love when talking to their friends and often combined with "here's" <"Here's *where* we met. Here's *where* we went on our first date. Here's *where* we had our first fight. Here's *where* we knew it was serious. Here's *where* he asked me to marry him. Here's *where* we're going on our honeymoon."> **where are we?** \'hwer-'ar-'wē\ question women ask men when their relationship has reached a plateau <She: *"Where are we?"* He: "At the Outback having dinner." She: "No, *where are we?"*>

whipped cream \'hwipt-'krēm\ *n* a cream with a high butterfat content that when churned at a high speed thickens and expands to a consistency lovers enjoy licking off each other's bodies during passionate sex – see *WET AND MESSY* **Whipped Cream and Other Delights** \'hwipt-'krēm-'ənd-əthər-dē-līts\ *n* 1965 LP by Herb Alpert's Tijuana Brass, whose classic album cover

depicts a young woman wearing a dress made of whipped cream and suggestively licking her fingers; to honor the album's 40th anniversary, it was rerecorded and the photo image restaged

whippoorwill \\'hwi-pər-ˌwil\\ *n* a North American bird *(Caprimulgus vociferus)* and member of the nightjar family, whose haunting, nocturnal call has long been as-

sociated with oncoming death or bad luck <"Hear that lonesome *whippoorwill*, he sounds too blue to cry." –HANK WILLIAMS, JR., "I'm So Lonesome I Could Cry">

WHIPPOORWILL

White, Barry \\'hwīt-bä-ˈrē\\ (1944–2003, né Barry Eugene Carter) **a :** R&B singer whose suave delivery and velvety voice make a listener feel as if he or she is the midst of a deep passionate kiss **b :** after compiling a 3-girl group called Love Unlimited in the early 1970s, for which he sang back-up, he went solo, turning out hit after hit *such as* "I'm Gonna Love You Just a Little More Baby," "You're My First, My Last, My Ev-

erything," and "I've Got So Much to Give" **c :** his records and albums have sold over 100 million worldwide – called also the *Walrus of Love*

whorella \\ˌhȯ-ˈre-lä\\ *n* a promiscuous gay male <"Look, *whorella*, you can stay in one night – it's Christmas Eve."> – see *HORNDOG*

Whore of Babylon \\'hȯr-əv-ˈba-bə-ˌlän\\ *n* **a :** a mysterious, allegorical figure of supreme evil who is mentioned in the *Bible* and is theorized to symbolize the antichrist or the pagan city of ancient Rome **b :** commonly used today to refer to a person who is wildly promiscuous <"Before meeting Pat, I was the *Whore of Babylon*.">

wildflower \\'wī(-ə)ld-ˌflau-(-ə)rs\\ *n* a non-cultivated, flowering plant of which there are 15,000 species that grow in the U.S. and Canada alongside highways and in fields and attract butterflies and savvy boyfriends who know that a hand-picked bouquet of

WILDFLOWER

them will mean more to a girlfriend than a dozen red roses

willing \\'wi-liŋ\\ *n* a condition similar to hypnosis and occurring early in a relationship, when a boyfriend or girlfriend is cheerfully eager to do anything for the object of his or her affection no matter how difficult <"He was *willing* to remove a 25-ft. hedge of forsythia." –JESSICA BARD, newlywed, on how her then boyfriend would show up at her farm while they were dating and volunteer to do chores, *The New York Times*> – see *HERCULEAN*

wind chime \\ˌwind-'chīm\\ *n* a cluster of objects made of materials *such as* glass, clay, metal, and bamboo that is hung outdoors near a window and designed to make a tinkling sound when the wind kicks up or one's lover approaches <*as in Body Heat*, 1981, *dir* Lawrence Kasdan, starring Kathleen Turner and William Hurt>

A DRINKING SONG

Wine comes in at the mouth
And love comes in at the eye;
That's all we shall know for truth
Before we grow old and die.

I lift the glass to my mouth,
I look at you, and I sigh.
 –W. B. YEATS

wine \\'wīn\\ *n* **a** : a bottled drink made from fermented grapes that a person carefully selects, opens, pours, sips, and shares, knowing that it can turn a friendship into something more heady **b** : wine must always be consumed in moderation <"The *wine* urges me on, the bewitching *wine*, which sets even a wise man to singing and to laughing gently and rouses him up to dance and brings forth words which were better unspoken." –HOMER, CA. 900 B.C.>

wine cellar \\'wīn-'se-lər\\ *n* a seductive attribute that says one has taste and expertise in the art of fine living when having a date over for dinner <"Can't hear you. I'm in the *wine cellar*."> **wine glass** \\'wīn-gläs\\ *n* a goblet for drinking wine that has a foot and a long stem and that one holds gently between the fingers of one's upside down palm, as if cupping a lover's breast or other organ

WINE

wink \\'wiŋk\\ *n* a spontaneous facial exclamation point in which a twinkling eye is quickly opened and shut to communicate interest in another person and that has the effect of taking him or her by surprise <"Oh, jeez, Janice, the cashier just *winked* at me."> **wink-wink** \\'wiŋk-'wiŋk\\ *interj* a phrase that comes at the end of a sentence to let one know what's really going down <"I see, it's a body massager, *wink-wink*.">

wisteria \\wis-'tir-ē-ə\\ *n* a gorgeous climbing vine with purple, violet, pink, or white flowers that signifies spring is here **wisteria laning** \\wis-'tir-ē-ə-'lā-niŋ\\ *vb* a term taken from the popular TV show *Desperate Housewives* to describe an unfaithful man who is having sex with a desperate housewife <"She broke up with Lance 'cause she found out he was *wisteria laning* her.">

(The) Wizard of Oz \\thə-'wi-zərd-əv-'äz\\ *n* title character of the 1900 book by L. Frank Baum, who tells the Tin Woodsman, "A heart is not judged by how much you love but by how much you are loved by others."

wobbly boots \\'wä-bə-lē-'büts\\ *n* a condition in which one gets nervous and leaves before a date arrives <"So, where's David?" "He got the *wobbly boots* and evaporated.">

WOOD

wood \\'wùd\\ *n* the hard fibrous substance from trees that is used for burning in fireplaces to create warmth and coziness **morning wood** \\'mòr-niŋ-'wùd\\ *n* the hard fibrous substance that men often wake up with – see *ERECTION*

woof \\'wùf\\ *n* a hunky man <"Asante is certainly a *woof*.">

words \\'wərdz\\ *n* **a :** a way for lovers to express their thoughts and feelings to one another, of which the *Oxford English Dictionary* lists more than 500,000 varieties **b :** however lovely and plentiful, words must be chosen carefully as they can act as emotional sticks and stones, breaking hearts and causing pain and suffering, and once expressed, cannot be taken back ***antidotes*** flowers, chocolates, cards, wine, dinner out, weekends away, pleading for forgiveness, saying, "I'm sorry."

302

World War II \\'wər(-ə)ld-'wȯr-'tü\ *n* (1939–1945) the global war between the Axis and the Allies during which the most romantic love songs of all time were composed *such as* "I Don't Want to Walk Without You, Baby" (Frank Loesser/Jule Styne), "I'll Be Seeing You" (Sammy Fain/Irving Kahal), and "I'll Get By as Long as I Have You" (Roy Turk/Fred Ahlert)

World Wife Carrying Competition \\'wər(-ə)ld-'wīf-'ka-ˌrē-iŋ-ˌkäm-pə-'ti-shən\ *n* **a :** an annual competition held in Finland in which men run a 253.5 m. obstacle course of sand, grass, and gravel while carrying their wives **b :** 3 carrying styles are allowed: piggyback, fireman (over the shoulder), and Estonian (in which the wife hangs upside-down with her legs over her husband's shoulders and her face in his lower back) **c :** the contest is supposedly reminiscent of the country's past, when a man would run into a village and carry off a woman to be his wife **d :** wife carrying is a growing sport and is now being practiced in several U.S. states, including Maine and Michigan

WIFE CARRYING

Wynette, Tammy \\'wi-net-'ta-mē\ (1942–1998, née Virginia Wynette Pugh) **a :** Mississippi-bred "Stand By Your Man" hairdresser-turned-Nashville superstar who in the 1960s and 1970s had 17 number-one hit singles, earning her the title "First Lady of Country Music" **b :** her personal

TAMMY WYNETTE

life was as tumultuous as her songs, having been plagued with health problems and in 1978 abducted from a Nashville shopping mall and beaten by unknown assailants **c :** as for standing by her man, she had 5 husbands (*as in* "D-I-V-O-R-C-E") **d :** died in her sleep of natural causes

Xanadu \\'za-nə-ˌdü\ *n* the splendiferous summer capital of Kubla Khan's Mongol empire whose opulence inspired

KUBLA KHAN

Samuel Taylor Coleridge (1772-1834) to write his great poem "Kubla Khan," which begins "In *Xanadu* did Kubla Khan / A stately pleasure-dome decree...." and which further inspired a 1980 roller-disco film of the same name starring Gene Kelly and Olivia Newton-John (as a Greek muse), the latter singing the eponymous title song, which begins "A place where nobody dared to go, the love that we came to know, they call it *Xanadu*...."

X-appeal \\'eks-ə-ˈpēl\ *n* a sexy quality in a man

X-dresser \\'eks-ˈdre-sər\ *n* a man who likes to wear women's clothing <*as in* "I had no idea until I looked in Gary's closet.">

xenogamy \zi-'no-gə-mē\ *n* cross-pollination; how flowers do it

xenogenesis \'ze-nə-'je-nə-səs\ *n* the production of a generation of offspring completely unlike its parents <*as in* "I can't believe Floyd and Melissa could have such good-looking children.">

Xerox \zē-räks\ *n* **1 :** a brand of copying machine where people unconsciously leave letters, pay stubs, and resumes so that the whole office has insider information on their personal life **2 :** a new boyfriend, girlfriend, husband, or wife who closely resembles the previous ones <"I met Keri's new boyfriend. He's a *Xerox* of all the others.">

XEROX

X-Files \'eks-'fī(-ə)lz\ *n* the long-running sci-fi series in which 2 FBI agents, Fox Mulder and Dana Scully (David Duchovny and Gillian Anderson), explore the weird and

X-FILES

the paranormal and which helped put Fox Broadcasting Company on the map before *The O'Reilly Factor*; as the *X-Files* progressed over its 9-year run, Mulder and Scully developed a close and ambiguous friendship, which some fans, known as "shippers" (short for "relationshippers") hoped was more than platonic

Xochiquetzal \shō-ki-'kā-tsäl\ *n* the Aztec goddess of flowers, fertility, and love <"*Xochiquetzal*, I don't know who to take to the Saturday night sacrifice, Quetzalxochitl or Noxochicoztl – they're both such sweet girls.">

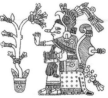

XOCHIQUETZAL

X-rated \'eks-'rā-təd\ *adj* **a :** something obscene or blue <"Dave and Shamara were yelling *X-rated* words at each other across the parking lot."> **b :** X-rated stems from a rating system for films agreed upon in 1968 by the Motion Picture Association of America (MPAA), the National Association of Theater Owners (NATO), and the International Film Importers & Distributors of America (IFIDA), which was

designed to replace the censorious Hays Production Code (*as in* G, PG, M. R, & X) **c :** though an X rating meant no one under 17 was allowed to see the film, it did not originally have the surly implications that it has since acquired **d :** in 1969 *Midnight Cowboy* (*dir* John Schlesinger) won the Oscar for Best Motion Picture, the only X-rated film to ever do so (though later re-rated) – see *X-RATED MOVIE LIST pp. 308–309*

X-ray eyes \'eks-'rā-'īz\ *n* the perceived ability to see through clothing <"If that guy at the bar doesn't stop staring at me.... It's like he's got *X-ray eyes*."> – see *ZOOM ON*

XY chromosomes \'eks-wī-krō-mə-sōmz\ *n* **a :** in genetics, the 2 chromosomes that determine the sex of an individual; males carry a single X and a single Y chromosome, while females carry 2 XXs and no Y **b :** when seen under a microscope the X chromosone is much larger than the Y, which would indicate that the female is not just the fairer of the sexes but also the stronger **XXXX** kisses signed at the end of a love letter from an XX to an XY or an XY to an XX or an XX to an XX or an XY to an XY

XYZ *vb* acronym for "examine your zipper" <"Billy, before you give your best man's speech, I suggest you *XYZ*.">

X-RAY EYES

X-RATED MOVIE LIST

These 10 adult movies were selected by sex educator and writer Dr. Gary E. Schubach as being the cream of the crop. You can visit his website at www.doctorg.com.

BEHIND THE GREEN DOOR
1972, DIRS JIM & ARTIE MITCHELL

HOUSE OF DREAMS
1990, DIR ANDREW BLAKE

INSATIABLE
1980, DIR GODFREY DANIELS

MARRIAGE AND OTHER 4-LETTER WORDS
1974, DIR RICK ROBINSON

THE OPENING OF MISTY BEETHOVEN
1976, DIR HENRY PARIS

THE PRIVATE AFTERNOONS OF PAMELA MANN
1974, DIR HENRY PARIS

SHOCK
1996, DIR MICHAEL NINN

TABOO I
1980, DIR KIRDY STEVENS

TALK DIRTY TO ME
1980, DIR ANTHONY SPINELLI

THREE DAUGHTERS
1986, DIR CANDIDA ROYALLE

Note Many X-rated film titles are based on popular Hollywood movie titles. The following list is a sampling:

A Pecker Runs Through It
Beverly Hills Cock
Breast Side Story
Bridge Over the River KY
Driving Into Miss Daisy
E.T. The Extra Testicle
Free My Willy
In Diana Jones and the Temple of Poon
Lord of the G-Strings
On Golden Blonde
Porn on the Fourth of July
Romancing the Bone
Shaving Ryan's Privates
Sorest Rump

yada yada yada \ˈyä-də-ˈyä-də-ˈyä-də\ *interj* an elliptical phrase consisting of nonsense words that one says when cutting to the chase and which often leaves out the juicy details; satirized on a *Seinfeld* episode in which George Costanza's new girlfriend says, "Yada yada yada," leaving him to think she left out the best part of her story and he'd been yada-yada'd – see *ANNA KARENINA*

GEORGE COSTANZA

yard sale \ˈyärd-ˈsāl\ *n* an outdoor weekend event during which people try to sell off unwanted household items and which has become a way for neighbors to meet and socialize with each other; occasionally one can find oneself carting off someone's discarded spouse or lover *var* garage sale

yawn \ˈyȯn\ *n* an opening of the mouth and a deep exhaling of air that is the result of dreariness or boredom and when done by

YAWN

311

one's partner during sex may be a sign that one needs to work on his or her technique

year \\'yir\\ *n* a (usu.) 365-day period that exists between birthdays, anniversaries, and Valentine's Day so that lovers have enough time to save up for special gifts **years** \\'yirz\\ *n* a measurement of time used to mark a particular era of one's life with a partner <"Those photos are from the Ron *years* and those are from the George *years*.">

yellow \\'ye-(ˌ)lō\\ *n adj* **a :** a primary color between green and orange that makes people feel happy **b :** yellow is the color of the sun and many varieties of flowers, birds, butterflies, and fruit, as well as sexy road signs *such as* Curves Ahead, Stop When Flashing, and Slippery When Wet

Yellowstone \\'ye-(ˌ)lō-ˈstōn\\ *n* the largest and oldest U.S. National Park that contains more than 3,000 hot springs and geysers, including Old Faithful, which shoots 3,700–8,400 gals. of boiling water to a height of 106–184 ft. every 91 mins. – see *REFRACTORY PERIOD*

YELLOWSTONE

yes \\'yes\\ *adv* a word that is purposely monosyllabic in English, Spanish *(si)*, French *(oui)*, Portuguese *(sim)*, and many other languages, so that when a person asks another to marry him or her, the flustered responder can easily accept without tripping over too many consonants ***ant*** no – see *MAYBE*

YIN YANG

yin yang \\'yin-ˈyäŋ\\ *n* a Chinese philosophy in which the yin and yang represent opposing principals of the universe *such as* active and passive, light and dark, warm and cold, Arnold and Maria; these opposites are mutually dependent and operate in an ever-shifting cycle of balance, each giving meaning to the other ***syn*** we

Yo, Adrian! \\'yō-ˈā-drē-ən\\ *interj* Rocky Balboa's Neanderthal-like shouting of his girlfriend's name in the 1976 film *Rocky* (*dir* John Avildsen) – see *HEY STELLA!* **yo-yo** \\'yō-ˈyō\\ *n* a man who swings both ways

ROCKY BALBOA

yoni \\'yō-nē\\ *n* **a :** Sanskrit for the vagina and loosely translated to mean "sacred space" or "sacred temple" **b :** in the *Kama Sutra* a woman is classified as either a deer or an elephant, depending on the depth of her yoni

You're In the Army Now \\yər-'in-thə-'är-mē-'naů\\ *n* 1941 war comedy (*dir* Lewis Seiler) that features movie history's longest screen kiss, between Jane Wyman (as Bliss Dobson) and Regis Toomey (as Capt. Joe Radcliffe), which goes on for 3 mins. and 5 secs. and according to the film's promos leads "to a hilarious climax"

you wish \\'yü-'wish\\ *interj* expression indicating disbelief <"I'm going to marry an heiress." "*You wish*."> *syn* as if

Yquem (Château d') \\'ē-kem-sha-'tō-d\\ *n* a sweet French Sauternes that wine connoisseurs, including Proust, Dumas, Verne, and even Hannibal Lecter considered to be the greatest wine in the world; a bottle can easily cost hundreds of dollars, while one vintage bottle from 1887 recently sold for $56,588 <"I have mentioned elsewhere that Château Mar-

YUMMY MUMMY

gaux is the wine I would serve to seduce a woman. Well *Château d'Yquem* would be the one served on the wedding night once the guests have departed and the night is your own." –WINE JOURNAL>

yummy mummy \\'yə-mē-'mə-mē\\ *n* a mother who turns her son's friends on – see *MRS. ROBINSON*

zaftig \ˈzäf-tig\ *adj* [Yiddish] pleasingly plump – see *BBW, BEAR*

Zandar \ˈzan-dar\ *n* a metaphorical planet on which one lands when intoxicated or very happy <"Caroline left me on *Zandar* last night.">

ZANDAR

za za zoo \ˈzä-ˈzä-ˈzü\ *n* a phrase used to describe a person who has a charismatically sexy something <"That new pilates instructor radiates *za za zoo*.">

zebra \ˈzē-brə\ *n*
a : a member of the horse family native to

ZEBRA

Africa that sports a stunningly chic wardrobe of black and white stripes **b :** when a young female is ready to mate, she strikes a pose that attracts suitors, who may have to fight off her overly protective father *note* whether they are white with black stripes or black with white stripes is a matter of scientific debate **zebra fanny** \ˈzē-brə-ˈfa-nē\ *n* salt-and-pepper pubic hairs <"The worst part about getting older isn't my head turning gray – it's my *zebra fanny*.">

Zeffirelli, Franco (b. 1923) Italian film and opera director and set designer known for his grandiose, romantic productions; his Shakespearean film interpretations proved popular popcorn fare for the masses *such as Romeo and Juliet* (1968), starring then teenagers Olivia Hussey and Leonard Whiting, both of whom had controversial nude scenes; *The Taming of the Shrew* (1967), starring then wedded Richard Burton and Elizabeth Taylor; and *Hamlet* (1997), with Mel Gibson as the moody Dane to Helena Bonham Carter's Ophelia

zelophilia \'zē-lō-'fi-lə-ä\ *n* sexual arousal from feelings of jealousy <"It's OK if you flirt with me in front of my husband, Rocco. He's a *zelophiliac*.">

ZEPHYR

zephyr \'ze-fər\ *n* a gentle breeze that blows across a lover's face and tousles his or her hair <"Fair laughs the morn, and soft the *zephyr* blows." –THOMAS GRAY, 1716-1771> **Zephyr** *n* a glamorous pre-Amtrak train made of stainless steel that traversed U.S. rails from the early 1930s until the mid-1970s – called also *Streamliner*

zeppelin \'ze-p(ə)-lən\ *n* **1 : a :** a pre–World War II airship that was originally manufactured in Germany and floated throughout Europe and eventually around the world **b :** filled with hydrogen, it was quite literally the only way to go *as in* the Hindenburg disaster, when the world's largest airship (the length of 3 Boeing 747s and the height of the Statue of Liberty) exploded in front of a large crowd of spectators in Lakehurst, New Jersey, killing 35 of its 97 passengers **2 :** a person who is full of hot air <"He told me about his job, his deals, his golf game – spare me from that *zeppelin*."> *syn* gasbag

zero \'zē-rō\ *n* a person who feels like a nothing or is perceived as a loser in the romance or dating department and has only one way to go *as in* up <"From *zero* to hero – a major hunk! *Zero* to hero

- who'da thunk." –DAVID ZIPPEL/ALAN MEN-
KEN, "Zero to Hero"> *ant* ten

Ziegfeld, Florenz \'zig-
ˌfeld-'flȯr-ən(t)s\ (1869–1932)
a : master New York show-
man who believed in "glo-
rifying the American girl"
and in so doing produced

FLORENZ ZIEGFELD elaborate reviews from
1907 to 1931 based on the Folies-Bergères
of Paris and popularly known as Ziegfeld's
Follies **b :** of his "girls," who included
Louise Brooks, Marion Davies, and Barba-
ra Stanwyck, he said, "Beauty, of course,
is the most important requirement and
the paramount asset of the applicant.
When I say that, I mean beauty of face,
form, charm and manner, personal mag-
netism, individuality, grace and poise."
c : married to Billie Burke *aka* Glinda the
Good Witch in *The Wizard of Oz*

zing \'ziŋ\ *n* sex appeal **zing zang zoom**
\'ziŋ-'zaŋ-'züm\ *n* an immediate conver-
sion of sexual energy <"Yeah, but my first
girlfriend, Ruthie, that was *zing zang
zoom*.">

zingiberaceous \'zin-ji-bə'rā-shəs\ *adj*
a : belonging to the ginger family **b :** zingy
<"Everyone loves Toni 'cause she's so
zingiberaceous.">

ziploc \'zip-ˌläk\ *n* a small plastic bag that
zips shut and is used to keep produce fresh
and to transport personal items when trav-
eling *such as* shampoos, conditioners, and
lubricants

zipper \'zi-pər\ *n* **a :** a de-
vice for closing women's
dresses and men's trou-
sers that consists of 2 toothed tracks and

ZIPPER

a pulley **b :** patented as a "clasp locker" in
1893 by Chicago inventor Whitcomb Jud-
son and since then has made getting in and
out of clothes much easier – see *QUICKIE*

zippo \'zi-pō\ *n* zilch; nada; nothing
<"How'd your date go with Dolores last
night? Get any?" "*Zippo*.">

zircon \'zər-ˌkän\ *n* **1 :** a mineral found in ig-
neous rocks that is used as a substitute for
diamonds **2 :** a girl who is pretty enough to
date but who one can't get serious about

zodiac signs \'zō-dē-,ak-'sīnz\ *n* the 12 divisions of the zodiac that define a person's personality based on his or her birthday and that can instantly size up a potential love match by one interested party asking the other, "What's your *sign?*"

ZODIAC SIGNS

ZODIAC LOVE MATCHES
When mate choosing, check out these traits:

Aquarius (Jan 20–Feb 18) Likes groups and group activities but tends to dominate them
Pisces (Feb 19–Mar 20) Likes to play the martyr and has dependency issues with lovers and chemical substances
Aries (March 21–April 19) Basically, what one sees is what one gets
Taurus (April 20–May 20) A stubborn but sensual person and pleasure seeker
Gemini (May 21 – June 21) Communicative and sociable but on a superficial level; likes to play tricks
Cancer (June 22–July 22) Supportive and nurturing but possessive, too
Leo (July 23–Aug 22) Arrogant and self-centered but trustworthy
Virgo (Aug 23–Sept 22) Likes to keep fit through exercise and healthful eating
Libra (Sept 23–Oct 22) Peacemaker who likes art, beauty, and harmonious surroundings
Scorpio (Oct 23–Nov 21) Intrigued by the dark side of life and loves having orgasms
Sagittarius (Nov 22–Dec 21) An idealist who can be emotionally distant; a heartbreaker who likes his or her freedom
Capricorn (Dec 22–Jan 19) Serious and determined and needs to lighten up

zombie \'zäm-bē\ *n* a dull or boring date with little personality <"At least he wasn't a total *zombie* in bed.">

zoo daddy \'zü-'da-dē\ *n* a divorced or separated father who takes his kids to the zoo or a theme park on visiting days

zoom on \'züm-'ȯn\ *vb* to stare intensely at someone – see *X-RAY EYES*

zoo style \'zü-'stī(-ə)l\ *n* down and dirty sex

ZORRO

Zorro \'zä-rō\ *n* **a :** Spanish for "fox" and the secret identity of Don Diego de la Vega, the sexy, Latin-blooded Robin Hood of early 19th-c. Spanish-era S California **b :** although Don Diego presents himself to the world as a lazy, foppish aristocrat, he is quick to change into his black costume with matching cape and fight for the rights of the oppressed and powerless, leaving behind his trademark "Z" that he cuts with his sword **c :** played on screen by heartthrobs *such as* Douglas Fairbanks, Jr., Guy Williams, and Antonio Banderas

zygomatic major muscle \ˌzī-gə-'ma-tik-'mā-jər-'mə-səl\ *n* the main lifting mechanism of the upper lip that allows a person to smile

zzzzzz \zzzzzz\ *n* the sound a satisfied person makes upon falling asleep after making love – see *AAH*

finis

ABBREVIATIONS IN THIS WORK

adj	adjective	**E**	east/eastern	**min**	minute	**sec**	second
adv	adverb	**esp**	especially	**mpg**	miles per gallon	**sq**	square
aka	also known as	**ft**	feet	**N**	north/northern	**syn**	synonym
ant	antonym	**gal**	gallon	**n**	noun	**tbsp**	tablespoon
b	born	**in**	inch	**oz**	ounce	**tsp**	teaspoon
c	century	**interj**	interjection	**pop**	population	**usu**	usually
ca	circa	**lb**	pound	**prep**	preposition	**var**	variation
conj	conjunction	**m**	meter	**pt**	pint	**vb**	verb
dir	director	**mi**	mile	**S**	south/southern	**W**	west/western

ACKNOWLEDGMENTS

I'd like to thank the poets, authors, song-writers, scientists, behaviorists, artists, Internet strangers, and others whose interpretations of love I've drawn upon, quoted, paraphrased, twisted, and learned from. I'd like to thank everyone whose heart has ever soared, been broken, or given away. I'd like to thank those who told me intimate things I didn't know, especially Natasha Khandekar, Sean McCabe, Mark Richardson, Jennifer Lee, and Ted Southwick. I'd like to thank my blue Doberman, Monty, who was there at the beginning, though not at the end. Love does indeed have four legs and floppy ears. Lastly, and mostly, I'm indebted to my editor, Jennifer Dixon, who let me get away with nothing and everything at the same time. I thank her for her expertise and judgment, chapter by chapter. From chapters A through Z, everyone here has made my definitions possible. JOHN STARK